Mauritshuis

General Catalogue

J.M. Meulenhoff bv, Amsterdam
in cooperation with The Mauritshuis, The Hague

COLOFON

COMPILATION
Nicolette Sluijter-Seijffert, with the assistance of Rieke van Leeuwen, Jim van der Meer Mohr and Michiel Plomp.
Marjolein de Boer and Ben Broos (Appendix).

Copyright © 1993 J.M. Meulenhoff bv, Amsterdam and the Mauritshuis, The Hague.

Copyright illustrations © 1993 by the Mauritshuis, The Hague.
All rights reserved. No part of the contents of this book may be reproduced in any form, without the prior written permission from the publishers.

ISBN 90 290 4033 5
J.M. Meulenhoff bv, Amsterdam

DESIGN
Ton Ellemers, Amsterdam

TRANSLATION
Michael Hoyle, Amsterdam
Jennifer Kilian & Katy Kist, Amsterdam (Appendix)

TYPESETTING
Zetcentrale Meppel bv, Meppel

LITHOGRAPHY
Fotolitho Boan b.v., Utrecht

PRINTING
De Lange/Van Leer b.v., Deventer

BINDING
Binderij Callenbach b.v., Nijkerk

MAURITSHUIS *Illustrated General Catalogue*

Illustrated

Contents

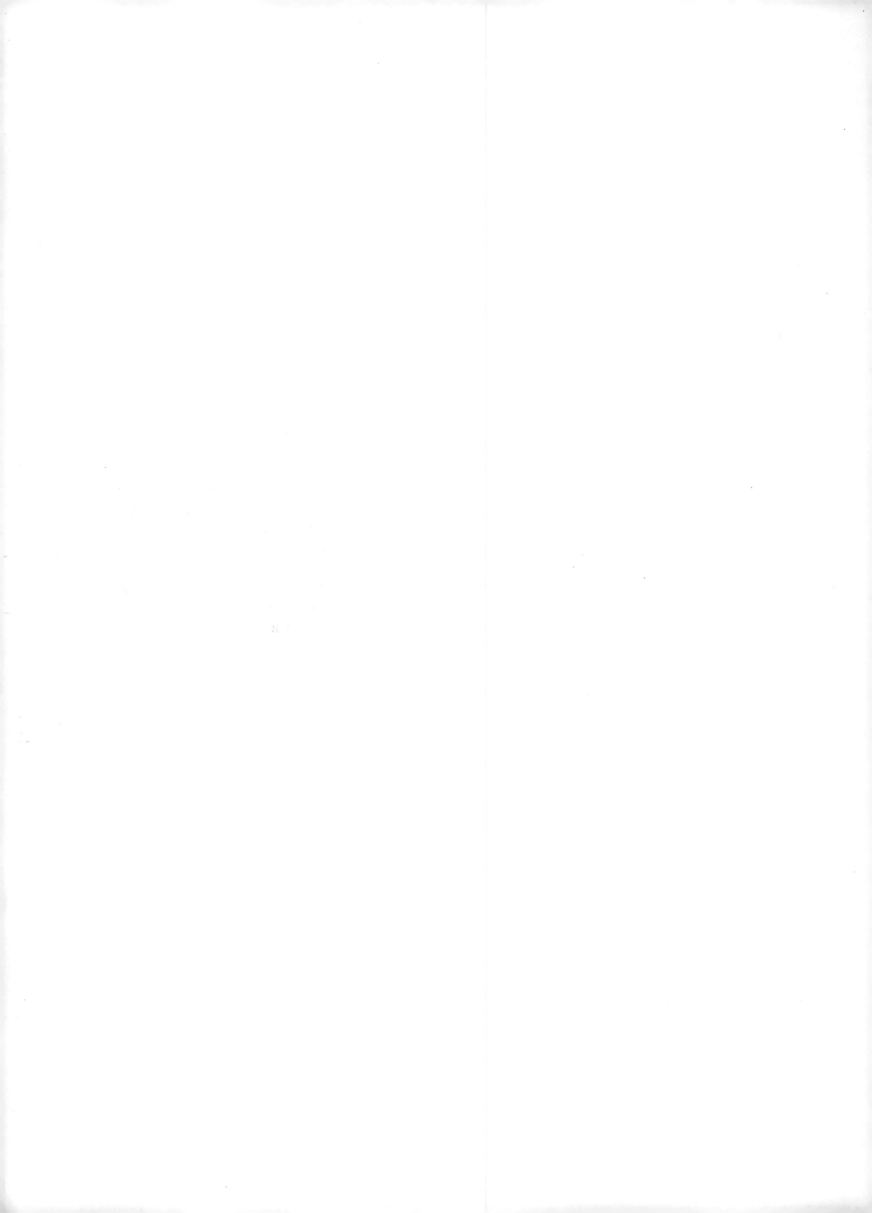

Preface

In 1977 the Mauritshuis published its *Illustrated General Catalogue*. It was the first complete and fully illustrated catalogue of the museum and included principal data on the works of art and their authors. Unfortunately, this publication is no longer available. A modified version of the catalogue appeared in 1985 as an appendix to the extensive volume *The Royal Picture Gallery 'Mauritshuis'* in the series *Art Treasures of Holland*. Nevertheless, for some time the Mauritshuis has felt an obligation to its visitors to publish an updated edition of the *Illustrated General Catalogue*. The present catalogue is meant to satisfy this need. While it is basically a reprint of the 1985 appendix, a number of essential modifications have been introduced. Apart from the correction of a few serious errors, the acquisitions and permanent loans that have entered the collection since 1985 are included in a supplement. These additions and corrections have been incorporated in the indices and bibliography. A further change is the inclusion of 16 colour reproductions of some of the most important paintings in the collection.

Since the publication of the 1977 catalogue, many colleagues have provided us with valuable new information on the works of art in the Mauritshuis. Grateful use has been made of that scholarship for the 1985 and present editions. We are particularly indebted to Mrs M.E. Tiethoff-Spliethoff, Messrs S.M. Bailey, F.J. Duparc Sr †, J. Foucart, P. Gatacre, J. Murrell and P. Rosenberg. Finally I would like to express my thanks to J.M. Meulenhoff bv, our publishers.

We hope that this catalogue will serve all those interested in the arts, amateurs and professionals alike, in becoming better acquainted with the collection, and thus enable them to enjoy more fully the art treasures in the Mauritshuis.

F.J. Duparc
The Hague, April 1993

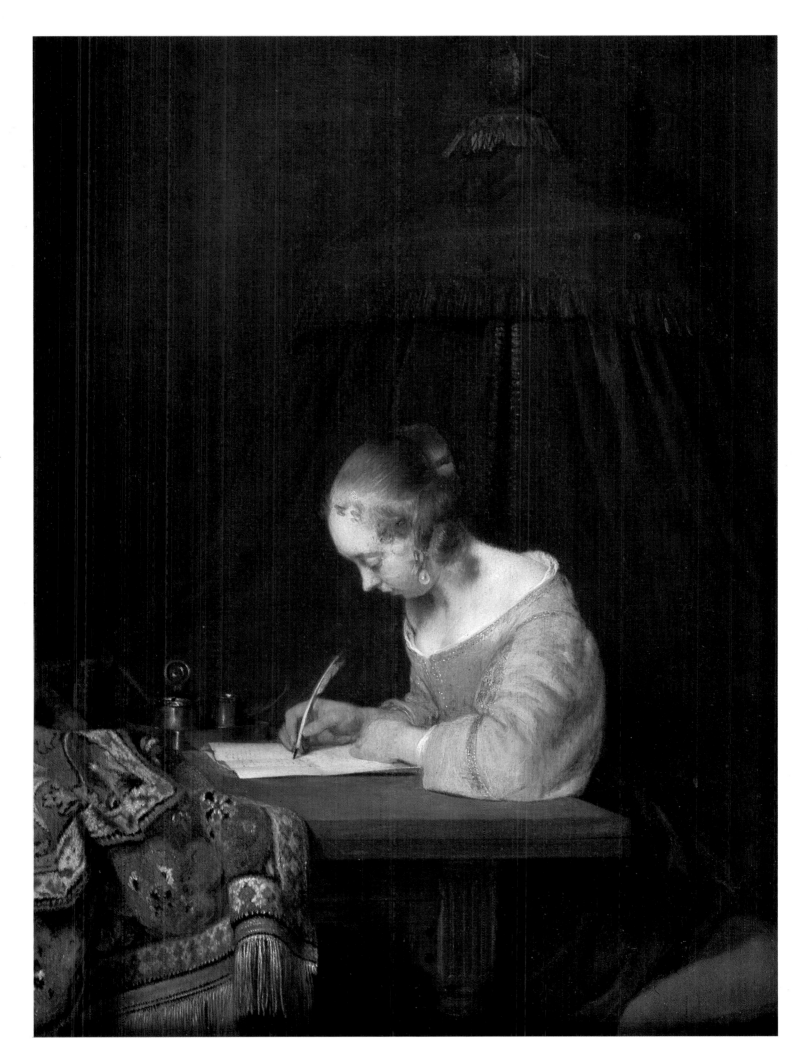

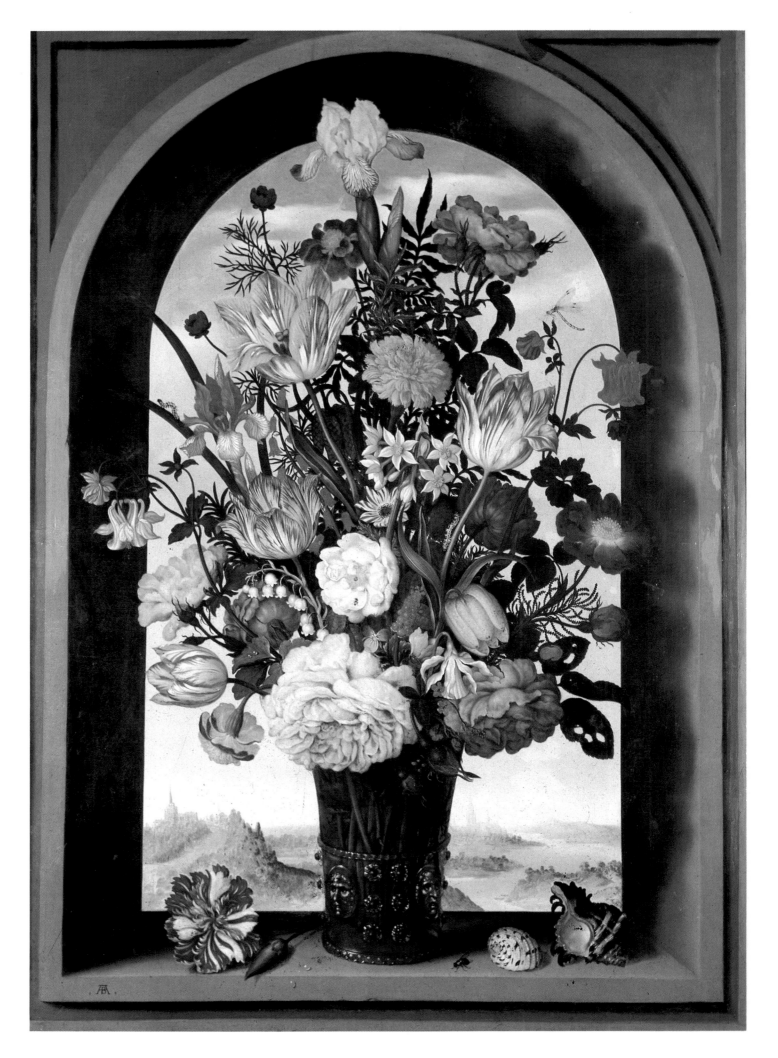

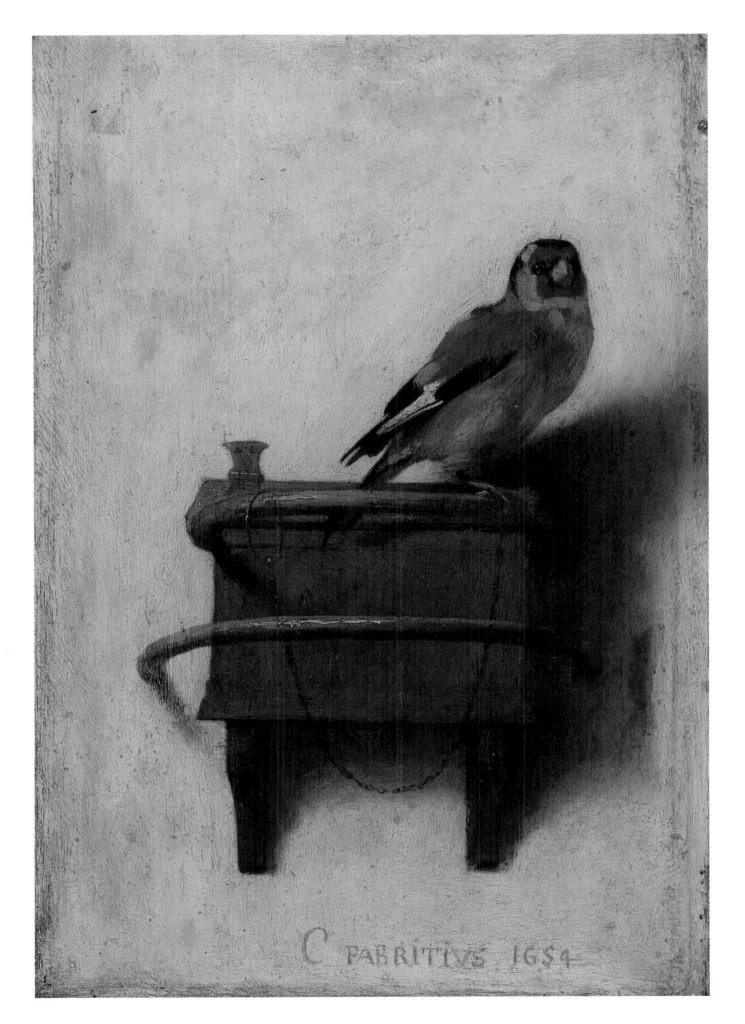

LEFT: Ambrosius Bosschaert the Elder, *Vase with flowers* Carel Fabritius, *The goldfinch*

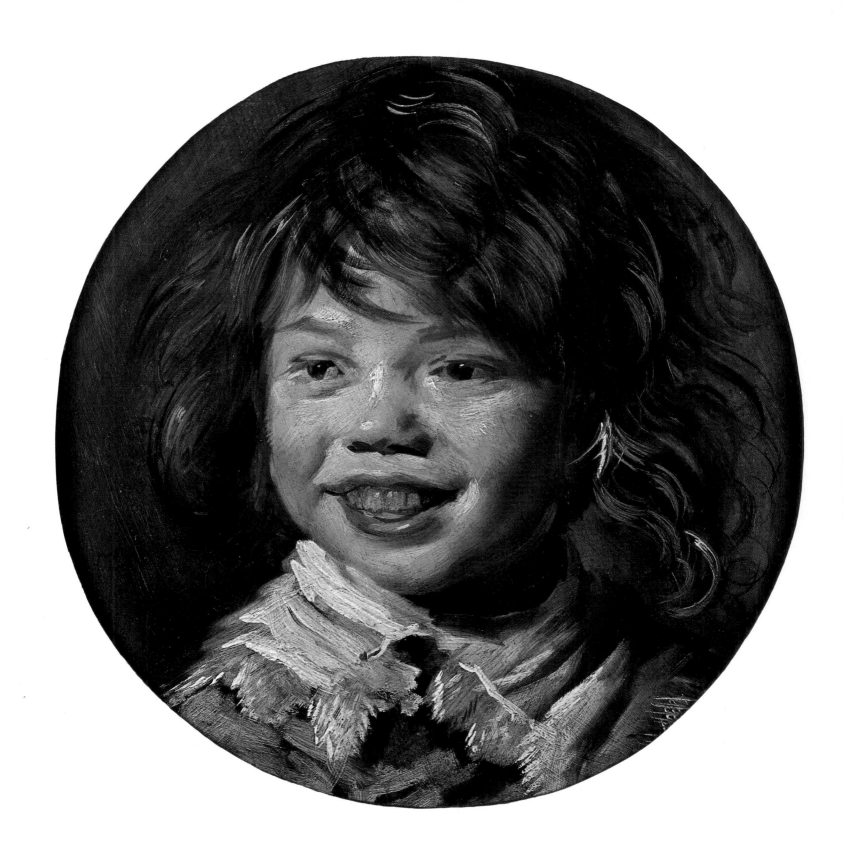

Frans Hals, *Laughing boy*

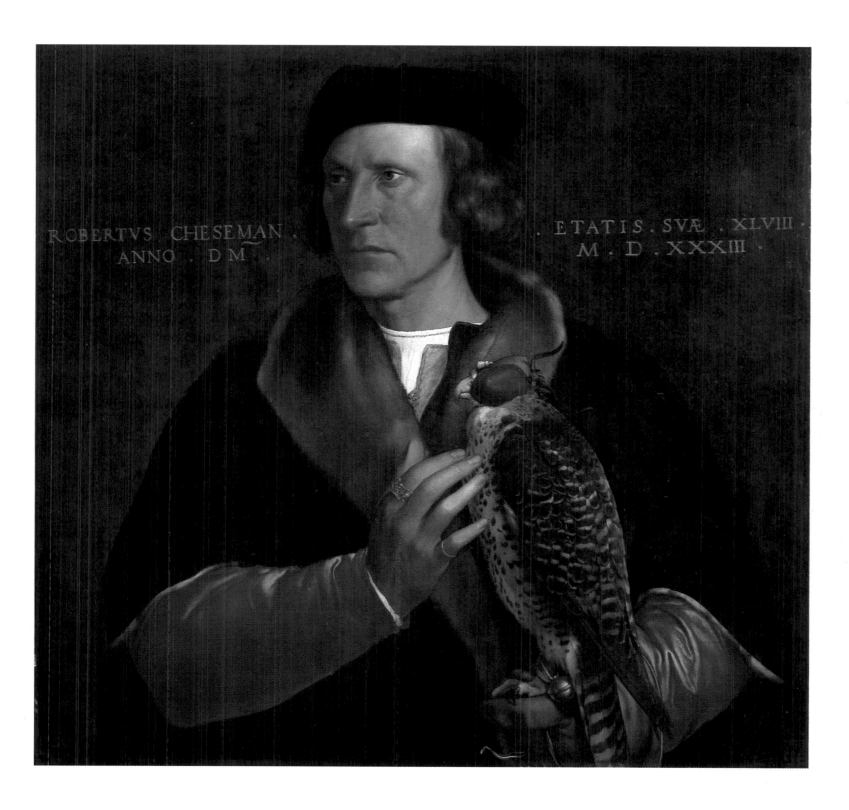

Hans Holbein the Younger, *Portrait of Robert Cheseman*

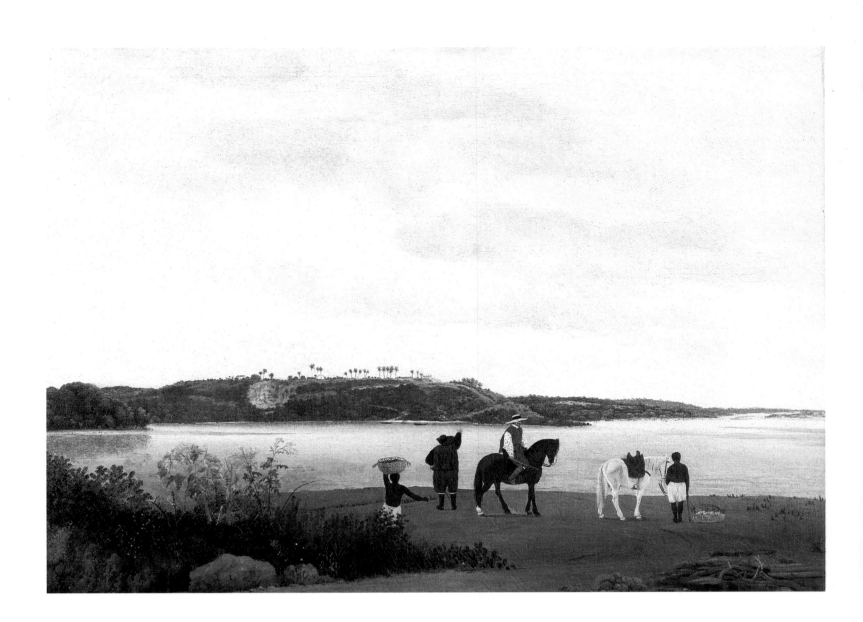

Frans Post, *Itamaraca Island, Brazil*

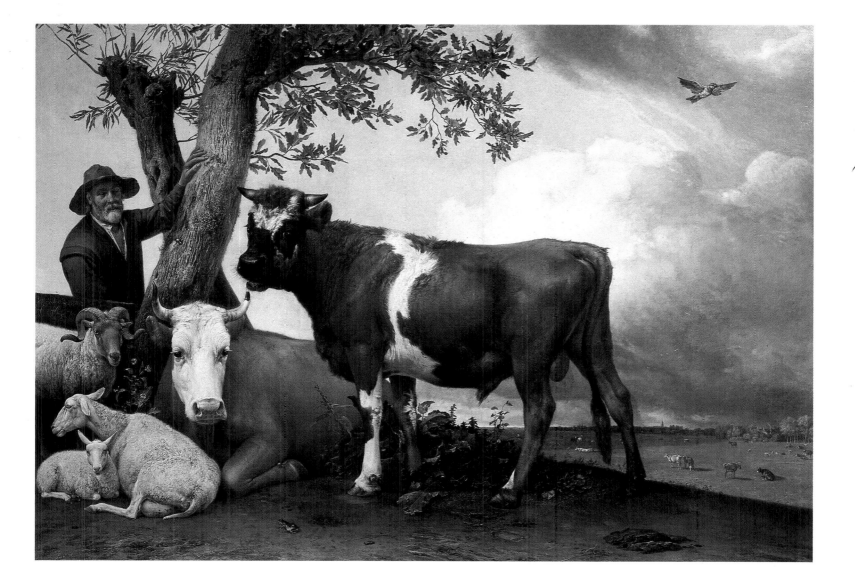

Paulus Potter, *The young bull*

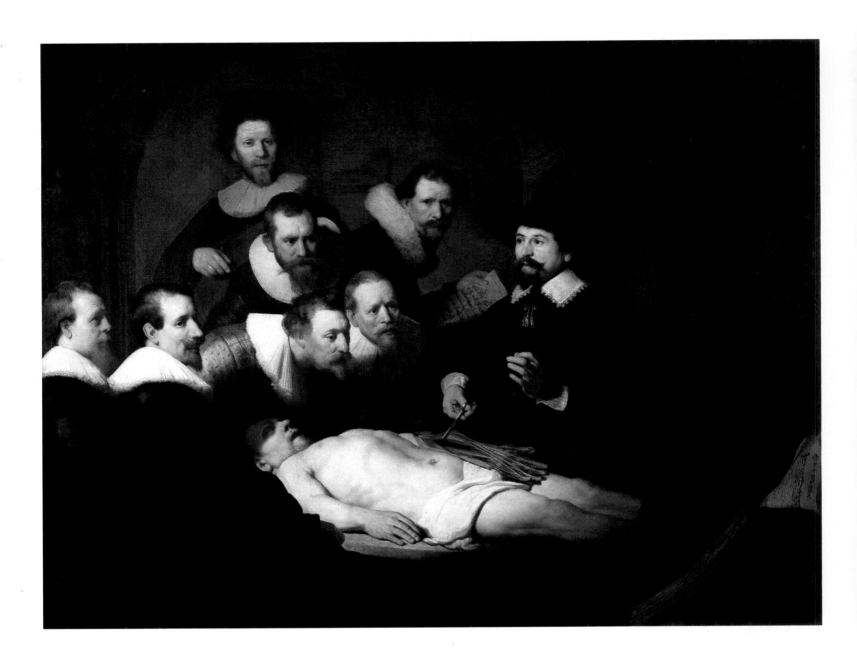

Rembrandt van Rijn, *The anatomy lesson of Dr Nicolaas Tulp*

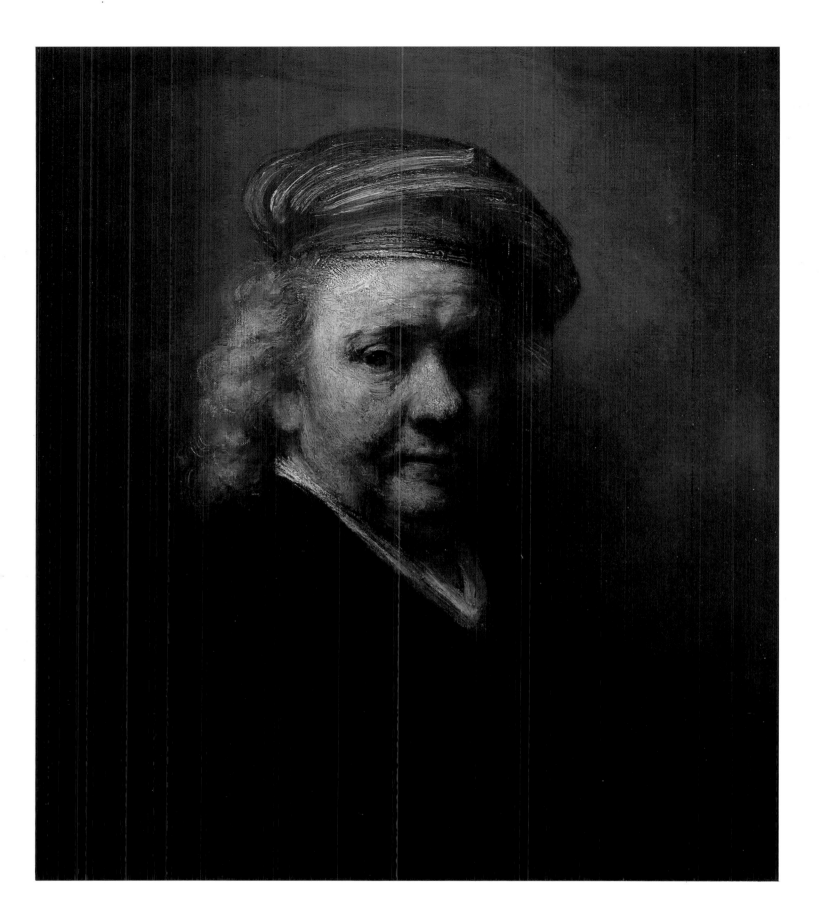

Rembrandt van Rijn, *Portrait of the artist as an old man*

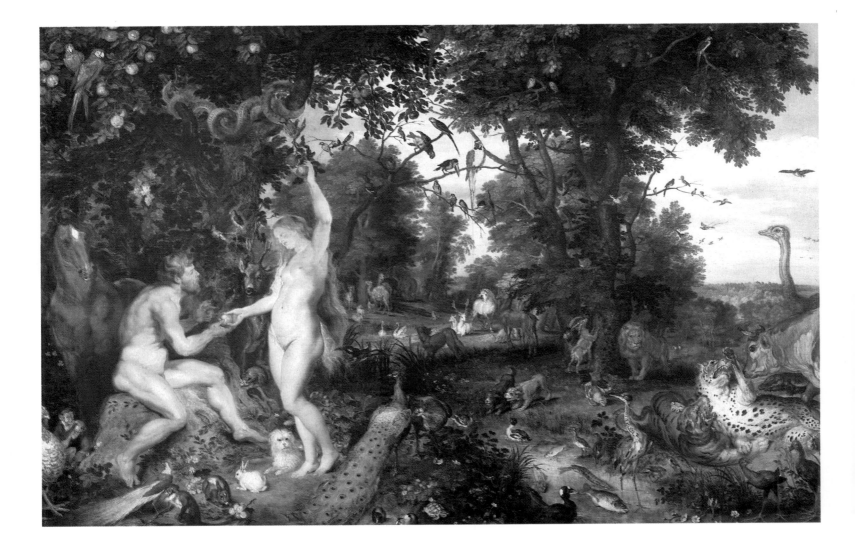

Peter Paul Rubens and Jan Brueghel the Elder, *Adam and Eve in Paradise*

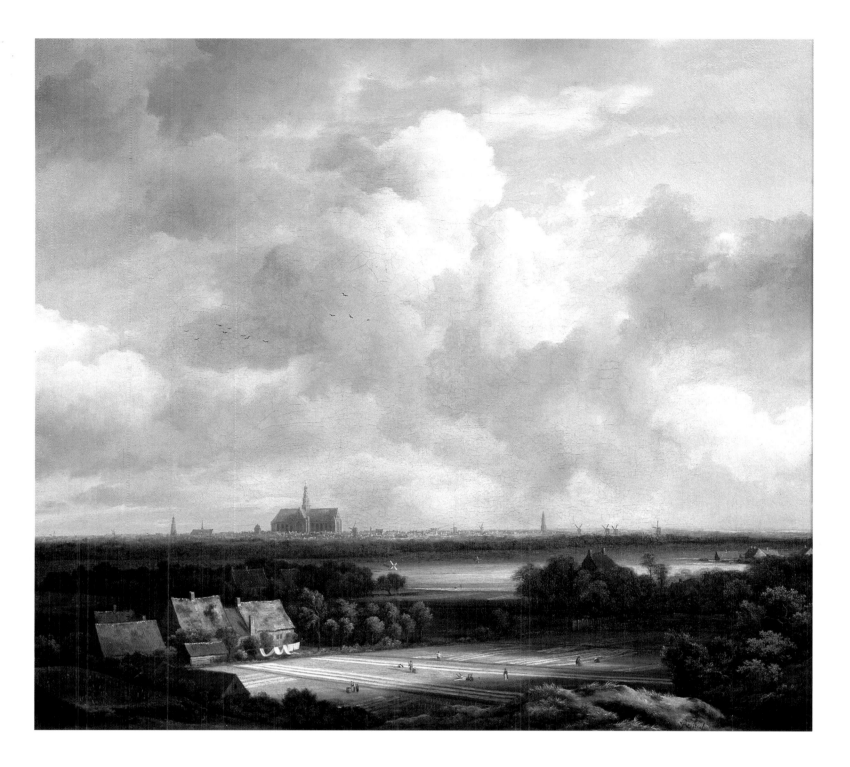

Jacob van Ruisdael, *View of Haarlem with bleaching grounds*

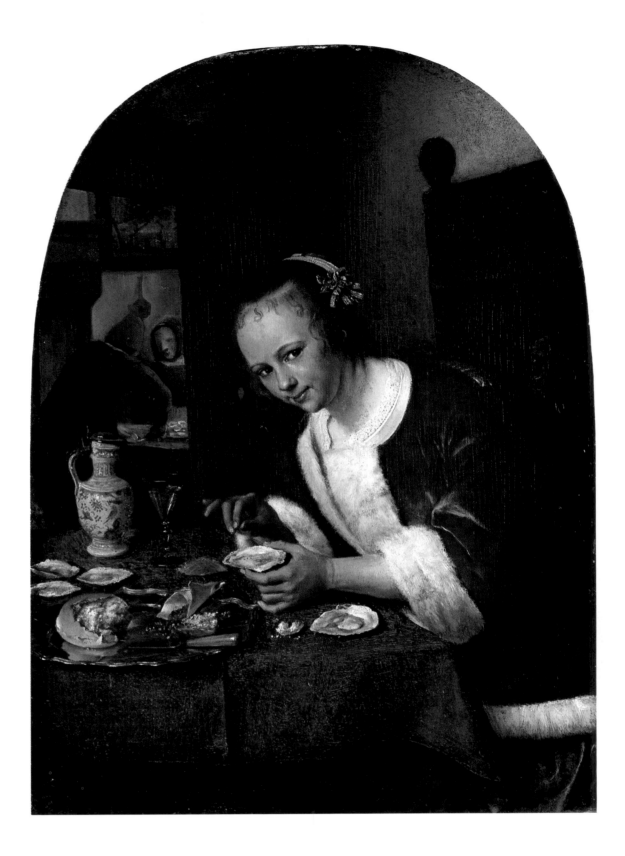

Jan Steen, *Girl eating oysters*

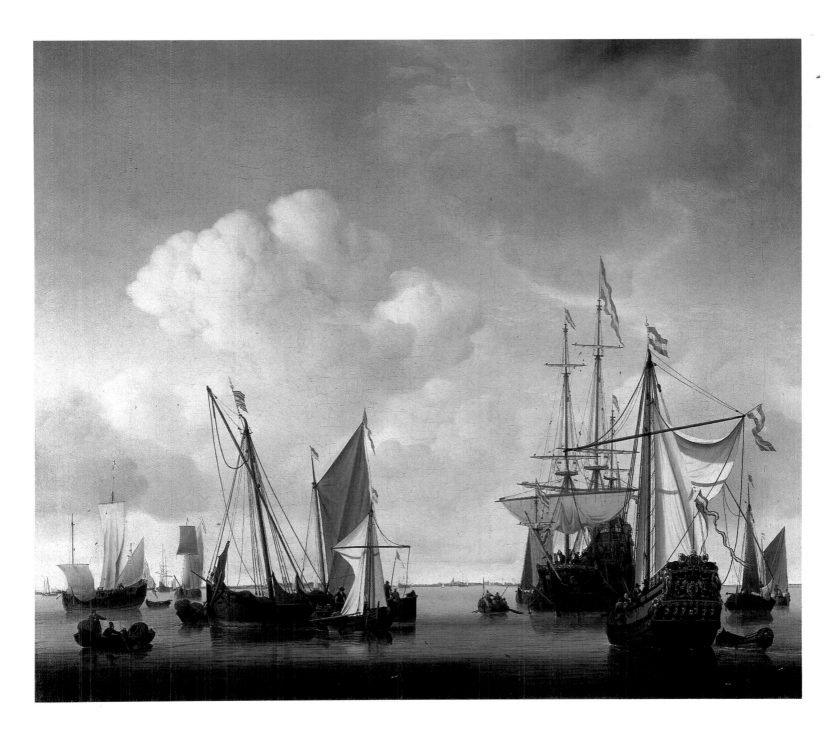

Willem van de Velde the Younger, *Ships in the roads*

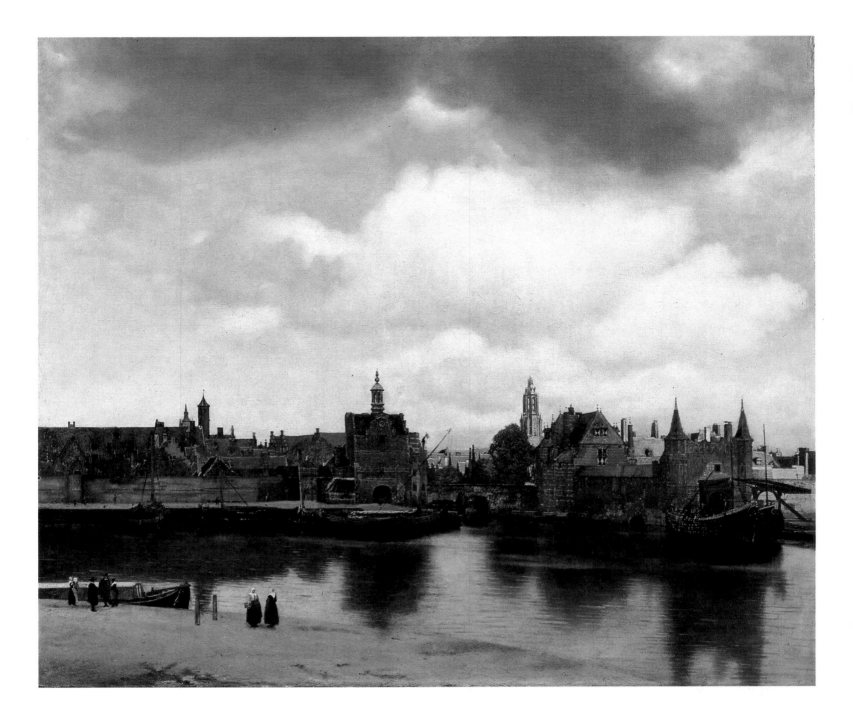

Johannes Vermeer, *View of Delft*

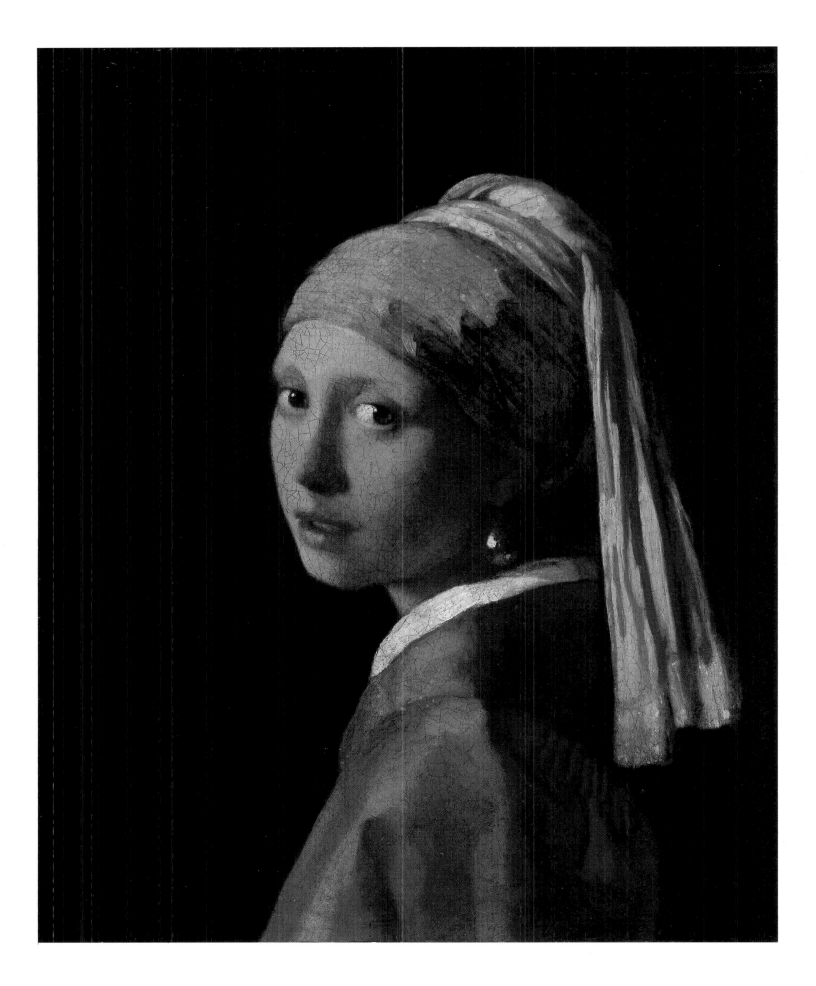

Johannes Vermeer, *Head of a girl*

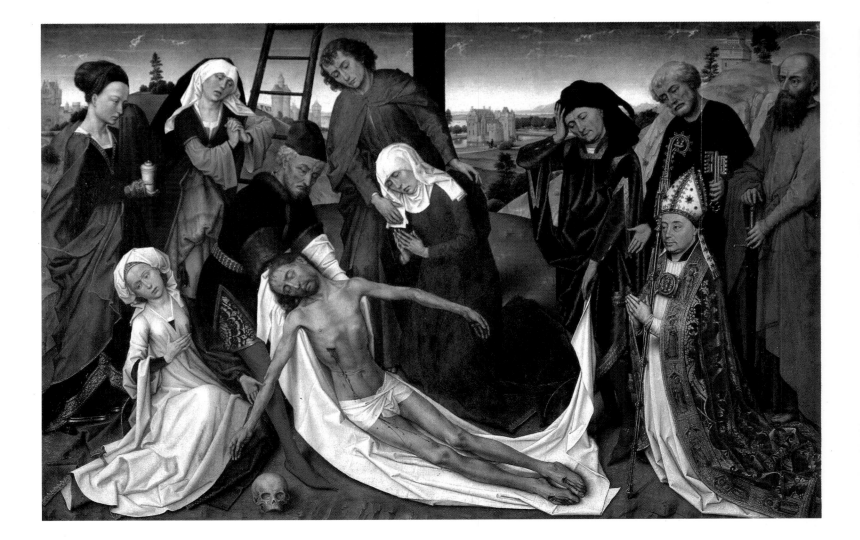

Rogier van der Weyden, *The lamentation of Christ*

Note

This *Concise catalogue* is based on the *Illustrated general catalogue* of 1977, but has been expanded and modified to bring it into line with the latest art-historical views. The main body of the catalogue consists of an alphabetical listing of artists with their works. The inventory numbers are only in sequence within an artist's entry, his name being repeated in the form of a ▪ .

Works which can not be safely attributed to an artist, works from his school, and copies, are given in order of inventory number after the attributable works.

The entries are arranged as follows: artist's name (in bold), title of the work (italics), brief biography (after the first entry), support, dimensions in centimetres (height before width), signature.

Selected data on the provenance is marked ▪. Selected literature is preceded by a •. Literature cited more than once in the catalogue is given in abbreviated form; for the full title see 'Key to Abbreviated Literature'. Finally, ▸ indicates additional information on the work in question.

There are separate sections for masters with acquired names and monogrammists.

'Anonymous Paintings' are ranked first by country (not by city or region) and then by inventory number. Anonymous miniatures and sculptures are dealt with in the same way.

'Changed Attributions' lists those works which have been reattributed since 1977. They are arranged alphabetically by the name given in the 1977 catalogue.

Artists who contributed to a work by another master will be found in the 'Collaborators' section. For example, the figures in Gerrit Berckheyde's *The Hofvijver, The Hague* were painted by Jan van Hughtenburgh. The painting is catalogued under Berckheyde, while Van Hughtenburgh is listed as a collaborator with a reference to inv.no 690, Berckheyde. Where two artists contributed on a more or less equal basis there is a cross-reference in the main body of the catalogue.

A further refinement is the list of inventory numbers. The missing numbers are either those of works lost during the Second World War, or of works which have been returned to the original lenders. The former are listed in the 1977 *Illustrated general catalogue*.

2

Willem van Aelst | *Flower still life*

Born 1627 in Delft, died ca 1683, probably in Amsterdam. Pupil of his uncle E. van Aelst, Delft, and of O. Marseus van Schrieck, Florence. In France and Italy from 1645 to 1656.

Canvas, 62.5x49. Signed and dated: *Guillmo. van Aelst. 1663.*
■ Het Loo, 1763; Cabinet Prince Willem V.
● BERGSTRÖM 1956, p. 223, fig. 186; BOL 1969, p. 326; PARIS 1970-71, p. 3, no 1; DROSSAERS & LUNSINGH SCHEURLEER 1974-76, II, p. 644, no 110, III, p. 203, no 2; AMSTERDAM 1982, pp. 50, 100, no 55, ill.

3

■ | *Still life with dead game*

Canvas, 58.8x47.8. Signed and dated: *Guillmo. van Aelst. 1671.*
■ unknown.

836

Pieter Aertsen | *The crucifixion*

Born 1509 in Amsterdam, died there in 1575. Pupil of A. Claesz. Joined the Antwerp guild of St Luke in 1535. Left in 1555/56 to return to Amsterdam.

Panel, 27.6x26.7.
■ coll. L. Ruzicka, Zürich; donated by Mr and Mrs Lugt-Klever, 1947.
● J. Bruyn, *Master Drawings* 3 (1965), pp. 360, 366, note 13; J. de Coo, *Jahrbuch der Rheinischen Denkmalpflege* 27 (1967), pp. 254-256, fig. 239; CAT. MAURITSHUIS 1968, p. 5, ill.; J. Bruyn, O.H. 84 (1969), p. 80; CAT. MAURITSHUIS 1970, no 6, ill.
► Whether the painting has to be attributed to Aertsen or Beuckelaer is uncertain.

723

Gerrit Alberts, Attributed to | *Portrait of a man, probably Mathias Lambertus Singendonck (1678-1742), burgomaster of Nijmegen.*

Born 1663 in Nijmegen, died there in 1757. Influence of the work of Sir G. Kneller.

Canvas, 79x63 (oval).
■ bequest of Miss M.J. Singendonck, The Hague, 1907.
► Has entered previous catalogues as Dutch School.

Antonio Allegri, see *Correggio.*

1045

Pieter van Anraadt | *Still life with jug and a glass of beer*

Born prior to 1640 in Utrecht, died 1678 in Deventer. Worked in Deventer from 1660 on. His portraits are influenced by G. ter Borch, who also worked in Deventer at that time.

Canvas, 67x58.8. Signed and dated: *Pieter van / van Anraadt / An. 1658.*
■ coll. Vitale Bloch, The Hague; coll. C. Norris, Polesden Lacey; coll. Sidney van den Bergh, Wassenaar; purchased with the aid of the Johan Maurits van Nassau Foundation and the Rembrandt Society in 1972.
● VROOM 1945, pp. 170, 171, fig. 154, p. 197; A.B. de Vries, *De verzameling Sidney van den Bergh,* Wassenaar 1968, p. 12, ill.; BERNT 1969-70, I, no 15, ill.; BOL 1969, p. 81, fig. 69; BERGSTRÖM 1977, p. 173, ill.; H.R. Hoetink, *Boymans Bijdragen,* Rotterdam 1978, pp. 104-110, fig. 1; VROOM 1980, I, pp. 120-121, fig. 160, II, p. 9.

950

Jan Asselijn | *Imaginary Italian landscape*

Born ca 1615/20 in Dieppe or Diemen, died in 1652 in Amsterdam. Influenced by E. van de Velde. Stayed in Rome. Married in Lyons in 1644, worked till 1646 in Paris.

Canvas, 52.5x45. Signed: *JA.F.*
■ coll. Graf Czernin, Vienna; kunsth. A. Brod, London; purchased by the Johan Maurits van Nassau Foundation, 1962; on permanent loan from the Johan Maurits van Nassau Foundation, 1962.
● CAT. MAURITSHUIS 1970, no 42, ill.; STELAND-STIEF 1971, p. 93, no 206, p. 158, fig.LXIII; CAT. MAURITSHUIS 1980, pp. 1-2, 145, ill.; A.C. Steland-Stief, O.H. 94 (1980), p. 242, fig. 40.
► The round building seems to have been inspired by the tomb of Cecilia Metella in Rome.

399

Balthasar van der Ast | *Shells*

Born 1593 or 1954 in Middelburg, died 1657 in Delft. Influenced by his brother-in-law and master A. Bosschaert. Worked in Utrecht from 1619, in Delft from 1632.

Copper, 7.8x12.5.
■ purchased in 1876.
● BOL 1960, p. 80, no 81.

1066

■ | *Fruit still life*

Panel, 46x64.5. Signed and dated: *B. van der Ast fe 1620.*
■ coll. H. Girardet, Kettwig, Germany; kunsth. P. de Boer, Amsterdam; purchased with the aid of the Rembrandt Society in 1983.
● L.J. Bol, O.H. 70 (1955), p. 153, no 23, fig. 5; AMSTERDAM 1983 (2), p. 108, no 12, ill.; JAARVERSL. VER. REMBRANDT 1983, pp. 94-95, ill.

461

Jacques André Joseph Aved | *Portrait of Willem IV, Prince of Orange-Nassau (1711-1751)*

Born 1702, probably in Douai, died 1766 in Paris. A pupil of B. Picart, Amsterdam, and later of A.S. Belle. Worked in Paris and from 1751 to 1753 in The Hague.

Canvas, 113x87.5. Signed and dated: *J. Aved f. 1751.*
■ probably Nationale Konst-Gallery, The Hague, 1806.
● G. Wildenstein, *Le peintre Aved*, Paris 1922, II, pp. 60-62, nos 40-42; STARING 1947, p. 23.
► Posthumous portrait. There is a replica in the Rijksmuseum, Amsterdam, and a copy in Het Loo Palace.

785

Hendrick Avercamp | *Winter scene*

Born 1585 in Amsterdam, died 1634 in Kampen. Worked in Amsterdam and from ca 1614 in Kampen.

Panel, 36x71. Signed: *HA.*

■ coll. Snouck van Loosen, Enkhuizen; purchased by the Rijksmuseum, Amsterdam, 1886, inv.no A1320; on loan from the Rijksmuseum, Amsterdam, since 1924.
● E. Haverkamp-Begemann, O.K.2 (1958), no 1, ill.; PLIETZSCH 1960, p. 86, fig. 144; BERNT 1969-70, I, no 36, ill.; CAT. RIJKSMUSEUM 1976, p. 91; C.J. Welcker, D.J. Hensbroek-van der Poel, *Hendrick en Barent Avercamp*, Doornspijk 1979, p. 206, no S 16, ill. XVI, pl. IV; CAT. MAURITSHUIS 1980, pp. 4, 146, ill.; A. Blankert et al., *Hendrik Avercamp, 1585-1634, Barent Avercamp, 1612-1679: Frozen silence,* Amsterdam (Waterman Gallery) 1982, pp. 80-81, no 5, ill.

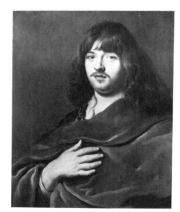

543

Jacob Adriaensz. Backer | *Portrait of a man*

Born 1608 in Harlingen, died 1651 in Amsterdam. A pupil of L. Jacobsz., Leeuwarden. He worked for the rest of his life (from ca1632) in Amsterdam.

Panel, 71x60.5.
■ purchased in 1888 (as a self-portrait by F. Bol).
● BAUCH 1926, p. 92, no 166; SUMOWSKI 1983, p. 197, no 34, ill.

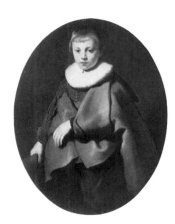

747

 | *Boy in grey*

Canvas, 94x71 (oval). Signed and dated: *I: Debacker 1634.*
■ coll. Steengracht, The Hague; donated to the museum in 1914 by Mrs C.A. Rose-Molewater.
● BAUCH 1926, pp. 92-93, no 167, ill.; ROSENBERG, SLIVE & KUILE 1977, p. 150, fig. 106; SUMOWSKI 1983, p. 200, no 52, ill.

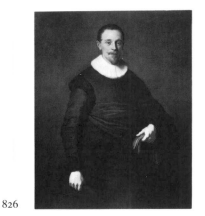

826

■ | *Portrait of a man*

Canvas, 127x99.
■ donated by E.J. Philips, The Hague, 1939.
● *John G. Johnson Collection: Flemish and Dutch paintings*, Philadelphia 1972, p. 3, no 484; BLANKERT 1982, no R 167; SUMOWSKI 1983, p. 201, no 58, ill.
▶ Has formerly been attributed to G. Flinck and F. Bol.

1057

■ | *Half-figure of a shepherd with a flute*

Panel, 50.8x39.4. Signed: *JAB.*
■ coll. Reedtz-Thott, Gavnoe Castle, Denmark; R. Noortman Gallery, London; purchased in 1977.
● BAUCH 1926, pp. 37, 84, no 86, ill.; KETTERING 1983, p. 78, fig. 101; SUMOWSKI 1983, p. 197, no 36, ill.; ROME 1983, pp. 8, 21, no 1, p. 87, ill.
▶ Formerly believed to be a self-portrait, but this is probably incorrect.

5

Johannes de Baen | *Portrait of Johan Maurits, Count (later Prince) of Nassau Siegen (1604-1679), Governor of Brazil (1636-1644), founder of the Mauritshuis*

Born 1633 in Haarlem, died 1702 in The Hague. Pupil of his uncle H. Pieman, Emden, and of J. Backer, Amsterdam. Spent a short time in London as court painter. Worked in The Hague from 1660 onwards.

Canvas, 157.2x114.
■ purchased in 1820 by King Willem I.
● MARTIN 1935-36, II, p. 164, fig. 86.
► One of the many replicas of this portrait in existence.

454

■ | *Allegory on Cornelis de Witt as prime mover of the victory at Chatham (1667)*

Canvas, 66x99.
■ donated by W. Hoog, 1879.
● R. van Luttervelt, BULL. R.M. 8 (1960), pp. 49-51.
► Copy after a large commemorative painting in the town hall of Dordrecht, which was destroyed during the riots in 1672. A model for or a replica of the original work is in the Rijksmuseum, Amsterdam, inv.no A4648.

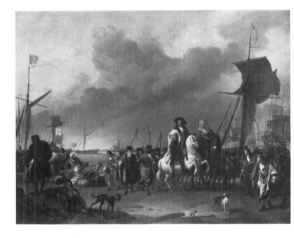

6

Ludolf Bakhuysen | *The arrival of Prince Willem III at Oranjepolder in January 1691*

Born 1631 in Emden, died 1708 in Amsterdam. Pupil of A. van Everdingen and H. Dubbels. Worked in Amsterdam from 1649 on.

Canvas, 53.5x67.5 Signed and dated: *1692 L. Bakhuis*.
■ Het Loo, 1763; Cabinet Prince Willem v.
● HOFSTEDE DE GROOT 1907-28, VII, p. 243, no 23; PRESTON 1974, p. 4;
DROSSAERS & LUNSINGH SCHEURLEER 1974-76, II, p. 641, no 40, III. p. 206,
no 14; NEW YORK 1979, no 60, ill.
► A preliminary drawing at Windsor Castle, as J. de Bisschop.

8

■ | *The dock of the Dutch East India Company at Amsterdam*

Canvas, 126x140. Signed and dated; *LBakhuiz 1696*.
■ transferred to the museum by the Ministry of Colonial Affairs, 1842; on loan to the Amsterdams Historisch Museum since 1956.
● HOFSTEDE DE GROOT 1907-28, VII, pp. 255-256, no 71; A. Blankert, *Amsterdams Historisch Museum: Schilderijen daterend van voor 1800: voorlopige catalogus*, Amsterdam 1975-79, p. 28, no 29.

782

Alexander Hugo Bakker Korff | *'La fille du héros'* (formerly: *The Warrior*)

Born 1824 in The Hague, died 1882 in Leiden. Pupil of C. Kruseman; studied at the academies of The Hague and Antwerp.

Panel, 56x80. Signed and dated: *A.H. Bakker Korff 1875*.
■ bequest of Mrs C.A. Rose-Molewater, 1923.
● CAT. LAKENHAL 1983, p. 62, no 22, ill.; on loan to the Stedelijk Museum Lakenhal, Leiden, since 1923.
► A preliminary drawing in the Stedelijk Museum Lakenhal, Leiden, inv.no. 988.

234

Hendrick van Balen | *Naiads filling the horn of plenty*

Born 1575, probably in Antwerp, died there in 1632. Visited Italy ca 1600, where he could have met H. Rottenhammer in Venice. Travelled to Holland with Rubens and J. Brueghel between 1611/12 and 1616.

Panel, 67.5x107.

- Het Loo, 1763; Cabinet Prince Willem V.
- I. Jost, N.K.J. 14 (1963), p. 125, note 128; DROSSAERS & LUNSINGH SCHEURLEER 1974-76, II, p. 644, no 103, III, p. 214, no 54; ERTZ 1979, p. 390.
- Formerly attributed to Rubens. The landscape and the fruit are by the school of J. Brueghel.

898

Jacopo de' Barbari | *Portrait of Hendrik, Duke of Mecklenburg (1479-1552), called 'Der Friedfertige'*

Born ca 1440 in Venice, died prior to 1515 in Mechelen. Worked at several princely courts in Germany and Flanders after 1500.

Panel, 59.3x37.5. Inscribed: *Henricv refero dvce megapolese, Magni filivm annos natv, octo et vigiti M.D.VII, a natali christiao, calendis, maiis.*
- coll. J.C.H. Heldring, Amsterdam; kunsth. J. Goudstikker, Amsterdam; tranferred to the Mauritshuis by the Rijksdienst Beeldende Kunst, 1960.
- L. Servolini, *Jacopo de' Barbari*, Padua 1944, pp. 61, 145-146, fig. XXXIX; CAT. MAURITSHUIS 1968, pp. 7-8, ill.; BASLE 1974, no 3, fig. 5; *Martin Luther und die Reformation in Deutschland*, Germanisches Nationalmuseum, Nuremberg 1983, p. 136, no 155, ill.
- Several copies known.

9

Bartholomeus van Bassen | *Interior of a Catholic church*

Born ca 1590, probably in Antwerp, died 1652 in The Hague. Worked in Delft in 1613, and in The Hague from 1622 on. Styled himself after the Steenwijcks. E. van de Velde, F. Francken II and A. Palamedesz painted staffage figures in his paintings. It is likely that G. Houckgeest was his pupil.

Canvas, 61x83. Signed and dated: *B. van Bassen 1626.*
- Oranienstein Castle, 1726; Cabinet Prince Willem V.
- MARTIN 1935-36, I, pp. 274-275, fig. 158; DROSSAERS & LUNSINGH SCHEURLEER 1974-76, II, p. 371, no 343, III, p. 203, no 3; JANTZEN 1979, p. 62, no 39, fig. 21.
- Some of the figures may be by E. van de Velde.

10

Adriaen Cornelisz. Beeldemaker, Attributed to | *Fox Hunt*

Born 1618 in Rotterdam, died 1709 in The Hague. Except for two brief periods in Leiden (1650-1651 and 1673-1675) worked in The Hague.

Canvas, 59.5x85.5.
- uncertain.
- Recently convincingly attributed to C.B.A. Ruthard (1630-? after 1703) by F. Meyer, The Hague.

541

Sybrand van Beest | *Hog market*

Born probably in The Hague ca 1610, died 1674 in Amsterdam. Pupil of P. van Veen, The Hague. Was co-founder of Pictura, the Hague artists' society. Moved to Amsterdam some time before 1670.

Panel, 44x68. Signed and dated: *S.vBeest 1638.*
- purchased in 1888.
- BERNT 1969-70, I, no 70, ill.; CAT. MAURITSHUIS 1980, pp. 5-6, p. 146, ill.

400

Cornelis Pietersz. Bega | *Peasant inn*

Born ca 1632 in Haarlem, died there in 1664. Travelled 1652/53 to Germany and Switzerland. Pupil of A. van Ostade.

Canvas, 47x58. Dated: *Ano.1658.*
- purchased in 1876.
- PHILADELPHIA 1984, p. 133, note 2.

30

391

Abraham Cornelisz. Begeyn | *The quarry*

Born ca 1630 in Leiden, died 1697 in Berlin. Mentioned in Leiden in 1655 and 1663, in Amsterdam in 1672 and in The Hague in 1681. Court painter in Berlin from 1688 on. Developed under the influence of C.P. Berchem and O. Marseus van Schrieck. He visited England and France.

Canvas, 67.5x81. Signed and dated: *A Begein 1660*.
■ purchased in 1876
● BERNT 1948-62, I, no 58, ill.; BOL 1969, p. 262, fig. 251; CAT. MAURITSHUIS 1980, pp. 6-7, 147, ill.; SALERNO 1977-80, II, p. 768.

11

Claes Pietersz. Berchem | *The childhood of Bacchus*

Born 1620 in Haarlem, died 1683 in Amsterdam. Pupil of his father, the still-life painter P. Claesz. and of C. Moeyaert, P. de Grebber, J. Wils and J. van Goyen. Influenced by J.B. Weenix. He probably stayed in Italy from 1653 to 1655. Upon his return he worked in Haarlem and in Amsterdam.

Canvas, 202x262. Signed and dated: *C Berrighem. 1648*.
■ purchased in 1827
● HOFSTEDE DE GROOT 1907-28, IX, p. 62, no 42; SCHAAR 1958, p. 28; ROSENBERG, SLIVE & KUILE 1977, p. 306; PARIS 1970-71, p. 11.

535

Jacob Adriaensz. Bellevois | *View of a river with ships*

Born ca 1621 in Rotterdam, died there in 1676. Worked in Rotterdam, in Gouda ca 1671, in Hamburg in 1672, then again in Rotterdam. Developed under the influence of S. de Vlieger and Julius Porcellis, Rotterdam.

Canvas, 106x122.5. Signed: *Jbellevois*.
■ in 1885 transferred from the Courthouse at The Hague (as Simon de Vlieger).
● F. Willis, *Die Niederländische Marinemalerei*, Leipzig (1911), p. 58, ill., pl. XIV; BERNT 1969-70, I, no 78, ill.; BOL 1973, p. 334, note 381; PRESTON 1974, p. 9; CAT. MAURITSHUIS 1980, pp. 7-8, 148, ill.

12

■ | *Wild boar hunt*

Canvas, 50.3x77.8. Signed and dated: *Berchem 1659*.
■ coll. W. Lormier, The Hague, 1754; coll. G. van Slingelandt, The Hague, 1768; Cabinet Prince Willem V.
● HOFSTEDE DE GROOT 1907-28, IX, p. 89, no 138; MARTIN 1950, p. 76, no 137, ill.; SCHAAR 1958, p. 59; DROSSAERS & LUNSINGH SCHEURLEER 1974-76, III, p. 204, no 6; CAT. MAURITSHUIS 1980, pp. 9, 149, ill.

13

■ | *Shepherds beside Roman ruins* (formerly: *Fording a brook*)

Canvas, 63.5x76.5. Signed and dated: *Berchem 1661*.
■ coll. P.L. de Neufville, Amsterdam, 1765; Cabinet Prince Willem V.

• HOFSTEDE DE GROOT 1907-28, IX, p. 157, no 370; SCHAAR 1958, p. 64; DROSSAERS & LUNSINGH SCHEURLEER 1974-76, III, p. 204, no 4; CAT. MAURITSHUIS 1980, pp. 9-10, 150, ill.; SALERNO 1977-80, II, p. 718, fig. 33.2.

14

■ | *Travellers attacked by brigands*

Canvas, 95.3x105. Signed: *Berchem*.
■ coll. G. Bicker van Zwieten, The Hague, 1741; purchased in 1816.
• HOFSTEDE DE GROOT 1907-28, IX, p. 84, no 122; SCHAAR 1958, p. 85; CAT. MAURITSHUIS 1980, pp. 10-11, 151, ill.

1058

■ + J.B. Weenix | *The calling of St Matthew*

Panel, 94.2x116. Signed: *Berchem gemaeckt, Weenix gedaen*.
■ coll. W. Lormier, The Hague, 1743; kunsth. R. Noortman, London; purchased in 1979 with the aid of the Rembrandt Society.
• HOFSTEDE DE GROOT 1907-28, IX, p. 58, no 24; F.J. Duparc, O.H. 94 (1980), pp. 37-43, ill.; WASHINGTON 1980-81, p. 198; SCHLOSS 1982, p. 12.

690

Gerrit Adriaensz. Berckheyde | *The Hofvijver, The Hague*

Born 1638 in Haarlem, died there in 1698. Pupil of his brother Job. Worked in Haarlem; visited Cologne and Heidelberg with his brother. Mainly painted views of Haarlem, The Hague and Amsterdam.

Canvas, 53.7x63.3. Signed: *Gerrit Berckheyde. Hughtenburgh.*
■ coll. J. van der Marck, Leiden, 1773; bequest of T.H. Blom Coster, The Hague, 1904.
• CAT. THYSSEN-BORNEMISZA 1969, p. 39; LEEUWARDEN 1979-80, p. 3, no 35, ill.
► Figures by J. van Hughtenburgh.

796

■ | *The Hofvijver, The Hague*

Canvas, 58x68.5. Signed: *gerret: Berck Heijde.*
■ coll. John Hope, Amsterdam, 1783; on loan since 1928; bequest of jhr W.A. van den Bosch, Vught, 1956.
• CAT. MAURITSHUIS 1970, no 48, ill.; J.W. Niemeijer, N.K.J. 32 (1982), p. 174, no 25.

746

Job Adriaensz. Berckheyde | *View of a Dutch canal* (formerly: *The Oude Gracht, Haarlem*)

Born 1630 in Haarlem, died there in 1693. Pupil of J.W. de Wet. Visited Germany. Worked in Haarlem from 1654 on.

Panel, 43.5x39.3. Signed and dated: *J. Berckheyd: 1666* (probably not authentic).
■ coll. G. van der Pals, Rotterdam, 1824; coll. Steengracht; purchased with the aid of the Rembrandt Society, 1913.
• FRITZ 1932, p. 84; MARTIN 1935-36, II, p. 396, fig. 208; H.P. Baard, O.K. 9 (1865), no 33, ill.; STECHOW 1966, p. 127, fig. 257; BERNT 1969-70, I, no 90, ill.; WAGNER 1971, pp. 23-24, 35; AMSTERDAM 1977, pp. 210-211, no 107, ill.; VRIES 1984, pp. 17-18, fig. 7.

671

Christoffel van den Berghe | *Winter scene*

Documented in Middelburg between 1619 and 1628. Follower of A. Bosschaert. Formerly known as Monogrammist C.V.B.

Copper, 11.5x16.5. Signed: *CVB*.
■ bequest of A.A. des Tombe, The Hague, 1903.
● L.J. Bol, O.H. 71 (1956), pp. 189-192; BOL 1969, pp. 106-107; BOL 1982, p. 9, fig. 7.
► Companion piece to no 672.

672

 | *Summer scene*

Copper, 11.5x16.5. Signed: *CVB*.
■ bequest of A.A. des Tombe, The Hague, 1903.
● L.J. Bol, O.H. 71 (1956), pp. 189-192; BOL 1969, pp. 106-107; BERNT 1969-70, I, no 103, ill.; BOL 1982, p. 9, fig. 8.
► Companion piece to no 671.

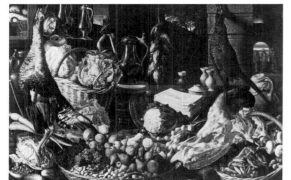

965

Joachim Beuckelaer | *Kitchen tableau with Christ at Emmaus*

Born ca 1530 in Antwerp, where he died in 1573. Inscribed as a master in the Antwerp guild of St Luke, 1560. Pupil of his uncle P. Aertsen.

Panel, 110x169.
■ on loan from the P. & N. de Boer Foundation, Amsterdam, since 1960.

● CAT. MAURITSHUIS 1968, p. 8, ill.; OSTEN & VEY 1969, p. 305; K.P.F. Moxey, *P. Aertsen, J. Beuckelaer, and the rise of secular painting in the context of the Reformation*, New York/London 1977, p. 100, fig. 58.
► Formerly attributed to P. Aertsen.

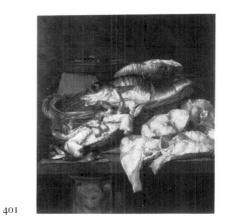

401

Abraham Hendricksz. van Beyeren | *Still life with seafood*

Born 1620 or 1621 in The Hague, died 1690 in Overschie. Thought to have been a pupil of P. de Putter. Worked in Leiden, The Hague, Delft, Amsterdam, Alkmaar and Overschie.

Canvas, 75.8x68. Signed: *AVBf*.
■ purchased in 1876.
● BERNT 1969-70, I, no 105, ill.

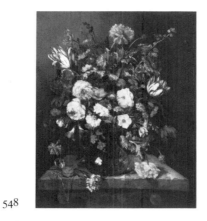

548

 | *Flower still life*

Canvas, 80x69. Signed: *AVBf*.
■ purchased in 1889.
● BERNT 1969-70, I, no 106, ill.; BERGSTRÖM 1977, p. 177, ill.

665

 | *Still life of fruit and precious objects* (formerly: *Ornamental still life*)

Panel, 98x76. Signed: *AVB*.

■ given on loan in 1902; bequest of A. Bredius, 1946.

959

678

■ | *Fish still life*

Canvas, 68x59.
■ bequest of A.A. des Tombe, 1903.

697

■ | *Still life with game and fowl*

Canvas, 79.5x68.
■ donated by L. Nardus, Arnouville, 1905.

1056

■ | *Banquet still life*

Canvas, 99.5x120.5. Signed: *A.B.f.*
■ Newhouse Gallery, New York; kunsth. S. Nystad, The Hague; purchased with the aid of the Rembrandt Society, 1977.
● JAARVERSL. VER. REMBRANDT 1977, pp. 46-48, ill.
▶ The artist has depicted himself in the reflection on the tankard in the foreground.

Herri met de Bles | *Paradise*

Born ca 1510 in Dinant or Bouvignes, died after 1555. Possibly the same as Herry de Patinier, who joined the Antwerp guild of St Luke in 1535 and who was a cousin of J. Patinier. He probably worked at the court of the Este in Ferrara, where he is supposed to have died. In Italy he was nicknamed 'civetta' (little owl) after the recurrent owls in his work.

Panel, 47 in diameter (tondo).
■ coll. H.G. van Otterbeek Bastiaans, Deventer; purchased by the Rijksmuseum, Amsterdam, in 1882 as J. Breughel I, inv.no A780; on loan from the Rijksmuseum, Amsterdam, since 1963.
● WINKLER 1924, p. 309; FRIEDLÄNDER 1967-76, XIII, p. 78, no 57, pl. 30 (in reverse); A.P. de Mirimonde, *L'Oeil* 156 (1967), p. 26, fig. 4; CAT. MAURITSHUIS 1968, pp. 8-9, ill.; CAT. RIJKSMUSEUM 1976, pp. 119-120; BRUSSELS 1977, p. 178, no 364.
▶ Paradise landscape with the Fountain of Life, Creation of Eve, Tree of Knowledge, the Fall and Expulsion; surrounded by the Firmament and the Waters.

16

Abraham Bloemaert | *Theagenes and Chariclea*

Born 1564 in Gorinchem, died 1651 in Utrecht. Pupil of J. de Beer. Worked in France from 1580 to 1583, then in Utrecht until 1591, followed by two years in Amsterdam. He then returned to Utrecht.

Canvas, 157.5x159.5. Signed and dated: *A. Bloemaert fe: 1626.*
■ Het Loo, 1713; Nationale Konst-Gallery, The Hague.
● DELBANCO 1928, p. 76, no 31; DROSSAERS & LUNSINGH SCHEURLEER 1974-76, I, p. 649, no 25, II, p. 603, no 24; THIEL 1981, p. 199, no 124, ill.
▶ Preliminary drawings at the Albertina, Vienna, Royal Academy, Edinburgh, and Rijksprentenkabinet, Amsterdam.

17

■ | *The marriage of Peleus and Thetis*

Canvas, 193.7x164.5. Signed and dated: *A. Bloemaert. fe. 1638.*
■ Cabinet Prince Wilem v.
● DELBANCO 1928, p. 77, no 47; BARDON 1960, p. 32; BERNT 1969-70, I, no 120, ill.; PIGLER 1974, II, p. 100, III, fig. 200; DROSSAERS & LUNSINGH SCHEURLEER 1974-76, III, p.205; ROSENBERG, SLIVE & KUILE 1977, p. 30, fig. 8.

1046

■ | *Banquet of the gods* (formerly: *The marriage of Peleus and Thetis*)

Canvas, 30.7x41.8. Signed and dated: *A. Blomaert 1598.*
■ coll. H. Becker, Dortmund; kunsth. H. Cramer, The Hague; purchased in 1973.
● M. Aronberg Lavin, O.H. 80 (1965), p. 125, note 10, fig. 9; R. Fritz, *Sammlung Becker, 1, Gemälde alter Meister*, Dortmund 1967, no 53, ill.; E.K.J. Reznicek, O.H. 9, (1975), p. 122.

554

Guilliam Du Bois | *Hilly landscape by a stream*

Thought to have been born ca 1623 or 1625 in Haarlem, died there in 1680. Travelled in Germany and Switzerland in 1652-1653. Influenced by J. van Ruisdael.

Panel, 61x84. Signed and dated: *G.D. Bois 1652.*

■ purchased in 1890.
● BROULHIET 1938, p. 186, ill., p. 398, no 169; BOL 1969, pp. 202-203, fig. 196; CAT. MAURITSHUIS 1980, pp. 13, 155, ill.

799

■ | *Dune landscape with road and church* (formerly: *Road through the dunes*)

Panel, 45.7x63.5. Signed and dated: *GD Bois 1649.*
■ donated by L. van den Bergh, Berlin, 1929.
● MARTIN 1950, pp. 67-68, no 94, ill.; BOL 1969, p. 202; CAT. MAURITSHUIS 1980, pp. 13, 154, ill.

19

Ferdinand Bol | *Portrait of Vice-Admiral Engel de Ruyter (1649-1683), son of Michiel Adriaensz. de Ruyter*

Born 1616 in Dordrecht, died 1680 in Amsterdam. Pupil of Rembrandt ca 1635. Worked in Amsterdam.

Canvas, 131x112 Signed and dated: *F. Bol, 1669.*
■ purchased in 1817 (uncertain, first mentioned in 1822).
● MARTIN 1935-36, II, p. 122; BLANKERT 1982, pp. 64, 128, no 88, fig. 96.
► The sea and ships in the background were painted by W. van de Velde the Younger. The work still has the original, richly decorated frame. A preparatory drawing is in the Graphische Sammlung, Munich.

585

■ | *Portrait of Admiral Michiel Adriaensz. de Ruyter (1607-1676)*

Canvas, 157.5x135.5. Signed and dated: *F. Bol. fecit Ao 1667.*
■ Admiralty of Amsterdam; ceded to the museum by the Navy Ministery in 1894 in exchange for an old copy of the same subject (inv.no 18).
● MARTIN 1935-36, II, p. 123, fig.66; MARTIN 1950, no 24, ill.; THIEL 1981, p. 193; BLANKERT 1982, pp. 3, 62, 124, no 77, fig. 86; AMSTERDAM 1984, pp. 219-220, no 54, ill.
▶ The sea and ships in the background were painted by W. van de Velde the Younger. Mounted in the original frame, like inv.no 19. There are many replicas known, including one in the Rijksmuseum, Amsterdam.

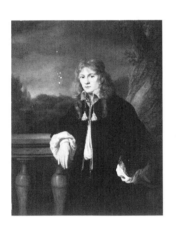

795

■ | *Portrait of a young man*

Canvas, 128x99. Signed and dated: *FBol 1652.*
■ purchased with the aid of the Rembrandt Society in 1927.
● MARTIN 1935-36, II, p. 122, fig. 65; BLANKERT 1982, pp. 33, 34, 62, 135, no 113, fig. 122; SUMOWSKI 1983, p. 312, no 168, ill.

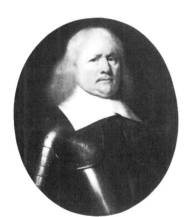

530

■ Attributed to | *Portrait of Maerten van Juchen, Commander of Wezel (d. 1672/73)*

Canvas, 74x60.5 (oval).
■ purchased in 1885.
● BLANKERT 1982, p. 182, no R185.

▶ A. Blankert suggested an attribution to Hendrick Berckman.

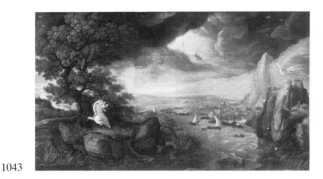

1043

Hans Bol | *Imaginary landscape with John the Evangelist on Patmos*

Born 1534 in Mechelen, died 1593 in Amsterdam. Worked in Mechelen and later in Antwerp. After fleeing Antwerp he settled in Amsterdam in 1584. Draughtsman and engraver, best known for his watercolours.

Watercolour on canvas, 47x82. Signed and dated: *Hans Bol/1564.*
■ Kunsth. S. Nystad, The Hague; purchased with the aid of the Rembrandt Society and the Prins Bernard Fund, 1972.
● JAARVERSL. VER. REMBRANDT 1972, pp. 14-15, ill.; E. and V. Bosshard-Van Brüggen, *Maltechnik Restauro* 1 (1974), pp. 16-20.

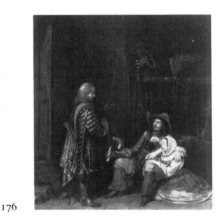

176

Gerard ter Borch | *Unwelcome news*

Born 1617 in Zwolle, died 1681 in Deventer. Pupil of his father, G. ter Borch the Elder, Zwolle, and of P. Molijn, Haarlem. According to Houbraken he travelled in Germany, Italy, France and Spain. He was in Münster, Westphalia, from 1646 to 1648. From 1650 to 1654 he lived in Zwolle, thereafter in Deventer.

Panel, 66.7x59.5. Signed and dated: *GTB 1653.*
■ coll. G. van Slingelandt, The Hague, 1752; Cabinet Prince Willem v.
● HOFSTEDE DE GROOT 1907-28, V, pp. 15-16, no 28; GUDLAUGSSON 1959-60, I, pp. 91-92, fig. 99, II, p. 109, no 99; THE HAGUE 1974, pp. 110-113, no 27, ills.

36

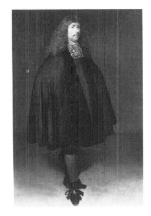

177

■ | *Portrait of the artist*

Canvas, 61x42.5.
■ coll. J. van der Marck, Leiden, 1773; purchased by King Willem I after 1828 and given to the Mauritshuis.
● HOFSTEDE DE GROOT 1907-28, V, p. 75, no 204; GUDLAUGSSON 1959-60, I, pp. 144-146, fig. 232, II, p. 210, no 232; THE HAGUE 1974, pp. 178-181, no 54, ills.

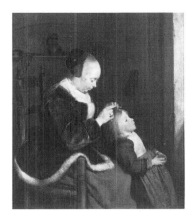

744

■ | *A mother fine-combing the hair of her child*

Panel, 33.5x29. Signed: *GTB*.
■ coll. Steengracht; purchased with the aid of the Rembrandt Society, 1913.
● HOFSTEDE DE GROOT 1907-28, V, pp. 22-23, no 46; GUDLAUGSSON 1959-60, I, p. 88, fig. 95, II, pp. 106-107, no 95; J. Bruyn, O.K. 3 (1959), nr. 6, ill.; BERNT 1969-70, I, no 147, ill.; THE HAGUE 1974, pp. 104-105, no 24, ill.; AMSTERDAM 1976, p. 41; DURANTINI 1983, p. 29.
► Companion piece in Rotterdam, Museum Boymans-van Beuningen (coll. Van der Vorm).

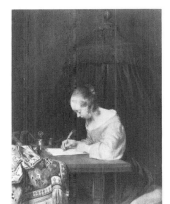

797

■ | *Woman writing a letter*

Panel, 39x29.5. Signed: *GTB*.
■ coll. Six, Amsterdam, 1928; donated by Henri W.A. Deterding, London, 1928.

● HOFSTEDE DE GROOT 1907-28, V, pp. 61-62, no 167; GUDLAUGSSON 1959-60, I, pp. 101-103, fig. 114, II, pp. 126-129, no 114; THE HAGUE 1974, pp. 130-131, no 34, ill.; AMSTERDAM 1976, pp. 36-39, no 2, ill.

883

■ | *Portrait of Cornelis de Graeff (1650-1678)*

Canvas, 38.5x28.5. Signed: *GTB*. Inscription (added later): *Cornelis de Graeff. Out XXIII Jaer. M.D. LXXIII.*
■ coll. Van Lennep-Deutz van Assendelft, The Hague, 1912; transferred by The Rijksdienst Beeldende Kunst, 1960.
● HOFSTEDE DE GROOT 1907-28, V, p. 81, no 229; GUDLAUGSSON 1959-60, I, p. 157, fig. 262, II, p. 226, no 262; THE HAGUE 1974, pp. 188-189, no 57, ill.; S.A.C. Dudok van Heel in: *Essays in northern European art presented to E. Haverkamp-Begemann*, Doornspijk 1983, p. 67, fig.3.

1050

■ | *Portrait of Caspar van Kinschot (1622-1649)*

Copper, 11x8 (oval).
■ coll. Van Kinschot, Leiden; on loan since 1975.
● HOFSTEDE DE GROOT 1907-28, V, p. 83, no 240; GUDLAUGSSON 1959-60, I, p. 59, fig. 51, II. p. 79, no 51; THE HAGUE 1974, pp. 76-77, no 12, ill.
► Member of the delegation of Holland, one of the United Provinces, during the peace negotiations at Münster from 1645 to 1648. Probably painted 1646/47.

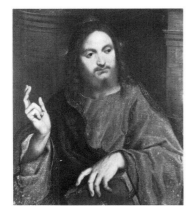

310

Paris Bordone | *Christ blessing*

Born 1500 in Treviso, died 1571 in Venice. Worked mostly in the surroundings of Venice. Travelled to Augsburg in 1540. Influenced by Titian, Savoldo and Moretto.

Canvas, 73.5x64. Signed: *PARIS... O...*
■ purchased with the Reghellini collection by King Willem I for the Mauritshuis, 1831; on loan to the Raadhuis, Wychen since 1936.
● B. Berenson, *Italian pictures of the Renaissance: Venetian school*, London/ New York 1957, I, p. 45; G. Čanova, *Paris Bordone*, Venice 1964, p. 79, pl. 65.

679

Ambrosius Bosschaert the Elder | *Vase with flowers*

Born 1573 in Antwerp, died 1621 in The Hague. Worked in Middelburg, Utrecht and Breda. His three sons were also flower painters.

Panel, 64x46. Signed: *AB*.
■ bequest of A.A. des Tombe, The Hague, 1903.
● H.T. van Guldener, O.K. 1 (1957), no 27, ill.; BOL 1960, p. 65, no 37, fig. 24; BOL 1969, p. 25; BERNT 1969-70, I, no 155, ill.; MITCHELL 1973, p. 65, fig. 85; BERGSTRÖM 1977, p. 179, ill.; ROSENBERG, SLIVE & KUILE 1977, pp. 334-335, fig. 264; MÜNSTER 1979-80, pp. 20-21. no 1, ill.; BERGAMO 1981, pp. 13-14, fig. 5; BOL 1982, p. 50, fig. 7.

20

Jan Both | *Italian landscape*

Born ca 1615 in Utrecht, died there in 1652. Most probably pupil of A. Bloemaert. Visited France and Italy. Worked in Utrecht from 1641 onwards. W. de Heusch followed him. He influenced C.P. Berchem, A. Pynacker en A. Cuyp.

Canvas, 108.2x125.8. Signed: *J. Both*.
■ purchased in 1816.
● HOFSTEDE DE GROOT 1907-28, IX, p. 438, no 56; BURKE 1976, pp. 203-204, no 37, fig. 34; CAT. MAURITSHUIS 1980, pp. 15-16, 156, ill.

21

■ | *Italian landscape*

Copper on panel, 51x70. Signed: *J. Both*.
■ purchased in 1817.
● HOFSTEDE DE GROOT 1907-28, IX, p. 470, no 166; BURKE 1976, pp. 204-205, no 38, fig. 35; CAT. MAURITSHUIS 1980, pp. 16-17, 157, ill.

Le Bourguignon, see Jacques *Courtois*.

762

Dieric Bouts, Milieu of | *The resurrection*

Born between 1410 and 1420 in Haarlem, died 1475 in Louvain. Settled in Louvain between 1445 and 1448, where he was appointed city painter in 1468. Influenced by P. Christus and R. van der Weyden.

Panel, 28.5x23.5.
■ purchased in 1920.
● FRIEDLÄNDER 1967-76, p. 66, no 56, fig. 69; CAT. MAURITSHUIS 1968, pp. 9-10, ill.
► Formerly attributed to Aelbert Bouts. Painted ca 1480.

544

Richard Brakenburgh | *Portrait of a young girl*

Born in 1650, Haarlem, died there in 1702. Pupil of A. van Ostade, H. Mommers and possibly of J. Steen, whom he imitated. Lived in Haarlem and for a brief period in Leeuwarden.

Canvas, 88.5x70.5. Signed and dated: *R. Brakenburgh 1683*.
■ purchased in 1888.

808

Jan de Bray | *Portrait of a boy* (wrongly known as *The orphan*)

Born ca 1627, Haarlem, died there in 1697. Son and pupil of S. de Bray. He lived his whole life in Haarlem, except for a few years ca 1688 in Amsterdam.

Panel, 59.5x47. Signed and dated: *1654 Oudt 6 JD Braij*.
■ purchased in 1932.
● J.W. von Moltke. MARBURGER J. 11-12 (1938-39), pp. 423-424, 483, no 168.

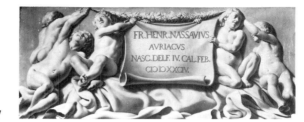

437

Salomon de Bray | *Putti bearing a cartouche with Frederik Hendrik's date of birth*

Born in Amsterdam, in 1597 according to Houbraken; died 1664 in Haarlem. Pupil of H. Goltzius and C. Cornelisz. van Haarlem. Also worked as an architect and published the *Architectura moderna* in 1631. Father and master of J. de Bray.

Canvas, 103.5x255. Signed and dated: *SD Bray 1651*. Inscribed: *FR. HENR. NASSAVIVS AVRIACUS NASC. DELF. IV. CAL. FEB MDXXCIV*.
■ Huis ten Bosch, The Hague (Oranjezaal).
● J.W. von Moltke, MARBUGER J. 11-12 (1938-39), p. 384, no 64; J.G. van Gelder, N.K.J. 2 (1948-49), pp. 121, 149, no 4; H. Peter-Raupp, *Die Ikonographie des Oranjezaal*, Hildesheim 1980, pp. 37-38, fig. 9.

562

Quiringh Gerritsz. Brekelenkam | *The leechwoman* (formerly: *The blood letting*)

Born ca 1620 probably in Zwammerdam, died 1668 in Leiden, where he had been working prior to 1648. Developed under the influence of G. Dou.

Panel, 48x37. Signed: *QVB*.
■ coll. Mr Hendrik Twent, Leiden, 1789; on loan since 1892; bequest of A. Bredius, 1946.
● PLIETZSCH 1960, p. 42, fig. 52; JONGH 1967, pp. 34-38, fig. 22; L.A. Stone-Ferrier, *Dutch Prints of Daily Life*, The Spencer Museum of Art, Lawrence Kansas 1983, pp. 92-94, fig. 15.
► Companion piece in the Rijksmuseum, Amsterdam. inv.no A685.

303

Agnolo Bronzino (Agnolo di Cosimo di Mariano), Studio of | *Portrait of a lady*

39

Born 1503 in Monticelli, died 1572 in Florence. Pupil of R. del Garbo and of Pontormo. Court painter of Cosimo I de' Medici, Florence.

Panel, 95x73.
■ purchased by King Willem I for the Mauritshuis with the De Rainer collection, 1821; on loan to the Rijksmuseum, Amsterdam, inv.no C1344, since 1948.
● B. Berenson, *The Florentine painters of the Renaissance*, New York 1909, p. 123.
▸ Formerly attributed to A. Allori. Attributed to Bronzino by Berenson.

607

Adriaen Brouwer | *A fat man*

Born ca 1605/06 in Oudenaerde, died 1638 in Antwerp. He is recorded in Amsterdam ca 1625/26 and also in Haarlem (1628). According to Houbraken he was a pupil of F. Hals. Worked in Antwerp after 1631.

Panel, 23x16.
■ purchased in 1897.
● HOFSTEDE DE GROOT 1907-28, III, pp. 690-691, no 229; J. Buyck, N.K.J. 15 (1964), p. 221, fig. 1; KNUTTEL 1962, pp. 159, 182-183, pl. XII; DELFT 1964, no 18; P.J.J. van Thiel, SIMIOLUS 2 (1967-68), p. 94, note 3; MAASTRICHT 1982, p. 52, no 11, ill.,
▸ Wrongly thought to be a self-portrait. May be a depiction of Gluttony; several copies are known.

847

■ | *Inn with drunken peasants*

Panel, 19.5x26.5. Signed: *AB*.
■ coll. A.L. van Heteren, The Hague, 1752; Koninklijk Museum, Amsterdam, 1809; Rijksmuseum, Amsterdam, inv.no A64; on loan from the Rijksmuseum, Amsterdam, since 1948.
● HOFSTEDE DE GROOT 1907-28, III, p. 628, no 102; G. Knuttel, O.K. 4 (1960), no 9, ill.; KNUTTEL 1962, pp. 87-89, fig. 46-49, pl. III; CAT. RIJKSMUSEUM 1976, p. 152; MAASTRICHT 1982, p. 32, no 1, ill.

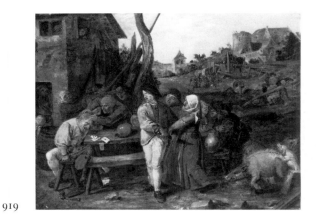

919

■ | *Fighting peasants*

Panel, 25.5x34 (traces of a monogram).
■ coll. W. Lornier, The Hague, 1752; coll. Van Heteren Gevers, 1809; Koninklijk Museum, Amsterdam; Rijksmuseum, Amsterdam, inv.no A65; on loan from the Rijksmuseum, Amsterdam, since 1963.
● HOFSTEDE DE GROOT 1907-28, III, pp. 657-658, no 166; KNUTTEL 1962, pp. 78-80, fig. 40-43; BERNT 1969-70, I, no 196, ill.; CAT. THYSSEN-BORNEMISZA 1969, p. 57; CAT. RIJKSMUSEUM 1976, p. 152; MAASTRICHT 1982, p. 34, no 2, ill.

962

■ | *The smoker*

Panel, 29.4x21.3.
■ coll. Dalton, Brodsworth Hall, Doncaster; bequest of Mr and Mrs Bruyn-van der Leeuw to the Rijksmuseum, Amsterdam, 1961, inv.no A4040; on loan from the Rijksmuseum, Amsterdam, since 1963.
● E.R. Meyer, BULL. R.M. 9 (1961), p. 46, fig. 3; J.L. Cleveringa, BULL.R.M. 9 (1961), p. 63, no 3; KNUTTEL 1962, pp. 140-142, fig. 92; E. de Jongh, ALB. AMIC. VAN GELDER 1973, pp. 205-206, note 41; CAT. RIJKSMUSEUM 1976, p. 152; AMSTERDAM 1976, pp. 54-57, no 7, ill.; MAASTRICHT 1982, pp. 13-15, fig. 5.

233

Jan Brueghel the Elder | *Garland of vegetables and fruit around a depiction of Cybele*

Born 1568 in Brussels, died 1625 in Antwerp. Son of P. Brueghel the Elder. Travelled to Italy (1590-1596) and Prague (1604). Worked in Brussels and especially in Antwerp.

Panel, 106x70.
■ coll. J.A. van Kinschot, Delft, 1767; Cabinet Prince Willem V.
● I. Jost, N.K.J. 14 (1963), pp. 94, 121, fig. 20; DROSSAERS & LUNSINGH SCHEURLEER 1974-76, III, p. 204, no 7; ERTZ 1979, pp. 313, 323, 353, 614, no 340, fig. 386.
▸ Painted before 1618. The figures are by H. van Balen. There is a replica with minor changes in the Prado, Madrid.

285

■ | *Christ releasing the souls in limbo*

Copper, 26.5x35.5. Signed and dated: *I. Brveghel 1597.*
■ Het Loo, 1713; Binnenhof, The Hague, 1754; Cabinet Prince Willem V.
● R.A. Peltzer, J. KUNSTH. SAMML. A.K. 33 (1916), pp. 332, 345, no 32; CAT. MAURITSHUIS 1968, p. 11, ill.; DROSSAERS & LUNSINGH SCHEURLEER 1974-76, I, p. 677, no 839, p. 698, no 69, II, p. 479, no 24, III, p. 206, no 16; ERTZ 1979, pp. 124, 501, fig. 127.
▸ Probably a copy by J. Brueghel the Younger; the figures were thought to be by H. Rottenhammer.

253

■ + Peter Paul Rubens | *Adam and Eve in Paradise*

See P.P. Rubens

283

■ Attributed to | *The rest on the flight to Egypt*

Copper, 21.5x29.5.
■ Het Loo, 1763; Cabinet Prince Willem V.
● R.A. Peltzer, J. KUNSTH. SAMML. A.K. 33 (1916), pp. 293, 332, 345, no 31; CAT. MAURITSHUIS 1968, pp. 10-11. ill.; DROSSAERS & LUNSINGH SCHEURLEER 1974-76, II, p. 645, no 119, III. p. 205, no 9; ERTZ 1979, p. 501.
▸ The figures were thought to be by H. Rottenhammer, but are probably by H. van Balen. Cf. the painting of the same subject in a private German collection (ERTZ 1979, p. 558, no 10, pl. 2). A copy in the Kunsthistorisches Museum, Vienna.

236

■ Circle of | *Paradise*

Copper, 13.5x19.5.
■ added to the collection after 1817.
● SPETH-HOLTERHOFF 1957. p. 110, fig. 39; ERTZ 1979, p. 248, note 299.

966

Hendrick ter Brugghen | *The deliverance of St Peter*

Born in Utrecht(?), probably in 1588, died in 1629 in Utrecht. Pupil of A. Bloemaert, Utrecht. Influenced by the work of Caravaggio during a stay in Italy, 1604-1614.

Canvas, 105x85. Signed and dated: *HTBrugghen 1624.*

■ coll. Count von Moltke, Copenhagen; coll. A. Anderson, Copenhagen; kunsth. G. Cramer, The Hague; purchased with the aid of the Rembrandt Society, 1963.
● SCHNEIDER 1933, p. 39, fig. 176; B. Nicolson, *Hendrick Terbrugghen*, London 1958, pp. 59-60, pl. 97, no A19; CAT. MAURITSHUIS 1970, no 14, ill.; P.J.J. van Thiel, BULL. R.M. 19 (1971), p. 109; B. Nicolson, *The international Caravaggesque movement*, Oxford 1979, p. 99; THE HAGUE 1982, p. 82, no 22, ill.

739

Bartholomaeus Bruyn the Elder | *Portrait diptych of a man and a woman; Lucretia* (verso of the woman's portrait)

Born 1493, probably in Wezel, died 1555 in Cologne, where he had been working since 1515. Developed under the influence of J.J. van Calcar and J. van Cleve.

Panel, each wing 68x48.5 (ending in a pointed arch). Dated: *1529*.
■ bequest of Mr R.W.J. baron van Pabst van Bingerden, The Hague 1912.
● COLOGNE 1955, p. 14, nos 5-6; WESTHOFF-KRUMMACHER 1965, pp. 107-109, nos 13-14, ill.; CAT. MAURITSHUIS 1968, pp. 14-15, ill.
► The sitters are members of the Rolinxwerd family; probably Johannes Rolinxwerd and his wife Christine von Sternenberg.

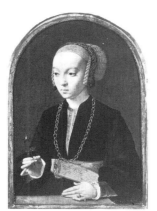

889

■ | *Portrait of a young woman*

Panel, 34.5x24; painted surface 31.5x21.5 (ends in a round arch).

■ donated to the Rijksmuseum, Amsterdam, by C. Hoogendijk in 1912, inv. no A2559; on loan from the Rijksmuseum, Amsterdam, since 1951.
● COLOGNE 1955, p. 37, no 10; J. Bruÿn, O.K. 6 (1962), no 6, ill.; WESTHOFF-KRUMMACHER 1965, p. 141, no 65, ill.; CAT. MAURITSHUIS 1968, p. 16, ill.; CAT. RIJKSMUSEUM 1976, p. 156.
► A coat of arms on the verso. Probably the engagement portrait of one of Prof. Peter Bellinghausen's daughters.

875

François Bunel II | *The confiscation of the contents of a painter's studio*

Born ca 1550 in Blois, died some time after 1593, probably in Paris. Court painter to Henri IV of Bourbon, later king of France, from 1582.

Panel, 28x46.5.
■ tranferred to the Mauritshuis by the Rijksdienst Beeldende Kunst in 1960.
● F. Lugt, O.H. 53 (1936), p. 97. ill.; CAT. MAURITSHUIS 1968, pp. 16-17, ill.; *Luther und die Folgen für die Kunst*, Hamburg, Hamburger Kunsthalle, München 1984, p. 151, no 25, ill.
► Attributed to Bunel by S.J. Gudlaugsson; previously considered Flemish.

272

Friedrich Bury | *Amor triumphant*

Born 1763 in Hanau, died 1823 in Aachen. Pupil of A. Tischbein, attended the Düsseldorf academy. Lived in Rome from 1782 to 1799 and formed a friendship there with Goethe. Worked mostly in Berlin from then on.

Canvas, 152x121.
■ donated by Queen Frederika Louise Wilhelmina, wife of King Willem I.

Paolo Caliari, see Paolo *Veronese*.

754

Abraham van Calraet | *Still life with peaches and grapes*

Born 1642 in Dordrecht, died there in 1722. Follower of A. Cuyp and probably his pupil.

Canvas, 89x73. Signed: *A v Calraet*.
▪ given on loan in 1918; bequest of A. Bredius, 1946.
● A. Bredius, *Oude Kunst 2* (1917), p. 109, ill.; BERNT 1969-70, I, no 216. ill.; BOL 1982, p. 12, fig. 2.

313

Luca Cambiaso | *Madonna and child*

Born 1527 in Moneglia, near Genoa, died 1585 near Madrid. Worked in Genoa and from 1583 in Spain.

Panel, 82x67.
▪ purchased by King Willem I for the Mauritshuis with the De Rainer collection, 1821; on loan to the Raadhuis, Wychen, since 1936.
● *Luca Cambiaso e la sua fortuna*, Palazzo dell' Esposizione, Genoa 1956, no 27, ill.; SUIDA 1958, p. 158, fig. 96.

314

▪ | *The birth of Mary*

Canvas, 183x168.

▪ purchased by King Willem I for the Mauritshuis with the De Rainer collection, 1821; on loan to the Raadhuis, Wychen, since 1936.
● SUIDA 1958, p. 158, fig. 367.
► Two portraits on the left were possibly added later.

1062

Jacob van Campen | *Argus, Mercury and Io*

Born 1595 in Haarlem, died 1657 in Amersfoort. Pupil of F. de Grebber. In 1617 he travelled to Italy. Between 1621 and 1628 he worked with P. Saenredam. He was an architect and painter of historical subjects.

Canvas, 204x194.
▪ purchased from kunsth. J. Hoogsteder, The Hague, in 1981.
● THE HAGUE 1982, pp. 84-85, no 23, ill.

567

Jan van de Cappelle | *Winter scene*

Born 1626 in Amsterdam, died there in 1679. Self-taught. Influenced by S. de Vlieger.

Canvas, 51.8x61.8. Signed and dated: *I.v. Cappelle fe. 1653*.
▪ perhaps coll. Sir Joshua Reynolds (as Isaack van Ostade); purchased from kunsth. Colnaghi, London, 1893.
● HOFSTEDE DE GROOT 1907-28, VII, p. 220, no 148; MARTIN 1950, p. 65, no 83, ill.; STECHOW 1966, p. 96, fig. 188; BERNT 1969-70, I, no 244, ill.; RUSSELL 1975, pp. 30, 34, 84, no 148, fig. 24; CAT. MAURITSHUIS 1980, p. 18, 158, ill.

820

■ | *Ships off the coast*

Canvas, 72.5x87. Signed and dated: *I V Capelle 1651*.
■ donated by Henri W.A. Deterding, London, 1936.
● HOFSTEDE DE GROOT 1907-28, VII, p. 214, no 133; MARTIN 1950, p. 82, no 166; STECHOW 1966, pp. 106-107, note 28, p. 207, fig. 212; BOL 1973, p. 227, fig. 232; RUSSELL 1975, pp. 21, 22, 28, 80, no 133, fig. 19; CAT. MAURITSHUIS 1980, pp. 19-20, 159, ill.

307

Luca Carlevarijs | *Roman ruins*

Born 1663 in Udine, died 1730 in Venice. Is considered the most important precursor of Canaletto.

Canvas, 75.5x56.5
■ Nationale Konst-Gallery, The Hague.
● DONZELLI 1957, p. 53; THIEL 1981, p. 208, no 171, ill.
▶ Companion piece to no 308. Formerly attributed to B. Bellotto.

308

■ | *Roman ruins*

Canvas, 75.5x56.5.
■ Nationale Konst-Gallery, The Hague.
● DONZELLI 1957, p. 53; THIEL 1981, p. 208, no 173, ill.
▶ Companion piece to no 307. Formerly atributed to B. Bellotto.

315

Annibale Carracci, Copy after | *The holy family*

Born 1560 in Bologna, died 1609 in Rome. Pupil of his uncle Lodovico. Worked in Rome from 1595.

Canvas, 51x39.
■ purchased by King Willem I for the Mauritshuis with the Reghellini collection, 1831; on loan to the Ministry of Home Affairs, The Hague, since 1916.
▶ One of the many copies after a lost original by Carracci; cf. the copy in the Uffizi, inv.no 1349 (CAT. UFFIZI 1979-80, p. 207, ill.).

300

Mateo Cerezo the Younger | *The penitent Mary Magdalene*

Born ca 1626 in Burgos, died 1666 in Madrid. Pupil of J. Carreño de Miranda. Influenced by Van Dyck and Titian. Worked in Madrid.

Canvas, 103.2x83. Signed and dated: *Matheo. Zereco ft añ do 1661*.
■ purchased by King Willem I from Countess Bourke, Paris, 1823; on loan to the Rijksmuseum, Amsterdam, inv.no C1347, since 1948.
● P. van Vliet, BULL. R.M. 14 (1966), pp. 134, 136, fig. 4; CAT. RIJKSMUSEUM 1976, p. 166, ill.
▶ The Residenzgalerie in Salzburg contains a different version. There are several copies known.

Cornelis Janson van Ceulen, see Cornelis *Jonson* van Ceulen.

237

Philippe de Champaigne | *Portrait of Jacobus Govaerts*

Born 1602 in Brussels, died 1674 in Paris. Pupil of N. Poussin. Worked in Paris.

Canvas, 135x108. Inscribed: *M. Episcop Aet Svae: 29: Ao: 1665.*
■ purchased by King Willem I from General Rottiers, 1823; on loan to the Rijksmuseum, Amsterdam, since 1927 (inv.no C1183).
● B. Dorival, *Philippe de Champaigne 1602-1674,* Paris 1976, p. 320, no 1748, ill.; CAT. RIJKSMUSEUM 1976, p. 167.

656

Jean Baptiste Siméon Chardin | *Still life*

Born 1699 in Paris, died there in 1799. Pupil of Cazès and N. Coypel.

Canvas, 33x41. Signed: *chardin.*
■ given on loan in 1901; bequest of A. Bredius, 1946.
● G. Wildenstein, *Chardin*, Zürich 1963, p. 163, no 143, fig. 62.

943

Pieter Claesz | *Vanitas still life*

Born ca 1597 in Burgsteinfurt, died 1660 in Haarlem, where he started working before 1617. Father and first master of C.P. Berchem.

Panel, 39.5x56. Signed and dated: *PC. AO. 1630.*

■ coll. D. Hultmark, Saltsjöbaden, Sweden; kunsth. S. Nystad, The Hague; acquired with the aid of the Stichting Openbaar Kunstbezit, the Rembrandt Society and the Prins Bernard Fund, 1960.
● VROOM 1945, p. 199, no 32; Bergström 1956, p. 165, fig. 141; CAT. MAURITSHUIS 1970, no 25, ill.; VROOM 1980, I, pp. 95-96, figs.61, 135, II, p. 19, no 58; BERGAMO 1981, p. 11, fig. 1.

947

 | *Still life with a lighted candle*

Panel, 26.1x37.3. Signed and dated: *PCAo 1627.*
■ coll. O. Hedberg, Stockholm; kunsth. S. Nystad, The Hague; purchased in 1961.
● BERGSTRÖM 1956, p. 120, fig. 105; L.J. Bol, O.K. 7 (1963), no 3, ill.; CAT. MAURITSHUIS 1970, no 24, ill.; BERGSTRÖM 1977, p. 183, ill.; MÜNSTER 1979-80, p. 452, no 234, ill.; VROOM 1980, I, pp. 23-25, fig. 15, II, pp. 17-18, no 49.

895

Joos van Cleve | *Portrait of a man*

Born ca 1485, probably in Cleves, died ca 1540 in Antwerp. Also known as Van der Beke. The same as the Master of the Death of the Virgin. Worked mostly in Antwerp, also at the French and English royal courts.

Panel, 45.8x43.
■ possibly Honselaarsdijk 1707 or Leeuwarden 1633; Nationale Konst-Gallery, The Hague, 1801 (as a Holbein portrait of Maximilian of Austria); Rijksmuseum. Amsterdam, inv.no A165; on loan from the Rijksmuseum, Amsterdam, since 1951.
● FRIEDLÄNDER 1967-76, IX, p. 68, no 87, pl. 102; CAT. MAURITSHUIS 1968, pp. 17-18, ill.; DROSSAERS & LUNSINGH SCHEURLEER 1974-76, I, p. 534, no 283, II, p. 506, no 61 or II, p. 37, no 140; CAT. RIJKSMUSEUM 1976, p. 169; THIEL 1981, p. 197, no 110, ill.,
▶ The attribution to J. van Cleve by W. von Bode and A. Bredius has found general acceptance.

45

348

■ Circle of | *Christ and John the Baptist as children*

Panel, 39x58.
■ purchased with the De Rainer collection, 1821.
● G. Glück, *Pantheon* 2 (1928), p. 502; CAT. MAURITSHUIS 1968, pp. 18-19, ill.; FRIEDLÄNDER 1967-76, IXa, p. 57, no 37b, pl. 55; I. Hecht, *Apollo* 113 (1981), pp. 222-229, fig. 2; SILVER 1984, p. 222.
▶ The composition is derived from Leonardo da Vinci.

392

Pieter Codde | *Festivity with masked dancers*

Born 1599 in Amsterdam, died there in 1678. Influenced by F. Hals. He was also active in literary circles in Amsterdam.

Panel, 50x76.5. Signed and dated: *PCodde Ao 1636.*
■ purchased in 1876.
● PLIETZSCH 1960, p. 30, fig. 19; K. Renger, J. BERLINER MUSEEN 14 (1972), pp. 190-192, fig. 27; C.P. Playter, *Willem Duyster and Pieter Codde*, Harvard 1972 (diss.), p. 77; PHILADELPHIA 1984, p. 77, fig. 1.

445

■ | *Backgammon players*

Panel, 20.4x27 (octagonal). Signed and dated: *Codde fecit 1628.*
■ coll. Heemskerck van Beest; transferred from the Nederlandsch Museum van Geschiedenis en Kunst in 1878.
● for backgammon see: AMSTERDAM 1976, pp. 109-111, no 22.
▶ Originally oval (12.5x18.5); enlarged by the painter himself.

857

■ | *Portrait of a married couple*

Panel, 43x35. Signed and dated: *PC 1634.*
■ coll. Counts Bentinck, Middachten; transferred to the Mauritshuis by the Rijksdienst Beeldende Kunst, 1960.
● SMITH 1982, p. 122, fig. 52; D.R. Smith, ART BULL. 64 (1982), p. 265, fig. 9.

810

Edwaert Collier | *Vanitas still life*

Born in Breda ca 1640, died after 1706. Worked in Haarlem, from 1673 on in Leiden. Travelled to London.

Panel, 19.5x17. Signed and dated: *E. Collier. 1675.* Inscription on the book: *Van de Eydelheydt des levens* (On the vanity of life).
■ donated by W.E. Duits, London, 1934.
● BOL 1969, p. 354.

81

Leendert van der Cooghen | *Doubting Thomas*

Born ca 1610 in Haarlem, died there in 1681. Pupil of J. Jordaens. Worked in Antwerp and Haarlem.

Canvas, 111x155.2. Signed and dated: *L.V. Cooghen 1654.*
■ purchased in 1876.

• J. Bolten et al., *Rembrandt and the incredulity of Thomas*, Leiden 1981, p. 20, note 11.

238

Gonzales Coques | *Interior with picture collection*

Born 1614 in Antwerp, died there in 1684. Pupil of P. Brueghel III and of D. Ryckaert. Worked in Antwerp.

Canvas, 176x210.5.
■ coll. Jacob de Wit, Antwerp, 1741; Het Loo, 1763; Cabinet Prince Willem V.
● E. Reznicek, BULL. R.M. 2 (1954), pp. 43-46; SPETH-HOLTERHOFF 1957, pp. 172-181; DELFT 1964, no 26; DROSSAERS & LUNSINGH SCHEURLEER 1974-76, II, p. 642, no 60, III, p. 212, no 42.
▸ This painting is possibly of Antoine van Leyen (1628-1686), Antwerp magistrate and collector, and his wife Marie-Anne van Eywerven and their two daughters. The architecture is attributed to D. van Deelen.

22

Cornelis Cornelisz. van Haarlem | *Massacre of the innocents*

Born 1562 in Haarlem, where he died in 1638. Pupil of P. Pietersz., Haarlem and of G. Coignet, Antwerp. Visited France in 1579. With Goltzius and C. van Mander he established the so-called Haarlem Academy. Also worked as an architect.

Canvas, 270x255. Signed and dated: *C.C.f.A. 1591*.
■ ordered by the burgomasters of Haarlem, 1591; Prinsenhof, Haarlem; ceded to the state by the city of Haarlem, 1804; acquired through exchange with the Rijksmuseum, Amsterdam, 1825; on loan to the Frans Hals Museum, Haarlem, since 1917.
● ROSENBERG, SLIVE & KUILE 1977, pp. 23-24, fig. 1; WASHINGTON 1980-81, p. 79, fig. 3; BIESBOER 1983, pp. 27-28, fig. 12.
▸ Combined with wings by M. van Heemskerck (inv.nos 51, 52) into a triptych, prior to 1604.

23

— | *The wedding of Peleus and Thetis*

Canvas, 247x420.
■ Prinsenhof, Haarlem, 1593; ceded to the state by the city of Haarlem, 1804; on loan to the Frans Hals Museum, Haarlem, since 1913.
● BARDON 1960, p. 30, fig. XIV; WASHINGTON 1980-81, pp. 56-58, fig. 2.

918

— Attributed to | *Before the flood*

Copper, 23.9x27.5. Signature indistinct: *CH* (monogram) or *M*.
■ Arcade Gallery, London; purchased in 1954.
● BARDON 1960, p. 31; CAT. MAURITSHUIS 1968, p. 19, ill.; CAT. MAURITSHUIS 1970, no 8, ill.; W. Stechow, *Art Quarterly* 35 (1972), pp. 166-167, fig. 7.

880

Cornelis Cornelisz., called **Kunst** | *The circumcision; Mary of the annunciation in grisaille* (verso)

Born 1493 in Leiden, died there in 1544. Worked alternately in Leiden and Bruges. Pupil of his father, C. Engebrechtsz., Leiden.

Panel, 48x27.
■ purchased from Muller & Co., Amsterdam, 1898, by the Rijksmuseum, Amsterdam, inv.no A1725; on loan from the Rijksmuseum, Amsterdam, since 1948.
● FRIEDLÄNDER 1967-76, XI, pp. 40, 78, no 106, pl. 90; HOOGEWERFF 1936-47, III, p. 374, figs. 98-99; CAT. MAURITSHUIS 1968, pp. 19-20, ill.; CAT. RIJKSMUSEUM 1976, p. 175.

► Left wing of a triptych. Ca 1520, in the milieu of C. Engebrechtsz. Might have been painted by his son Cornelis Kunst; formerly attributed to J. de Cock.

I

Jacob Cornelisz. van Oostsanen | *Salome with the head of John the Baptist*

Also called Jacob Cornelisz. of Amsterdam. Born before 1470 in Oostzaan, died 1533 in Amsterdam. Worked mainly in Amsterdam.

Panel, 73*x*53.5. Signed and dated: *IA 1524* (between the letters I and A is the painter's mark).
■ Oranienstein Castle; transferred to the Cabinet Prince Willem v, 1795; on loan to the Rijksmuseum, Amsterdam, since 1948 (inv.no C1349).
● FRIEDLÄNDER 1967-76, XII, p. 118, no 284, pl. 150; HOOGEWERFF 1936-47, III, p. 126, fig. 64; N. Beets, J.G. van Gelder, *Kunstgeschiedenis der Nederlanden*, Utrecht 1954-56, I, p. 438; DROSSAERS & LUNSINGH SCHEURLEER 1974-76, II, p. 112, no 901, III, p. 241, no 193; CAT. RIJKSMUSEUM 1976, p. 176.

301

Correggio (Antonio Allegri), Copy after | *Madonna and child*

Born ca 1489, died 1534 in Reggio Emilia. Worked primarily in Parma.

Panel, 54*x*41.
■ purchased by King Willem I for the Mauritshuis with the De Rainer collection, 1821; on loan to the Rijksdienst Beeldende Kunst, The Hague.
► Copy after *La Zingarella* by Correggio, Museo Nazionale di Capodimonte, Naples.

302

■ Copy after | *Christ on the Mount of olives*

Panel, 40*x*27.
■ purchased by King Willem I for the Mauritshuis with the De Rainer collection, 1821; on loan to the Raadhuis, Bemmel.
► Copy after the left part of *The agony in the garden* by Correggio, Apsley House, London; there are many copies known (cf. C.M. Kaufmann, *Catalogue of paintings in the Wellington Museum*, London 1982, pp. 46-48, fig. 32).

Agnolo di Cosimo di Mariano , see Agnolo *Bronzino* .

287

Piero di Cosimo (Piero di Lorenzo) | *Portrait of Francesco Giamberti (1405-1480)*

Born 1461/62 in Florence, died there ca 1521. Pupil of Cosimo Rosselli, whose name he adopted. Worked with this teacher on the frescoes of the Sistine Chapel, Rome. Worked mostly in Florence.

Panel, 47.5*x*33.7.
■ coll. Francesco Sangallo, Florence; British Royal Collection; coll. Stadholder-King Willem III; Cabinet Prince Willem v; on loan to the Rijksmuseum, Amsterdam (inv.no C1367) since 1948.
● CAT. RIJKSMUSEUM 1976, p. 444, ill.; BACCI 1976, pp. 91, 93-95, no 37, ill.
► Companion piece to no 288 (portrait of his son). Posthumous portrait, painted about the same time as no 288.

288

■ | *Portrait of Giuliano da San Gallo (1445-1516), architect and sculptor*

Panel, 47.2x33.5.
■ coll. Francesco Sangallo; coll. Stadholder-King Willem III; Cabinet Prince Willem V; on loan to the Rijksmuseum, Amsterdam (inv.no C1368).
● CAT. RIJKSMUSEUM 1976, p. 444, ill.; BACCI 1976, pp. 91, 93-95, no 36, ill.
▶ Companion piece to no 287 (portrait of his father). Most important artist of the San Gallo family of architects. Worked mostly in Florence, for Pope Julius II among others. Discovered the *Laocoon* during the excavations in the Domus Aurea, Rome.

290

Jacques Courtois, called Le Bourguignon | *Cavalry engagement*

Born in St Hippolyte (France), died 1675 in Rome. Lived in Italy from ca 1635.

Copper, 12x15.
■ purchased with the De Rainer collection, 1821.

891

Lucas Cranach the Elder | *Portrait of Philip Melanchton (1497-1560)*

Born 1472 in Kronach, died 1553 in Weimar. Worked mainly in Wittenberg. Contacts with M. Luther and P. Melanchton.

Panel, 36x23. Signed with the letter *L* and bearing Cranach's mark, the crowned snake.

■ donated by C. Hoogendijk to the Rijksmuseum, 1912, inv.no A2561; on loan from the Rijksmuseum, Amsterdam, since 1951.
● CAT. MAURITSHUIS 1968, p. 21, ill.; CAT. RIJKSMUSEUM 1976, p. 180.
▶ Probably not entirely autograph.

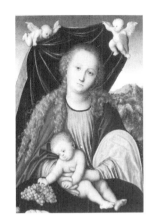

917

■ | *Madonna and child*

Panel, 62.7x42. Bears Cranach's mark, the crowned snake.
■ coll. Lichnowsky, Kuchelna, Silesia; coll. P. Cassirer, Berlin, 1929; transferred to the Mauritshuis by the Rijksdienst Beeldende Kunst in 1960.
● CAT. MAURITSHUIS 1968, p. 20, ill.; BASLE 1974, no 383, fig. 283; M.J. Friedländer, J. Rosenberg, *The paintings of Lucas Cranach*, Amsterdam 1978, p. 95, no 130, ill.

890

Lucas Cranach the Younger | *Portrait of a man with a red beard*

Born 1515 in Wittenberg, died 1586 in Weimar. Pupil of his father, L. Cranach the Elder.

Panel, 64x48. Bears Cranach's mark, the crowned snake, and dated: *1548*.
■ donated by C. Hoogendijk to the Rijksmuseum, Amsterdam, in 1912, inv.no A2560; on loan from the Rijksmuseum, Amsterdam, since 1951.
● CAT. MAURITSHUIS 1968, p. 21, ill.; BASLE 1974, no 642, fig. 353a; CAT. RIJKSMUSEUM 1976, p. 180.

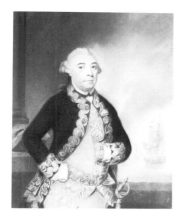

539

Pieter Frederik de la Croix | *Portrait of Vice-Admiral Johan Arnold Zoutman (1724-1793)*

Born 1709 in France, died 1782 in The Hague. Self-taught. Worked in The Hague, where he joined the artists' society Pictura in 1755.

Pastel, on paper 45x37.5. Signed and dated: *P.F. de la Croix decit 1781.*
■ donated by jhr V. de Stuers, 1887, together with a portrait of Zoutman's wife (Anonymous, Dutch school, inv.no 540); on loan to the Nederlands Scheepvaart Museum, Amsterdam, since 1931, inv.no B179(1).

24

Abraham van Cuylenborch | *Diana and her companions*

Born about 1610 in Utrecht, died there in 1658. Most original pupil and follower of C. van Poelenburch. Painted mostly rocky caverns with nymphs and satyrs bathing.

Panel, 32x40. Signed: *A V Cuylenborch f.*
■ was added to the collection after 1817.
● BERNT 1969-70, I, no 283, ill.; SALERNO 1977-80, I, p. 286.

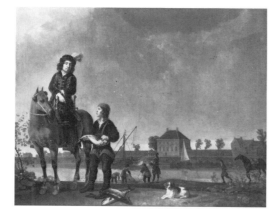

25

Aelbert Cuyp | *Equestrian portrait of Pieter de Roovere*

Born 1620 in Dordrecht, died there in 1691. Pupil of his father, J.G. Cuyp. His early work shows the influence of J. van Goyen and S. van Ruysdael; later on of J. Both.

Canvas, 123.5x154. Signed: *A. cuyp.*
■ purchased in 1820.
● HOFSTEDE DE GROOT 1907-28, II, p. 20, no 42; REISS 1975, p. 204; DORDRECHT 1977-78, pp. 78-79, no 25, ill.; LEEUWARDEN 1979-80, pp. 18-23, fig. 23; CAT. MAURITSHUIS 1980, pp. 23-24, 161, ill.
The De Roovere coat of arms is on the horse's harness. The sitter is probably Pieter de Roovere (1602-1652) in his function as supervisor of the salmon fishery in the Dordrecht district.

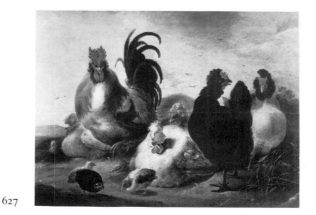

627

■ | *Cock and hens*

Panel, 55x74. Signed and dated: *A:cuijp Ao 1651.*
■ given on loan, 1889; bequest of A. Bredius, 1946.
● HOFSTEDE DE GROOT 1907-28, II, p. 221, no 800; BOL 1969, p. 242; REISS 1975, p. 211.

822

■ | *Ruins of Rijnsburg Abbey near Leiden*

Panel, 49.7x74. Signed: *A. cuyp.*
■ donated by Henri W.A. Deterding, London, 1936.
● CAT. MAURITSHUIS 1980, pp. 21-23, 160, ill.,

829

■ | *Girl with peaches*

Canvas, 63.5x48.2. Signed: *A: cuyp: f.*
■ purchased in 1938.
● BERNT 1969-70, I, no 284a, ill.; DORDRECHT 1977-78, pp. 72-73, no 22, ill.

963

■ | *Migrating peasants in a southern landscape*

Panel, 38.1x52.2. Signed: *A. cuyp.*
■ coll. J.B.P. Lebrun, Paris; purchased in 1963.
● HOFSTEDE DE GROOT 1907-28, II, p. 135, no 465; CAT. MAURITSHUIS 1970, no 47, ill.; REISS 1975, pp. 79, 208; CAT. MAURITSHUIS 1980, pp. 24-26, 162, ill.

821

■ Circle of | *Cattle on a river*

Panel, 46x74. Signed: *A. cuyp.*
■ coll. Earl Howe, London; purchased with the aid of the Van Weel bequest and the Rembrandt Society, 1936.
● HOFSTEDE DE GROOT 1907-28, II, p. 107, no 372; MARTIN 1935-36, II, pp. 341, 346, fig. 186a; REISS 1975, p. 207; CAT. MAURITSHUIS 1980, pp. 26-27, 163, ill.

843

Gerard David | *Forest scene*

Born ca 1460 in Oudewater, died 1523 in Bruges. Worked in Bruges, where he was the most important artist after the death of H. Memling.

Two panels, each 90x30.5.
■ purchased by the Rijksmuseum, Amsterdam, from Duveen Brothers Gallery, Paris, 1942, inv.no A3134, A 3135; on loan from the Rijksmuseum, Amsterdam, since 1948.
● FRIEDLÄNDER 1967-76, VIb, p. 100, no 160, pl. 163-165; OSTEN & VEY 1969, p. 307; CAT. MAURITSHUIS 1968, pp. 21-22, ill.; CAT. RIJKSMUSEUM 1976, p. 189.
▸ The outsides of the wings of a triptych; the insides (donors and Sts Jerome and Vincent) as well as the middle panel, with the Adoration, are in the Metropolitan Museum of Art, New York (cat. 1980, p. 43, no 49.7.20a-c).

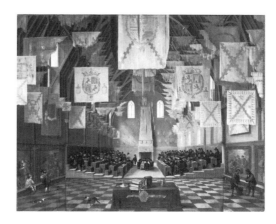

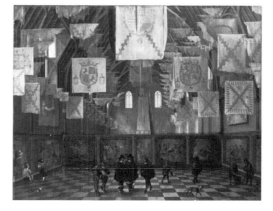

26

Dirck van Delen | *The Knight's Hall during the 1651 assembly of the States-General*

Born 1605 in Heusden, died 1671 in Arnemuiden. Follower of H. van Steenwijck II.

Panel, 52x66; with a copper plate, 9x42.
■ purchased from Mr Teissier, 1819; on loan to the Rijksmuseum, Amsterdam, since 1948 (inv.no C1350).
● R.van Luttervelt, BULL. R.M. 8 (1960), pp. 38-39, fig. 10; CAT. RIJKSMUSEUM 1976, p. 190; JANTZEN 1979, p. 223, no 142.

▶ There is a painted metal flap attached to the panel. When it is closed one sees figures in the foreground with a dividing partition behind them, blocking off the view of the rest of the hall. When the flap is open the view of the assembly is revealed in the background, and a table takes the place of the foreground figures.

27

Philip van Dijk | *Judith*

Born 1680 in Amsterdam, died 1753 in The Hague. Pupil of A. Boonen in Amsterdam, where he presumably worked until 1708, when he settled in Middelburg. From 1719 he worked mostly in The Hague, and in 1725 and 1736 he was in Kassel as court painter to the Elector of Hessen. Follower of A. van der Werff.

Panel, 28x30.5. Signed and dated: *P: van Dijck 1726.*
■ Palace, Leeuwarden, 1731; Cabinet Prince Willem v.
● DROSSAERS & LUNSINGH SCHEURLEER 1974-76, II, p. 405, no 500, III, p. 209, no 31.

28

■ | *Woman playing the lute*

Panel, 15.5x12.5. Signed: *PVDijk.*
■ coll. G. van Slingelandt, The Hague, 1768; Cabinet Prince Willem v.
● DROSSAERS & LUNSINGH SCHEURLEER 1974-76, III, p. 208, no 28.

29

■ | *Lady attending to her toilet*

Panel, 29.5x23.5. Signed: *Ph:v.Dijk,F:.*
■ Palace, Leeuwarden, 1731; Cabinet Prince Willem v.
● DROSSAERS & LUNSINGH SCHEURLEER 1974-76, II, p. 405, no 498, III, p. 208, no 29.

30

■ | *The bookkeeper*

Canvas, 26x21.
■ Palace, Leeuwarden, 1731; Cabinet Prince Willem v: on loan to the Nederlands Postmuseum, The Hague.
● DROSSAERS & LUNSINGH SCHEURLEER 1974-76, II, p. 405, no 502, III, p. 209, no 30.

712

■ | *Portrait of Mathias Lambertus Singendonck (1648-1742), burgomaster of Nijmegen*

Canvas, 53x44.5 (oval). Signed: *P. van Dijk.*
■ bequest of Miss M.J. Singendonck, The Hague, 1907.
● E.W. Moes, *Iconographia Batava*, Amsterdam 1897-1905, II, p. 379, no 7209.
▶ Companion piece to no 713.

713

■ | *Portrait of Agneta Catherina Hoeuft (1689-1758), second wife of Mathias Lambertus Singendonck*

Canvas, 53x44 (oval).
■ bequest of Miss M.J. Singendonck, The Hague, 1907.
● companion piece to no 712.

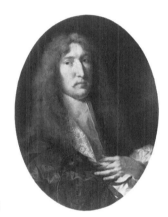

228

Henrich Dittmars | *Portrait of a man*

Probably born in Hamburg, died 1677 in Copenhagen. Influenced by Dutch artists like J. de Bray and A. van den Tempel.

Panel, 50x37.5 (oval). Signed and dated *H. Ditmars Fec: 1664.*
■ purchased after 1817.
● S. Gudlaugsson, O.H. 60 (1943), p. 147.
► Formerly regarded as a portrait of Johan de Witt.

31

Simon van der Does | *Shepherdess and sheep*

Born 1653, probably in Amsterdam, died after 1718 in Antwerp. Pupil of his father, J. van der Does. Worked primarily in The Hague, Haarlem and Amsterdam, and for brief periods in Brussels and Antwerp.

Canvas, 60x70. Signed and dated: *S: van der Does. MDCCXI.*
■ acquired in an exchange with the Rijksmuseum, Amsterdam, 1825.

● CAT. MAURITSHUIS 1980, pp. 27-28, 164, ill.

32

Gerard Dou | *Young mother with her child*

Born 1613 in Leiden, died there in 1675. Was Rembrandt's first pupil in Leiden, 1628-31. Dou was the first of the Leiden School of so-called 'fine painters' and the most renowned in his day.

Panel, 73.5x55.5 (ends in a round arch). Signed and dated *G Dou 1658.*
■ it is not certain whether this painting was bought from the artist by the States-General or from Van de Bye by the East India Company; part of the gift of the States-General to King Charles II of England in 1660; coll. King James II; coll. Stadholder-King William III; Het Loo, inv. 1713, no 155; Het Loo, inv. 1763, no 86; Cabinet Prince Willem V.
● MARTIN 1901, pp. 65-67, 232, no 305; HOFSTEDE DE GROOT 1907-28, I, p. 376, no 110; PLIETZSCH 1960, p. 42, fig. 50; DROSSAERS & LUNSINGH SCHEURLEER 1974-76, I, p. 695, no 4, II, p. 643, no 86, III, p. 209, no 32; ROSENBERG, SLIVE & KUILE 1977, p. 146, fig. 104; SUMOWSKI 1983, p. 533, no 284, ill.

33

■ | *Young woman holding a lamp*

Panel, 19x14.
■ Het Loo, 1763; Cabinet Prince Willem V.
● MARTIN 1901, p. 236, no 235; HOFSTEDE DE GROOT 1907-28, I, p. 416, no 230; DROSSAERS & LUNSINGH SCHEURLEER 1974-76, II, p. 643, no 83, III, p. 209, no 33.

34

Joost Cornelisz. Droochsloot | *Village scene* (formerly: *Village kermis*)

Born 1586, probably in Utrecht, died there in 1666. May have been a pupil of A. Bloemaert. In his work we see the influence of R. Savery and D. Vinckboons.

Panel, 44.5x80. Signed and dated: *JC. DS. 1652.*
■ purchased in 1873; on loan to the Centraal Museum, Utrecht, since 1925.
● CAT. MAURITSHUIS 1980, pp. 28-29, 165, ill.; AMSTERDAM 1984, pp. 158-159, no 31, ill.
▶ Companion piece to no 35.

35

■ | *River landscape* (formerly: *Village view*)

Panel, 44.5x80. Signed and dated: *JC. DS. 1652.*
■ purchased in 1873; on loan to the Netherlands Permanent Mission to the EEC, Brussels.
● CAT. MAURITSHUIS 1980, pp. 29, 165. ill.; AMSTERDAM 1984, pp. 158-159, no 31, ill.
▶ Companion piece to no 34.

Guillaume Du Bois, see Guillaume Du *Bois*.

320

Gaspard Dughet | *Mountainous landscape*

Born 1615 in Rome, died there in 1675. Brother-in-law, pupil and follower of N. Poussin.

Canvas, 48.6x64.
■ purchased with the De Rainer collection, 1821; on loan to the Rijksmuseum, Amsterdam, since 1948 (inv.no C1351).
● CAT. RIJKSMUSEUM 1976, p. 203, ill.

Karel Du Jardin, see Karel du *Jardin*.

440

Cornelis Dusart | *Peasant inn*

Born 1660 in Haarlem, died there in 1704. Pupil and follower of A. van Ostade.

Panel, 40.5x49.5. Signed (probably later): *Corn. dusart.* (with the forged signature of A. van Ostade painted over it).
■ purchased in 1877.
▶ Started by A.van Ostade, completed by C. Dusart.

408

Willem Cornelisz. Duyster | *An officer*

Born 1598/99 in Amsterdam, died there in 1635. It has been suggested that he studied under P. Codde, but this is unlikely since they were contemporaries.

Panel, 40x31.5.
■ purchased in 1876.
● BERNT 1969-70, I, no 348, ill.

791

Abraham van Dyck | *Old man, asleep*

Born 1635/36, died 1672 in Amsterdam. Probably a pupil of Rembrandt and influenced by N. Maes.

Canvas, 50.8x47. Signed: *AVDyck f.*
■ donated by J. Goudstikker, Amsterdam, 1926.
● SUMOWSKI 1983, p. 672, ill.

239

Anthony van Dyck | *Portrait of Pieter Stevens (1590-1668), Antwerp art lover and painter*

Born 1599 in Antwerp, died 1641 in London. Pupil of H. van Balen and notably of Rubens. Worked in Antwerp until 1620, then in London for one year, next in Italy until 1627, when he returned to Antwerp. After 1632 he remained in London, where he was court painter to Charles I.

Canvas, 112x99.5. Signed and dated: *Aet. Svae 37. 1627 Ant.o. van Dijck. fecit.*
■ coll. G. van Slingelandt, The Hague, 1752; Cabinet Prince Willem V.
● A. Leveson Gower, O.H. 28 (1910), pp. 73-76; C. Hofstede de Groot, O.H. 34 (1916), p. 68; GLÜCK 1931, p. 285, ill., p. 550; SPETH-HOLTERHOFF 1957, pp. 14-19; DROSSAERS & LUNSINGH SCHEURLEER 1974-76, III, p. 208, no 24; SMITH 1982, p. 87, fig. 36.

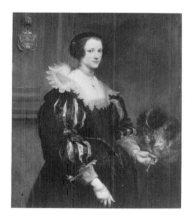

240

■ | *Portrait of Anna Wake (born 1606), wife of Pieter Stevens; married 1628*

Canvas, 112.5x99.5. Signed and dated: *Aet. Svae 22. An 1628. Ant.o van dyck fecit.*
■ coll. G. van Slingelandt, The Hague, 1752; Cabinet Prince Willem V.
● GLÜCK 1931, p. 284, ill., p. 550; SPETH-HOLTERHOFF 1957, p. 15; DROSSAERS & LUNSINGH SCHEURLEER 1974-76, III, p. 107, no 23; SMITH 1982, p. 87, fig. 35.

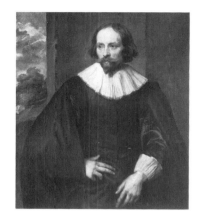

242

■ | *Portrait of the painter Quintijn Simons (born 1592)*

Canvas, 98x84.
■ coll. G. van Slingelandt, The Hague, 1768; Cabinet Prince Willem V.
● GLÜCK 1931, p. 343, ill., p. 556; H. Vey, *Die Zeichnungen Anton van Dycks,* Brussels 1962, I, p. 272, nr. 200; H. Gerson, O.K. 11 (1967), no 48, ill.; DROSSAERS & LUNSINGH SCHEURLEER 1974-76, III, p. 208, no 25; Chr. Brown, *Van Dyck,* Oxford 1982, p. 153, fig. 155, p. 229.
▶ A preparatory drawing in the British Museum, London; a print by P. de Jode the Younger in the 'Iconography' of Van Dyck.

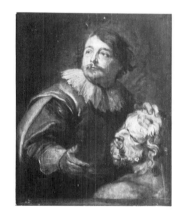

243

■ Copy after | *Portrait of Andreas Colijns de Nole (1598-1638), Antwerp sculptor*

Panel, 24x19.
■ purchased in 1874.

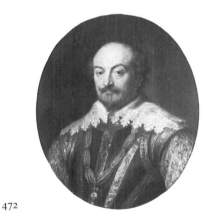

472

■ Copy after | *Portrait of Count Jan III of Nassau-Siegen (1583-1638)*

Canvas, 73x60 (oval).
■ unknown.
▶ Compare the print in mirror image by Lucas Vorsterman I in Van Dyck's 'Iconography'.

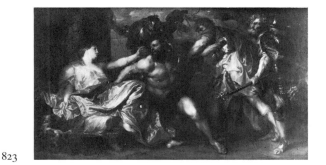

823

■ Copy after | *Samson and Delilah*

Canvas, 148x258.
■ acquired through government mediation, 1936.
▸ Modern copy of a painting by Van Dyck, Kunsthistorisches Museum, Vienna.

Philip van Dijk see after Dirck van *Deelen*

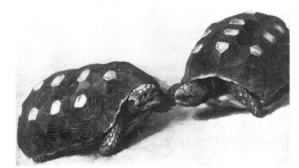

957

Albert Eckhout | *Two Brazilian tortoises*

Born ca 1610 in Groningen, died there in or before 1666. Possibly a pupil of J. van Campen. Accompanied Johan Maurits van Nassau-Siegen to Brazil from 1637 to 1644. Thereafter worked in Groningen, Amersfoort and from 1653 to ca 1664 in Germany, mainly in Dresden. Then returned to Groningen.

Paper on panel, 30.5x51.
■ coll. J.C.H. Heldring, Oosterbeek; purchased by the Johan Maurits van Nassau Foundation, 1963; given on permanent loan to the Mauritshuis.
● H.E. van Gelder, O.H. 75 (1960), pp. 5-30; L.J. Bol, O.K. 10 (1966), no 57, ill.; BOL 1969, p. 200, fig. 194; CAT. MAURITSHUIS 1970, no 23, ill.; THE HAGUE 1979-80, p. 172, no 207, ill.; see P.J.P. Whitehead, M. Boeseman, *A portrait of 17th-century Brazil animals, plants and people by the artists of Count Johan Maurits* (to be published shortly).

1048

Gerbrandt van den Eeckhout | *Christ and the woman of Samaria at the well*

Born 1621 in Amsterdam, died there in 1674. Worked in Amsterdam, and according to Houbraken he was a pupil and friend of Rembrandt (apprenticeship, probably from 1635 until 1640). Influenced by P. Lastman's works. Eeckhout was primarily a history painter, although he also produced genre scenes and portraits.

Oil on paper, 12.7x11.4. Signed and dated: *G. Eeckhout 16..*
■ coll. E.G. Spencer-Churchill, Northwick Park; kunsth. D.M. Koetser, Zürich; donated by Mr and Mrs J. Hoogsteder, The Hague, 1974.
● MONTREAL 1969, p. 83, no 45, ill.

295

Juan Antonio de Frias y Escalante | *A gipsy woman*

Born 1630 in Cordoba, died 1670 in Madrid. Influenced by A. van Dyck and B.E. Murillo.

Canvas, 97x127.
■ coll. Von Schepeler, Aachen; purchased in 1839; on loan to the Raadhuis, Geertruidenberg.

953

Allert van Everdingen | *View of Montjardin Castle*

Born 1621 in Alkmaar, died 1675 in Amsterdam. Probably a pupil of R. Savery (Utrecht) and P. Molyn (Haarlem). Brother of C.B. van Everdingen. Allert made a journey to Norway and Sweden in 1644.

Canvas, 73x95.5.
■ coll. O. Busch, Amsterdam; H. Schaeffer Galleries, New York; purchased in 1962.
● PLIETZSCH 1960, p. 105; H.A.J. Hos, O.H. 76 (1961), p. 208; BOL 1969, pp. 206-207, fig. 200; CAT. MAURITSHUIS 1970, no 32, ill.; A. Ingraham Davies, *Allart van Everdingen*, New York 1978, pp. 254-258, 353, no 155, fig. 371; CAT. MAURITSHUIS 1980, pp. 29-31, 166, ill.
▸ A drawing with the same subject is in the Albertina, Vienna (inv.no 9587).

39

Cæsar Boetius van Everdingen | *Diogenes looking for an honest man*

Born ca 1617 in Alkmaar. died there in 1678. Brother of the above. Studied under J.G. Bronchorst in Utrecht. Worked in Alkmaar and Haarlem (1648-1657). Everdingen also executed work for the Oranjezaal in Huis ten Bosch, The Hague.

Canvas on panel, 76x103.5. Signed and dated: *Anno 1652 CVE*.
■ bequest of the Dowager Steyn née Schellinger to Prince Willem v, 1783.
● V. Bloch, O.H. 53 (1936), pp. 258-260; R. Wishnevsky, *Portraits historiés*, Munich 1967, pp. 91-93, 222, no 137; J. Bruyn, SIMIOLUS 4 (1970), pp. 44-46; PARIS 1970-71, p. 70, no 75; LONDON 1976, pp. 41-42, no 38, ill.; DROSSAERS & LUNSINGH SCHEURLEER 1974-76, III, p. 210, no 36; WASHINGTON 1980-31, pp. 214-215, no 56, ill.; SCHLOSS 1982, p. 155, note 56.
■ The ten figures directly around Diogenes with the lamp are clearly portraits; they have tradionally been identified (most probably wrongly) as members of the Steyn family of Haarlem.

798

Barent Fabritius, Attributed to | *The departure of Benjamin*

Born 1624 in Midden-Beemster, died 1673 in Amsterdam. Pupil of Rembrandt.

Panel, 74x62.
■ coll. A. Bredius: given on loan, 1929; bequest of A. Bredius, 1946.
● D. Pont, *Barent Fabritius*, Utrecht 1958, p. 129, no 2.
► Doubtful attribution; ascribed by D. Pont to C.D. à Renesse.

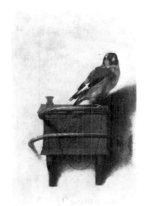

605

Carel Fabritius | *The goldfinch (Het puttertje)*

Born 1622 in Midden-Beemster, died 1654 in Delft. Worked in Amsterdam from 1641 to 1643, where he must have been Rembrandt's pupil, and from 1650 in Delft.

Panel, 33.5x22.8. Signed and dated: *C. Fabritius 1654*.
■ coll. J.G.J. Camberlyn, Brussels; given by Camberlyn to E.J.T. Thoré; bought by A. Bredius for the Mauritshuis, Paris, 1896.
● HOFSTEDE DE GROOT 1907-28, I, p. 581, no 16; SCHUURMAN 1947, p. 55; K. Boström, O.H. 65 (1950), pp. 81-83; PLIETSCH 1960, p. 48; A.B. de Vries, O.K. 8 (1964), no 33, ill.; ROSENBERG, SLIVE & KUILE 1977, p. 191, fig. 138; JONGH 1967, p. 49; M. Tóth-Ubbens in: *Miscellanea I.Q. van Regteren Altena*, Amsterdam 1969, pp. 155-159; BOL 1969, p. 299; M.L. Wurfbain in: *Opstellen voor H. van de Waal*, Amsterdam/Leiden 1970, pp. 233-240; BROWN 1981, pp. 47-58, 126-127, no 7. fig. III.

828

■ Attributed to | *Head of an old man* (formerly: *Head of a Polish Jew*)

Panel, 26x21.
■ coll. Harrach, Vienna; donated by the widow of H.L. Larsen in his memory, 1938.
● SCHUURMAN 1947, p. 36; PLIETSZCH 1960, p. 47; ROSENBERG, SLIVE & KUILE 1977, p. 155; PARIS 1970-71, p. 196, no 189; BROWN 1981, p. 129, no A1, fig. 10.

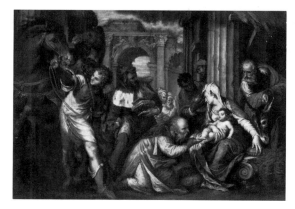

311

Paolo Farinato | *The adoration of the kings*

Born 1524, probably in Verona, died there in 1606. Son and pupil of
Giovanni Battista Farinato. Influenced by Michelangelo, Giulio Romano
and Paolo Veronese.

Canvas, 115x161. Signed with the mark of the artist, a snail shell.
▪ purchased by King Willem I for the Mauritshuis with the De Rainer
collection, 1821; on loan to the Rijksmuseum, Amsterdam (inv.no C1352),
since 1948.
● BERENSON 1907, p. 214; THIEME-BECKER 1907-1949, XI, p. 272; G. Fiocco,
J. KUNSTH. SAMML. WIEN, N.F. I (1927), p. 125, fig. 70; B. Berenson, *Italian
pictures of the Renaissance, Florentine school*, Oxford 1932, p. 180.
► Formerly attributed to Carlo Caliari; attributed to Farinato by B.
Berenson.
There is a preliminary drawing at the Pinacoteca Malaspina, Pavia.

398

Domenico Feti, Copy after | *Ecce homo*

Born ca 1589 in Rome, died 1624 in Venice. Worked in Mantua and Venice.

Panel, 58x68.
▪ purchased by King Willem I for the Mauritshuis with the Reghellini
collection, 1831.
► Late copy of a painting by Feti in the Alte Pinakothek, Munich, inv.no
478.

676

Govert Flinck | *Girl by a high-chair*

Born 1615 in Cleves, died 1660 in Amsterdam. Pupil of L. Jacobsz. in
Leeuwarden and of Rembrandt in Amsterdam (ca 1633-1636).

Canvas, 114.2x87.3. Signed and dated: *G. Flinck. f 1640.*
▪ bequest of A.A. des Tombe, The Hague, 1903.
● MOLTKE 1965, p. 152, no 413, pl. 46; PLIETZSCH 1960, pp. 177-178, fig.
323; MONTREAL 1969, pp. 89-90, no 60, ill.; PARIS 1970-71, p. 73, no 77.

696

▬ | *Portrait of a man*

Canvas, 72.5x58.7. Signed: *G. Flinck 16...*
▪ bequest of T.H. Blom Coster, The Hague, 1904.
● MOLTKE 1965, p. 121, no 264, ill.

866

▬ *Portrait of a man*

Panel, 75x59 (oval). The signature was largely removed at one time to make
room for a false Rembrandt signature. This has now been taken off and the
remains of the first name can be seen again. Dated: *1637.* Inscribed: *AEt.
44.*
▪ coll. Mniszech, Paris; coll. De Jonge, Paris, 1911; coll. F. Lugt, The
Hague; transferred to the Mauritshuis by the Rijksdienst Beeldende Kunst,
1960.

58

• A. Behr, 'The Iconography of Menasseh ben Israel,' *Transactions of the Jewish Historical Society of England* XIX, z.j., pp. 191-198; MARTIN 1935-36, II, p. 115, fig. 62; MOLTKE 1965, pp. 109-110, no 213, pl. 34; PLIETZSCH 1960, p. 177, fig. 322; E. Winternitz, *Metropolitan Museum Journal* 12 (1977), p. 105.
▸ The traditional identification of Menasseh ben Israel (1604-1657), which is largely based on a resemblance to an etched portrait by Rembrandt dated 1636, is rejected by A. Behr. In 1637 Menasseh ben Israel was 33 years old. A portrait of a woman (signed and dated 1641), a companion piece to no 866, is mentioned at the Mniszech auction, Paris (Georges Petit), 9/11.4.1902, no 109.

347

Marcello Fogolino | *Enthroned Madonna and child with six saints*

Documented between 1508 and 1548. Worked in Vicenza, Venice, Padua and Pordenone. Influenced by Bartolommeo Montagna and Il Pordenone.

Canvas, 266x195. Signed: *Marcellvs Vincentinvs P.*
▪ purchased by King Willem I for the Mauritshuis with the Reghellini collection, 1831; on loan to the Rijksmuseum, Amsterdam (inv.no C1129), since 1924.
● F.D.O. Obreen, *Archief voor Nederlandsche kunstgeschiedenis*, VII, 1888-1890, pp. 63-65; THIEME-BECKER 1907-47, XII, p. 141; CAT. RIJKSMUSEUM 1976, p. 229, ill.; H.W. van Os, *The early Venetian paintings in Holland*, Maarssen 1978, pp. 88-91, no 20, fig. 56.
▸ The saints, from left to right, are Catherine, Francis, John the Baptist, John the Evangelist, Anthony of Padua and Mary Magdalene.
Formerly attributed to Giovanni Bellini. Attributed to Fogolino by V. de Stuers (see Obreen).

316

Marc Antonio Franceschini | *Adam and Eve*

Born 1648 in Bologna, died there in 1729. Pupil of G.M. Galli da Bibiena and of C. Cignani. Worked in Bologna.

Canvas, 234x158.
▪ coll. Elector of Saxony; Cabinet Prince Willem V; Louvre, Paris, 1795-1815; on loan to the Rijksmuseum, Amsterdam (inv.no C1348), since 1948.
● H. Voss, *Zeitschrift für Kunstgeschichte* 2 (1933), pp. 196-197, fig. 11.
▸ Formerly attributed to C. Cignani; attribution to Franceschini by H. Voss.

244

Frans Francken II | *Ball at the court of Albert of Austria (1559-1621) and his wife Isabella Clara Eugenia of Spain (1566-1633), governors of The Netherlands*

Born 1581 in Antwerp, died there in 1642. Pupil of his father, Frans Francken I. Uncle and master of Frans Francken III.

Panel, 68x113.5. Signed: *Den J. ffranck.*
▪ coll. Countess of Albemarle, The Hague, 1744; Het Loo, inv.no 1743; Cabinet Prince Willem V.
● HÄRTING 1983, pp. 204, 207, no A336, fig. 103.
▸ The architecture is attributed to P. Vredeman de Vries. Philips Willem (1554-1618), the eldest son of Willem I of Orange, is seen in the centre with his wife Eleonora de Bourbon, Princesse de Condé (1587-1619).

687

Jan Fyt | *Dead birds, cage and net*

Born 1611 in Antwerp, died there in 1661. Pupil of F. Snijders. Travelled through France and Italy in the 1630s.

Canvas, 48.4x81.5.
▪ purchased in 1904.
● E. Greindl, *Les peintres flamands de nature morte au XVIIe siècle*, Brussels 1956, p. 165.

867

▪ *Still life with dead birds*

Panel, 52.5x67.5
▪ transferred to the Mauritshuis by the Rijksdienst Beeldende Kunst, 1960.

● GREINDL 1983, p. 353, no 230.

925

■ *Still life of a hunter's bag*

Canvas, 121.5x97.5. Formerly signed: *Johannes Fyt pinx.. 16...*
■ donated by Mr and Mrs H.A. Wetzlar, Amsterdam, 1955.
● CAT. MAURITSHUIS 1970, no 12, ill.; AUCKLAND 1982, pp. 130-131, no 21, ill.; GREINDL 1983, p. 349, no 66.

245

Marten Josef Geeraerts | *Allegory of autumn*

Born 1707 in Antwerp, died there in 1791. Pupil of A. Godyn.

Canvas, 85x100 (grisaille).
■ coll. Braamcamp; Cabinet Prince Willem V.
● BILLE 1961, I, p. 80, fig. 63; II, p. 96, no 63; A.J. van Dissel, N.K.J. 31 (1980), p. 398, note 12.

40

Aert de Gelder | *Judah and Tamar*

Born 1645 in Dordrecht, died there in 1727. Pupil of S. van Hoogstraten and ca 1661 of Rembrandt. Thereafter worked in Dordrecht. Follower of Rembrandt's late style.

Canvas, 80x97. Signed: *A. De Gelder f.*
■ donated by Count H. van Limburg Stirum, 1874.
● LILIENFELD 1914, p. 113, no 13; AMSTERDAM 1983 (1), pp. 166-167, no 38, ill.

737

■ *The temple entrance*

Canvas, 70.7x91. Signed and dated: *A. De Gelder. f 1679.*
■ coll. Seger Tierens, The Hague, 1743; coll. Van Bremen, The Hague, 1752; donated by F. Kleinberger, Paris, 1911.
● LILIENFELD 1914, pp. 171-172, no 111, fig. 3; W. Martin, *Oude Kunst* 2 (1917), pp. 14-16, figs. 4-5; PLIETZSCH 1960, p. 183, fig. 336; A. Bader, BURL.MAG. 112 (1970), pp. 691-692, fig. 43.

757

■ *Portrait of Herman Boerhaave (1668-1738), professor of medicine at Leiden*

Canvas, 79.2x63.5 (oval). Signed: *..e Gelder F.*
■ donated by D.A.J. Kessler, The Hague, 1918.
● LILIENFELD 1914, p. 193, no 160, fig. 14; W. Martin, BULL. N.O.B. 12 (1919), pp. 23-26, ill.; G.A. Lindeboom, *Iconographia Boerhaavii*, Leiden 1963, p. 6, no 12.

1047

■ *The presentation in the temple*

Canvas, 89x116.
■ Ch. Robinson, London; Walker Art Center, Minneapolis; B. Mont, New York; Dutch private collection; on loan since 1974; donated in 1987 by H.J. de Koster.
● LILIENFELD 1914, p. 147, no 50; *Rembrandt and his pupils*, North Carolina Museum of Art, Raleigh 1956, p. 119, no 42, ill.

321

Luca Giordano, Attributed to | *Four women making music*

Born 1632 in Naples, died there in 1705. Pupil of his father Antonio. Worked in Naples, Rome and Florence. Was court painter to Charles II of Spain, 1692-1702.

Canvas, 57.2x101.6.
■ purchased by King Willem I for the Mauritshuis with the De Rainer collection, 1821; on loan to the Rijksmuseum, Amsterdam (inv.no C1353), since 1948.
● CAT. MAURITSHUIS 1935, p. 162.
► Probably a fragment.

42

Hendrick Goltzius | *Minerva*

Born 1558 in Mühlbracht (Bracht), near Venlo, died 1617 in Haarlem. Pupil of his father J. Goltz and of D.V. Coornhert, influenced by B. Spranger. Travelled to Rome in 1590/91. Worked in Haarlem; achieved international fame, particularly as a graphic artist.

Canvas, 214x120.

■ Outger Jacobsz. Wijbo, Hoorn, 1671; purchased in 1875 with nos 43 and 44; on loan to the Frans Hals Museum, Haarlem, since 1917.
● E.W. Moes, O.H. 7 (1889), p. 153; HIRSCHMANN 1916, pp. 77-78, no 15, fig. 4; BRUSSELS 1971, pp. 161-165; AMSTERDAM 1984, pp. 84-89, no 6, fig. 2.
► Minerva is depicted as the personification of the theory of painting. The combination of nos 42, 43 and 44 is a defence of art against stupidity, envy and slander.

43

■ *Hercules and Cacus*

Canvas, 207x142.5. Signed and dated: *HG. Ao 1613*.
■ Outger Jacobsz. Wijbo, Hoorn, 1671; purchased in 1875 with nos 42 and 44; on loan to the Frans Hals Museum, Haarlem, since 1917.
● E.W. Moes, O.H. 7 (1889), p. 153; HIRSCHMANN 1916, p. 78, no 17; BRUSSELS 1971, pp. 161-165; E.K.J. Reznicek, O.H. 89 (1975), p. 112, note 31; AMSTERDAM 1984, pp. 84-89, no 6, fig. 3.
► As the personification of virtue defeating envy (Cacus), Hercules stands for the true artist.

44

■ *Mercury*

Canvas, 214x120. Signed and dated: *HG. Ao. 1611*.
■ Outger Jacobsz. Wijbo, Hoorn, 1671; purchased in 1875 with nos 42 and 43; on loan to the Frans Hals Museum, Haarlem, since 1917.
● E.W. Moes, O.H. 7 (1889), p. 153; HIRSCHMANN 1916, p. 77, no 14, fig. 3; BRUSSELS 1971, pp. 161-165; AMSTERDAM 1984, pp. 84-89, no 6, fig. 1.
► Here Mercury personifies the practice of art.

830

Jan Gossaert, called **Mabuse** | *Madonna and child*

Born ca 1478 probably in Maubeuge, died 1532 in Breda or Middelburg.

Panel, 25x19 (ends in a round arch).
■ purchased in 1939.
● FRIEDLÄNDER 1967-76, VIII, p. 94, no 29, pl. 31; ROTTERDAM 1965, pp. 180-182, no 29, ill.; CAT. MAURITSHUIS 1968, p. 24, ill.

841

■ *Portrait of Floris van Egmond (1469-1539), Count of Buren, Lord of IJsselstein*

Panel, 39x29.5. Inscribed: *L.*
■ Honselaarsdijk, 1707; Nationale Konst-Gallery, The Hague, 1800; Rijksmuseum, Amsterdam, inv.no A217; on loan from the Rijksmuseum, Amsterdam, since 1948.
● FRIEDLÄNDER 1967-76, VIII, p. 98, no 54, pl. 45; ROTTERDAM 1965, pp. 128-130, no 17, ill.; CAT. MAURITSHUIS 1968, pp. 23-24, ill.; OSTEN & VEY 1969, p. 190; DROSSAERS & LUNSINGH SCHEURLEER 1974-76, I, p. 528, no 151, II, p. 520, no 287; CAT. RIJKSMUSEUM 1976, p. 245; R. Marks, O.H. 94 (1977), p. 137, fig. 5; THIEL 1981, p. 191, no 49, ill.
▶ Floris van Egmond wears the chain of the Order of the Golden Fleece around his neck.

45

Abraham Govaerts | *Forest view*

Born 1589 in Antwerp, died there in 1626. Was indebted to J. Brueghel the Elder and G. van Coninxloo.

Panel, 62.5x101. Signed and dated: *A Govaerts 1.6.1.2..*
■ Oranienstein Castle; Cabinet Prince Willem V.
● THIERY 1953, p. 180; BERNT 1969-70, I, no 437, ill.; DROSSAERS & LUNSINGH SCHEURLEER 1974-76, III, p. 211; G.S. Keyes, *Master Drawings* 16 (1978), pp. 298-300, fig. 8.

551

Jan van Goyen | *View of Dordrecht from Papendrecht*

Born 1596 in Leiden, died 1656 in The Hague. According to Houbraken he was a pupil of E. van de Velde, Haarlem. Made several journeys, one of them probably to France, 1615. Worked in The Hague from 1632.

Panel, 46.5x72.8.
■ purchased in 1889.
● HOFSTEDE DE GROOT 1907-28, VIII, p. 17, no 44; DOBRZYCKA 1966, no 63, fig. 37; BERNT 1969-70, I, no 442, ill.; BECK 1973, II, p.141, no 290, ill.; BOL 1973, pp. 120-121; CAT. MAURITSHUIS 1980, pp. 33-34, 167, ill.

624

■ | *Estuary with sailing boats*

Panel, 41.2x55.8. Signed and dated: *vG 1655.*
■ given on loan in 1899; bequest of A. Bredius, 1946.
● HOFSTEDE DE GROOT 1907-28, VIII, pp. 250-251, no 1033; DOBRZYCKA 1966, no 238, fig. 115; BECK 1973, II, p. 368, no 821, ill.; BOL 1973, pp. 131-132, fig. 136; CAT. MAURITSHUIS 1980, pp. 38, 170, ill.

759

■ | *River view*

Panel, 37x64. Signed: *vG.*
■ coll. James Simon Berlin; donated by A.S. van den Bergh, The Hague, 1919.
● HOFSTEDE DE GROOT 1907-28, VIII, p. 132, no 548; DOBRZYCKA 1966, no 90; BECK 1973, I, p. 275, no 603, ill.; STECHOW 1975, p. 41; CAT. MAURITSHUIS 1980, pp. 34-35, 167, ill.

838

■ | *View on the Rhine near Elten*

Canvas, 81x152. Signed and dated: *vG 1653.*
■ given on loan from 1947 till 1962; purchased from coll. Ten Horn, Loon op Zand, 1975.
● DOBRZYCKA 1966, no 230, ill.; BECK 1973, II, p. 158, no 321, ill.; CAT. MAURITSHUIS 1980, pp. 36-37, 169, ill.
▶ The upper right corner is not original, probably 18th-century.

979

■ | *Fishermen by the lakeshore*

Paper on linen, 25x34. Signed and dated: *VG 1651.*
■ coll. M. Kappel, Berlin; coll. H.U. Beck, Berlin, Munich; purchased in 1967.
● HOFSTEDE DE GROOT 1907-28, VIII, p. 126, no 516, p. 132, no 544; H.U. Beck, *Apollo* 76 (1960), pp. 176-178; CAT. MAURITSHUIS 1970, no 19, ill.; BECK 1973, II, p. 123, no 254, ill.; CAT. MAURITSHUIS 1980, pp. 35-36, 168, ill.

Tiziano di Gregorio Vecellio, see *Titian.*

813

Tethart Philip Christian Haag | *Orang-utan*

Born 1737 in Kassel, died 1812 in The Hague. Son of J.F.C. Haag, court painter of prince Willem V; succeeded his father in this function ca 1758. Attended the academy of drawing in The Hague. Keeper of the Cabinet Willem V.

Canvas, 174x110.5. Signed and dated: *TPC Haag pinx. ad viv. 1777.*
■ uncertain.
● M. Mazel, *Die Haghe*, 1909, pp. 361-381; P. Tuijn, P.J. van der Feen, *Bijdragen tot de dierkunde*, 1969, p. 74.

47

Joris van der Haagen | *Panorama near Arnhem with the Rhine gate*

Born ca 1615, probably in Arnhem, died 1669 in The Hague, where he worked from ca 1640 on. Mentioned in Amsterdam in 1650 and 1657.

Canvas, 66x88.7
■ Honselaarsdijk Castle; Cabinet Prince Willem V.
● HAAGEN 1932, pp. 72-73, no 21; BOL 1969, p. 252; BERNT 1969-70, I, no 461, ill.; DROSSAERS & LUNSINGH SCHEURLEER 1974-76, II, p. 511, no 192, III, p. 215, no 61; CAT. MAURITSHUIS 1980, pp. 40, 171, ill.; ENSCHEDE 1980, pp. 54-55, no 11.
▶ The house on the far right may be the same as that on the extreme left of the following painting. Possibly a companion piece to no 46.

46

■ *Panorama near Arnhem*

Canvas, 66x88.7. Dated: *1649*.
■ Honselaarsdijk Castle; Cabinet Prince Willem V.
● HAAGEN 1932, p. 73, no 22; BOL 1969, p. 252; DROSSAERS & LUNSINGH SCHEURLEER 1974-76, II, p. 511, no 196, III, p. 235, no 166; F.J. Duparc, ANTIEK 13 (1978), pp. 282-284; CAT. MAURITSHUIS 1980, pp. 39-40, 171, ill.; ENSCHEDE 1980, pp. 34-35, no 1, ill.
▶ Possibly a companion piece to no 47. The Arnhem identification is uncertain.

Cornelis Cornelisz. van Haarlem, see Cornelis *Cornelisz*. van Haarlem.

1039

Johannes Hackaert | *Deer hunt in a forest*

Baptised 1628 in Amsterdam, died in or after 1685, probably in Amsterdam. He visited Switzerland and perhaps Italy from 1653 to 1657; afterwards worked in Amsterdam. Influenced by J. Both. A. van de Velde, J. Lingelbach and C.P. Berchem are said to have painted figures in his works.

Canvas, 69x54.
■ coll. A. van Beeftingh, Rotterdam, 1832; coll. J. Steengracht van Oostcapelle, The Hague; coll. E. Gutmann, Haarlem; Kunstmuseum Düsseldorf, 1942; purchased in 1971.
● HOFSTEDE DE GROOT 1907-28, IX, p. 5, no 14; CAT. MAURITSHUIS 1980, pp. 41-43, 174, ill.

470

■ Attributed to | *Italian landscape*

Panel, 28x34.5. Signed: *I.H.*
■ purchased in 1882.
● HOFSTEDE DE GROOT 1907-28, IX, p. 10, no 36; CAT. MAURITSHUIS 1980, pp. 41, 173, ill.

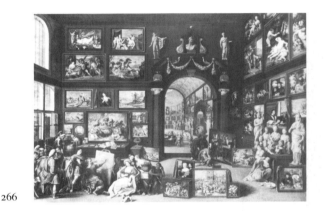

266

Willem van Haecht | *Alexander the Great visiting the studio of Apelles*

Born 1593 in Antwerp, died there in 1637. Son of T. Verhaecht. Visited Italy and France, worked in Antwerp on his return. Keeper of Cornelis van der Geest's picture collection.

Panel, 105x149.5.
■ coll. Elector of Saxony, Amsterdam, 1765; Cabinet Prince Willem V.
● F. Lugt, O.H. 53 (1936), p. 128, fig. 60; SPETH-HOLTERHOFF 1957, p. 104, fig. 38; J.S. Held, GAZ. B.A. 6/50 (1957), p. 61, note 18, p. 84; DELFT 1964, no 58, fig. 9; R. Genaille, BULL.MUS.ROY.BELG. 16 (1967), p. 92, fig. 11; F. Baudoin, *Rubens en zijn eeuw*, Antwerp 1972, p. 274, note 20; MITCHELL 1973, p. 32, fig. 31; M. Milner Kahr, ART BULL. 57 (1975), p. 234, fig. 10; SILVER 1984, p. 237, pl. 181.
▶ Some of the works displayed on the walls are from the collection of Cornelis van der Geest. The same is true of *The visit of the archdukes to C. van der Geest* in the Rubens House, Antwerp, and Van Haecht's other known painting in the C. Bestegui collection, Montfort-l'Amaury. The figures in the latter work repeat those in our painting almost literally.

135

Johan van Haensbergen | *Nymphs bathing*

Born 1642 in Gorinchem or Utrecht, died 1705 in The Hague. Pupil and follower of C. van Poelenburch, Utrecht. Worked in Utrecht until 1669, then in The Hague, where he painted portraits in the style of N. Maes.

Copper, 17.5x22.5.
■ Cabinet Prince Willem V.

601

■ | *Still life with a wicker jug*

Panel, 40x30.2. Signed and dated: *Joh. Haensbergh. Gorco: fec.1665.*
■ donated by T. Humphrey Ward, London, 1895.

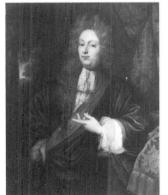

720

■ | *Portrait of Pieter Dierquens (1668-1714), bailiff of The Hague*

Canvas, 57.5x46. Signed and dated: *I.V.H. f 1690.*
■ bequest of Miss M.J. Singendonck, The Hague, 1907.
► Son from the first marriage of Elisabeth van Bebber with Johannes Dierquens; see Caspar Netscher, inv.no 714.
Companion piece to no 721 by Constantijn Netscher.

623

Claes Hals | *Woman reading*

Born 1628 in Haarlem, died there in 1686. Son and probably pupil of F. Hals. In his landscapes follower of J. van Ruisdael.

Panel, 30.8x24. Signed: *CH.*
■ purchased in 1899.
● A. Bredius, BURL.MAG. 38 (1921), p. 138; MARTIN 1935-36, I, pp. 382-383, fig. 228.

771-775

Dirck Hals | *The five senses*

Born 1591 in Haarlem, died there in 1656. Brother of F. Hals and possibly his pupil. May have spent some years between 1641 and 1649 in Leiden. Painted the same subjects as W. Buytewech and in a similar manner.

Five panels, 12 cm in diameter (round). All signed: *DH 1636.*
■ donated by Mr and Mrs A.F. Philips, Eindhoven, 1923.

1060

■ | *Merry company*

Panel, 30x51.1. Signed: *D Hals 1635.*
■ donated by jhr mr E.V.E. Texeira de Mattos, Monte Carlo, 1979.

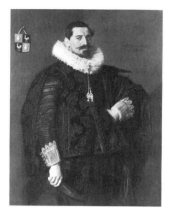

459

Frans Hals | *Portrait of Jacob Pietersz. Olycan (1596-1638)*

Born ca 1582/83, probably in Antwerp, died 1666 in Haarlem. Pupil of C. van Mander, Haarlem. Most important portrait painter of the generation before Rembrandt. According to Houbraken, A. Brouwer and A. van Ostade were his apprentices; J. Leyster and J.M. Molenaer may also have studies with Hals.

Canvas, 124.6x97.3. Inscribed: *AEtat Svae 29 Ao. 1625.*
■ purchased in 1880.
● HOFSTEDE DE GROOT 1907-28, III, p. 62, no 208; VALENTINER 1923, p. 42, ill., p. 309; TRIVAS 1941, no 18; SLIVE 1970-74, II, fig. 58, III, pp. 21-22, no 32; GRIMM 1972, p. 200, no 19; SMITH 1982, pp. 96-101, fig. 39.
▶ At upper left the sitter's coat of arms. Companion piece to no 460; the couple married in 1624. J.P. Olycan recurs in F. Hals's *Banquet of the civic guard of St George* (1627), Frans Hals Museum, Haarlem.

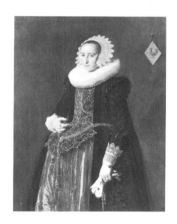

460

■ | *Portrait of Aletta Hanemans (1606-1653), wife of Jacob Pietersz. Olycan*

Canvas, 124.2x98.2. Inscribed: *AEtat Svae 19 ANo 1625.*
■ purchased in 1880.
● HOFSTEDE DE GROOT 1907-28, III, p. 63, no 209; VALENTINER 1923, p. 43, ill., p. 309; TRIVAS 1941, no 19; SLIVE 1970-74, II, fig. 59, III, p. 22, no 33; GRIMM 1972, p. 200, no 20; SMITH 1982, pp. 96-101, fig. 40.
▶ At upper right the sitter's coat of arms. Companion piece to no 459; the couple married in 1624.

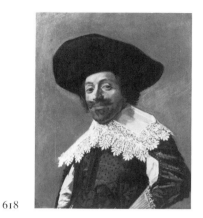

618

■ | *Portrait of a man*

Panel, 24.5x19.5.
■ purchased in 1898.
● HOFSTEDE DE GROOT 1907-28, III, p. 80, no 279; VALENTINER 1923, p. 155, ill., p. 316; TRIVAS 1941, no 55; SLIVE 1970-74, II, fig. 140, III, p. 54; GRIMM 1972, p. 203, no 82.

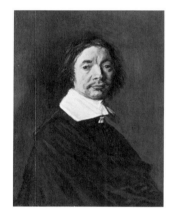

928

■ | *Portrait of a man*

Panel, 31.6x25.5.
■ coll. Gumprecht, Berlin, 1882; coll. Heilbluth, Copenhagen; coll. Bixby, St. Louis; H. Schaeffer Galleries, New York; purchased with the aid of the Johan Maurits van Nassau Foundation, 1957.
● HOFSTEDE DE GROOT 1907-28, III, p. 75, no 257; VALENTINER 1923, p. 286, ill., p. 323; TRIVAS 1941, no 103; J. Engelman, O.K. 6 (1962), no 15, ill.; SLIVE 1970-74, II, fig. 323, III, pp. 107-108, no 210; CAT. MAURITSHUIS 1970, no 16, ill.; GRIMM 1972, p. 206, no 158.

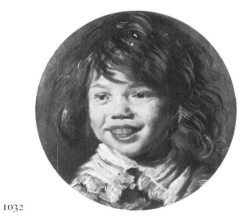

1032

 | *Laughing boy*

Panel, 29.5 in diameter (round). Signed: *FH.*

■ coll. Oppenheim, Cologne; coll. Mrs Friedländer-Fuld, Berlin; coll. Mrs Kühlmann, Berlin; purchased with the aid of the Rembrandt Society, the Prince Bernhard Func and the Johan Maurits van Nassau Foundation, 1968.
● HOFSTEDE DE GROOT 1907-28, III, p. 11, no 28; VALENTINER 1923, p. 31, ill., p. 307; A.B. de Vries, O.K. 13 (1969), no 24, ill.; SLIVE 1970-74, II, fig. 49, III, pp. 18-19; CAT MAURITSHUIS 1970, no 15, ill.; GRIMM 1972, p. 200, no 18; H.P. Baard, *Frans Hals*, New York 1981, p. 84, fig. 11.
► Three replicas are known to exist, one being in the museum in Dijon.

756

Harmen Hals | *Peasant smoking*

Born 1611 in Haarlem, died there in 1669. Eldest son and pupil of F. Hals. Influenced by A. Brouwer and J.M. Molenaer. Worked in Haarlem, Vianen and Gorinchem.

Panel, 63.3x48.
■ purchased in 1918.
● BULL. N.O.B. 1918, pp. 214-217, fig. 1.

241

Adriaen Hanneman | *Portrait of Constantijn Huygens (1596-1687) with his children*

Canvas, 204x173. Inscribed: *Ecce hereditas domini.* Dated: *Anno 1640.*
■ purchased in 1822.
● COLLINS BAKER 1912, I, pp. 85-88; C.A. Crommelin, *Maandblad van Beeldende Kunsten* 21 (1944), pp. 123-130; H.E. van Gelder, *Ikonografie van Constantijn Huygens en de zijnen*, The Hague 1957, p. 24, no 12, fig. 20; BERNT 1969-70, I, no 477, ill.; PARIS 1970-71, p. 131, no 134; KUILE 1976, pp. 59-61, no 6, fig. 5; AMSTERDAM 1982-83, pp. 8-9, ill.
► The renowned poet and statesman Constantijn Huygens in the centre. At upper right: Constantijn (1628-1697), who, like his father, became secretary to the prince of Orange. At upper left: Christiaen (1629-1695), famous scientist and astronomer. Lower right: Lodewijk (1631-1699), later bailiff of Gorinchem. Lower left: Philips (1633-1699). Upper centre: Suzanne (1637-1725), later the wife of Philips Doublet.

429

■ | *Portrait of Maria Henriette Stuart (1631-1630), wife of Prince Willem II of Orange*

Canvas, 130.5x120.8.
■ Honselaarsdijk Castle, 1719.
● BERNT 1969-70, II, no 822, ill. (as J. Mijtens); DROSSAERS & LUNSINGH SCHEURLEER 1974-76, I, p. 522, no 11; KUILE 1976, pp. 113-114, no 78a, fig. 37; THE HAGUE 1979-80, p. 209, no 273, ill.

693

■ | *Portrait of a man*

Canvas, 73x62.
■ bequest of T.H. Blom, The Hague, 1904.
● KUILE 1976, p. 76, no 16, fig. 29.

936

Gerrit Willemsz. Heda | *Still life with nautilus cup*

Birthdate unknown, died 1649, probably in Haarlem. Son and pupil of W.C. Heda. Active in Haarlem from 1637 onwards.

Panel, 68.5x50. Signed and dated: *Heda 1640.*
■ bequest of B.H. van der Linden, New York, 1959, in memory of his wife.
● VROOM 1945, pp. 134-135, fig. 116, p. 207, no 142; BOL 1969, p. 68, fig. 55; CAT. MAURITSHUIS 1970, no 26, ill.; VROOM 1980, II, p. 58, no 283, ill.

596

Willem Claesz. Heda | *Still life*

Born 1594/95 in Haarlem, died there ca 1680. He was presumably influenced by F. van Dyck. Worked in Haarlem.

Panel, 46x69.2. Signed and dated: *Heda. 1629.*
■ purchased in 1895.
● VROOM 1945, p. 210, no 175; BERGSTRÖM 1956, p. 124, fig. 109; CAT. THYSSEN-BORNEMISZA 1969, p. 168; BERGSTRÖM 1977, p. 193, ill.; VROOM 1980, I, pp. 66-69, fig. 84, II, p. 65, no 326.
► Remains of a second signature on the blade of the knife.

50

Cornelis de Heem | *Still life with fruit*

Born 1631 in Leiden, died 1695 in Antwerp. Son and pupil of J.D. de Heem. Worked in Antwerp.

Canvas, 65x50. Signed: *C. de Heem.*
■ Nationale Konst-Gallery, The Hague.
● THIEL 1981, p. 203, no 147, ill.

48

Jan Davidsz. de Heem | *Ornamental still life*

Born 1606 in Utrecht, died 1683/84 in Antwerp. Probably pupil of his father David de Heem the Elder. Around 1630 he worked for a few years in Leiden. Afterwards (1635/36) he settled in Antwerp; influenced by D. Seghers. Resided in his native city from 1669 to 1672, then returned to Antwerp.

Canvas, 94.7x120.5. Signed: *J.D. De Heem f.*
■ Cabinet Prince Willem V.
● GREINDL 1983, p. 360, no 61.

49

■ | *Garland of flowers and fruit*

Canvas, 60.2x74.7. Signed: *J.D. Heem. fecit.*
■ Het Loo, 1763; Cabinet Prince Willem V.
● BERGSTRÖM 1956, p. 210, fig. 175; GREINDL 1983, pp. 127, 361, no 62.

613

■ | *Still life with books*

Panel, 36.1x48.5. Signed and dated: *Johannes. de. Heem. 1628.* Inscriptions on books, centre and right: *G.A. BR. DEROOS treur spel van RODDRICK ende ALPHONSVS; I. WESTERBAENS.KVSIENS. CLACHTEN.*
■ purchased by the Rembrandt Society in 1910; transferred in 1912.
● BERGSTRÖM 1956, p. 163, fig. 139; BERNT 1969-70, II, no 492, ill.; A.P. de Mirimonde, JAARBOEK ANTWERPEN 1970, p. 251, fig. 3; LEIDEN 1970, p. 13, no 14, ill.; GREINDL 1983, pp. 123, 361, no 63.

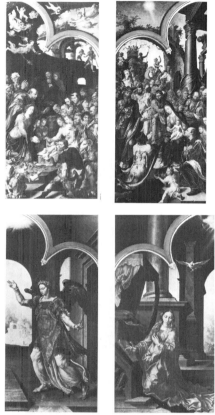

51-52

Maerten van Heemskerck | *The adoration of the shepherds;* verso: *The Virgin The adoration of the kings;* verso: *Archangel Gabriel*

Born 1498 in Heemskerk, died 1574 in Haarlem. Pupil of J. van Scorel. Travelled in Italy, 1532-1536/37. Influenced by Michelangelo. Worked in Haarlem.

Two panels, each 260x122.5.
■ made for the drapers' guild in 1546, Haarlem; ceded to the state by the city of Haarlem, 1805; on loan to the Frans Hals Museum, Haarlem, since 1917.
● L. Preibisz, *Martin van Heemskerck*, Leipzig 1911. p. 72, no 18, figs. V, VI; HOOGEWERFF 1936-47, IV, p. 236; JANTZEN 1979, p. 16, 224, no 160j; R. Grosshans, *Maerten van Heemskerck, die Gemälde*, Berlin 1980, p. 171, no 55, figs. 80-85; BIESBOER 1983, pp. 23-27. figs. 9-11.
▶ Wings of triptych; on the versos a continuous representation of the Annunciation. Ca 1591 the centre panel was replaced by the *Massacre of the innocents* (inv.no 22) by C. Cornelisz. van Haarlem, who also pieced out the wings to rectangular shape.

801

Hendrick Heerschop | *Visit to the doctor*

Born 1620/21 in Haarlem, died after 1672, possibly a pupil of Rembrandt in Amsterdam. Pupil of W.C. Heda, Haarlem. Documented in Haarlem in 1648 and 1661.

Panel, 53x43.5. Signed and dated: *Heerschop: 1668.*

■ donated by B. Svenonius, Stockholm, 1930.
● SUMOWSKI 1983, pp. 83, 87, note 35, p. 108, ill.

1055

Antoon François Heijligers | *Interior of the Rembrandt Room, Mauritshuis, 1884*

Born 1828 in Batavia (Dutch East Indies), died 1897 in The Hague. Lived and worked in Geertruidenberg, Grave and Brussel. In 1878 he settled in The Hague.

Panel, 47x59. Signed and dated: *A.F. Heijligers* 1884.
■ purchased in 1976.

54

Bartholomeus van der Helst *Portrait of the painter Paulus Potter (1625-1654)*

Born 1613 in Haarlem, died 1670 in Amsterdam, where he had always worked. Probably a pupil of N. Eliasz. Pickenoy. Van der Helst was a very fashionable portrait painter from about the mid-1640s onwards.

Canvas, 99x80. Signed and dated: *B. vander.helst.1654.*
■ coll. L.L. van Reenen, The Hague; purchased by King Willem I in 1820.
● GELDER 1921, p. 172, no 117.

545

■ | *Portrait of a young woman*

Canvas, 78x67.
■ purchased in 1888.
● GELDER 1921, p. 209, no 548.

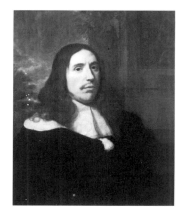

568

■ | *Portrait of a man*

Panel, 77x62.5. Signed and dated: *B. van der Helst. 1660.*
■ anonymous donation, 1893.
● GELDER 1921, p. 171, no 112.
▶ The sitter is probably a member of the Persijn family. Companion piece to no 569.

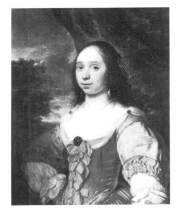

569

■ | *Portrait of a woman*

Panel, 77x62.5. Signed and dated: *B. van der.helst 165(9).*
■ anonymous donation, 1893.
● GELDER 1921, p. 171, no 113.
▶ Companion piece to no 568.

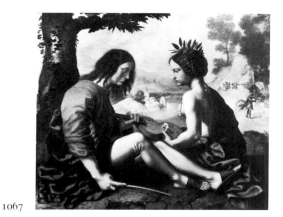

1067

Jan Sanders van Hemessen | *Poetry and the poet*

Active from ca 1522 till 1556. Trained in Antwerp, where he mostly worked. Probably travelled to Italy and France (Fontainebleau).

Panel, 159x189.
■ acquired in 1984 with the aid of the Rembrandt Society and the Johan Maurits van Nassau Foundation.
● G. Bandmann, *Melancholie und Musik*, Cologne 1960, pp. 111-118, pl. 54; P. Wescher, J. BERLINER MUSEEN 12 (1970), pp. 34-60, fig. 7; E. Winternitz, *Musical instruments and their symbolism in western art, studies in iconology*, New Haven/ London 1977, p. 202, fig. 91; B. Wallen, *Jan van Hemessen, an Antwerp painter between Reform and Counter-Reform*, Ann Arbor, Michigan 1983, p. 24, fig. 131.

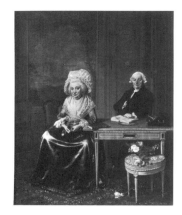

827

Wybrand Hendriks | *Portrait of Jacob Feitema (1726-1797) and his wife Elisabeth de Haan (1735-1800)*

Born 1744 in Amsterdam, died 1831 in Haarlem. Attended the Academy in Amsterdam. Worked in Haarlem. Travelled to England and spent some time in Ede, Gelderland.

Canvas, 85.5x69.5. Signed and dated: *Wd Hendriks Pinxit 1790.*
■ coll. jhr F.A.E.L. Smissaert, Laren (N.H.); purchased in 1937.
● STARING 1956, p. 172, pl. LIII; MINNEAPOLIS 1971, p. 51, no 29, fig. 90; *Wybrand Hendriks*, Teylers Museum, Haarlem 1972, p. 23, no 14.
▶ Originally there was a third figure, possibly a daughter, on the left. It was probably painted out by the artist himself.

55

Willem de Heusch | *Mountain landscape in Italy* (formerly: *River valley with two fishermen*)

Probably born before 1625 in Utrecht, died there in 1692. Perhaps pupil of J. Both, Utrecht. It is uncertain whether he travelled to Italy.

Copper, 21.5x29. Signed: *GDHeusch: f* (on the verso too: *GDHeusch: f:*).
■ purchased in 1816.
● BOL 1969, p. 267; CAT. MAURITSHUIS 1980, pp. 43, 175, ill.
► Companion piece to no 56.

56

■ | *Mountain and river landscape in Italy* (formerly: *River valley and wandering shepherds*)

Copper, 21.5x29. Signed: *GDHeusch: f:* (on the verso too: *GDHeusch: f:*).
■ purchased in 1816.
● MARTIN 1950, p. 71, no 114, ill.; BOL 1969, p. 267; CAT. MAURITSHUIS 1980, pp. 43-44, 176, ill.
► Companion piece to no 55.

53

Jan van der Heyden | *The church of St. Andreas, Düsseldorf*

Born 1637 in Gorkum, died 1712 in Amsterdam. Worked in Amsterdam, where he became known mainly as the inventor of the fire-hose and the man who introduced street lighting. Undertook journeys throughout his native area, to the southern Netherlands and into the Rhineland. A. van de Velde often painted the staffage figures in his work.

Panel, 51x63.5. Signed and dated: *V. Heyde A 1667*.
■ Oranienstein Castle, 1726: Cabinet Prince Willem V.
● HOFSTEDE DE GROOT 1907-28, VIII, p. 375, no 57; FRITZ 1932, pp. 92-93; BERNT 1969-70, II, no 522, ill.; WAGNER 1917, p. 60, 75, no 37, ill.; DROSSAERS & LUNSINGH SCHEURLEER 1974-76, II, p. 372, no 346, III, p. 213, no 48.

531

■ | *Still life with Bible*

Panel, 27x20.7. Signed and dated: *I.v.d.Heyde 1664*.
■ purchased in 1885.
● HOFSTEDE DE GROOT 1907-28, VIII, p. 452, no 334; WAGNER 1971, pp. 51, 113, no 211, ill.
► The Bible lies open at the book of Jeremiah.

815

■ | *The church of Veere*

Canvas, 31.5x36. Signed: *J.VDH*.
■ coll. Blumenthal, Paris; purchased in 1935.
● HOFSTEDE DE GROOT 1907-28, VIII, p. 414, no 189; H. Gerson, O.K. 7 (1963), no 5, ill.; WAGNER 1971, p. 83, no 75.

868

| *The Oudezijds Voorburgwal in Amsterdam*

Panel, 41.2x52.5. Signed: *VHeiden*.
■ Valerius Röver, Delft, 1713; Prince Wilhelm VIII of Hesse, Kassel, 1750; Hermitage, Leningrad, 1815; coll. F. Mannheimer, Amsterdam, 1936; transferred to the Mauritshuis by the Rijksdienst Beeldende Kunst in 1961.
● HOFSTEDE DE GROOT 1907-28, VIII, p. 366, no 25; E.W. Moes, O.H. 31 (1913), p. 19, no 44; MARTIN 1950, p. 108, no 285, ill.; BERNT 1969-70, II, no 520, ill.; WAGNER 1971, pp. 18, 31, 32, 60, 68, no 6, ill.; AMSTERDAM 1977, pp. 214-215, no 122, ill.; VRIES 1984, pp. 13-14, ill., 4.
▸ The Oude Kerk in the background. The Koninklijk Oudheidkundig Genootschap, Amsterdam, possesses a counter-impression in reverse of a preliminary drawing.

Antoon François Heijligers see after Hendrick *Heerschop*

884

Meindert Hobbema | *A watermill*

Born 1638 in Amsterdam, died there in 1709. Pupil of J. van Ruisdael. His output was greatly reduced after 1668.

Panel, 59.3x83.6. Signed: *M. Hobbema*.
■ coll. J. Rombouts, Dordrecht; bequest of L. Dupper Wzn, Dordrecht, 1870 to the Rijksmuseum, Amsterdam, inv.no A156; on loan since 1950.
● HOFSTEDE DE GROOT 1907-28, IV, p. 393, no 66; J. Rosenberg, J. PREUSS. KUNSTSAMML. 48 (1927), p. 142, fig. 9; MARTIN 1935-36, II, pp. 314-315; BROULHIET 1938, p. 379, no 20, ill.; MARTIN 1950, pp. 69-70, no 106, ill.; STECHOW 1966, pp. 157-158; CAT. RIJKSMUSEUM 1976, p. 277; CAT. MAURITSHUIS 1980, pp. 46-48, 178, ill.

899

| *Imaginary view of Deventer*

Panel, 55x69.5. Signed: *m. hobbema*.
■ donated by E. Vis, Lausanne, 1950.
● HOFSTEDE DE GROOT 1907-28, IV, p. 377, no 20a; BROULHIET 1938, p. 394, no 132, ill.; CAT. MAURITSHUIS 1980, pp. 45-46, 177, ill.; ENSCHEDE 1980, pp. 58-59, no 13, ill.

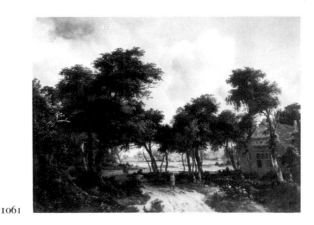

1061

| *Ruined cottages in a forest*

Panel, 53.3x71.7. Signed: *M.Hobbema*.
■ coll. C. Brind; coll. T.G. Heywood–Lousdale; kunsth. R. Noortman, London; purchased with the aid of the Rembrandt Society and the Johan Maurits van Nassau Foundation in 1980.
● HOFSTEDE DE GROOT 1907-28, IV, p. 434, no 184; MACLAREN 1960, p. 170, under no 995.

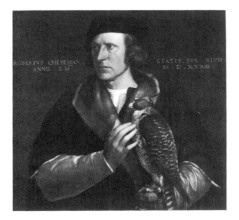

276

Hans Holbein the Younger | *Portrait of Robert Cheseman (1485-1547), courtier of King Henry VIII of England*

Born 1497/98 in Augsburg, died 1543 in London. Pupil of his father H. Holbein the Elder, Augsburg. By 1515 he was living with his brother Ambrosius, who is also recorded as a painter, at Basel. He probably visited Italy 1517-1519. From 1532 lived in England, which he had visited before (1526-1528); became court painter to Henry VIII in 1536.

Panel, 59x62.5. Inscribed: *ROBERTVS CHESEMAN . . ETATIS . SVAE . XLVIII . ANNO . DM . . M . D . XXXIII.*
■ coll. King Charles II of England; coll. Willem III at Het Loo; coll. Prince Johan Willem Friso 1712; Het Loo 1713; Cabinet Prince Willem V.
● GANZ 1950, p. 241, no 72, pl.109; CAT. MAURITSHUIS 1968, pp. 24-25, ill.; SALVINI & GROHN 1971, p. 101, no 82, pl. XXXVIII; DROSSAERS & LUNSINGH SCHEURLEER 1974-75, I, p. 679, no 679, no 887, p. 697, no 35, II, p. 639, no 9, III. p. 215, no 60; NEW YORK 1979, p. 106, no 75, ill.

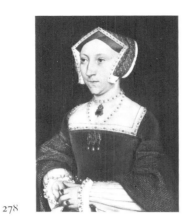
278

■ Studio of | *Portrait of Jane Seymour (1513-1537), Queen of England, third wife of Henry VIII*

Panel, 26.3x18.7.
■ coll. Prince Johan Willem Friso, 1712; Het Loo, 1763; Cabinet Prince Willem V.
● GANZ 1950, p. 278, no 95, pl. 136; CAT. MAURITSHUIS 1968, pp. 26-28, ill.; SALVINI & GROHN 1917, p. 105, no 106, ill.; DROSSAERS & LUNSINGH SCHEURLEER 1974-76, II, p. 269, no 281, p. 645, no 125 (?), III, p. 215, no 59.
► Several examples are known.

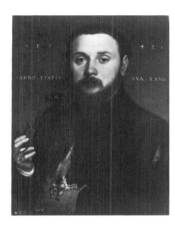
277

■ | *Portrait of a man with a hawk*

Panel, 25x19. Inscribed: *1542. ANNO,ETATIS.SVAE.XXVIII.*
■ coll. King Charles II of England; coll. Stadholder-King Willem III at Het Loo; Het Loo, 1713; Cabinet Prince Willem V.
● GANZ 1950, p. 255, no 121, pl. 162; A.B. de Vries, O.K. 3 (1959), no 19, ill.; CAT. MAURITSHUIS 1968, pp. 25, 26, ill.; OSTEN & VEY 1969, p. 230; SALVINI & GROHN 1971, p. 109, no 136, ill.; DROSSAERS & LUNSING SCHEURLEER 1974-76, I, p. 679, no 899, p. 697, no 31, II, p. 654, no 120, III, p. 215, no 58.

279

■ Copy after | *Portrait of Desiderius Erasmus (1467-1536)*

Panel, 24x19.
■ purchased with the De Rainer collection, 1821.
● H. Brunin, BULL.MUS.RGY.BELG. 17 (1968), pp. 155-160.

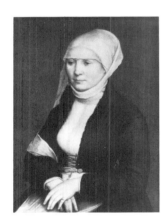
275

■ Attributed to | *Portrait of a young woman*

Panel, 45x34.
■ coll. King Charles I of England; coll. Joan de Vries, Amsterdam; coll. G. van Slingelandt, The Hague; Cabinet Prince Willem V.
● GANZ 1950, p. 231, no 38, pl. 68; BASLE 1960, no 197, fig. 74; CAT. MAURITSHUIS 1968, p. 28, ill.; OSTEN & VEY 1969, p. 226; SALVINI & GROHN 1971, p. 88, no 19, ill., fig. V; J. Fletcher, BURL. MAG. 116 (1974), p. 252, note 7; DROSSAERS & LUNSINGH SCHEURLEER 1974-76, III, p. 233, no 158; J. Fletcher, *Apollo* 117 (1983), p. 93.
Formerly thought to be a portrait of Holbein's wife, Elisabeth Schmid.

405

Gijsbert Gillisz. d'Hondecoeter | *Cock and hens*

Born 1604 in Amsterdam or Utrecht, died 1653 in Utrecht. Pupil of his father, Gillis d'Hondecoeter. Worked in Amsterdam. Documented in Utrecht 1630-1632.

Panel, 52x70.
■ purchased in 1876.

59

61

Melchior d'Hondecoeter | *The raven robbed of the feathers he wore to adorn himself*

Born 1636 in Utrecht, died 1695 in Amsterdam. Pupil of his father, Gijsbert d'Hondecoeter, and apparently of his uncle J.B. Weenix. Worked in The Hague from 1659 to 1663, afterwards in Amsterdam.

Canvas, 176x189 . Signed and dated: *M dhondecoeter Ao 1671.*
■ Het Loo, 1757; Cabinet Prince Willem v.
● MARTIN 1935-36, p. 440, fig. 232; DROSSAERS & LUNSINGH SCHEURLEER 1974-76, II, p. 640, no 26, III, p. 214, no 52.

■ | *Geese and ducks*

Canvas, 115x136. Signed: *M d'Hondecoeter.*
■ Oranienstein Castle, 1726; Cabinet Prince Willem v.
● DROSSAERS & LUNSINGH SCHEURLEER 1974-76, II, p. 371, no 340, III, p. 213, no 50-51.

60

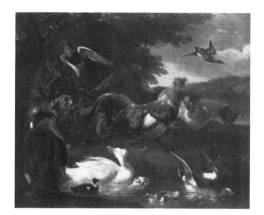

62

■ | *Scene with exotic animals*

Canvas, 169x156.8. Signed: *M d'Hondecoeter.*
■ Het Loo, 1713; Cabinet Prince Willem v; on loan to the Rijksmuseum Het Loo, Apeldoorn, since 1984.
● G.A. Evers, *Gelre* 15 (1912), pp. 533-534; G.A. Evers, *Gelre* 17 (1914), pp. 201-213; DROSSAERS & LUNSINGH SCHEURLEER 1974-76, I, p. 667, no 536, II, p. 607, no 143, III, p. 214, no 53; NEW YORK 1979, pp. 97-98, no 61, ill.
► Formerly thought to depict the zoological garden of Stadholder-King Willem III at Het Loo.

■ | *Hens and ducks*

Canvas, 115x136. Signed: *M D'Hondekoeter.*
■ Oranienstein Castle, 1726; Cabinet Prince Willem v.
● DROSSAERS & LUNSINGH SCHEURLEER 1974-76, II, p. 371, no 340, III, p. 213, no 50-51.

968

■ | *Dead rooster*

Canvas, 76x62.5. Signed: *M: d'Hondekoeter.*
■ Kunsth. S. Nystad, The Hague; purchased in 1964.
● CAT. MAURITSHUIS 1970, no 46, ill.

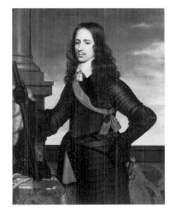

63

Gerard van Honthorst | *Portrait of Willem II, Prince of Orange (1626-1650)*

Born 1590 in Utrecht, died there in 1656. Pupil of A. Bloemaert, Utrecht. During his stay in Italy, probably from 1610 to 1620, he was influenced by the works of Caravaggio and his Roman followers. Settled in Utrecht; spent a short time in England in 1628. Was court painter in The Hague from 1637 to 1652.

Canvas, 117.2x92.6.
■ probably transferred to the Nationale Konst-Gallery, The Hague, from one of the stadholders' palaces.
● BRAUN 1966, p. 267, no 118e; THIEL 1981, p. 191, no 47 (?).
► Partial replica of the double portrait in the Rijksmuseum, Amsterdam, inv.no. A871.

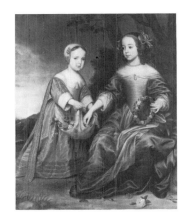

64

■ | *Portrait of Willem III, Prince of Orange (1650-1702) and his aunt, Maria van Nassau (1642-1688), as children*

Canvas, 130.5x108.2. Signed and dated: *G.Honthorst 1653*.
■ Huis ten Bosch, The Hague, 1668.
● A. Staring, N.K.J. 3 (1950-51), pp. 161-162; BRAUN 1966, pp. 273-274, no 123; DROSSAERS & LUNSINGH SCHEURLEER 1974-76, I, p. 281, no 1177.

65

■ | *A child picking fruit*

Canvas, 108.5x83.5.
■ probably from Honselaarsdijk Castle; Nationale Konst-Gallery, The Hague.
● BRAUN 1966, p. 291, no W 15 (as Willem van Honthorst); DROSSAERS & LUNSINGH SCHEURLEER 1974-76, I, p. 521, no 2; THIEL 1981, p. 205, no 156, ill.
► Possibly a daughter of Prince Frederik Hendrik.

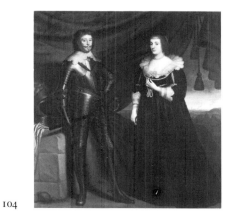

104

■ | *Portrait of Frederik Hendrik, Prince of Orange (1584-1647), and his wife Amalia van Solms Braunfels (1602-1675)*

Canvas, 213x201.4.
■ painted for Constantijn Huygens, 1637/38; from his residence on Het Plein, The Hague.
● BRAUN 1966, pp. 251-253, no 103; THE HAGUE 1979-80, p. 48, no 14, ill.

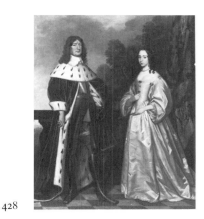

428

■ | *Portrait of Friedrich Wilhelm I, Elector of Brandenburg (1620-1688), and his wife Louise Henriette van Nassau (1627-1667)*

Canvas, 220x181.
■ probably from one of the stadholders' palaces.
● BRAUN 1966. pp. 268-271, no 119; DROSSAERS & LUNSINGH SCHEURLEER 1974-76, I, p. 538, no 9 (?).
► Replica of the portrait in the Rijksmuseum, Amsterdam, inv.no. A873. In 1646 Friedrich Wilhelm married the eldest daughter of Stadholder Frederik Hendrik.

430

 | *Portrait of Frederik Hendrik, Prince of Orange*

Panel, 74.3x60.
■ unknown.
● BRAUN 1966, p. 252, no 103b.

835

Pieter de Hooch | *A man smoking and a woman drinking in a courtyard* (formerly: *A courtyard in Delft*)

Born 1629 in Rotterdam, died 1684 in Amsterdam. Pupil of C.P. Berchem, together with J. Ochtervelt. In 1653 worked as painter and servant to Justus de la Grange. Settled in Delft in 1655. Moved to Amsterdam around 1660/61.

Canvas, 78x65.
■ coll. John Smith, 1822; coll. Lord and Lady Wantage, London, 1888; coll. Earl of Crawford, London, 1921; donated by Mr en Mrs Ten Cate-van Wulfften Palthe, Almelo, 1947.
● HOFSTEDE DE GROOT 1907-28, I, p. 558, no 297; W.R. Valentiner, *Pieter de Hooch*, Berlin-Leipzig 1929, p. 43, ill., p. 272; CAT. MAURITSHUIS 1970, no 35, ill.; SUTTON 1980, p. 85, no 35B, pl. 35.
► Another version with four figures is in the National Gallery of Art, Washington.

66

Samuel van Hoogstraten | *Young woman with a letter*

Born 1627 in Dordrecht, died there in 1678. Was a pupil of Rembrandt in Amsterdam in the 1640s. Worked in Vienna, Rome, London and The Hague, though most of the time in Dordrecht, where he published his well-known *Inleyding tot de hooge schoole der schilderkonst* in 1678.

Canvas, 214x179. Signed: *SvH*.
■ Cabinet Prince Willem V.
● L. Cust & A. Malloch, BURL.MAG. 29 (1916), pp. 292-297; MARTIN 1950, p. 111, no 298; PLIETZSCH 1960, p. 75; BERNT 1969-70, II, no 553, ill.; DROSSAERS & LUNSINGH SCHEURLEER 1974-76, III, p. 213, no 49.
► The Van Hoogstraten coat of arms over the door. Possibly painted for the Pictura artists' society in The Hague.

57

Gerard Houckgeest | *Ambulatory of the Nieuwe Kerk in Delft, with the tomb of William the Silent*

Born 1600 in The Hague, died 1661 in Bergen op Zoom. Initially lived in The Hague, then in Delft from 1635 to 1652 and afterwards in Steenbergen and Bergen op Zoom. Probably a pupil of B. van Bassen. Briefly (around 1650) exerted a strong influence on H. van Vliet and E. de Witte.

Panel, 65.5x77.5. Signed and dated: *GH 1651*.
■ Cabinet Prince Willem V.
● ROSENBERG, SLIVE & KUILE 1977, pp. 327-328, fig. 259; WHEELOCK 1977, p. 233, fig. 52; JANTZEN 1979, pp. 99, 225, no 170; LIEDTKE 1982, pp. 38-53, fig. 23, pl. V.
► The painter repeated parts of this view in other works (one in the National Museum, Stockholm, and one formerly in coll. J. Goudstikker, Amsterdam).

58

■ | *The tomb of William the Silent in the Nieuwe Kerk in Delft*

Panel, 56x38 (ends in a round arch). Signed and dated: *GH 1651*.
■ coll. W. Lormier, The Hague, 1757; Cabinet Prince Willem v.
● MARTIN 1935-36, II, p. 405, fig. 212; MARTIN 1950, p. 109, no 287, ill.; BERNT 1969-70, II, no 558, ill.; L. de Vries, J. HAMB. KUNSTSAMML. 20 (1975), pp. 40, 52, fig. 15; DROSSAERS & LUNSINGH SCHEURLEER 1974-76, III, p. 212, no 43; WHEELOCK 1977, pp. 221-222, fig. 38; JANTZEN 1979, p. 98, no 169; SUTTON 1980, p. 17, fig. 10; LIEDTKE 1982, p. 30, note 34, p. 35, note 5, pp. 36-47, fig. 3, pl. IV.
► A similar composition dated 1650 is in the Kunsthalle, Hamburg.

67

Jan van Hughtenburgh | *Portrait of Hendrik Casimir II (1657-1696), stadholder of Friesland, Groningen and Drenthe, as a general*

Born 1647 in Haarlem, died 1733 in Amsterdam. Pupil of T. Wijck. Travelled to Paris and possibly to Rome. By 1670 returned to Haarlem. Also worked in The Hague and Amsterdam. Painted a series of battle scenes for Prince Eugene of Savoy.

Canvas, 121x165. Signed and dated: *Hughtenburgh.f. 1692*.
■ Het Loo, 1763; Nationale Konst-Gallery, The Hague; on loan to the Rijksmuseum, Amsterdam, since 1933 (inv.no. C1226).
● CAT. RIJKSMUSEUM AMSTERDAM 1976, p. 292, ill.; DROSSAERS & LUNSINGH SCHEURLEER 1974-76, II, p. 642, no 65; LEEUWARDEN 1979-80, pp. 66-67, no 24, ill.; THIEL 1981, p. 205, no 153, ill.

68

■ | *Cavalry engagement*

Canvas, 53.2x62.5. Signed: *HB*.
■ coll. P. de la Court van der Voort, Leiden, 1766; Cabinet Prince Willem v.
● DROSSAERS & LUNSINGH SCHEURLEER 1974-76, III, p. 213, no 46; CAT. MAURITSHUIS 1980, pp. 48-49, 179, ill.

69

■ | *Attack on a convoy*

Canvas, 53.2x62.5. Signed: *HB*.
■ coll. P. de la Court van der Voort, Leiden, 1766; Cabinet Prince Willem v.
● DROSSAERS & LUNSINGH SCHEURLEER 1974-76, III, p. 212, no 45; CAT. MAURITSHUIS 1980, p. 49, p. 180, ill.

792

Ozias Humphrey, Attributed to | *Portrait of a man*

Born 1742 in Honiton, died 1810 in London. Worked in London from 1763 on. Travelled to Italy, France and Switzerland in 1773-1777 and to India 1785-1787.

Panel, 11.5x9 (oval).
■ donated by C. Hofstede de Groot, The Hague, 1926, in honour of the 25th anniversary of W. Martin's directorship of the Mauritshuis.
► Companion piece to no 793.

77

793

■ Attributed to | *Portrait of a woman*

Panel, 11.5x9 (oval).
■ from the same donation as no 792.
► Companion piece to no 793.

70

Jan van Huysum | *Fruit still life*

Born 1682 in Amsterdam, died there in 1749. Pupil of his father, Justus van Huysum.

Copper, 21x27. Signed: *Jan van Huijsum fecit.*
■ purchased in 1816.
● HOFSTEDE DE GROOT 1907-28, X, p. 378, no 204; GRANT 1954, p. 28, no 163; AMSTERDAM 1983 (2), p. 134, no 68, ill.

71

■ | *Flower still life*

Copper, 21x27. Signed: *Jan van Huijsum fecit.*
■ purchased in 1816.
● HOFSTEDE DE GROOT 1907-28, X, p. 368, no 149; GRANT 1954, p. 24, no 110.

72

■ | *Italian landscape*

Canvas, 59x70. Signed: *Jan van Huijsum.*
■ Nationale Konst-Gallery, The Hague.
● MOES & BIEMA 1909, p. 222; HOFSTEDE DE GROOT 1907-28, X, p. 339, no 9.

299

Ignacio de Iriarte | *Landscape with hunting scene*

Born 1621 in Azcoitia, died 1685 in Seville. Pupil of F. Herreras the Elder in Seville. Worked in Seville from 1642.

Canvas, 104x82.
■ purchased by King Willem I for the Mauritshuis at the auction of the coll. Comtesse Bourke, Paris, 1823; on loan to the Rijksmuseum, Amsterdam (inv.no C1371), since 1984;
● G. Kubler & M. Soria, *Art and architecture in Spain and Portugal and their American dominions 1500 to 1800*, Hammondsworth 1959 p. 388, note 8; P. van Vliet, BULL. R.M. 15 (1966), pp. 134-140, fig. 5; CAT. RIJKSMUSEUM 1976, p. 295, ill.
► Formerly attributed to Velasquez.

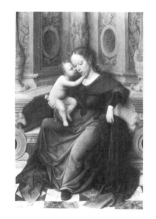

958

Adriaen Isenbrant | *Enthroned Madonna and child*

Date and place of birth unknown; died 1551 in Bruges, where he became master of the painter's guild in 1510. Pupil of G. David.

Panel, 61x41.5.
■ coll. Thomas Baring, Earl of Northbrook, London; bequest of Mr and Mrs de Bruyn-van der Leeuw to the Rijksmuseum, Amsterdam, 1961, inv.no A4045; on loan since 1963.
● FRIEDLÄNDER 1967-76, XI, p. 87, no 173, pl. 132; CAT. MAURITSHUIS 1968, p. 29, ill.; CAT. RIJKSMUSEUM 1976, p. 296.

688

Cornelis Jonson van Ceulen I | *Portrait of Jan Beck (?-1676), elector of Middelburg, and his children*

Born 1593 in London of Flemish parents, died 1661 in Utrecht. Influenced by A. van Dyck. Worked in England for a long time. Settled in Middelburg in 1643. Also worked in The Hague, Utrecht and Amsterdam.

Canvas, 182x151.5. Signed and dated: *Cornelis Janson. van Ceulen fecit 1650*. Inscribed: *1650. Dulcia vallantur duris* (The soft is surrounded by the hard).
■ bequest of Countess C. van Bylandt, The Hague, 1904.
● COLLINS BAKER 1912, I, p. 85.
► L.J. van der Klooster has identified the sitters as Jan Beck, his three daughters and two sons (the child at lower centre is a boy).

73

Karel du Jardin | *Waterfalls near Tivoli* (formerly: *A waterfall in Italy*)

Born ca 1622, place of birth unknown; died 1678 in Venice. Probably pupil of C.P. Berchem. Travelled to France and Italy. On his return in 1652 he worked in Amsterdam, The Hague and then again in Amsterdam. Visited Italy a second time in 1675, went to North Africa and Tangier.

Canvas, 64.2x69.5. Signed and dated: *K. dv. Iardin/fe/1673*.
■ coll. P.L. de Neufville, Amsterdam, 1765; coll. G. van Slingelandt, The Hague, 1768; Cabinet Prince Willem V.
● HOFSTEDE DE GROOT 1907-28, IX, p. 342, no 184; BROCHHAGEN 1958, pp. 120-122; BLANKERT 1978, pp. 209-210; CAT. MAURITSHUIS 1980, pp. 52-53, 183, ill.

74

■ | *Landscape with a shepherdess with a distaff*

Panel, 32x40.
■ coll. C. van Droste, The Hague, 1717; coll. G. van Slingelandt, The Hague, 1768; Cabinet Prince Willem V.
● HOFSTEDE DE GROOT 1907-28, IX, p. 309, no 57; BROCHHAGEN 1958, p. 89; CAT. MAURITSHUIS 1980, pp. 51-52, 182, ill.

760

■ | *Young shepherd playing with his dog*

Panel, 31.2x37 6. Signed: *K: dv Iardin f* (not original).
■ coll. Duc de Choiseul, 1772; coll. H.A. Steendracht van Duivenvoorde, The Hague 1803; donated by J. Goudstikker, Amsterdam, 1919.
● A. Bredius, *Oude Kunst* 5 (1919), p. 49; HOFSTEDE DE GROOT 1907-28, IX, p. 310, no 58; BROCHHAGEN 1958, pp. 88-89; A.B. de Vries, O.K. 4 (1960), no 29, ill.; ROSENBERG, SLIVE & KUILE 1977, p. 310, fig. 246; BLANKERT 1978, pp. 207-208, no 128, ill.; CAT. MAURITSHUIS 1980, pp. 50-51, 181, ill.; SALERNO 1977-80, II, p. 738, fig. 124.6.

75

■ Copy after | *Young shepherd milking a goat*

Panel, 31x26.
■ Purchased with the Reghellini collection, 1831.
▸ Original in the Alte Pinakothek, Munich; another copy in the museum in Naples.

849

Jacob Jordaens | *Marsyas punished by the muses*

Born 1593 in Antwerp, died there in 1678. Pupil of A. van Noort. Often worked with Rubens. The kings of England, Spain and Sweden were among his patrons. In 1649 he painted *The triumph of Frederik Hendrik* in Huis ten Bosch.

Canvas, 77x120.
■ Cabinet Van Heteren Gevers, The Hague-Rotterdam; purchased by the Rijksmuseum, Amsterdam, 1809. inv.no A601; on loan since 1948.
● PUYVELDE 1953, p. 198; R.-A. d'Hulst, BULL.MUS.ROY.BELG. 10 (1961), pp. 34-36; *Jacob Jordaens*, National Gallery of Canada, Ottawa 1968-69, p. 117, no 78, ill.; A.P. de Mirimonde, JAARBOEK ANTWERPEN 1969, p. 212; CAT. RIJKSMUSEUM 1976, p. 309; E.K.J. Reznicek, O.H. 94 (1977), pp. 92-94, fig. 16; HULST 1982, p. 174, fig. 147.

937

■ | *The adoration of the shepherds*

Panel 125.5x96. Signed: *I.Ior.*
■ coll. Prince Lichnowski, Kuchelna (Silesia); coll. Rhodius, Bennebroek; purchased with the aid of the Johan Maurits van Nassau Foundation, 1959.
● PUYVELDE 1953, p. 187; H. Gerson, O.K. 5 (1961), no 14, ill.; CAT. MAURITSHUIS 1970, no 11, ill.; J.B. Knipping, *Iconography of the Counter Reformation in The Netherlands*, Leiden 1974, II, p. 429; HULST 1982, p. 331, note 55.
▸ The Mauritshuis painting is a version with slight variations of the *Adoration* in the National Museum, Stockholm, which is dated 1618 and signed in full (inv.no 488, 124x93).

927

Willem Kalf | *Still life with drinking cup*

Born 1619 in Rotterdam, died 1693 in Amsterdam. Perhaps pupil of F. Rijckhals. Influenced by Rembrandt. He was in Paris from ca 1640 till 1644/46.

Canvas, 49.9x42.4. Signed and dated: *W.Kalf 1659*.
■ Kunsth. S. Nystad, The Hague; purchased with the aid of the Rembrandt Society and the Johan Maurits van Nassau Foundation, 1957.
● CAT. MAURITSHUIS 1970, no 38, ill.; GRISEBACH 1974, pp. 117, 152, 157, 255, no 97, fig. 106; AUCKLAND 1982, pp. 90-91, no 10, ill.

971

■ | *Still life with shells*

Panel, 25x33. Signed: *W. Kalf.*
■ coll. A. Goldschmidt, Berlin; kunsth. S. Nystad, The Hague; purchased in 1965.
● BERNT 1969-70, II, no 606, ill.; CAT. MAURITSHUIS 1970, no.39, ill.; GRISEBACH 1974, pp. 178-179, 281, no 144, fig. 158.
► Companion piece to no 972.

972

■ | *Still life with shells and coral*

Panel, 25x33. Signed: *W. Kalf.*
■ coll. A. Goldschmidt, Berlin; kunsth. S. Nystad, The Hague; purchased in 1965.
● CAT. MAURITSHUIS 1970, no 40, ill.; GRISEBACH 1974, pp. 178-179, 281, no 145, fig. 159.
► Companion piece to no 972.

825

Bernard Keil, called **Monsú Bernardo** | *Teasing*

Born 1624 in Helsingör, Denmark; died 1687 in Rome. Pupil of Rembrandt in Amsterdam, 1640-1644. Worked there until 1651, then in Italy for the rest of his life.

Canvas, 59x72.

■ donated by V. Bloch, The Hague, 1936.
● V. Bloch, *Maandblad voor Beeldende Kunsten,* 22 (1946), pp. 77-82.

79

Alexander Keirincx | *Wooded landscape*

Born 1600 in Antwerp, died 1652 in Amsterdam. Initially worked in Antwerp. Documented in Amsterdam from 1636 until his death. Worked in London in 1625 and 1640-1641. Worked at times in Utrecht.

Panel, 64x92. Signed: *A. Keirincx.*
■ Noordeinde Palace, 1632; Honselaarsdijk, 1755; Nationale Konst-Gallery, The Hague, 1800.
● THIERY 1953, pp. 180, 183; BERNT 1969-70, II, no 613, ill ; DROSSAERS & LUNSINGH SCHEURLEER 1974-76, I, p. 235, no 1246, II, p. 511, no 194; THIEL 1981, p. 208, no 170, ill.
► Figure staffage by an artist from the circle of C. van Poelenburgh.

225

Adriaen Thomasz. Key | *Portrait of William the Silent, Prince of Orange (1533-1584)*

Born ca 1544 probably in Antwerp, died there after 1589. Pupil of J. Hack and possibly of his uncle, W. Key. Influenced by A. Mor. Worked in Antwerp.

Panel, 48x34.
■ unknown, probably from one of the stadholders' palaces.
● E.A. van Berensteyn, *Iconographie van Prins Willem I van Oranje,* Haarlem 1933, p. 13, no 62, fig. 10; R. van Luttervelt, O.K. 2 (1958), no 16, ill.; J. Bruin, O.H. 75 (1960), pp. 112-114, fig. 1; A. Staring, O.H. 75 (1960), p. 165; P. Philippot, BULL.MUS.ROY.BELG. 14 (1965), p. 192; CAT. MAURITSHUIS 1968, pp. 29-30, ill.; CAT. THYSSEN BORNEMISZA 1969, p. 204.
► One of a number of portraits which were probably based on a full-length portrait no longer in existence. Autograph replica. Other replicas in the Rijksmuseum. Amsterdam. and in coll. Thyssen-Bornemisza, Lugano (dated 1579).

923

Jan Keynooghe | *Perseus and Andromeda*

Born ca 1507, died in Mechelen after 1570. According to C. van Mander pupil of M. Cock, Antwerp.

Panel, 22.4 in diameter (round). Signed and dated: *IKvM 1561* (indistinctly). On the sword of Perseus: *harpe*.
■ Kunsth. S. Nystad, The Hague, purchased in 1955.
● CAT. MAURITSHUIS 1968, pp. 30-31, ill.; CAT. MAURITSHUIS 1970, no 5, ill.
► Attributed to Keynooghe by E. Haverkamp-Begemann on the basis of the monogram.

77

Thomas de Keyser | *Portrait of a scholar*

Born 1596/97 in Amsterdam, died there in 1667. Son and pupil of the architect and sculptor H. de Keyser; worked as an architect himself. Influenced by N. Eliasz. Pickenoy and C. van der Voort.

Panel, 82.5x61. Signed and dated: *TDK ANo. 1631*.
■ coll. Neufville, Amsterdam, 1765; Cabinet Prince Willem v.
● OLDENBOURG 1911, p. 79, no 64, pl.XII; PARIS 1970-71, p. 120; DROSSAERS & LUNSINGH SCHEURLEER 1974-76, III, p. 218, no 77.

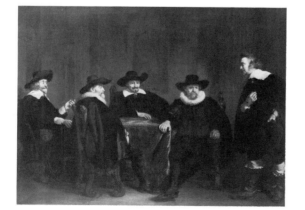

78

 | *The burgomasters of Amsterdam learning of the arrival of Maria de' Medici*

Panel, 28.5x38.
■ coll. S. de Leeuw, Amsterdam, 1692; coll. G. Braamcamp, Amsterdam, 1771; Cabinet Prince Willem v; on loan to the Amsterdams Historisch Museum, since 1980.
● D.C. Meyer, O.H. 6 (1888), pp. 232-233; OLDENBOURG 1911, p. 79, no 63, pl. XIX; BILLE 1961, I, p. 85, II, no 102, ill.; DROSSAERS & LUNSINGH SCHEURLEER 1974-76, III, p. 218, no 76.
► Sitters from left to right: Abraham Boom, Petrus Hasselaar, Albert Coenraedsz. Burgh, Antonius Oetgens van Waveren. The man entering, Cornelis van Davelaer, is announcing the arrival of Maria de' Medici, who visited Amsterdam in 1638.

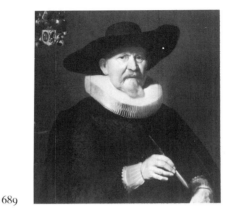

689

 | *Portrait of a man, probably Hans van Hogendorp (1569-1652)*

Panel, 73.5x68.5. Signed and dated: *TDKeyser Ano. 1636 AEtatis Svae 66.*
■ bequest of the Dowager A.L.T.A. Grisart, The Hague, 1904.
● OLDENBOURG 1911, p. 79, no 65, pl. XVIII; L.J. van der Klooster, *De Nederlandse Leeuw*, 1959, pp. 1-3.

806

 | *Portrait of Loef Vredericx(1590-1668) as an ensign*

Panel, 92.5x69. Signed and dated: *Anno TDK 1626*. Inscibed on the verso: *Loef, Vredericx, soon.van.V.I.ist geworden Ano 1626 den 15 Augusti* (Loef, son of Vrerijk Janssen, became ensign of the city of Amsterdam in 1626).
■ Russian imperial collections in the Gatschina palace near Leningrad; purchased with the aid of the Rembrandt Society and private industrialists, 1931.
● JAARVERSL.VER.REMBRANDT 1931, p. 13, ill.; PLIETZSCH 1960, p. 174, fig. 315; *The age of Rembrandt*, San Francisco, The California Palace of the Legion of Honor, 1966, p. 63, no 28.

814

Isaac van Kipshaven *Decorative still life*

Born 1635 (?), probably in Amsterdam; died after 1670. Painted still lifes and portraits. Worked in Amsterdam. Follower of W. van Aelst in his still lifes.

Canvas, 84x73. Signed and dated: *IV Kipshaven 1661*.
■ donated by D. Katz, Dieren, 1935.
● BERNT 1969-70, II, no 625, ill.; AUCKLAND 1982, pp. 96-99, no 12, ill.

781

Barend Cornelis Koekkoek | *Brook by the edge of the forest*

Born 1803 in Middelburg, died 1862 in Cleves. Pupil of his father Johan Hendrik. Attended the Amsterdam Academy. Often travelled to Germany and Belgium.

Panel, 79x105.5. Signed and dated: *B.C. Koekkoek fec.1849*.
■ bequest of Mrs C.A. Rose-Molewater, 1923; on loan to the Gemeentemuseum, The Hague, since 1923.
● F. Gorissen, *B.C. Koekkoek*, Düsseldorf 1962, no 49/80, ill.

80

Philips Koninck, Copy after | *The mouth of a river*

Born 1619 in Amsterdam, died there in 1688. Pupil of his brother Jacob and perhaps of Rembrandt. Worked in Amsterdam.

Canvas, 65x78
■ purchased in 1830.
● H. Gerson, *Philip Koninck*, Berlin 1936, p. 40, note 81, p. 106, no 31: MACLAREN 1960, under no 836, p. 211.
► Copy (19th-century?) of the painting in the National Gallery, London.

36

Salomon de Koninck | *The adoration of the kings*

Born 1609 in Amsterdam, died there in 1656. Pupil of D. Colijns, F. Venant and N. Moeyaert. Worked in Amsterdam, under the influence of Rembrandt.

Canvas, 81x66 (ends in a round arch).
■ Cabinet Prince Willem v.
● DROSSAERS & LUNSINGH SCHEURLEER 1974-76, III, p. 19, no 24, p. 209, no 35; COLOGNE 1982, pp. 215-216, no 98, ill.

904

Hans Suess von Kulmbach | *Mary Cleophas and her family*

Born ca 1475/80, probably in Kulmbach; died 1522 in Nuremberg. Influenced by J de' Barbari and, very strongly, by A. Dürer. May still have been a pupil of M. Wohlgemut. Worked primarily in Nuremberg.

Panel, 54x28.
■ transferred to the Mauritshuis by the Rijksdienst Beeldende Kunst, 1960.
● WINKLER 1959, p. 69.
► Depicted are Mary Cleophas, daughter of St Anne and her second husband Cleophas, her husband Alphaus and their children: St Jude (with club), St James the Less and St Simon (with saw). Was probably part of an altar of the Holy Kinship together with no 905 and other panels (perhaps the two panels in the Barnes Foundation, Merion, U.S.A.).

905

■ | *Mary Salome and her family*

Panel, 54*x*28. Dated: *1513*.
■ trasferred to the Mauritshuis by the Rijksdienst Beeldende Kunst, 1960.
● WINKLER 1959, p. 69.
▸ Depicted are Mary Salome, daughter of St Anne and her third husband Salomas, her husband Zebedee and their children: St James the Great (with sack) and John the Evangelist (with chalice). Part of the same altar as no 904.

Cornelis Kunst, see Cornelis *Cornelisz.,* called Kunst.

776

Louis Jean François Lagrenée, Attributed to | *Woman bathing*

Born 1725 in Paris, died there in 1805. Pupil of C. van Loo. He visited Rome (before 1754) and Leningrad, 1760-1762.

Copper, 38.5*x*30.
■ donated by M.J.F.W. van der Haagen, The Hague, 1923.
▸ Formerly attributed to Carle van Loo.

82

Gerard Lairesse | *Ulysses recognises Achilles among the daughters of Lycomedes*

Born 1640 in Liège, died 1711 in Amsterdam. Pupil of his father Reinier and of B. Flémalle, liège. Especially known for writings on the theory of art. Went blind about 1690.

Canvas, 139*x*191. Signed: *G. Lairesse.*
■ Het Loo, 1763; Cabinet Prince Willem v.
● DROSSAERS & LUNSINGH SCHEURLEER 1974-76, II, p. 639, no 10, III, p. 219, no 83.

83

■ | *Bacchus and Ariadne*

Canvas, 175*x*93.
■ Soestdijk, 1712; Nationale Konst-Gallery, The Hague.
● DROSSAERS & LUNSINGH SCHEURLEER 1974-76, I, p. 622, no 28; THIEL 1981 , p. 212, no 201, ill.

446

■ | *Glorification of Stadholder-King Willem III*

Canvas, 64.2*x*78. Signed: *G. de Lairesse.*
■ Binnenhof, The Hague, 1754; Court of the stadholder, The Hague, 1764; Het Loo (?); Nationale Konst-Gallery, The Hague.
● DROSSAERS & LUNSINGH SCHEURLEER 1974-76, II, p. 479, no 20; III, p. 22, no 59; THIEL 1981, pp. 209-210, no 177, ill.

84

Jan Willemsz. Lapp | *Italian landscape w th shepherdesses*

Documented in The Hague in 1625. Possibly visited Italy. Little is known about his life. His work is rare.

Canvas, 58.9x68.2. Signed: *J Lapp*.
- purchased in 1880: Nationale Konst-Gallery, The Hague (?).
- MOES & BIEMA 1909, p. 32 (?); CAT. MAURITSHUIS 1980, pp. 54, 184, ill.; SALERNO 1977-80, II, p. 770, fig. 130.1.

273

- Attributed to | *Italian landscape*

Copper, 16x12. Inscribed on verso: *Gio leo*.
- purchased with the De Rainer collection, 1821.
- CAT. MAURITSHUIS 1980, pp. 54, 186, ll.
- Formerly attributed to A'dam Elsheimer

274

- Attributed to | *Lalian landscape*

Copper, 16x12.
- purchased with the De Rainer collection, 1821.
- CAT. MAURITSHUIS 1980, pp. 54, 185, ill.
- Formerly attributed to A'dam Elsheimer.

294

Nicolas de Largillière | *Portrait of Willem Hyacinth, Prince of Orange (1666-1743)*

Born 1656 in Paris, died there in 1746. Pupil of A. Goubau, Antwerp, afterwards of Sir P. Lely, England. He returned to Paris in 1678 where he and H. Rigaud were the most sought-after portrait painters.

Canvas, 130x106.
- probably Binnenhof, The Hague, 1754.
- C. de Clercq, *Rolduc's Jaarboek* 1961, p. 65; DROSSAERS & LUNSINGH SCHEURLEER 1974-76, II, p. 478, no 6.
- Willem Hyacinth, Prince of Nassau Siegen (1666-1743), called himself Prince of Orange after the death of Willem III in 1702.

393

Pieter Pietersz. Lastman | *The raising of Lazarus*

Born ca 1583 in Amsterdam, died there in 1633. Pupil of G. Pietersz., called Swelinck ca 1602, Amsterdam. Developed in Rome and Venice (1603-1607?) under the influence of Elsheimer and Caravaggio. Afterwards worked in Amsterdam where J. Lievens (ca 1618/20) and Rembrandt (1623) were his pupils.

Panel, 64x97.5. Signed and dated: *Plastman fecit 1622 FECIT A 1622*.
- purchased in 1875; on loan to the Stedelijk Museum De Lakenhal, Leiden, since 1957.
- FREISE 1911, p. 60, no 67; FUCHS 1968, p. 13, fig. 9; CORPUS 1982, p. 305; CAT. LAKENHAL 1983, p. 192, no 1752, ill.

322

Filippo Lauri | *Landscape with shepherds*

Born 1623 in Rome, died there in 1694. Pupil of his father B. Lauwers and of A. Caroselli. Influenced by P.F. Mola.

Canvas, 69x56.
■ purchased by King Willem I for the Mauritshuis with the Reghellini collection, 1831; on loan to the Dutch Embassy in Moscow.

231

Sir Peter Lely, Copy after | *Portrait of Stadholder-King Willem III (1650-1702)*

Born Pieter van der Faes in Soest (Westphalia), 1618, died 1680 in London, where he had been working since 1647. Follower of A. van Dyck.

Canvas, 232x140.
■ unknown.
● COLLINS BAKER 1912, II, pp. 17-18; A. Staring, N.K.J. 3 (1950-51), pp. 179-180.
► Probably a copy by Willem Wissing.

289

Andrea de Leone, Attributed to | *The peddlers*

Born in Naples 1610, died there in 1685. Pupil of Belisario Corenzo and Aniello Falcone.

Canvas, 98x132.
■ purchased by King Willem I for the Mauritshuis with the Reghellini collection, 1831; on loan to the Rijksmuseum Amsterdam (inv.no C1346), since 1948.
● CAT. RIJKSMUSEUM 1976, p. 344, ill.; CAT. MAURITSHUIS 1977, p. 138.
► Formerly attributed to Sébastien Bourdon.

870

Nicolas Bernard Lépicié | *Portrait of a boy*

Born 1735 in Paris, died there in 1784. Pupil of his father B. Lépicié and of C. van Loo.

Canvas, 40x32.
■ coll. David Weill, Paris; coll. F. Mannheimer, Amsterdam; transferred to the Mauritshuis by the Rijksdienst Beeldende Kunst, 1960.
● P. Gaston-Dreyfus, *Nicolas-Bernard Lépicié*, Paris 1923, no 79.

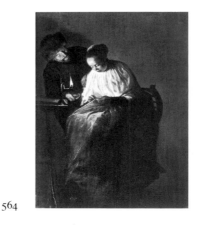

564

Judith Leyster | *Man offering money to a young woman*

Born 1609 in Haarlem, died 1660 in Heemstede. Probably a pupil of F. Hals. Married the painter J.M. Molenaer in 1636.

Panel, 30.9x24.2. Signed and dated: *ILS*1631*.
■ purchased in 1892.
● J. Harms, O.H. 44 (1972), pp. 145, 154, 231-233, no 13; BERNT 1969-70, II, no 678, ill.; F.F. Hofrichter, *The Feminist Art Journal*, vol. 4, no 3 (1975), pp. 23-26, ill.; *Women artists: 1550-1950*, Los Angeles County Museum of Art, Los Angeles 1976-77, pp. 139-140, no 23; M.S. Young, *Apollo* 105 (1977), p. 58; PHILADELPHIA 1984, p. 154, fig. 3.
► The star in the monogram stands for the last part of the artist's name: Leyster (ster=star).

85

Jan Lievens | *Study of an old man*

Born 1607 in Leiden, died 1674 in Amsterdam. Pupil of J. van Schooten, Leiden, and of P. Lastman, Amsterdam (ca 1619-1621). Close artistic contact with Rembrandt is documented for the second half of the 1620s in Leiden. In London from 1632 to ca 1635 and in Antwerp from 1636 to 1645. Worked in Amsterdam, The Hague and Leiden from 1644 onwards.

Panel, 66x52.
■ Leeuwarden Palace; Cabinet Prince Willem v.
● SCHNEIDER & EKKART 1973, p. 132, no 159, p. 329; DROSSAERS & LUNSINGH SCHEURLEER 1974-76, III, p. 228, no 133; B. Brenninkmeyer- de Rooy, ANTIEK 1976 p. 171, fig. 133; BRAUNSCHWEIG 1979, pp. 76-77, no 21, ill.
► In BRAUNSCHWEIG 1979 considered to be a copy after Herzog Anton Ulrich Museum, Braunschweig, inv.no 243.

86

Johannes Lingelbach | *Harbour on the Mediterranean*

Born 1622 in Frankfurt, died 1674 in Amsterdam. According to Houbraken, he was in France and Rome from 1642 to 1650. After that he continued to work in Amsterdam

Canvas, 154x194. Signed and dated: *I Lingelbach/1670*.
■ elector of Saxony, Amsterdam, 1765; Cabinet Prince Willem v.
● DROSSAERS & LUNSINGH SCHEURLEER 1974-76, III, p. 219, no 78; CAT. MAURITSHUIS 1980, pp. 56, 189, ill.; SCHLOSS 1982, pp. 23, 39, 40, fig. 42.

87

■ | *Harvesting the hay*

Panel, 41x52.5. Signed: *I. Lingelbach*.
■ coll. G. van der Pot van Groeneveld, Rotterdam, 1781; acquired through an exchange with the Rijksmuseum, Amsterdam, 1825.
● BOL 1969, p. 251; CAT. MAURITSHUIS 1980, pp. 55-56 188, ill.
► Very similar works in London (dated 1644), Schwerin and Kassel.

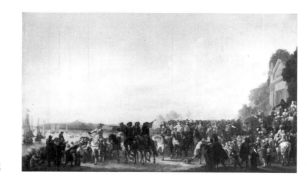

88

■ | *Charles II halting at the estate of Wema on the Rotte during his journey from Rotterdam to The Hague, 25 May 1660*

Canvas, 57.3x98.5. Signed: *I. Lingelbach*.
■ Het Loo, 1763; Cabinet Prince Willem v; on loan to the Rijksmuseum, Amsterdam, since 1933. (inv.no C1223).
● MARTIN 1935-36, II, pp. 459-460, fig. 242; BOL 1969, p. 252; DROSSAERS & LUNSINGH SCHEURLEER 1974-76, II, p. 640, no 23, III, p. 219, no 80; CAT. RIJKSMUSEUM 1976, pp. 248-349.
► A less probable identification of the subject is: The troops of Prince Willem II halting at the estate of Welna on the Amstel during their march on Amsterdam, 31 May – 4 August 1650. Companion piece to no 89.

89

■ | *The departure of Charles II of England from Scheveningen, 2 June 1660*

Canvas, 58.5x99.2. Signed: *I. Lingelbach*.
■ Het Loo, 1763; Cabinet Prince Willem v; on loan to the Rijksmuseum, Amsterdam, since 1933 (inv.no C1242).
● MARTIN 1935-36, II, p. 459; BOL 1969, p. 252; DROSSAERS & LUNSINGH SCHEURLEER 1974-76, II, p. 640, no 22, III, p. 219, no 79; CAT. RIJKSMUSEUM 1976, p. 349.
► Companion piece to no.88.

951

 | *Italian landscape with resting peasants*

Canvas on panel, 57.4x47.5. Signed: *J. Lingelbach f.*
■ coll. W. Lormier, The Hague, 1754; coll. Moltke, Copenhagen, 1871; H. Drucker, Copenhagen; kunsth. H. Cramer, The Hague; purchased in 1962.
● BOL 1969, p. 258; CAT. MAURITSHUIS 1970, no 34, ill; CAT. MAURITSHUIS 1980, pp. 55, 187, ill.

599

Jacob van Loo | *Portrait of a lady*

Born 1614 in Sluis, died 1670 in Paris. Grandfather of C. van Loo. His earliest known works are genre paintings in the manner of P. Codde. In 1642 he became a citizen of Amsterdam, where he had a flourishing career. After a fight in 1660 he left for Paris.

Canvas, 88.5x75.5. Signed: *J:v Loo fecit.*
■ donated by Hendrik Willem Mesdag, The Hague, 1895.

885

 | *Wooing*

Canvas, 73.3x66.8.
■ coll. A. Jaffé, Berlin; purchased in 1950.
● ZEITSCHR. B.K. 59 (1925-26), pp. 72, 74-76; CAT. MAURITSHUIS 1970, no 34, ill.

Piero di Lorenzo, see Piero di *Cosimo*.

309

Benedetto Luti, Attributed to | *The Holy family and St Anne*

Born 1666 in Florence, died 1724 in Rome. Pupil of A. Gabbiani. Influenced by C. Maratta. Worked in Rome.

Canvas, 99x74.5.
■ coll. De Bourck, Paris; purchased by Willem I for the Mauritshuis, 1823; on loan to the Rijksmuseum, Amsterdam (inv.no C1345), since 1948.
● G. Briganti, *Pietro da Corona*, Florence 1962, p. 277.
► Formerly attributed to P. da Cortona.

722

Isaac Luttichuys | *Portrait of a young lady*

Born 1616 in Austin Friars (london), died 1673 in Amsterdam. Was already working in Amsterdam prior to 1638. First influenced by Rembrandt, then by B. van der Helst. He was the brother of S. Luttichuys, still-life painter.

Canvas, 126x101.
■ bequest of Miss M.J. Singendonck, The Hague, 1907.
► Previously catalogued as Dutch School ca 1640. Painted after 1660. A portrait of a young lady in exactly the same posture, but with different clothes, appeared on the art market in New York (see: W.R. Valentiner, *The Art Quarterly* 1 (1938), p. 176, fig. 23).

Mabuse, see Jan *Gossaert*.

90

Nicolaes Maes | *Portrait of Jacobus Trip 1575-1661), merchant of Dordrecht*

Born 1634 in Dordrecht, died 1693 in Amsterdam. Pupil of Rembrandt in the late 1640s or early 1650s. Worked in Dordrecht from 1653 to 1673, then in Amsterdam. He also visited Antwerp, probably in the early or mid-1660s. After about 1660 he painted portraits exclusively; prior to that he did genre paintings as well.

Canvas, 126x100.5. Signed and dated: *AET 84. N.Maes 16..*
- transferred to the Mauritshuis from the Navy Ministry in 1821.
- HOFSTEDE DE GROOT 1907-28, VI, p. 564, no 322; C. Hofstede de Groot, O.H. 45 (1928), p. 262, no 7; MACLAREN 1960, pp. 329-330; AMSTERDAM 1983 (I), pp. 196-197, no 52.

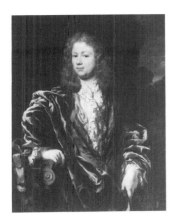

717

■ | *Portrait of Cornelis ten Hove (1658-1694), secretary to the Treasury*

Canvas, 58x46. Signed: *Maes.*
- bequest of Miss M.J. Singendonck, The Hague, 1907.
- HOFSTEDE DE GROOT 1907-28, VI, p. 534, no 193.
▶ Companion piece to no 718.

718

■ | *Portrait of Catharina Dierquens (1664-1715), wife of Cornelis ten Hove*

Canvas, 58x46. Signed: *Maes.*
- bequest of Miss M.J. Singendonck, The Hague, 1907.

- HOFSTEDE DE GROOT 1907-28, VI, p. 534, no 194.
▶ Daughter of Elisabeth van Bebber and her first husband Johannes Dierquens; see Caspar Netscher, inv.no 714.
Companion piece to no 717.

328

Alessandro Magnasco | *Landscape with a hermit, a pilgrim and a peasant woman*

Born 1667, probably in Genoa, where he died in 1749. Pupil of his father Stefano and of F. Abbiati. Influenced by S. Rosa and P. Mulier. Worked in Milan and Genoa.

Canvas, 138.5x109.8 (oval).
- purchased by King Willem I for the Mauritshuis with the Reghellini collection, 1831; on loan to the Rijksmuseum, Amsterdam (inv.no C1356), since 1948.
- GEIGER 1949, p. 67, fig. 23; CAT. RIJKSMUSEUM 1976, p. 359, ill.
▶ Companion piece to no 329.
Formerly attributed to S. Rosa; sometimes attributed to M. Ricci.

329

■ | *Landscape with monks, shepherds and a pilgrim*

Canvas, 138.5x109.8 (oval).
- purchased by King Willem I for the Mauritshuis with the Reghellini collection, 1831; on loan to the Rijksmuseum, Amsterdam (inv.no C1357), since 1948.
- GEIGER 1949, p. 67; CAT. RIJKSMUSEUM 1976, p. 360, ill.
▶ Companion piece to no 328.
Formerly attributed to S. Rosa; sometimes attributed to M. Ricci.

332

■ | *Three Camaldolite monks in exaltation*

Canvas, 54.2x38.5.
■ purchased by King Willem I from kunsth. Snijers & Rottiers, Antwerp, 1822; on loan to the Rijksmuseum, Amsterdam (inv.no C1358), since 1948.
► CAT. RIJKSMUSEUM 1976, p. 359, ill.
Companion piece to no 333.

333

■ | *Three Capuchin monks in meditation*

Canvas, 54.5x38.9.
■ purchased by King Willem I from kunsth. Snijers & Rottiers, Antwerp, 1822; on loan to the Rijksmuseum, Amsterdam (inv.no C1359), since 1948.
● CAT. RIJKSMUSEUM 1976, p. 359, ill.
► Companion piece to no 322.
There is a repetition in the Galleria Nazionale Corsini, Rome (inv.no 14628).

816

■ | *Massacre of the innocents*

Canvas, 65.5x83.5.
■ coll. Salomons, Amsterdam; donated by E.J. Philips, The Hague, 1935; on loan to the Rijksmuseum, Amsterdam (inv.no C1360), since 1948.
● GEIGER 1949, p. 67; GENOA 1949, p. 34, no 34, fig. 39.

► Companion piece to no 817.
Sometimes attributed to S. Ricci. There is a different version in the coll. Modiano, Bologna.

817

■ | *The raising of Lazarus*

Canvas, 65.5x83.5.
■ coll. Salomons, Amsterdam; donated by E.J. Philips, The Hague; on loan to the Rijksmuseum, Amsterdam (inv.no C1361), since 1948.
● GEIGER 1949, p. 107, fig. 237; GENOA 1949, pp. 33-34, no 33, fig. 38.
► Companion piece to no 816.
Sometimes attributed to S. Ricci.

91

Cornlis de Man | *'La main chaude'* (formerly: **Merriment in a peasant inn**)

Born 1621 in Delft, died there in 1706. Spent much time in France and Italy between 1642 and 1654. Worked in Delft from 1654 onwards. His genre style was primarily influenced by J.M. Molenaer, later by G. Dou, P. de Hooch, J. Vermeer and J. Steen. His church interiors closely follow compositions by H. van Vliet.

Canvas, 69x84. Signed: *K. de Man*.
■ purchased in 1875.
● Cl. Brière-Misme, O.H. 52 (1935), pp. 24-25; AMSTERDAM 1976, pp. 158-161, no 37, ill.

856

■ *Interior of the Sᵗ Laurenskerk, Rotterdam*

Canvas, 39,5x46.5.
■ coll. Cook, Richmond; transferred to the Mauritshuis by the Rijksdienst Beeldende Kunst, 1960.
● LIEDTKE 1982, pp 118, 122, 123, no 291, fig. 107.
► Formerly attributed to G.A. Berckheyde and A. de Lorne.

770

Jacob Sibrandi Mancadan | *Landscape with a shepherd and a shepherdess*

Born 1602 in Minnertsga, Friesland; died 1680, probably in Leeuwarden. 1637-1639 burgomaster of Franeker. Worked in Franeker and after 1644 in Leeuwarden.

Panel, 34,8x27,7.
■ donated by H.E. ten Cate, 1923.
● CAT. MAURITSHUIS 1980, pp. 57, 190, ill.

887

■ *Italian landscape with ruins*

Panel, 30.5x50.
■ V. Bloch, The Hague; purchased in 1951.
● CAT. MAURITSHUIS 1970, no 27, ill.; CAT. MAURITSHUIS 1980, pp. 57-58, 191, ill.
► A painting of the same format in Cologne (Wallraf-Richartz Museum, inv. no 2989) may be a companion piece.

532

Otto Marseus van Schrieck | *Plants and insects*

Born 1619/20 in Nijmegen, died 1678 in Amsterdam. In 1652 he was in Rome with M. Withoos and S. van Hoogstraten. He probably visited England and France. Worked in Amsterdam. W. van Aelst was his pupil.

Canvas, 102.3x75.8. Signed and dated: *Otto Marseus D. Schrick 1665*.
■ purchased in 1886.
● BOL 1969, p. 335; BOL 1982, p. 102.

842

Quinten Massys | *Madonna and child*

Born 1465/66 in Louvain, died 1530 in Antwerp, where he had been working since 1491. Directed a large and influential studio.

Panel, 75x63.
■ possibly Diego Duarte, Amsterdam; coll. Albertina Agnes, Leeuwarden, 1681; coll. Stadholder-King Willem III, Het Loo, 1713; Nationale Konst-Gallery, The Hague; Rijksmuseum, Amsterdam inv.no A247; on loan since 1948.
● G.J. Hoogewerff, *Nederlandsche schilders in Italië in de XVIe eeuw*, Utrecht 1912, p. 24; WINKLER 1924, p. 204; J. Bergström. BURL. MAG. 97 (1955), p. 307, fig. 4; SPETH-HOLTERHOFF 1957, p. 101; I. Bergström, KONSTHIST. TIDSKR. 30 (1961), p. 31, fig. 1; FRIEDLÄNDER 1967-76, VII, p. 68, no 67, pl. 52; CAT. MAURITSHUIS 1968, pp. 39-40, ill.; BOSQUE 1975, p. 222; DROSSAERS & LUNSINGH SCHEURLEER 1974-76, II, p. 112, no 899, p. 520, no 289; CAT. RIJKSMUSEUM 1976, p. 370; THIEL 1981, p. 196, no 108, ill; SILVER 1984, pp. 78, 230-231.
► There are several replicas in existence; this one may not be autograph either.

961

■ | *The carrying of the cross*

Panel, 82.5x59 (ends in a round arch).
■ bequeathed by Mr and Mrs De Bruyn-van der Leeuw, to the
Rijksmuseum, Amsterdam, 1961, inv.no A4048; on loan since 1963.
● E.R. Meijer, BULL. R.M. 9 (1961), p. 47; J.L. Cleveringa, BULL. R.M. 9
(1961), p. 65, no 11; FRIEDLÄNDER 1967-76, VII, p. 80, no 167, pl. 120; CAT.
MAURITSHUIS 1968, pp. 38-39, ill.; BOSQUE 1975, p. 158; R. Schuder,
Hieronymus Bosch, Berlin 1975, p. 69, ill.; CAT. RIJKSMUSEUM 1976, p. 370;
SILVER 1984, pp. 96-97, 121, 208, no 15, pl. 89.

298

Juan Bautista Martinez del Mazo, Attributed to | *Portrait of Infante
Balthasar Carlos (1629-1646), son of Philip IV*

Born between 1612 and 1616 in Beteta (?), died 1667 in Madrid. Pupil and
associate of Velasquez.

Canvas, 149.5x112.5.
■ purchased by King Willem I for the Mauritshuis with the De Rainer
collection, 1821; on loan to the Rijksmuseum, Amsterdam (inv.no C1362),
since 1948.
● THIEME-BECKER 1907-47, XXXIV, p. 194; J.A. Gaya Nuño, *La pintura
Español fuera de España*, Madrid 1958, no 1720; P. van Vliet, BULL. R.M. 14
(1966), pp. 140-143; E. Harris, *Journal of the Warburg and Courtauld
Institutes* 30 (1967), p. 418; CAT. RIJKSMUSEUM 1976, p. 373, ill.
► Is considered a studio work of Velasquez, possibly after a lost original by
the master. Possibly cut off; there is a larger version in the British royal
collection (Buckingham Palace). Attributed to Del Mazo by Gaya Nuño.

Girolamo Mazzola, see *Parmigianino.*

323

Lodovico Mazzolino | *Massacre of the innocents*

Born ca 1480 in Ferrara, died there ca 1528. Pupil of D. Pannetti and E. de'
Roberti. Influenced by L. Costa and D. Dossi. Worked in Ferrara.

Panel, 31x38. Falsely dated: *1548 FE.*
■ purchased by King Willem I for the Mauritshuis with the De Rainer
collection, 1821; on loan to the Rijksmuseum, Amsterdam (inv.no C1363),
since 1948.
● CAT. MAURITSHUIS 1935, pp. 191-192; S. Zamboni, *L. Mazzolino* , Milan
1968, pp. 35-36, no 2, fig. 61a; CAT. RIJKSMUSEUM 1976, p. 374, ill.
► There are other paintings by Mazzolino of the same subject in the Uffizi,
Florence, and in the Galleria Doria Pamphilj, Rome.

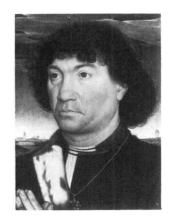

595

Hans Memling | *Portrait of a man*

Born ca 1435 in Seligenstadt near Frankfurt, died 1494 in Bruges. Probably a
pupil of R. van der Weyden, Brussels. Documented in Bruges from 1465.

Panel, 30.1x22.3.
■ purchased by the Rembrandt Society, 1894; taken over, 1895.
● J. Bruyn, O.K. 5 (1961), no 2, ill.; FRIEDLÄNDER 1967-76, VIa, p. 55, no 79,
pl. 118; CAT. MAURITSHUIS 1968, pp. 37-38, ill.; K.B. McFarlane, *Hans
Memling,* Oxford 1971, p. 14, fig. 147.
► A coat of arms on the verso. This panel must have been the right wing of a
diptych.

93

Gabriël Metsu | *A huntsman*

Most probably born 1629 in Leiden, died 1667 in Amsterdam. According to Houbraken a pupil of G. Dou, Leiden. He was first active as a history painter, under the influence of N. Knüpfer. Around the 1650s he turned toward genre painting. His work shows the influence of P. de Hooch, J. Vermeer, J. Steen and G. ter Borch. Worked in Leiden, and from 1657 in Amsterdam.

Panel, 28x22.8. Signed and dated: *G. Metsu, 1661.*
■ coll. G. van Slingelandt, The Hague, 1768; Cabinet Prince Willem v.
● HOFSTEDE DE GROOT 1907-28, I, p. 318, no 207; LEIDEN 1966, pp. 70-71, no 19, ill.; S.J. Gudlaugsson, O.H. 83 (1968), p. 31; E. de Jongh, SIMIOLUS 3 (1968-69), p. 41, note 46; PARIS 1970-71, p. 143; ROBINSON 1974, pp. 28-29, 115, fig. 29; PHILADELPHIA 1984, p. 251, note 2.

94

■ | *A young woman composing music*

Panel, 57.8x43.5. Signed: *G. Metsu.*
■ coll. G. van Slingelandt, The Hague, 1768; Cabinet Prince Willem v.
● HOFSTEDE DE GROOT 1907-28, I, p. 299, nr. 162; LEIDEN 1966, pp. 114-115, no 41, ill.; S.J. Gudlaugsson, O.H. 83 (1968), pp. 34-35; ROBINSON 1974, pp. 39, 200, fig. 158, P. Fischer, *Music in paintings of the Low Countries in the 16th and 17th centuries*, Amsterdam 1975, pp. 96-97, ill.; NEW YORK 1979, no 95; PHILADELPHIA 1984, pp. 149-150, fig. 1.

95

■ | *Justice triumphant*

Canvas, 153x120.5. Signed: *G. Metsu.*
■ coll. Sara de Witte, Leiden, 1667; Nationale Konst-Gallery, The Hague; transferred to the Mauritshuis in 1817.
● MOES & BIEMA 1909, p. 138, 100; HOFSTEDE DE GROOT 1907-28, I, p. 20, no 20; A. Bredius, *Künstlerinventare*, The Hague 1917, IV, p. 1237; MARTIN 1935-36, I, p. 110; LEIDEN 1966, pp. 46-47, no 7, ill.; S.J. Gudlaugsson, O.H. 83 (1968), p. 16; PARIS 1970-71, p. 139; ROBINSON 1974, pp. 25-26, 112, fig. 22; W.P.J.A. Weebers, *Isack Mes, genreschilder te Dordrecht*, 1976, pp. 41-47, fig. 26, 27; THIEL 1981, p. 206, no 158.

37

Martin Meytens the Younger | *Portrait of Emperor Francis I of Austria (1708-1765)*

Born 1695 in Stockholm, died 1770 in Vienna. Travelled much and spent a long time in Italy. From 1727 worked mostly at the court of Maria Theresia, Vienna.

Canvas, 166x123.
■ Nationale Konst-Gallery, The Hague; on loan to Gedeputeerde Staten, Maastricht, since 1925.
● THIEL 1981, p. 203, no 144, ill.
► Companion piece to no 38.

38

■ | *Portrait of Empress Maria Theresa (1717-1780)*

Canvas, 166x133.
■ Nationale Konst-Gallery, The Hague; on loan to Gedeputeerde Staten, Maastricht, since 1925.
▸ Companion piece to no 37.

749

Michiel Jansz. van Mierevelt | *Portrait of Cornelis van Aerssen (1545-1627), clerk to the States-General*

Born 1567 in Delft, died there in 1641. He studied with several masters; finally with Anthonie van Blocklandt at Utrecht. Worked in both Delft and The Hague; executed numerous commissions for the stadholders and their court. Had many pupils and assistants.

Panel, 72.2x59.8.
■ bequest of Baron W.F.E. van Aerssen Beyeren van Voshol, 1914.
▸ Companion piece to no 750.

750

■ | *Portrait of François van Aerssen (1572-1641), legate to the French court, son of Cornelis van Aerssen*

Panel, 72.8x59.8.
■ bequest of Baron W.F.E. van Aerssen Beyeren van Voshol, 1914.
▸ Companion piece to no 749.

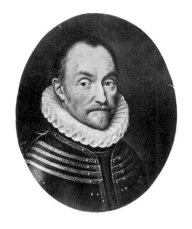

96

■ Studio of | *Portrait of Willem 1, Prince of Orange (1533-1584)*

Copper, 28x23 (oval).
■ purchased in 1828.
▸ Belongs to a series of six portraits (nos 96-101).

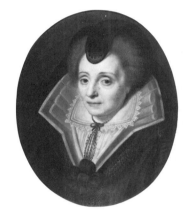

97

■ Studio of | *Portrait of Louise de Coligny (1555-1620), fourth wife of Prince Willem 1*

Copper, 28x23 (oval). Signed: *Mierevelt.* (there is also a second, false signature).
■ purchased in 1828.
▸ Belongs to a series of six portraits (nos 96-101).

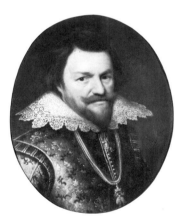

98

■ Studio of | *Portrait of Philips Willem, Prince of Orange (1554-1618), eldest son of Prince Willem 1*

Copper, 28x23 (oval). Signed: *Mierevelt.*
■ purchased in 1828.
▸ Belongs to a series of six portraits (nos 96-101).

99

■ Studio of | *Portrait of Stadholder Maurits, Prince of Orange (1567-1625)*

Copper, 28x23 (oval). Signed and dated: *Mierevelt. AEtatis 49 AO 1617.*
■ purchased in 1828; on loan to the Musée Municipal, Orange, France.
► Belongs to a series of six portraits (nos 96-101).

100

■ Studio of | *Portrait of Stadholder Frederik Hendrik, Prince of Orange (1584-1647)*

Copper, 28x23 (oval). Signed: *Mierevelt.*
■ purchased in 1828; on loan to the Musée Municipal, Orange, France.
► Belongs to a series of six portraits (nos 96-101).

101

■ Studio of | *Portrait of Frederik V, Elector Palatine and King of Bohemia (1596-1632). known as the Winter King*

Copper, 28x23 (oval). Signed: *M. Mierevelt* (false) and dated: *AEtatis 16 Ao.1613.*
■ purchased in 1828.
► Belongs to a series of six portraits (nos 96-101).

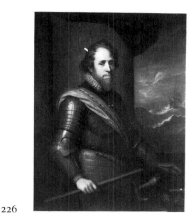

226

■ Studio of | *Portrait of Stadholder Maurits, Prince of Orange (1567-1625)*

Canvas, 119x94.5.
■ purchased in 1819.

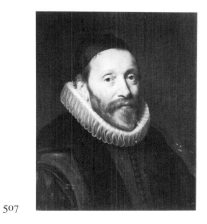

507

■ Studio of | *Portrait of Johannes Uyttenbogaert (1557-1644)*

Panel, 48.5x40.
■ purchased for the Nationale Konst-Gallery, The Hague, 1803.
● MOES & BIEMA 1909, p. 62.
► Uyttenbogaert was chaplain to Prince Maurits. He led the Remonstrants and was the founder of the Brotherhood of Remonstrants.

106

Frans van Mieris the Elder | *A boy blowing bubbles*

Born 1635 in Leiden, died there in 1681. Pupil of G. Dou and of the portrait and history painter A. van den Tempel. He received commissions from Cosimo III de' Medici and Archduke Leopold Wilhelm. Worked in Leiden, where he had many pupils.

Panel, 25.5x19 (ends in a round arch). Signed and dated: *M.DC.LXIII. F. van Mieris. fect. Lugd. Bat..*
■ coll. W. Lormier, The Hague, 1763; coll. G. van Slingelandt, The Hague, 1786; Cabinet Prince Willem V.

● HOFSTEDE DE GROOT 1907-28, X, p. 60, no 229; MARTIN 1950, p. 87, no 88, ill.; PLIETZSCH 1980, p. 52, note 1; JONGH 1967, pp. 80-81, fig. 67; ROBINSON 1974, p. 90; DROSSAERS & LUNSINGH SCHEURLEER 1974-76, III, p. 220, no 909; NEW YORK 1979, no 96, ill.; NAUMANN 1981, II, pp. 70-76, no 58, ill.; SUMOWSKI 1983, p. 502, 522, ill.
► Many other examples are known.

107

■ | *Portrait of Florentius Schuyl (1619-1669), professor of medicine and botany at Leiden*

Copper, 21x16.5. Signed ad dated: *F. van Mieris. fe. Ao 1666-.*
■ coll. G. van Slingelandt, The Hague, 1786; Cabinet Prince Willem v.
● HOFSTEDE DE GROOT 1907-28, X, p. 74, no 275; DROSSAERS & LUNSINGH SCHEURLEER 1974-76, III, p. 220, no 89; NAUMANN 1981, pp. 79-80, no 63, ill.
► Another example was in the coll. Bosch van Drakestein, Nieuw Amelisweerd; present location unknown.

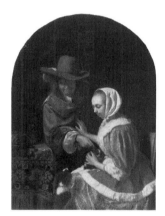

108

■ | *Teasing the pet*

Panel, 27.5x20 (ends in a round arch). Signed and dated: *Fv Mieris Ao 1660.*
■ coll. C. Baron Droste, The Hague, 1717; coll. Bicker van Zwieten, The Hague, 1741; coll. G. van Slingelandt, The Hague, 1786; Cabinet Prince Willem v, The Hague.
● HOFSTEDE DE GROOT 1907-28, X, p. 53, no 208; MARTIN 1950, p. 86, no 186, ill.; PLIETZSCH 1960, p. 52; MACLAREN 1960, p. 249; ROBINSON 1974, p. 91; DROSSAERS & LUNSINGH SCHEURLEER 1974-76, III, p. 220, no 88; NAUMANN 1981, I, pp. 60-63, 68, 110, 128, fig. 67, II, pp. 40-43, no 35; PHILADELPHIA 1984, 258, no 75, ill., pl.58.
► In 1717 Droste identified the figures as Van Mieris and his wife; this statement remains uncontested. Maybe companion piece to no 819. Several other examples are known.

819

■ | *Oyster dinner*

Panel, 27x20 (ends in a round arch). Signed and dated: *F. Van Mieris fescit Leyd. Bat Ao. 1661.*
■ Elector Johan Wilhelm of Pfalz-Neuburg, Düsseldorf and Mannheim, 1748; brought to the Electoral Gallery, Munich, 1806; Alte Pinakothek, Munich, 1925; kunsth. D.A. Hoogendijk, Amsterdam, 1931; donated by Henri W.A. Deterding, London, 1936.
● HOFSTEDE DE GROOT 1907-28, X, p. 29, no 102a; PLIETZSCH 1960, p. 54; NAUMANN 1981, I, pp. 60-64, 79, 110, 128, II, pp. 43-48, no 36; PHILADELPHIA 1984, p. 258, fig. 1.
► The painter and his wife probably served as models. Possibly the companion piece to no 108. Several other examples are known.

860

■ | *Inn scene*

Panel, 42.8x33.3. Formerly signed: *F. van Mieris 1658.*
■ coll. F. Mannheimer, Amsterdam; taken by Hitler to Linz; transferred to the Mauritshuis by the Rijksdienst Beeldende Kunst, 1960.
● HOFSTEDE DE GROOT 1907-28, X, p. 29, no 102; MARTIN 1950, pp. 86-87, no 187, ill.; PLIETZSCH 1960, p. 51, fig. 64; E. de Jongh, SIMIOLUS 3 (1968-69), p. 41; F.W.S. van Thienen, O.K. 13 (1969), no 28, ill.; KURETSKY 1979, 15-16, 30, 61-62, fig. 24; NAUMANN 1981, I, pp. 17, 55-57, 59, 63-64, 104-108, 128, II, pp. 26-27, no 23, ill.; DURANTINI 1983, p. 268; PHILADELPHIA 1984, pp. 277-278, fig. 1.
► Original signature (*F. van Mieris 1658*) above the door to the right seems to have been removed during the restoration of 1948. A replica in the National Museum, Prague.

109

Willem van Mieris | *A grocer's shop*

Born 1662 in Leiden, died there in 1747. Pupil of his father F. van Mieris. Follower of his father and G. Dou.

Panel, 49.5x41. Signed and dated: *W. van Mieris. Fe. 1717.*
■ Het Loo; Cabinet Prince Willem V.
● HOFSTEDE DE GROOT 1907-28, X, p. 154, no 193; BERNT 1969-70, II, no 769, ill.; DROSSAERS & LUNSINGH SCHEURLEER 1974-76, II, p. 640, no 30, III, p. 221, no 91.
► The relief - here a compilation of motifs by the Flemish sculptor F. Duquesnoy – is of the same kind as seen earlier in works by G. Dou. The companion piece to this painting, *The poultry shop*, is in the Louvre, Paris.

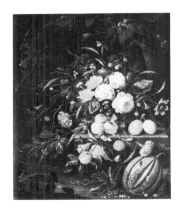

110

Abraham Mignon | *Flowers and fruit*

Born 1640 in Frankfurt, died 1679 in Utrecht. Pupil of J. Marrell, Frankfurt. In 1669 they were both members of the St Luke Guild in Utrecht. Mignon attended the studio of J.D. de Heem. Maria Sibylle Merian was his pupil.

Canvas, 75x63. Signed: *AB. Mignon: fe.*
■ Oranienstein Castle, 1726; Cabinet Prince Willem V.
● KRAEMER-NOBLE 1973, p. 24, no A36; DROSSAERS & LUNSINGH SCHEURLEER 1974-76, II, p. 371, no 339, III, p. 222.

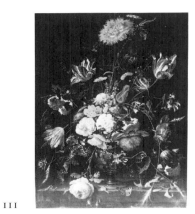

111

▰ | *Summer flowers*

Canvas, 90x72.5. Signed: *A.B. Mignon.fec.*
■ Oranienstein Castle, 1726; Cabinet Prince Willem V.
● KRAEMER-NOBLE 1973, p. 23, no A34, pl. 10; DROSSAERS & LUNSINGH SCHEURLEER 1974-76, II, p. 371, no 338, III, p. 222.
► Companion piece to no 112.

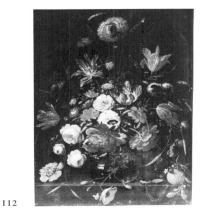

112

■ | *Summer flowers*

Canvas, 90x72.5. Signed: *AB. Mignon: fec.*
■ Oranienstein Castle, 1726; Cabinet Prince Willem V.
● KRAEMER-NOBLE 1973, pp. 23-24, no A35, pl. 11; DROSSAERS & LUNSINGH SCHEURLEER 1974-76, II, p. 371, no 338, III, p. 222.
► Companion piece to no 111.

729

George van der Mijn | *Portrait of Cornelis Ploos van Amstel (1726-1798), engraver and collector*

Born 1726/27 in London, died 1763 in Amsterdam. He left London with his older brother Frans in 1741. In 1753 he became a citizen of Amsterdam and was listed as member of the St Luke Guild. His known *oeuvre* is small; he only painted portraits.

Canvas, 55x45.7. Formerly signed and dated: *G van der Mijn 1748* (?).
- purchased in 1911.
- J.W. Niemeijer, N.K.J. 13 (1962), p. 184, fig. 3, pp. 204-205, no 4; J.W. Niemeijer, O.K. 9 (1965), no 22, ill.; A. Staring, N.K.J. 20 (1969), p. 200, fig. 1, pp. 216-221; MINNEAPOLIS 1971, p. 65, no 46, fig. 44; NIEMEIJER 1980, pp. 169-179, fig. 77; SMITH 1982, p. 113, fig. 46.
- ▸ These portraits (including inv.no 730) are depicted in J. Maurer's painting *Ploos van Amstel showing his collection to his guests*, now in Petworth House, near Salisbury.

114

■ | *Portrait of Maria, Princess of Orange (1642-1688)*

Canvas, 150x185.5. Signed: *JANMijtens F.* (the first four letters in monogram).
- Nationale Konst-Gallery, The Hague, 1800.
- LEEUWARDEN 1979-80, pp. 58-59, no·18, ill.; THIEL 1981, p. 184, no 13, ill.
- ▸ The horse's caparison bears the monogram *PVO* (= Princess Van Oranje). Maria, youngest daughter of Stadholder Frederik Hendrik, married Lodewijk Hendrik Maurits, Count Palatine von Simmern in 1666.

730

■ | *Portrait of Elisabeth Troost (1730-1790), wife of the above, daughter of Cornelis Troost*

Canvas, 55x45.7. Signed and dated: *G. van der Mijn.1748.*
- purchased in 1911.
- J.W. Niemeijer, N.K.J. 13 (1962), pp. 188-189, 204-205; J.W. Niemeijer, O.K. 9 (1965), no 22, ill.; A. Staring, N.K.J. 20 (1969), pp. 200-201, fig. 2, pp. 216-221; MINNEAPOLIS 1971, pp. 65-66, no 47, fig. 45; NIEMEIJER 1980, pp. 169-179, fig. 78; SMITH 1982, p. 113, fig. 47.
- ▸ The date '1748' is questionable, since they married in 1758.

115

Claes Cornelisz. Moeyaert | *Hippocrates visiting Democritus*

Amsterdam 1590/91, died 1655 in Amsterdam. It is not known with whom he studied. He painted mainly historical themes. Among his students were S. Koninck, N. Berchem and J.B. Weenix.

Panel, 80x85. Signed and dated: *Cl.M.f.1636.*
- purchased in 1873.
- W. Stechow, OUDH. JAARBOEK 4 (1924), pp. 34-38, fig. 2; A. Tümpel, O.H. 88 (1974), pp. 92, 95, fig. 127, pp. 103, 107, 142 (note 248), p. 269, no 191.

113

Johannes Mijtens | *Portrait of Wolphart van Brederode (1649-1679)*

Born ca 1614 in The Hague, died there in 1670. Pupil of his father D. Mijtens the Younger and of his uncle D. Mijtens the Elder. Via his uncle influenced by A. van Dyck. Portrait painter active in The Hague.

Canvas, 106.5x85. Signed: *JANMijtens F.* (the first four letters in monogram).
- unknown.
- AMSTERDAM 1984, pp. 205-206, no 49, ill.
- ▸ The painting is still in its original, elaborately carved frame.

394

■ | *Mercury and Herse*

Panel, 53.8x84. Signed and dated: *C L Moeyaert. f Ao 1624.*
- purchased in 1874 together with no 395.

● FREISE 1911, p. 169; MARTIN 1935-36, I, pp. 144-145, fig. 84; BOL 1969, p. 166; A. Tümpel, O.H. 88 (1974), pp. 78-82, fig. 106, p. 265, no 167; SALERNO 1977-80, I, p. 162, fig. 33.2; WASHINGTON 1980-81, p. 134.

395

■ | *The triumphal march of Bacchus*

Panel, 53x83. Signed and dated: *C L Moeyaert. fe. Ao 1624.*
■ purchased in 1874 together with no 394.
● MARTIN 1935-36, I, p. 145; ROSENBERG, SLIVE & KUILE 1977, p. 34; A. Tümpel, O.H. 88 (1974), pp. 78-82, fig. 105, p. 264, no 156; WASHINGTON 1980-81, pp. 134-135, no 24, ill.

297

Pieter van Mol, Attributed to | *Study of a young man's head*

Born in Antwerp in 1599, died in Paris 1650, where he worked from 1631, becoming court painter in 1640.

Canvas, 46x40.
■ coll. Rottiers; purchased by King Willem I in 1823.
● E. de Callatay, REVUE BELGE 40 (1970), pp. 95-98, fig. 1.
► Entered previous catalogues as Murillo and Flemish school. Later attributed to Jacob van Oost. Attribution to Pieter van Mol by De Callatay.

407

Jan Miense Molenaer | *Merry peasants*

Born ca 1610 in Haarlem, died there in 1668. Possibly a pupil of F. Hals; his earlier paintings are connected in style with Hals. In 1636 he married the painter Judith Leyster. Soon after their wedding they moved to Amsterdam. In 1648 they returned to Heemstede, near Haarlem and remained there (except for six months spent in Amsterdam in 1665).

Canvas, 111x148. Signed and dated: *J. Molenaer 16.2* (probably 1662)
■ purchased in 1876.

572

■ | *Touch*

Panel, 19.5x24.2. Signed and dated: *IMR 1637.*
■ purchased in 1893.
● J. Harms, O.H 44 (1927), pp. 223-225; ROSENBERG, SLIVE & KUILE 1977, p. 175; PARIS 1970-71, p. 146.
► Belongs to a series of five panels (nos 572-576).

573

■ | *Sight*

Panel, 19.6x23.9. Signed: *IMR.*
■ purchased in 1893.
● J.Harms, O.H. 44 (1927), pp. 223-225; ROSENBERG, SLIVE & KUILE 1977, p. 175; PARIS 1970-71, p. 146.
► Belongs to a series of five panels (nos 572-576).

574

 | *Sound*

Panel, 19.4x24.2.
■ purchased in 1893.
● J. Harms, O.H. 44 (1927), pp. 223-225; MARTIN 1935-36, I, p. 370, fig. 219; ROSENBERG, SLIVE & KUILE 1977, p. 175; PARIS 1970-71, p. 146.
▸ Belongs to a series of five panels (nos 572-576).

575

 | *Smell*

Panel, 19.5x24.3. Signed: *IMR*.
■ purchased in 1893.
● J. Harms, O.H. 44 (1927), pp. 223-225; ROSENBERG, SLIVE & KUILE 1977, p. 175; PARIS 1970-71, p. 146.
▸ Belongs to a series of five panels (nos 572-576).

576

 | *Taste*

Panel, 19.6x24.1. Signed: *IMR*.
■ purchased in 1893.
● J. Harms, O.H. 44 (1927), pp. 223-225; ROSENBERG, SLIVE & KUILE 1977, p. 175; PARIS 1970-71, p. 146.
▸ Belongs to a series of five panels (nos 572-576).

691

 | *Peasant wedding*

Panel, 43.5x56.7.
■ bequest of T.H. Blom Coster, The Hague, 1904.

116

Louis de Moni | *A lace worker with a boy blowing bubbles*

Born 1698 in Breda, died 1771 in Leiden. Pupil of F. van Kessel and J.A. Biset, Breda, then of Ph. van Dijk, The Hague. Worked in Leiden.

Panel, 39x42. Signed and dated: *L:De Moni f.1742*.
■ purchased in 1829; on loan to the Stedelijk Museum De Lakenhal, Leiden, since 1922.
● CAT. LAKENHAL 1983, p. 227, ill.

Monsu Bernardo, see Bernard *Keil*.

117

Anthonis Mor van Dashorst | *Portrait of a goldsmith*

Born 1516/19 in Utrecht, died 1575 in Antwerp. Pupil of J. van Scorel. Following a sojourn in Rome (1550-51) he worked at the Portugese court in Lisbon and for Philip II in Madrid. He travelled to England in 1554 and to Spain again in 1559. Afterwards he worked in Utrecht and Antwerp.

Panel, 118.5x90. Inscribed: *A..tatis xxxv.1564.*
■ coll. Sir P. Lely, London, 1682; coll. G. van Slingelandt, The Hague, 1768. Cabinet Prince Willem V.
● HYMANS 1910, pp. 138-139, ill.; MARLIER 1934, p. 100, no 28; H.E. van Gelder, N.K.J. I (1947), pp. 47-59, ill.; A.B. de Vries, O.K. 6 (1962), no 28, ill.; CAT. MAURITSHUIS 1968, p. 41, ill.; FRIEDLÄNDER 1967-76, XIII, p. 103, no 368; OSTEN & VEY 1969, p. 297; DROSSAERS & LUNSINGH SCHEURLEER 1974-76, III, p. 222, no 97; J.L. de Meyere, J. OUD UTRECHT, 1978, pp. 144-145, fig. 24; E.E.H. Groeneveld, JAARBOEK ANTWERPEN, 1981, p. 114, note 75.
► The sitter is in all probability Steven van Herwijck (ca 1529-1570), Utrecht goldsmith.

559

■ | *Portrait of a man*

Canvas, 69x55.8. Signed and dated: *Antonius morus pingebat Ao 1561.*
■ purchased in 1889.
● HYMANS 1910, p. 127; MARLIER 1934, p. 99, no 25; CAT. MAURITSHUIS 1968, pp. 40-41, ill.; FRIEDLÄNDER 1967-76, XIII, p. 103, no 366, p. 108; J.L. de Meyere, J. OUD UTRECHT, 1978, p. 142, fig. 22; E.E.H. Groeneveld, JAARBOEK ANTWERPEN, 1981, p. 114, note 71.
► Formerly considered a portrait of Prince Willem I. Possibly the replica of a larger original; the head only is autograph.

861

Louis Gabriel Moreau the Elder | *Fashionable company in a garden*

Born 1739 in Paris, died there in 1805. Pupil of M. de Machy.

Panel, 30x25.
■ coll. D. Weil, Paris, 1923; coll. F. Mannheimer, Amsterdam; transferred to the Mauritshuis by the Rijksdienst Beeldende Kunst, 1960.
● G. Wildenstein, *Louis Moreau*, Paris 1923, p. 62, no 50.

705

Johan Moreelse | *Democritus, the laughing philosopher*

Born ca 1603 probably in Utrecht, died 1634 in Utrecht. Son of P. Moreelse. Influenced by H. ter Brugghen in the late 1620s. Probably worked in Utrecht.

Canvas, 84.5x73. Signed: *JPM* (it has been suggested that the 'P' was added later).
■ donated by L. Nardus, Arnouville, 1906.
● JONGE 1938, p. 129, no 3, fig. 200; A. Blankert, N.K.J. 18 (1967), pp. 52, 55-56 (note 54), 98, no 33, fig. 20; K. Fremantle, BURL. MAG 116 (1974), pp. 619-620; B. Nicolson, BURL. MAG. 116 (1974), p. 623; NICOLSON 1979, p. 75.
► There was very probably a pendant of Heraclitus. A replica in the collection of Lord Sackville, Knole (with companion piece).

118

Paulus Moreelse | *Portrait of the painter*

Born 1571 in Utrecht, died there in 1638. He is said to have been a pupil of M. J. van Mierevelt, Delft. Visited Italy, probably 1598-1602; always worked in Utrecht afterwards. D. van Baburen is the best known of his pupils.

Panel, 72x62.5
■ purchased in 1875.
● JONGE 1938, p. 99, no 123, pl. I.

655

■ | *Portrait of a lady*

Canvas, 117.5*x*95. Signed and dated: *1627 PM*.
■ given on loan in 1901; bequest of A. Bredius, 1946.
● JONGE 1938, p. 92, no 89, fig. 71; PLIETZSCH 1960, p. 166, fig. 294.

Anthony Moro, see Anthony *Mor* van Dashorst.

767

Giovanni Battista Moroni, Attributed to | *Portrait of Vercellino Olivazzi, senator of Bergamo*

Born ca 1525 in Albino, near Bergamo, died there in 1575. Pupil of A. Moretto in Brescia. Worked mainly in Bergamo.

Canvas, 98*x*81.
■ coll. P. Luppi, Bergamo; kunsth. J. Fischhof, Paris; coll. F. von Franz, Frankfurt; kunsth. Bachstitz, The Hague; purchased in 1922; on loan to the Rijksmuseum, Amsterdam (inv.no C1365), since 1948.
● D. Cugini, *Moroni pittore*, Bergamo 1939, p. 152, no 99.
▶ Attribution and identification have been handed down by tradition.

921

Jan Mostaert | *Joseph explaining the dreams of the cupbearer and the baker*

Born ca 1475 in Haarlem, where he died in 1555 or 1556. Worked in Haarlem and Mechelen.

Panel, 31.3*x*24.7.
■ coll. E. Aynard, Lyon, 1913; coll. L. Baron de Rothschild, Vienna; kunsth. Rosenberg & Stiebel, New York; purchased in 1955.
● A.B. de Vries, O.K. 8 (1964), no 4, ill.; CAT. MAURITSHUIS 1968, pp. 41-42, ill.; CAT. MAURITSHUIS 1970, no 2, ill.; B. Dubbe, ANTIEK 18 (1984), p. 290, fig. 5.
▶ Attributed to J. Mostaert. Formerly attributed to the Master of the portraits of the princes.

121

Frederik de Moucheron | *Italian landscape*

Born 1633 in Emden, died 1686 in Amsterdam. According to Houbraken he was a pupil of J. Asselijn and worked for several years in France. He probably visited Italy as well. Worked in Amsterdam for the rest of his life. It is said that the staffage figures in his work were usually painted by A. van de Velde and J. Lingelbach.

Canvas, 93.5*x*125. Signed: *Moucheron ft*.
■ purchased in 1827.
● Martin 1950, p. 71, no 113, ill.; M. Waddingham, *Paysagistes du 17e siècle*, Paris 1968, II, pp. 5, 8, pl. XVI; BLANKERT 1978 (1), p. 222, no 140, ill.; CAT. MAURITSHUIS 1980, pp. 58-59, 192, ill.; SALERNO 1977-80, II, p. 760.
▶ The staffage figures are attributed to J. Lingelbach.

122

■ Attributed to | *Landscape with ambush*

Canvas, 89*x*72.5. Signed: *Moucheron*.
■ unknown.
● MARTIN 1935-36, II, p. 325, fig. 178; CAT. MAURITSHUIS 1980, p. 59, 193, ill.

549

Pieter Mulier the Elder | *Choppy sea* (formerly called : *Haarlemmermeer*)

Born before 1615 in Haarlem, died there in 1670. He may have been a pupil of S. van Ruysdael. Painter of seascapes; influenced by J. Porcellis and J. van Goyen.

Panel, 39.5x60.5. Signed: *PML*.
■ donated by A. Bredius, The Hague, 1889.
● BOL 1973, p. 143, fig. 146; CAT. MAURITSHUIS 1980, pp. 59-60, 194, ill.

296

Bartolomé Esteban Murillo | *Madonna and child*

Born 1618 in Seville, died there in 1682. Pupil of J. del Castillo. Influenced by Titian, Rubens, A. van Dyck and Ribera. Worked in Seville.

Canvas, 188x137.5.
■ coll. A.J. Snijders, Antwerp; purchased by King Willem I for the Mauritshuis, 1818; on loan to the Rijksmuseum, Amsterdam (inv.no C 1366), since 1948.
● P. van Vliet, BULL. R.M. 14 (1966), p. 132, fig. 2; CAT. RIJKSMUSEUM 1976, p. 403; *Bartolomé Murillo 1617-1672*, Museo del Prado, Madrid/Royal Academy of Arts, London, Madrid 1982, pp. 168-169, cat. no 25, p. 97, ill.

123

Michiel van Musscher | *Family portrait*

Born 1645 in Rotterdam, died 1705 in Amsterdam. According to Houbraken he was a pupil of A. van den Tempel, G. Metsu and A. van Ostade.

Canvas, 90x106. Signed and dated: *Ao:1681 in Amsterdam, MI:v: Musscher. Pinxit.*
■ purchased in 1829.

748

■ | *Portrait of Thomas Hees (1634-1635), resident and commissioner of the States-General to the government of Algiers, Tunis and Tripoli, with his nephews Jan (1670-1671) and Andries (b.1662/63) Hees, and a servant*

Canvas, 83x76. Signed and dated: *Michiel v. Musscher. Pinxit. Anno M.D.C.LXXXVII.*
■ bequest of Jhr Mr J.H. Hora Siccama and Jhr W. Hora Siccama, 1914; on loan to the Rijksmuseum, Amsterdam, since 1932 (inv.no C1215).
● STARING 1956, p. 98, pl. XVI; PLIETZSCH 1960, p. 1960, p. 74, fig. 117; P.J.J. van Thiel, BULL. R.M. 17 (1969), p. 8; W.H. Vroom, ONS AMSTERDAM 24 (1972), p. 179; CAT. RIJKSMUSEUM 1976, p. 404.

George van der Mijn see after Abraham *Mignon*

Johannes Mijtens see after Abraham *Mignon*

124

Pieter Nason | *Portrait of Willem Frederik, Count of Nassau (1613-1664), Stadholder of Friesland*

Born 1612 in Amsterdam, died ca 1689 in The Hague. Portrait painter, worked in Amsterdam until 1638, then in The Hague. He possibly travelled to England (1663) and to Germany (1666).

Canvas, 121x93.6. Signed and dated: *Nason.f 1662*.
■ unknown; possibly from one of the stadholders' palaces; on loan to the Rijksmuseum, Het Loo Palace, since 1984.
● PARIS 1970-71, p. 73.
► Compare: miniatures. anonymous, Dutch school, no 1024.

248

Peeter Neeffs the Younger | *Interior of the Onze Lieve Vrouwekerk in Antwerp*

Born 1620 in Antwerp, died there after 1675. Pupil of his father, Peeter Neeffs the Elder. Worked in Antwerp. F. Francken III, J. van Eijck and B. Peeters painted staffage figures in his works.

Panel, 34x47.6. Signed: *Peeter neeffs ffrank.*
■ Stadholder's Court, The Hague, 1763; Cabinet Prince Willem v.
● BERNT 1969-70, II, no 834, ill.; DROSSAERS & LUNSINGH SCHEURLEER 1974-76, III, p. 19, no 14, p. 223, no 104; JANTZEN 1979, pp. 46, 230, no 339.
▶ Staffage figures are by F. Francken III.

682

Aert van der Neer | *Landscape by moonlight*

Born 1603/04 probably in Amsterdam, died there in 1677. He was possibly a pupil of the brothers R. and G. Camphuyzen. Influenced by H. Avercamp. He worked in Amsterdam. His sons Jan and Eglon were also painters.

Panel, 46.5x37.8.
■ purchased in 1900 by the Rembrandt society; acquired by the Mauritshuis in 1903.
● HOFSTEDE DE GROOT 1907-28, VII, pp. 408-409, no 196; MARTIN 1950, p. 65, no 82, ill.; CAT. MAURITSHUIS 1980, pp. 62, 195, ill.

787

■ | *Ice sports*

Panel, 25x36.5. Signed and dated: *AVDN 7 fe ... 1635.*
■ coll. A. de Ridder, Kronberg, 1910; purchased with the aid of the Rembrandt society and private individuals, 1924.
● HOFSTEDE DE GROOT 1907-28, VII, pp. 481-482, no 494; CAT. MAURITSHUIS 1980, pp. 61-62, 194, ill.; BACHMANN 1982, p. 115, fig. 85.
▶ The date, which is also read as 1655 or 1675, is not authentic.

912

■ | *Landscape at sunset* (formerly: *Landscape at sunrise*)

Panel, 44.8x63. Signed: *AVDN.*
■ coll. J.G. Verstolk van Soelen, The Hague, 1846; coll. Earl of Northbrook, London, 1889; coll. E.A. Veltman, Bussum; purchased in 1953.
● HOFSTEDE DE GROOT 1907-28, VII, p. 376, no 54; A.B. de Vries, BULL. R.M. I (1953), pp. 82-83, ill.; STECHOW 1966, p. 178, fig. 358; CAT. MAURITSHUIS 1970, no 30, ill.; CAT. MAURITSHUIS 1980, pp. 62-63, 196, ill.; BACHMANN 1982, p. 106, fig. 76.

913

■ | *Landscape by moonlight*

Panel, 44.8x63. Signed: *AVDN.*
■ see nr. 912.

• HOFSTEDE DE GROOT 1907-28, VII, p. 376, no 53; A.B. de Vries, BULL. R.M. I (1953), pp. 82-83, ill.; STECHOW 1966, p. 178, fig. 359; CAT. MAURITSHUIS 1970, no 31, ill.; CAT. MAURITSHUIS 1980, pp. 63-64, 197, ill.; BACHMANN 1982, p. 106, fig. 75.
► Inv.nos 912 and 913 used to be regarded as pendants, but given the composition and dating this seems unlikely.

862

Eglon van der Neer | *Interior with a woman washing her hands* (formerly: *A house of pleasure*)

Born ca 1634 in Amsterdam, died 1703 in Düsseldorf. Pupil of his father A. van der Neer and J van Loo. Visited France. Worked in Rotterdam from 1664 to 1679, thereafter in The Hague, Amsterdam and Brussels (1679-1690) and from 1690 onwards in Düsseldorf (court painter to the Elector Palatine, Johan Wilhelm).

Panel, 49x39.5. Signed and dated: *Eglon.vander Neer 1675.*
■ coll. V. Rotschild, London, 1937; coll. F. Mannheimer, Amsterdam, 1943; transferred to the Mauritshuis by the Rijksdienst Beeldende Kunst, 1960.
• HOFSTEDE DE GROOT 1907-28, V, p. 518, no 44; PLIETZSCH 1960, p. 187, fig. 342; AMSTERDAM 1976, pp. 194-195, no 48, ill.; PHILADELPHIA 1984, pp. 270-271, fig. 2.

125

Caspar Netscher | *Company making music*

Born ca 1639 probably in Heidelberg, died 1684 in The Hague. Pupil of H. Coster, Arnhem, and ca 1654 of G. ter Borch, Deventer. He married in Bordeaux in 1659. Returned to the Netherlands in 1662, and spent the remainder of his life in The Hague.

Panel, 44x36. Signed and dated: *C.Netscher.Ao.1665.*
■ coll. G. van Slingelandt, The Hague, 1768; Cabinet Prince Willem v.
• HOFSTEDE DE GROOT 1907-28, V, p. 194, no 115; MARTIN 1935-36, II, pp. 242-243, fig. 135; PLIETZSCH 1960, p. 61; BERNT 1969-70, II, no 850, ill.; PHILADELPHIA 1984, pp. 274-275, fig. 2.
► The background relief probably shows the Abduction of Helen.

126

■ | *Portrait of Maurits Le Leu de Wilhem (1643-1724), president of the council of Brabant*

Canvas, 48.5x39.8. Signed and dated: *C Netscher. 1677.*
■ bequest of Jonkvrouw P.E.A. de Forestier d'Orges van Waalwijk, 1885.
• HOFSTEDE DE GROOT 1907-28, V, p. 227, no 222.
► Formerly thought to portray Mr Johan Philips van Leeffdael.

127

■ | *Portrait of Maria Timmers (1657-1753), wife of the above; married 1683*

Canvas, 48.2x39.7. Signed and dated: *C Netscher:fec 1683.*
■ the same bequest as no 126.
• HOFSTEDE DE GROOT 1907-28, V, p. 227, no 223; PLIETZSCH 1960, p. 62, fig. 94; BERNT 1969-70, II, no 127, ill.
► Formerly thought to portray Henrietta Florentina van Vladeracken.

714

■ | *Portrait of Elisabeth van Bebber (1643-1704), wife of Michiel ten Hove; married 1662*

Canvas, 49x40. Signed and dated: *C.Netscher 167..*
■ bequest of Miss M.J. Singendonck, The Hague, 1907.
► Companion piece to no 715.

715

■ | *Portrait of Michiel ten Hove (1640-1689), magistrate of Haarlem, Grand Pensionary of Holland*

Canvas, 48.8x39.4.
■ see no 714.
► Companion piece to no 714.

716

■ Copy after | *Portrait of Johan de Witt (1625-1672), Grand Pensionary of Holland*

Canvas, 47x43.
■ bequest of Miss M.J. Singendonck, The Hague, 1907.
► Copy after a portrait in Hanover.

686

Constantijn Netscher | *Portrait of a man*

Born 1668 in The Hague, died there in 1723. Pupil of his father, Caspar Netscher.

Canvas, 52.2x43.1 (oval). Signed and dated: *Consts: Netscher 1715*.
■ bequest of P.M. Netscher, 1903.

721

■ | *Portrait of Anna Maria Roman (1680-1758), wife of Pieter Dierquens; married 1704*

Canvas, 57.5x46. Signed and dated: *Const.Netscher 17(10)*.
■ bequest of Miss M.J. Singendonck, The Hague, 1907.
► Companion piece to the portrait of her husband by J. van Haensbergen, inv.no 720. This wife's portrait was also attributed to Haensbergen until a restoration in 1971 revealed Constantijn Netscher's signature.

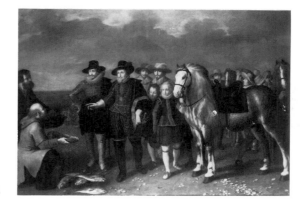

476

Adriaen van Nieulandt | *Maurits and Frederik Hendrik, Princes of Orange, on the beach at Scheveningen*

Born 1587 in Antwerp, died 1658 in Amsterdam. Pupil of P. Isaacsz. and F. Badens, Amsterdam. He possibly visited Italy.

Canvas, 137x199.7.
■ purchased in 1884.
● LEEUWARDEN 1979-80, p. 49, no 12, ill.
► A preliminary drawing is in coll. F. Lugt, Paris (inv.no 5209).

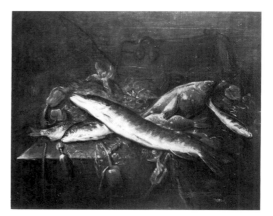

602

Pieter van Noordt | *Fish still life*

Born 1602. Worked in Leiden 1626 to 1648, then probably in Zwolle.

Canvas, 65x82. Falsely signed: *A:Cuyp*.
■ purchased in 1895.
● C. Hofstede de Groot, O.H. 19 (1901), p. 143.

195

Jacob Ochtervelt | *The fishmonger*

Born 1634 in Rotterdam, died 1682 in Amsterdam. According to Houbraken J. Ochtervelt and P. de Hooch were fellow pupils under C.P. Berchem in Haarlem. Between 1672 and 1674 he moved from Rotterdam to Amsterdam.

Canvas, 55.5x44.
■ purchased in 1826.
● MARTIN 1935-36, I, p. 211; MARTIN 1950, p. 103, no 261, ill.; PLIETZSCH 1960, p. 65; KURETSKY 1979, pp. 36, 70-71, no 42, pp. 75, 82, fig. 123; PHILADELPHIA 1984, p. 279, note 1.
► Although the existence of a signature (*Jac⁰ Ochtervelt*) was noted in the catalogues of 1895, 1935 and 1977, this inscription is not visible today. Closely related works in St Louis (1665) and Leningrad (1669).

681

Hendrick ten Oever | *View of the Herengracht, Amsterdam*

Born 1639 in Zwolle, died there in 1716. Studied under C. de Bie in Amsterdam. In 1665 he returned to Zwolle; remained there for the rest of his life.

Panel, 36.8x42. Signed: *H. ten Oever fc:* (on the verso dated: *1690*; probably not authentic).
■ purchased in 1903.
● E. Plietzsch, *Pantheon* 29 (1942), pp. 133, 136, ill.; J. Verbeek, J.W. Schotman, *H. ten Oever*, Zwolle 1957, p. 28, no 33, fig. 16; BERNT 1969-70, II, no 876, ill.
► During restoration in 1978 a second dog (not original) was removed.

537

Jan Olis | *A scholar*

Born ca 1610(?) in Gorkum. died 1676 in Heusden. He may have been in Rome in 1631; later spent a long time in Dordrecht. Documented in Heusden from 1656 onwards.

Panel, 26x20.6. Signed: *J.olis.*
■ purchased in 1887.
● BERNT 1969-70, II, no 878, ill.

468

Maria van Oosterwyck | *Flowers in an ornamental vase*

Born 1630 in Nootdorp. died 1693 in Uitdam. Pupil of J.D. de Heem. Influenced by W. van Aelst. Worked in Delft and Amsterdam.

Canvas, 62x47 5. Signed: *Maria van Oosterwyck.*
■ purchased in 1882.
● MARTIN 1935-36, pp. 429-430, fig. 227; BOL 1969, pp. 318-319, fig. 291; BERGSTRÖM 1977, p. 205; AMSTERDAM 1982, pp. 48-49, 98, no 52, ill.

Jacob Cornelisz. van Oostsanen, see Jacob *Cornelisz.* van Oostsanen.

128

Adriaen van Ostade | *Peasants in an inn*

Born 1610 in Haarlem, died there in 1685. According to Houbraken he was
a pupil of F. Hals; influenced by A. Brouwer and Rembrandt. Worked in
Haarlem. C. Bega, C. Dusart and his brother Isaack were his pupils.

Panel, 47.5x39. Signed and dated: *Av. Ostade 1662.*
■ coll. H. van Slingelandt, The Hague, 1759; Cabinet Prince Willem v.
● C. Hofstede de Groot, o.h. 10 (1892), pp. 230-231; ROSENBERG 1900, pp.
54-55, fig. 53, p. 75; HOFSTEDE DE GROOT 1907-28, III, p. 339, no 636;
MARTIN 1935-36, I, pp. 393-394, fig. 234; DROSSAERS & LUNSINGH
SCHEURLEER 1974-76, III, p. 223, no 106.

129

■ | *The violinist*

Panel, 45x42. Signed and dated: *A v Ostade. 1673.*
■ coll. G. van Slingelandt, The Hague, 1752; Cabinet Prince Willem v.
● ROSENBERG 1900, pp. 83-84, fig. 85; HOFSTEDE DE GROOT 1907-28, III, p.
277, no 429; MARTIN 1935-36, I, p. 394; DROSSAERS & LUNSINGH
SCHEURLEER 1974-76, III, p. 223, nr. 105; NIEMEYER 1980, pp. 262-263, no
17; SCHNACKENBURG 1981, I, pp. 124-125, no 227.
► A watercolour of the same subject (also dated 1673) is in the Pierpont
Morgan Library, inv.no 134; C. Ploos van Amstel made an engraving after
the latter.

580

■ | *Festive peasants*

Panel, 47.3x63.6. Signed and dated: *Av.ostad.163...*
■ purchased in 1894.
● ROSENBERG 1900, p. 24; HOFSTEDE DE GROOT 1907-28, III, p. 320, no 565;
MARTIN 1935-36, I, p. 388, fig. 231; SCHNACKENBURG 1981, I, p. 83, no 19.
► A preliminary drawing is at Hergiswil (Switzerland).

807

■ | *The merry drinkers*

Panel, 30.5x25. Signed and dated: *Av. Ostade.1659.*
■ coll. Steengracht, Paris, 1913; purchased in 1932.
● HOFSTEDE DE GROOT 1907-28, III, p. 243, no 325.

745

Isaack van Ostade | *Farmer with a boar*

Born 1621 in Haarlem, died there in 1649. According to Houbraken he was
a pupil of his older brother Adriaen. Worked in Haarlem.

Panel, 27.1x25.3. Signed and dated: *Av ostade 1644.*
■ coll. Steengracht; purchased with the aid of the Rembrandt Society, 1913.
● HOFSTEDE DE GROOT 1907-28, III, p. 493, no 122; W. Martin, BULL. N.O.B.
7 (1914), p. 8, ill.; CAT. MAURITSHUIS 1980, pp. 66, 745, ill.
► Formerly attributed to Adriaen and Isaack van Ostade in turn. Isaack's
signature was probably changed to that of his more famous brother.

789

■ | *Travellers outside an inn*

Panel, 75x109. Signed and dated: *Isaack van Ostade/1646.*
■ coll. A. de Rothschild, London, 1902; purchased with the aid of the
Rembrandt Society, 1925.

• HOFSTEDE DE GROOT 1907-28, III, p. 465, no 22, p. 474, no 56; MARTIN 1935-36, p. 406, fig 243; STECHOW 1966, p. 28; CAT. MAURITSHUIS 1980, pp. 66-67, 200, ill.

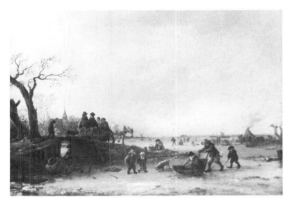

864

■ | *Ice sports*

Panel, 34x49. Signed: *Isaak Ostade.*
■ coll. J.W. Six van Vromade, Amsterdam, 1920; coll. F. Mannheimer, Amsterdam; transferred to the Mauritshuis by the Rijksdienst Beeldende Kunst, 1960.
• HOFSTEDE DE GROOT 1907-28, III, p. 543, no 249; CAT. MAURITSHUIS 1980, pp. 65, 198, ill.

546

Hendrik Ambrosius Pacx | *The princes of Orange and their families riding out from The Buitenhof, The Hague.*

Born 1602/03 in Amsterdam, where he was still working in 1658.

Canvas, 145x214.
■ bequest of Count A. van der Straten Ponthoz, The Hague, 1888.
• C. Hofstede de Groot, O.H. 17 (1899), p. 166; BOL 1969, p. 245; LEEUWARDEN 1979-80, p. 17, fig. 16; N. Sluijter-Seijffert, *Tableau* 6 (1983-84), pp. 52-53, ill.
► Attributed to Pacx by C. Hofstede de Groot; formerly considered the work of P. van Hillegaert. Probably painted before 1625. Depicted, from left to right: Frederick v, the Winter King; his wife Elizabeth Stuart, daughter of James I of England; a masked woman; an unidentified figure; Stadholder Maurits, Prince of Orange; Philips Willem, Prince of Orange; William the Silent; Stadholder Frederik Hendrik, Prince of Orange; Willem Lodewijk, Count of Nassau; an unidentified figure; Ernst Casimir, Count of Nassau-Dietz.
Several of the portraits are posthumous. The painting is a historical impossibility and may have been meant as a tribute to the Houses of Orange and Nassau.
Compare a print by W.J. Delff, dated 1621. There are several variants, one in the Rijksmuseum, Amsterdam, attributed to P. van Hillegaert.

615

Anthonie Palamedesz | *Company dining and making music*

Born 1601 in Delft, died 1673 in Amsterdam. He was a pupil of M.J. van Mierevelt, Delft. Later influenced by Haarlem and Amsterdam painters like D. Hals, P. Codde and W. Duyster. Worked in Delft.

Panel, 47.4x72.6. Signed and dated: *A palamedes.1632.*
■ purchased in 1900.
• MARTIN 1935-36, I, pp. 364-366, fig. 212; F. Baumgart, MARBURGER J. 13 (1944), pp. 145-147, fig. 45; BERNT 1969-70, II, no 901, ill.; BLANKERT 1978 (2), pp. 11-12, fig. 1; PHILADELPHIA 1984, p. 292, fig. 1.

130

Abraham de Pape | *Old woman plucking a rooster*

Born ca 1621 in Leiden, died there in 1666. Pupil of G. Dou.

Panel, 49x41. Signed: *A. de Pape.*
■ purchased in 1827.
• BERNT 1969-70, II, nr. 903, ill.; SUMOWSKI 1983, pp. 501, 503, note 18, p. 505, ill.

324

Il Parmigianino (Girolamo Mazzola), Copy after | *The circumcision*

Born 1503 in Parma, died 1540 in Casal Maggiore. Pupil of his uncles Michele and Pier Ilario Mazzola. Worked in Rome from 1523 to 1572.

Panel, 43x33.

■ coll. De Bourck, Paris; purchased in 1823; on loan to the Raadhuis, Wychen, since 1936.
► Another copy after *The circumcision*, attributed to Parmigianino, Institute of Arts, Detroit (canvas, 41.9x31.4).

354

■ Copy after | *St Barbara*

Panel, 40x33.
■ purchased by King Willem I for the Mauritshuis with the Reghellini collection, 1831.
► Copy after *St Barbara* by Parmigianino, Prado Museum, Madrid (canvas, 48x39, inv.no 282). There is another copy in the coll. the Duke of Devonshire, Chatsworth.

894

Joachim Patenir, Manner of | *Landscape with the temptation of St Anthony*

Born ca 1480 in Dinant, died 1524 in Antwerp. Registered as a master in the Bruges guild, 1515, and in the Antwerp guild, 1520.

Panel, 28x57.
■ donated by the Kessler-Hülsmann family, Brussels, to the Rijksmuseum, Amsterdam, 1940 (inv.no A3336); on loan from the Rijksmuseum, Amsterdam, since 1951.
● M.J. Friedländer, *Essays über die Landschaftsmalerei und andere Bildgattungen*, The Hague 1947, p. 62; E. Castelli, *Simboli e imagine*, Rome 1966, p. 27, pls. V-VI; FAGGIN 1968, p. 39, note 13; KOCH 1968, p. 98; CAT. MAURITSHUIS 1968, pp. 43-44; CAT. RIJKSMUSEUM 1976, p. 436.
► Painted in Antwerp, ca 1520.

834

Giovanni Antonio Pellegrini | *The wounded Porus before Alexander the Great*

Born 1675 in Venice, died there in 1741. Pupil of P. Pagani and probably of S. Ricci as well. Influenced by L. Giordano and contemporary French art. Worked in Italy, England, Germany, Flanders, Holland, France and Austria.

Pen drawing, washed in sepia, 29x36. Signed on the verso: *Di Antonio Pellegrini*.
■ kunsth. J.H. Wiegersma, Utrecht; donated by J.G. van Gelder, 1946.
● A. Bettagno, *Catalogo della mostra 'Disegni e dipinti di Giovanni Antonio Pellegrini 1675-1741'*, Venice 1959, no 65, fig. 65; G. Karas, *Acta Historiae Artium* 11 (1965), p. 298, fig. 10; CAT. MAURITSHUIS 1970, no 50, ill.
► It is not totally clear if Porus or Darius is depicted. Our drawing is related to Pellegrini's painting in the Cassa di Risparmio, Padua. There is another related design in coll. Cini, Venice. The Museum of Ravenna contains an oil sketch.

834a

■ | *Decoration of the great hall* (3 ceiling paintings; 4 paintings in grisaille; 2 chimney pieces; 6 flower pieces (round))

Canvas, 188x260; 256x108.5; 235x168; 88.5 (diameter). Signed: *Pellegrini F.*
■ these decorations were painted during the restoration of the Mauritshuis after the fire of 1704; they were completed in 1718.
▶ The ceiling paintings depict, from right to left: the sun god Apollo, Aurora (the dawn) and Night being put to flight.
The female figures painted in grisaille are the four elements: Water (woman with sceptre), Fire (jug with flame), Sky (peacock) and Earth (horn of plenty). The chimney pieces may depict the four Temperaments allied to the elements: on the left the sanguine and choleric Temperaments, on the right the melancholic and phlegmatic ones.
The six flower pieces may not be autograph.

474

Christoffel Pierson | *Portrait of Joris Goethals (1584/86-1670), clergyman of Blaricum and Hoorn*

Born 1631 in The Hague, died 1714 in Gouda. Worked in Schiedam and Gouda.

Panel, 37.4x28.2. Signed and dated: *Chr: Pierson. 1667.*
■ bequest of W.N. Lantsheer, 1883.

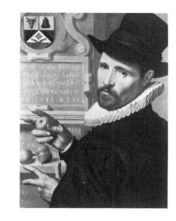

4

Pieter Pietersz. | *Portrait of Cornelis Cornelisz. Schellinger (1551-1635)*

Born ca 1543 in Antwerp, died 1603 in Amsterdam. Son and pupil of P. Aertsen. Worked in Haarlem and especially in Amsterdam.

Panel, 68x51. Inscribed: *Wert in dit Jaer tot Delft doorschoten. Twelck veel mensche heeft verdroten.* (Was shot this year in Delft to the grief of many) *ANo.1584.AE.T.33. Obiit AO 75. Elc syn tyt.* (every man his own time).
■ purchased in 1874.
● P. Wescher, o.h. 46 (1929), pp. 165-166, fig. 12; HOOGEWERFF 1936-47, IV, p. 571; A.B. de Vries, *Het Noord-nederlandsch portret in de tweede helft van de 16e eeuw*, Amsterdam 1934, p. 68; JONGH 1967, pp. 78-79, fig. 65; CAT. MAURITSHUIS 1968, pp. 44-45, ill.
▶ The verses refer to the death of William the Silent.

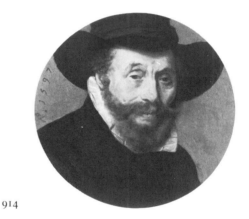

914

■ | *Portrait of a man*

Panel, 42.5 in diameter (round). Dated: *Ao. 1597.*
■ coll. A. Figdor, Vienna, 1930; kunsth. S. Nystad, The Hague; purchased in 1953.
● A.B. de Vries, BULL. R.M. I (1953), pp. 79-80, ill.; S. Slive, o.h. 76 (1961), p. 174, fig. 3; CAT. MAURITSHUIS 1968, p. 45, ill.; CAT. MAURITSHUIS 1970, no 7, ill.

132

Adam Pijnacker | *Mountainous landscape with waterfall* (formerly: *Mountain stream*)

Born 1621 in Pijnacker near Delft, died 1573 in Amsterdam. Influenced by J. Both and J. Asselin. According to Houbraken he travelled three years in Italy. He is recorded in Delft around 165◼ and in Schiedam in 1658.

Canvas, 101x91. Formerly signed: *A Pijnacker*.
◼ coll. J. van der Marck, Leiden, 1773; acquired through exchange with the Rijksmuseum, Amsterdam, 1825.
● HOFSTEDE DE GROOT 1907-28, IX, p. 535, no 54; CAT. MAURITSHUIS 1980, pp. 68-69, 201, ill.; SALERNO 1977-80, II, pp. 694, 760, fig. 117.5.
► The figures may not be by A. Pijnacker himself.

Bonifazio de' Pitati, see Bonifazio *Veronese*.

133

Egbert Lievensz. van der Poel | *Fishing boats at night*

Born 1621 in Delft, died 1664 in Rotterdam. He entered the Delft guild in October 1650. In 1654/55 he had settled in Rotterdam.

Panel, 46.2x37. Signed: *E. van der Poel*.
◼ unknown.
● CAT. MAURITSHUIS 1980, pp. 70-71, 201, ill.

698

◼ | *Fish market*

Panel, 61.3x75. Signed and dated: *Evander Poel/1650*.
◼ donated by L. Nardus, Arnouville, 1905.
● CAT. MAURITSHUIS 1980, pp. 70, 202, ill.
► Possibly the fish market in Rotterdam.

134

Cornelis van Poelenburch | *Mercury struck by the beauty of Herse*

Born probably ca 1594/95 in Utrecht, died there in 1667. According to Sandrart he was a pupil of A. Bloemaert. Around 1617-1625 he worked in Italy: Rome and Florence; was in the service of the Grand Duke of Tuscany. From 1626 he was back in Utrecht. He worked at the court of Charles I in London from 1637 to 1641.

Panel, 18x27. Signed: *CP*.
◼ Het Loo, 1712; Leeuwarden Palace; Cabinet Prince Willem V.
● DROSSAERS & LUNSINGH SCHEURLEER 1974-76, I, p. 678, no 879, p. 696, no 23, III, p. 206, no 18, M. Roethlisberger, *Bartholomeus Breenbergh: the paintings*, Berlin/New York 1981, p. 38, no 50, ill.; SLUIJTER-SEIJFFERT 1984, pp. 86, 226, no 25.
► Formerly widely attributed to B. Breenbergh; the monogram was wrongly considered false.

1065

◼ | *Feast of the gods*

Copper, 38x49.
- donated by R. Noortman, 1982.
- SLUIJTER-SEIJFFERT 1984, pp. 92-93, 226, no 20.

946

Bastiaan de Poorter | *Portrait of Jean Zacharia Mazel (1792-1884), director of the Mauritshuis from 1841 to 1874*

Born 1813 in Meeuwen, Noord-Brabant, died there in 1880. Pupil of the academy in The Hague and of C. Kruseman. Director of the Amsterdam Academy.

Canvas, 116.5x87. Signed and dated: *B.de Poorter ft 1869.*
- donated by the Mazel family, 1960.

969

Jan Porcellis | *Shipwreck off the coast*

Born ca 1584 in Ghent, died 1632 in Zoeterwoude. According to Houbraken he was a pupil of H.C. Vroom. Worked successively in Rotterdam, Antwerp, Haarlem, Amsterdam, Leiden and The Hague. He was the father of the marine painter Julius Porcellis.

Panel, 36.5x66.5. Signed and dated: *JP 1631.*
- coll. B. Ingram, London, 1964; kunsth. H. Cramer, The Hague; purchased by the Johan Maurits van Nassau Foundation and given on loan to the Mauritshuis, 1964; purchased in 1989.
- GERSON 1951, p. 51, fig. 137; STECHOW 1966, p. 104; A.B. de Vries, O.K. 12 (1968), no 5, ill.; L. de Vries, ANTIEK 3 (1968), pp. 14-15, ill.; CAT. MAURITSHUIS 1970, no 17, ill.; BOL 1973, pp. 101-102, fig. 99; J. Walsh, jr., BURL. MAG. 116 (1974), p. 741, fig. 31; CAT. MAURITSHUIS 1980, pp. 71-72, 204, ill.; THE HAGUE 1982, pp. 170-171, no 65, ill.

706

Frans Post | *Brazilian landscape*

Born ca 1612 in Leiden, died 1680 in Haarlem. Accompanied Governor Johan Maurits van Nassau to Brazil, then a Dutch colony, in 1636. Post joined the Haarlem guild in 1646. Went to Paris 1660-1661 with Christiaen Huygens. His works usually portray Brazilian landscapes.

Panel, 50x69. Signed and dated: *F. Post/1667.*
- donated by P.J.D. van Dokkum, Utrecht, 1906.
- LARSEN 1962, pp. 113, 201, no 112, fig. 81; SOUSA-LEÂO 1973, pp. 92-93, no 52, ill.; CAT. MAURITSHUIS 1980, pp. 76-77, 206, ill.

915

■ | *Itamaraca Island, Brazil*

Canvas, 63.5x88.5. Signed and dated: *F. POST 1637 1/3.* Inscribed on the verso of the original canvas: *Het Eijlant ITamaraca gelijck het selve int Zuijden ver/thoont de stadt legt boven op den Berg beneden is het Fort/ orangien; het welck leit inden mont van de Zee op / dese manier sitten de Portugisen de peert/No 443* (The isle of Itamaraca as seen from the south, with the city on top of hill, and Fort Orange by the inlet. This is how the Portuguese ride their horses).
- E. Odinot, Paris; purchased by the Rijksmuseum, Amsterdam, 1879 (inv. no A4271); on loan since 1953.
- PLIETZSCH 1960, p. 166, fig. 198; LARSEN 1962, pp. 96, 98, 136-138, 185, no 2, fig. 23; H. Baard, O.K. 8 (1964), no 5, ill.; SOUSA-LEÂO 1973, pp. 23, 54-55, no 1, ill.; CAT. RIJKSMUSEUM 1976, p. 452; THE HAGUE 1979-80, p. 98, no 87, ill.; CAT. MAURITSHUIS 1980, pp. 73-76, 205, ill.

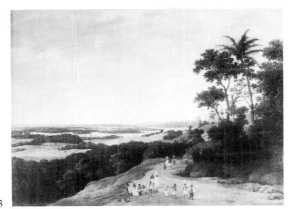

1063

■ | *Brazilian landscape*

Panel, 51x70. Signed and dated: *F. Post 1654.*
■ F. Muller, Amsterdam, 1919; Rijksmuseum Nederlands Scheepvaart Museum, Amsterdam, inv.no A89(1); on loan since 1980.
● LARSEN 1962, p. 189, no 26, fig. 45; SOUSA-LEÂO 1973, p. 69, no 19, ill.; THE HAGUE 1979-80, p. 111, no 103, ill.

765

Pieter Jansz. Post | *Cavalry engagement*

Born 1608 in Haarlem, died 1669 in The Hague. Architect to Johan Maurits van Nassau, for whom he built the Mauritshuis as designed by J. van Campen. It is uncertain whether he accompanied Johan Maurits to Brazil. Worked in Haarlem and The Hague.

Panel, 34.7x53.1. Signed and dated: *P.I.Post 1631.*
■ donated by Mr and Mrs A.F. Philips, Eindhoven, 1922.
● W. Martin, WALLRAF-R.JB. I (1930), pp. 231-235; S.J. Gudlaugsson, O.H. 69 (1954), pp. 60-62, 66, fig. 8; BERNT 1969-70, II, no 932, ill.; BOL 1969, p. 247; CAT. MAURITSHUIS 1980, pp. 78, 207, ill.
► A very similar work in the Wallraf-Richartz Museum, Cologne.
Companion piece to no 766.

766

■ | *Attack on an army train*

Panel, 34.7x53. Signed and dated: *P.I.Post 1631.*
■ donated by Mr and Mrs A.F. Philips, Eindhoven, 1922.

● W. Martin, WALLRAF-R.JB I (1930), pp. 231-235; S.J. Gudlaugsson, O.H. 69 (1954), pp. 60-62, 66, fig. 9; BOL 1969, p. 247; CAT. MAURITSHUIS 1980, pp. 78-79, 207, ill.
► Companion piece to no 765.

970

■ | *Landscape with hay shelter*

Panel, 53.3x79.5. Signed and dated: *P.Post 1633.*
■ C. Benedict, Paris, 1938; purchased from coll. W. Martin by the Johan Maurits van Nassau Foundation to mark the 70th birthday of A.B. de Vries, former director of the Mauritshuis, 1975.
● S.J. Gudlaugsson, O.H. 69 (1954), pp. 59, 64, fig. 7; BOL 1969, p. 148, fig. 141; PLIETZSCH 1960, pp. 113-114, fig. 191; SOUSA-LEÂO 1973, p. 24, fig. A; CAT. MAURITSHUIS 1980, pp. 79-80, 208, ill.

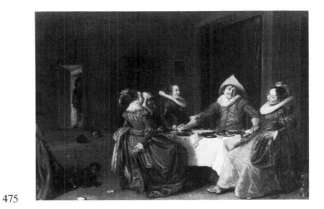

475

Hendrick Gerritsz. Pot | *Gallant company*

Born ca 1585, probably in Haarlem; died 1657 in Amsterdam. Worked in Haarlem and from 1648/50 onwards in Amsterdam. He painted the portrait of the English royal couple in London in 1632.

Panel, 41x56. Signed: *H.P.*
■ purchased in 1883.
● BERNT 1969-70, II, no 933, ill.

764

Hendrik Pothoven | *The main hall of the Binnenhof, The Hague, with the State Lottery Office*

Born 1725 in Amsterdam, died 1795 in The Hague. Pupil of P. van Dijk.

Canvas, 57x65.7. Signed and dated: *HPothoven P Ao 1779*.
■ bequest of J.G. de Groot Jamin, Amsterdam, 1921.
● A. Staring, *Die Haghe* 1923, pp. 98-103, ill.

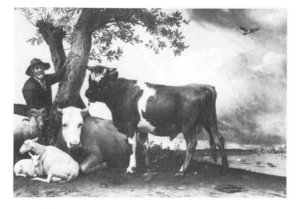

136

Paulus Potter | *The young bull*

Born 1625 in Enkhuizen, died 1654 in Amsterdam. Pupil of his father Pieter and perhaps of N. Moeyaert, both in Amsterdam. Worked in Amsterdam, Delft (1646-1648) and The Hague (1649-1652); then in Amsterdam again.

Canvas, 235.5x339. Signed and dated: *Paulus Potter/F.1647*.
■ Stadholder's Quarter, The Hague, 1763; Cabinet Prince Willem v.
● WESTRHEENE 1867, p. 147, no 6; HOFSTEDE DE GROOT 1907-28, IV, p. 635, no 48; ARPS-AUBERT 1932, pp. 16-18, 36, no 12; MARTIN 1935-36, II, pp. 328-329, fig. 179; MARTIN 1950, p. 32, no 122, ill.; BROCHHAGEN 1958, p. 36; BOL 1969, pp. 227-228; J.J. Susijn, *Maltechnik Restauro* 1973, pp. 44-45; P. ten Doesschate Chu, *French Realism and the Dutch Masters*, Utrecht 1974, p. 27, fig. 27; E.K.J. Reznicek, O.H. 89 (1975), pp. 119-121, fig. 15; DROSSAERS & LUNSINGH SCHEURLEER 1974-76, III, p. 21, no 42, p. 224, no 114; ROSENBERG, SLIVE & KUILE 1977, p. 279, fig. 224; CAT. MAURITSHUIS 1980, pp. 80-84, 209, ill.; ALPERS 1983, p. 19, fig. 8; F. Stella, *The Dutch Savannah*, Amsterdam 1984.

137

■ | *Cows reflected in the water*

Panel, 43.4x61.3. Signed and dated: *Paulus Potter/F.1648*.
■ coll. G. van Slingelandt, The Hague, 1768; Cabinet Prince Willem v.
● WESTRHEENE 1867, p. 148, no 7; HOFSTEDE DE GROOT 1907-28, IV, p. 649, no 81; ARPS-AUBERT 1932, p. 37, no 27; MARTIN 1935-36, I, p. 59, fig. 34; MARTIN 1950, p. 73, no 124, ill.; BERNT 1969-70, II, no 937, ill.; J. Nieuwstraten, O.K. (1971), no 24, ill.; DROSSAERS & LUNSINGH SCHEURLEER 1974-76, III, p. 225, no 115; ROSENBERG, SLIVE & KUILE 1977, p. 280, fig. 225; CAT. MAURITSHUIS 1980, pp. 84-85, 210, ill.

138

■ | *Cattle in the meadow*

Panel, 35.8x46.9. Signed and dated: *Paulus Potter/F.1652*.
■ coll. G. van Slingelandt, The Hague, 1768; Cabinet Prince Willem v.
● WESTRHEENE 1867, p. 149, no 8; HOFSTEDE DE GROOT 1907-28, p. 643, no 70; ARPS-AUBERT 1932, p. 40, no 61; MARTIN 1935-36, I, p. 59, fig. 34; MARTIN 1950, pp. 73-74, no 125, ill.; CAT. MAURTSHUIS 1980, pp. 85, 211, ill.

409

Pieter Symonsz. Potter | *Jacob urging Leah and Rachel to flee from Laban*

Born ca 1597/1600 in Enkhuizen, died 1652 in Amsterdam. Worked in Leiden ca 1628-1630, from 1631 onwards in Amsterdam. Spent some time in The Hague during 1647. He was the father and the first tutor of Paulus Potter.

Panel, 54 ×81.5. Signed and dated: *P.Potter f.1628*.
■ purchased in 1876.

116

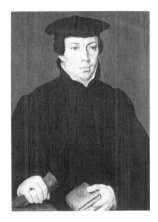

881

Pieter Pourbus | *Portrait of a young cleric*

Born in Gouda 1523/24, went as child to Bruges, died there in 1584. Possibly a pupil of J. Scorel. Probably worked together with L.Blondeel, his father-in-law. Father of Frans Pourbus.

Panel, 42x31. Inscribed: *H C B* (on the book).
■ Rijksmuseum, Amsterdam, inv.no A167; on loan since 1948.
● G. Ring, *Beiträge zur Geschichte niederländischer Bildnismalerei im 15. und 16. Jahrhundert*, Leipzig 1913, pp. 57, 88, 91, 158; CAT. MAURITSHUIS 1968, pp. 12-13, ill.; CAT. RIJKSMUSEUM 1976 p. 688, ill.; *Pieter Pourbus, meester-schilder 1524-1584*, Memlingmuseum, Bruges 1984, pp. 219-220, cat. no 18, fig. 99.
► Formerly attributed to Holbein and identified as Robert Sidney (1562-1626). Attributed to Pourbus by G. Ring (and Friedländer), later called Bruges or Southern Netherlands school. Again attributed to Pourbus.

783

Jan Provoost | *Triptych with Madonna and child, St John the Evangelist* (left wing), *and Mary Magdalene* (right wing)

Born ca 1465, died 1529 in Bruges. Was influenced by Q. Massys.

Panel, 44x31 (middle panel); 49.5x15 (each wing).
■ donated by C. Hoogendijk to the Rijksmuseum, Amsterdam, 1912, inv. no A2570; on loan since 1924.
● R. Bangel, *Cicerone 7* (1915), p. 172; CAT. MAURITSHUIS 1968, pp. 46-47, ill.; FRIEDLÄNDER 1967-76, ixb, p. 111, no 122, pl. 140, 141; CAT. RIJKSMUSEUM 1976, p. 457; BRUSSELS 1977, p. 143, no 304, ill.
► The Madonna was originally seated in a closed recess, which was partly substituted by a landscape later on. Attributed by M. Friedländer to Jan Provoost.

853

■ | *Madonna and child enthroned, with Sts Jerome and John the Baptist and a kneeling Cartnusian monk*

Panel, 75.5x65.
■ donated by C. Hoogendijk to the Rijksmuseum, Amsterdam, 1912, inv. no A2569; on loan since 1948.
● R. Bangel, *Cicerone 7* (1915), p. 172, fig. 2; WINKLER 1924, p. 144; E. Michel, GAZ. B A. 17 (1928), pp. 230-231, ill.; CAT. MAURITSHUIS 1968, p. 46, ill.; FRIEDLÄNDER 1967-76, ixb, p. 116, no 178, pl. 184; CAT. RIJKSMUSEUM 1976, p. 457; E Heller, *Das Altniederländische Stifterbild*, München 1976, no 292.
► Attributed to Jan Provoost by M. Friedländer.

131

Jan Symonsz. Pynas | *Mary and John at the Cross*

Born 1583/84 in Haarlem, died 1631 in Amsterdam. Travelled to Rome with his brother Jacob, and was influenced there by A. Elsheimer. Later influenced by P. Lastman. Worked in Amsterdam.

Panel, 116x84.5. Signed: *JanPijnas*.
■ purchased in 1874; on loan to the Rembrandthuis, Amsterdam, since 1917.
● K. Bauch, O.H. 52 (1935), p. 148; BERNT 1969-70, II, no 953, ill.; A. Tümpel, O.H. 88 (1974), pp. 57-58, fig. 77.

447

Pieter Jansz. Quast | *The Triumph of folly or Brutus playing the fool before King Tarquinius*

Born 1605/06 in Amsterdam, died there in 1647. Influenced by A. Brouwer. Worked in Amsterdam and The Hague.

Panel, 69.5x99. Signed and dated: *PQ1643*.
■ purchased in 1879; on loan to the Theatermuseum, Amsterdam, since 1959.
● A. Bredius, O.H. 20 (1902) ,p. 67; A. Heppner, MAANDBLAD B.K. 14 (1937), pp. 370-379; CAT. WASHINGTON 1980, p. 256, fig. 5; B.A. Stanton-Hirst, O.H. 96 (1982), p. 217, fig. 6.
► Quast probably derived the theme from a 'tableau vivant' written for the Eglantine Chamber of Rhetoric in Amsterdam by P.C. Hooft. A slightly earlier version of the same subject was purchased by the Toneelmuseum, Amsterdam in 1971.

658

■ | *Card players*

Panel, 32.4x33.7 (almost round).
■ purchased in 1901; on loan to the Gemeentemuseum, Arnhem, since 1952.
● A. Bredius, O.H. 20 (1902), pp. 67-68, ill.; W. Schupbach, *Medical History* 22 (1978), p. 277, fig. 7.
► The painting was originally oval and had more figures, as appears from a replica exhibited at the Rotterdamse Kunstkring in 1907.

498

Abraham Raguineau, Copy after | *Portrait of Prince Willem III (1650-1702) at the age of ten*

Born 1623 in London, died after 1681. Worked in The Hague, 's-Hertogenbosch, Leiden and Zierikzee.

Panel, 74x60. Dated: *Ao 1661*. Inscribed: *Aetat:10*.
■ uncertain.
● A. Staring, N.K.J. 3 (1950-51), pp. VI65-170, fig. 7; BRENNINKMEYER-DE ROOIJ 1983, fig. 2.
► Previously catalogued as Dutch school and considered to be a copy after Willem van Honthorst.

339

Raphael (Raffaello Sanzio), Copy after | *The holy family with John the Baptist*

Born 1483 in Urbino, died 1520 in Rome. Pupil of P. Perugino. Worked successively in Urbino, Florence and Rome.

Panel, 32.5x25.
■ purchased by King Willem I for the Mauritshuis with the De Rainer collection, 1821; on loan to the Netherlands Permanent Mission to NATO, Brussels.
► Small copy after a painting by Raphael, called *La Quercia*, in the Prado Museum, Madrid (canvas, 144x110, inv.no 303).

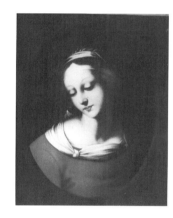

357

■ In style of or after | *Madonna*

Canvas, 49x40.
■ purchased by King Willem I for the Mauritshuis with the Reghellini collection, 1831; on loan to the Raad van State, The Hague, since 1922.
► After Raphael's Bridgewater Madonna, National Gallery of Scotland, lent by the Duke of Sutherland.
Has formerly been attributed to Sassoferrato.

119

Jan Anthonisz. van Ravesteyn | *Portrait of Amalia Elisabeth, Countess of Hanau (1602-1651), wife of Wilhelm V, Count of Hesse Cassel*

Born in The Hague ca 1570, died there in 1657. He was probably a pupil of M.J. van Mierevelt. Worked in The Hague almost all his life.

Panel, 64x56. Dated: *Anno 1617*. Inscribed: *Fil'de Hanau*.
■ Stadholder's Quarter, The Hague 1632; Honselaarsdijk Castle, 1755; sold later; purchased in 1820.
● S.W.A. Drossaers. O.H. 47 (1930), pp. 256-257, fig. 13; DROSSAERS & LUNSINGH SCHEURLEER 1974-76, I, p. 223, no 982, II, p. 508, no 120.
► Date and inscription were probably added later. It is also possible that this is Catharina Belgica (1578-1648), daughter of Prince Willem I of Orange, wife of Ludwig II, Count of Hanau, and the mother of Amalia Elisabeth.

120

■ | *Portrait of Ernestine Yolande, princesse de Ligne (died 1663), wife of Jan van Nassau Siegen*

Panel, 64x54. Inscription added later: *Ernestina, Femme de Conte Ian de Nass...*
■ Stadholder's Quarter, The Hague 1632; Honselaarsdijk Castle 1707; Honselaarsdijk 1755.
● S.W.A. Drossaers, O.H. 47 (1930), pp. 258-259, fig. 14; DROSSAERS & LUNSINGH SCHEURLEER 1974-76, I, p. 224, no 1002, p. 536, no 354, II, p. 508, no 132.

■ | *Series of 25 portraits of officers*

Canvas, all ca 115x95.
■ Honselaarsdijk Castle, 1694 and 1707.
● F.G.L.O. van Kretschmar, *Jaarboek van het Centraal Bureau voor Genealogie*, 1963, p. 3; DROSSAERS & LUNSINGH SCHEURLEER 1974-76, I, p. 455, no 9, p. 532, no 226; THIEL 1981, pp. 183-185, nos 1-7, 14-15, 16, 18, 19, 20-21; SMITH 1982, p. 16.
► Several are signed or bear a monogram. Dates from 1611 to 1624. Not all the portraits are autograph. Probably painted at the order of Prince Maurits.

139

■ | *Portrait of an unknown officer*

Canvas, 116.5x97. Dated: *A.1611*.

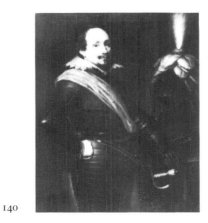

140

■ | *Portrait of an unknown officer*

Canvas, 114.9x93.5. Dated: *An. 1611*.

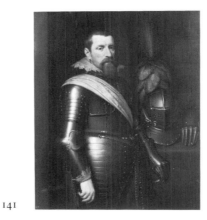

141

■ | *Portrait of an unknown officer*

Canvas, 118x97. Signed and dated: *R.F. An 1611*.

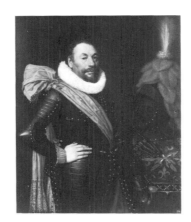

142

■ | *Portrait of an unknown officer*

Canvas, 117x98. Dated: *A: 1616*.

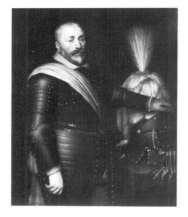

143

■ | *Portrait of an unknown officer*

Canvas, 117.5x96.5. Signed and dated: *R An⁰ 1612.*

415

■ | *Portrait of an unknown officer*

Canvas, 115x96.5. Signed and dated: *Ao:1624 R:F.*

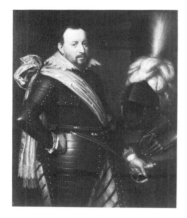

144

■ | *Portrait of an unknown officer*

Canvas, 118x97.5. Signed and dated: *R.F. An 1611.*

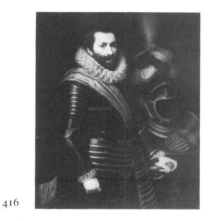

416

■ | *Portrait of an unknown officer*

Canvas, 115x96.5. Signed and dated: *JRavesteijn FA 1611.*

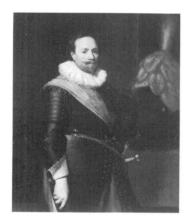

414

■ | *Portrait of an unknown officer*

Canvas, 114.5× 96.5. Dated: *Ao 1621.*

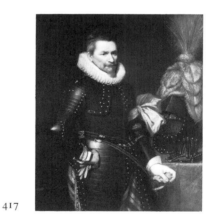

417

■ | *Portrait of an unknown officer*

Canvas, 115x96.5. Signed and dated: *Ao 1615 JR.*

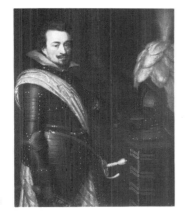

418

■ | *Portrait of Jan III, Count of Nassau Siegen (1583-1638)*

Canvas, 115x97. Signed and dated: *Ano 1611.JVRavesteyn Fecit.*

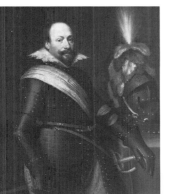

419

■ | *Portrait of Nicolaas Smelsinc (1506/61-1629)*

Canvas, 115x97. Signed and dated: *Ano. 1611 Ravest...*

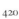

420

■ | *Portrait of Daniel de Hertaing (died 1626)*

Canvas, 114.5x96.5. Dated: *A 1612.*

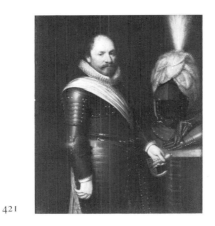

421

■ | *Portrait of an unknown officer*

Canvas, 115.5x94.5. Dated: *Anº 1612.*

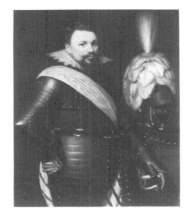

422

■ | *Portrait of an unknown officer*

Canvas, 115x96.5. Signed and dated: *JR Anº 1612 R.F.*

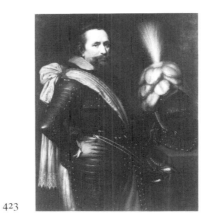

423

■ | *Portrait of an unknown officer*

Canvas, 113x93. Signed and dated: *Anº 1611 JRavesteyn.*

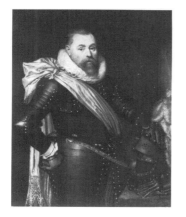

424

◼ | *Portrait of an unknown officer*

Canvas, 114x94. Signed and dated: *JR 1615.*

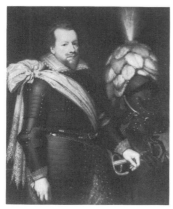

425

◼ | *Portrait of an unknown officer*

Canvas, 114x97. Dated: *An⁰ 1612.*

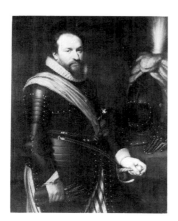

426

◼ | *Portrait of an unknown officer*

Canvas, 114.7x96.5. Signed and dated: *An:1611 RF.*

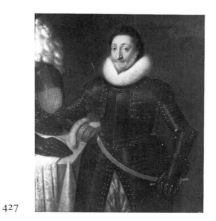

427

◼ | *Portrait of an unknown officer*

Canvas, 117x96.5. Signed and dated: *Aet 40. AO.1613. Fransise de Goltz. fecit.*
▸ There are no futher details available about this assistant of Ravesteyn.

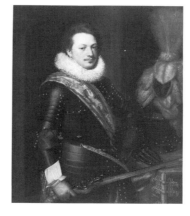

438

◼ | *Portrait of Reinout van Brederode (1597-1618)*

Canvas, 110x92
● PLIETZSCH 1960, p. 165, fig. 292; BERNT 1969-70, no 960, ill.

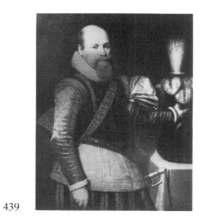

439

◼ | *Portrait of an unknown officer*

Canvas, 110x92.

122

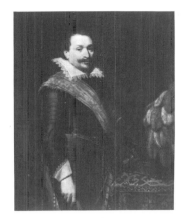

455

■ *Portrait of an unknown officer*

Canvas, 115x97. Dated: *Ao.1621.*

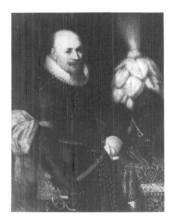

456

■ *Portrait of an unknown officer*

Canvas, 113x90.

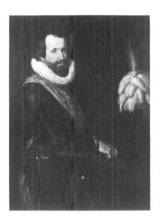

457

■ | *Portrait of an unknown officer*

Canvas, 116x96.5.

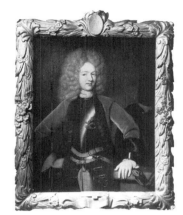

719

Nicolaes van Ravesteyn, | *Portrait of a man, probably a member of the Mackay family*

Born 1661 in Zaltbommel, died there in 1750. Pupil of G. Hoet, W. Doudyn and J. de Baen.

Canvas, 59.2x45.8.
■ bequest of Miss M.J. Singendonck, The Hague, 1907.
▸ Has entered previous catalogues as Dutch school.

304

Nicolas Regnier, In the style of or after | *St Irene nursing St Sebastian*

Born ca 1590 in Maubeuge (north of France), died 1667 in Venice. Pupil of A. Janssens in Antwerp and probably, from 1615, of B. Manfredi in Rome. Worked mostly in Venice.

Canvas, 133.5x164.5.
■ coll. Don Diego Godoy; purchased by King Willem I for the Mauritshuis with the Reghellini collection, 1831.
▸ Cf. different versions of the same subject, attributed to Regnier in the Museum at Rouen (canvas, 1.48x198, inv.no 853-6) and in the Ferens Art Gallery, Kingston-upon-Hull (canvas, 171x210).
Formerly attributed to Caravaggio.

145

Rembrandt Harmensz. van Rijn | *Simeon's song of praise*

Born 1606 in Leiden, died 1669 in Amsterdam. Pupil of J.I. van Swanenburgh, Leiden, and for six months (1623/24?) of P. Lastman, Amsterdam. In Leiden he collaborated with J. Lievens and G. Dou. Had many pupils in Amsterdam.

Panel, 61x48. Signed and dated: *RHL 1631*.
■ Het Loo, 1757; Cabinet Prince Willem v.
● HOFSTEDE DE GROOT 1907-28, vi, p. 48, no 80; BREDIUS 1935, no 543; BAUCH 1966, no 52; GERSON 1968, no 17; DROSSAERS & LUNSINGH SCHEURLEER 1974-76, ii, p. 643, no 88, iii, p. 227, no 129; VRIES 1978, pp. 72-81, no v, ill.; CORPUS 1982, pp. 331-337, no A34, ill.; SCHWARTZ 1984, p. 105, fig. 97.
► When the painting was in the collection of Willem v an arch-shaped piece was added to the top of the panel (now 74x48) to give it the same height as the *Young mother* by G. Dou (inv.no 32). Two small pieces of the original panel were lost at the upper corners when this was done.

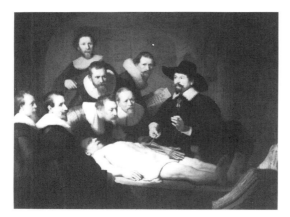

146

■ | *The anatomy lesson of Dr Nicolaas Tulp*

Canvas, 169.5x216.5. Signed and dated: *Rembrandt fe.1632*.
■ purchased in 1828 by King Willem i from the Amsterdam Surgeons' guild.
● HOFSTEDE DE GROOT 1907-28, vi, pp. 387-388, no 932; BREDIUS 1935, no 403; W.S. Heckscher, *Rembrandt's Anatomy of Dr. Nicolaas Tulp*, New York 1958; BAUCH 1966, no 530; GERSON 1968, no 100; E.K.J. Reznicek, O.H. 91 (1977), pp. 80-88, ill.; M.P. Carpentier Alting, O.H. 92 (1978), pp. 43-48; VRIES 1978, pp. 82-113, no vi, ill.; W. Schupbach, *The paradox of Rembrandt's 'Anatomy of Dr. Tulp'*, London 1982; SCHWARTZ 1984, p. 145, fig. 127.
► The date has been done over, as it is blacker in tone than the signature. Each figure carries a number, referring to a list held by one of them (a sketch of a dissected arm was originally on this page). It reads: *1 D Nicl Tulp 2 Jacob Blok 3 Hartman Hartm.. 4 Adriaan Slabr 5 Jacob de Witt 6 Mathijs Kalko.. 7 Jacob Koolveldt 8 Frans van Loenen.*

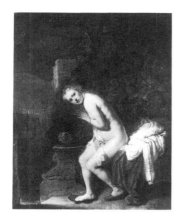

147

■ | *Susanna* (formerly: *Bathseba*)

Panel, 47.2x38.6. Signed and dated: *Rembrant f.f.1636*.
■ coll. G. van Slingelandt, The Hague, 1768; Cabinet Prince Willem v.

● HOFSTEDE DE GROOT 1907-28, vi, p. 37, no 57; BREDIUS 1935, no 505; BAUCH 1966, no 18; GERSON 1968, no 84; VRIES 1978, pp. 121-131, no viii, ill.
C. Eisler in: *Essays on northern European art, presented to E. Haverkamp-Begemann*, Doornspijk 1983, p. 85; K. Jones Hellerstedt, *Source: Notes in History of Art* 2 (1983), pp. 17-20, fig. 1; SCHWARTZ 1984, p. 173, fig. 180.
► A strip of wood, 4 cm wide, has been added to the panel down the righthand side; probably done before 1758.

148

■ | *Portrait of the artist as a young man*

Panel, 37.5x29.
■ coll. G. van Slingelandt, The Hague, 1768; Cabinet Prince Willem v.
● HOFSTEDE DE GROOT 1907-28, vi, p. 237-238, no 544; BREDIUS 1935, no 6; BAUCH 1966, no 295; GERSON 1968, no 39; DE VRIES 1978, pp. 41-47, no I, ill.; CORPUS 1982, pp. 225-230, no A21, ill.; WRIGHT 1982, pp. 17, 39, no 6, pl.14; SCHWARTZ 1984, p. 60, fig. 44.
► The panel is slightly reduced on all four sides. An etching closely resembling this portrait is dated 1629. A preliminary drawing is in the British Museum, London.

149

■ | *Portrait of the artist*

Panel, 62.5x47. Signed: *Rembrandt.f.*
■ coll. G. van Slingelandt, The Hague, 1768; Cabinet Prince Willem v.
● HOFSTEDE DE GROOT 1907-28, vi, p. 238, no 545; BREDIUS 1935, no 24; BAUCH 1966, no 311; GERSON 1968, no 189; VRIES 1978, pp. 114-119, no vii, ill.; WRIGHT 1982, pp. 23-24, 41, no 22, pl. 49; SCHWARTZ 1984, p. 189, fig. 201.

560

■ | *Study of an old man*

Canvas, 80x67.1. Signed and dated: *Rembrandt.f.1650.*
■ purchased in 1891
● HOFSTEDE DE GROOT 1907-28, VI, p. 184, no 384; BREDIUS 1935, no 130; BAUCH 1966, no 400 GERSON 1968, no 304; VRIES 1978, pp. 132-139, no IX, ill.; SCHWARTZ 1984, p. 305, fig. 338.
► Formerly called Rembrandt's brother Adriaen (1597/98-1652/53).

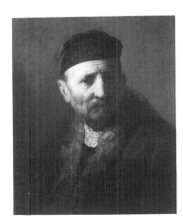

565

■ | *Head of an old man*

Panel, 46.9x38.8.
■ given on loan in 1892; bequest of A. Bredius, 1946.
● HOFSTEDE DE GROOT 1907-28, VI, p. 287, no 676; BREDIUS 1935, no 77; BAUCH 1966, no 116 GERSON 1968, no 36; VRIES 1978, pp. 56-61, no III, ill.; CORPUS 1982, pp. 431-437, noB 7, ill.; SCHWARTZ 1984, p. 64, fig. 56.
► The authors of th Rembrandt Research Project are uncertain whether this is an autograph work; it is linked with Rembrandt's Leiden works around 1630. This painting is commonly called *Rembrandt's father*.

584

■ | *Homer*

Canvas, 108x82.4. Signed and dated: *...andt f.1663*.
■ coll. Don Antonic Ruffo, Messina, 1661, 1663; Ruffo family until 1750; given on loan in 1894; bequest of A. Bredius, 1946.

● HOFSTEDE DE GROOT 1907-28, VI, p. 120, no 217; BREDIUS 1935, no 483; G. Bandmann, *Melancholie und Musik,* Cologne 1969, pp. 11-13; BAUCH 1966, no 244; GERSON 1968, no 371;; VRIES 1978, pp. 166-177, no XII, ill.; ALPERS 1983, p. 227, fig. 170; SCHWARTZ 1984 pp. 303-304, 312, 316, fig. 366, p. 349.
► Cut down right, left and below due to fire damage. The painting originally showed the poet teaching two pupils. A preliminary drawing is in the National Museum, Stockholm. Homer has been painted after the well-known Hellenistic bust, which is mentioned in Rembrandt's inventory of 1656. Commissioned by Marquis Vincenzo Ruffo of Messina (Sicily), as was *Aristotle contemplating the bust of Homer,* now in the Metropolitan Museum, New York.

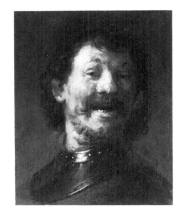

598

■ | *Laughing man*

Copper, covered with gold foil, 15.4x12.2.
■ purchased in 1895.
● HOFSTEDE DE GROOT 1907-28, VI, pp. 236-237, no 543; BREDIUS 1935, no 134; BAUCH 1966, no 113; W. Froentjes, O.H. 84 (1969), pp. 233-237, ill.; VRIES 1978, pp. 48-55, no II, ill.; CORPUS 1982, pp. 427-430, no B6, ill.; SCHWARTZ 1984, p. 62, fig. 49.
► Despite the unusual handling of paint it cannot be accepted with certainty as being original. Falsely considered a self-portrait. Etched in 1633 by J.G. van Vliet.

621

■ | *Saul and David*

Canvas, 130x164.3.
■ given on loan in 1898; bequest of A. Bredius, 1946.
● HOFSTEDE DE GROOT 1907-28, VI, p. 25-26, no 36; BREDIUS 1935, no 526; BAUCH 1966, no 35; I. Schmidt-Dörrenberg, *David und Saul,* Vienna 1969; VRIES 1978, pp. 148-165, no XI, ill.; SCHWARTZ 1984, pp. 321-329, fig. 369; H. Adams, ART BULL. 86 (1984), pp. 427-441.
► During an earlier restoration a section at upper right was renewed. Narrow strips have been added at top and bottom. The attribution is not accepted by all Rembrandt scholars. Lately attributed to Karel van der Pluym by H. Adams.

685

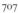 | *Two negroes*

Canvas, 77.8x64.4. Signed and dated: *Rembrandt f 1661.*
■ coll. De Montribloud, Paris, 1784; coll. Lord Berwick, Attingham Hall, Shropshire, England; given on loan in 1903; bequest of A. Bredius, 1946.
● HOFSTEDE DE GROOT 1907-28, VI, p. 166, no 336; BREDIUS 1935, no 310; BAUCH 1966, no 539; GERSON 1968, no 390; VRIES 1978, pp. 140-147, no X, ill.; SCHWARTZ 1984, p. 315, no 365.
▶ Signature and date not authentic. Possibly identical with the painting documented in Rembrandt's inventory of 1656.

707

■ | *Andromeda chained to the rock*

Panel, 34.5x25.
■ coll. Ch.A.M. Count de Proli, Antwerp, 1785; coll. jhr R.L. van den Bosch, Brussels, 1905; given on loan in 1907; bequest of A. Bredius, 1946.
● HOFSTEDE DE GROOT 1907-28, VI, p. 109, no 195; BREDIUS 1935, no 462; BAUCH 1966, no 254; GERSON 1968, no 55; VRIES 1978, pp. 62-71, no IV, ill.; CORPUS 1982, pp. 309-314, no A31, ill.; SCHWARTZ 1984, pp. 119-120, fig. 111.

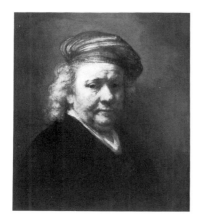

840

■ | *Portrait of the artist as an old man*

Canvas, 63.5x57.8. Signed and dated: *Rembrandt f.1669.*

■ coll. M. Kappel, Berlin, 1912; coll. E.G. Rathenau, Berlin, New York; purchased with the aid of the Rembrandt Society and friends of the museum, 1947.
● HOFSTEDE DE GROOT 1907-28, VI, pp. 230-231, no 527; BREDIUS 1935, no 62; BAUCH 1966, no 342; GERSON 1968, no 420; CAT. MAURITSHUIS 1970, no 29, ill.; VRIES 1978, pp. 178-187, no XIII, ill.; WRIGHT 1982, pp. 34, 45, no 58, pl.97; SCHWARTZ 1984, p. 354, fig. 421.
▶ The signature may have been redrawn. Another self-portrait from 1669 in the National Gallery, London.

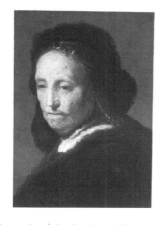

556

■ Copy after | *Study of an old woman*

Panel, 18.2x14.
■ given on loan in 1890; bequest of A. Bredius, 1946.
● HOFSTEDE DE GROOT 1907-28, VI, p. 290, no 686; BREDIUS 1935, no 67; VRIES 1978, pp. 188-193, no I, ill.; CORPUS 1982, pp. 662-666, no C41, ill.
▶ One of the numerous copies of a lost original that probably dated from 1631. This painting is commonly called *Rembrandt's mother*.

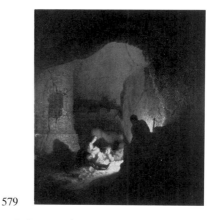

579

■ Imitator of | *Travellers resting*

Paper stuck on panel, 38x33.7. Signed: *Rembrandt. f.*
■ purchased in 1894.
● HOFSTEDE DE GROOT 1907-28, VI, p. 55, no 89; BREDIUS 1935, no 556; BAUCH 1966, no 50; VRIES 1978, pp. 200-203, no 3, ill.; CORPUS 1982, pp. 519-523, no C12, ill.
▶ An imitation dating from before 1745 and attributable to the same hand as *A man reading in a lofty room*, National Gallery, London.

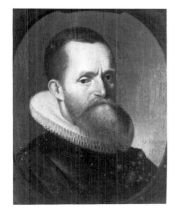

608

Jacob de Reyger | *Portrait of a man*

Born in Amsterdam, died ca 1645 in England.

Panel, 21.8x19. Signed: *J.D. Reijger.f.*
■ purchased in 1897.

280

Johann Heinrich Roos | *Italian landscape*

Born 1631 in Reipoltskirchen (Palatinate); died 1685 in Frankfurt. Pupil of G. du Jardin, C. de Bie and B. Graat, Amsterdam. After many travels he settled in Frankfurt (1667).

Canvas, 64x53. Signed and dated: *J.H. Roos fecit 1670.*
■ Leeuwarden Palace; Cabinet Prince Willem v.
● H. Jedding, *Der Tiermaler Johann Heinrich Roos*, Strassburg 1955, p. 220, no 67; DROSSAERS & LUNSINGH SCHEURLEER 1974-76, III, p. 228, no 134.

150

Johannes Rosenhagen | *Still life with fruit*

Dates unknown. Worked in The Hague around the middle of the 17th century.

Canvas, 55x70. Signed: *Johannes.Rosenhagen.f.*
■ purchased in 1873.

● D.F. Lunsingh Scheurleer. ANTIEK 6 (1971-72), pp. 40-42, fig. 6.

284

Hans Rottenhammer *The fall of Phaeton*

Born 1564 in Munich, died 1624 in Augsburg. Pupil of his father Thomas, and from 1582 of J. Donauer, Munich. Influenced later in Rome by the work of Michelangelo and in Venice by that of Tintoretto. Worked in conjunction with J. Brueghel the Elder.

Copper, 39x54.1. Signed and dated: *1604 Hns.Rotteh.F.*
■ coll. G. van Slingelandt, The Hague, 1768; Cabinet Prince Willem v.
● R.A. Peltzer, J. KUNSTH. SAMML. A.K. 33 (1916), pp. 322-324, 330, 345, no 30, fig. 16; CAT. MAURITSHUIS 1968, p. 47, ill.; G. Dogaer, JAARBOEK ANTWERPEN 1971. p. 215, no 138; DROSSAERS & LUNSINGH SCHEURLEER 1974-76, III, p. 228, no 135.

281

■ Attributed to | *The encounter of David and Abigail*

Canvas, 165x203.
■ Het Loo, 1757; Nationale Konst-Gallery, The Hague.
● R.A. Peltzer, J. KUNSTH. SAMML. A.K. 33 (1916), p. 354, no 22 (perhaps H. van Balen); DROSSAERS & LUNSINGH SCHEURLEER 1974-76, II, p. 640, no 21; THIEL 1981, p. 183, no 8, ill.
▶ Painted possibly with the help of H. van Balen or J. Brueghel.

282

■ Attributed to | *The baptism of the chamberlain of the Queen of Candace*

Panel, 160x194.
■ Het Loo, 1757; Nationale Konst-Gallery, The Hague.
● R.A. Peltzer, J. KUNSTH. SAMML. A.K. 33 (1916), p. 354, no 21 (perhaps H. van Balen); I. Jost, N.K.J. 14 (1963), p. 122 (as H. van Balen); DROSSAERS & LUNSINGH SCHEURLEER 1974-76, II, p. 640, no 28; THIEL 1981, p. 183, no 9, ill.
► Painted possibly with the help of H. van Balen or J. Brueghel the Elder.

250

Peter Paul Rubens | *Portrait of a young woman* (formerly: *Portrait of Isabella Brant (1591-1626)*)

Born 1577 in Siegen, died 1640 in Antwerp. Pupil of T. Verhaecht, A. van Noort and O. van Veen. Travelled in Italy and Spain from 1600 to 1608; then worked in Antwerp. Court painter to Archduke Albert; also worked frequently for Maria de' Medici in Paris. Went on diplomatic missions to Spain and England between 1628 and 1630 for Archduchess Isabella. Rubens had many pupils and assistants.

Panel, 97x67.8.
■ coll. G. van Slingelandt, The Hague, 1768; Cabinet Prince Willem V.
● OLDENBOURG 1921, p. 442; H. Vlieghe, *The Ringling Museum of Art Journal* 1983, p. 106, fig. 3; J. Müller Hofstede, *Pantheon* 51 (1983), p. 318, fig. 22.
► Possibly not entirely autograph. Other versions do exist, including one in the Wallace Collection, London.

251

■ | *Portrait of Helena Fourment (1614-1673), the artist's second wife*

Panel, 98x76.
■ coll. G. van Slingelandt, The Hague, 1768; Cabinet Prince Willem V.
● OLDENBOURG 1921, p. 436.
► According to C. Müller Hofstede (verbal communication, 1977) the portrait is autograph. Strips have been added below and at left and right.

252

■ | *Portrait of Michael Ophovius (1570-1637), bishop of 's-Hertogenbosch*

Canvas, 111.5x82.5.
■ purchased in 1882.
● OLDENBOURGH 1921, p. 167; *Het Beleg van 's-Hertogenbosch in 1629*, Noord-brabants Museum, 's-Hertogenbosch 1979, pp. 57-58, no 14, ill.; H. Vlieghe, *Corpus Rubenianum L. Burckhard: part XIX: portraits*, II, forthcoming, London 1986, no 126.
► Rubens' friend and, according to tradition, his confessor. A variant in the collection of E. Dulière, Brussels. An old-age portrait in the Bishop's Palace, 's-Hertogenbosch.

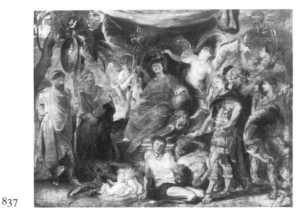

837

■ | *The triumph of Rome: The youthful Emperor Constantine honouring Rome*

Panel, 54x69.
■ coll. Sir H. Cook, Richmond, 1932; donated by B. and N. Katz, Dieren and Basel, 1947.

● OLDENBOURGH 1921, p. 233; L. van Puyvelde, *Die Skizzen des P.P. Rubens*, Frankfurt 1939, p. 32, no 7; ROTTERDAM 1953, p. 63, no 41, fig. 40; J.S. Held, ART BULL. 90 (1958), p. 147, fig. 6; CAT. MAURITSHUIS 1970, no 9, ill.; HELD 1980, I, pp. 65, 84-85, no 51, II, pl.52.
► Sketch for one of the twelve tapestries with scenes from the life of Constantine commissioned by King Louis XIII of France. This scene was never woven into a tapestry; in the end it was replaced by a depiction of the Death of Constantine.

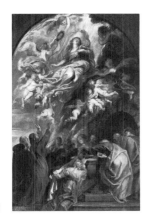

926

■ | *The assumption of the Virgin*

Panel, 90x61.
■ coll. John Webb, London, 1821; coll. Col. T. Davies, London; kunsth. Rosenberg and Stiebel, New York; purchased in 1956.
● ROTTERDAM 1953, p. 71, no 51, fig. 47; J.S. Held, *Les Arts Plastiques*, VI, 1953, p. 114, ill.; CAT. MAURITSHUIS 1970, no 10, ill.; F. Baudouin in: J.R. Martin, *Rubens before 1620*, Princeton 1972, p. 71, note 50; C. van de Velde, JAARBOEK ANTWERPEN 1975, pp. 270-271, fig. 10; HELD 1980, I, pp. 513-514, no 377, fig. 19, II, pl.368.
► This modello, made between 1619-1622, provided the basis for the final formulation of the Assumption of the Virgin to be placed on the high altar of Antwerp Cathedral in 1626.

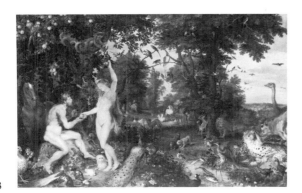

253

■ + Jan Brueghel the Elder | *Adam and Eve in Paradise*

Panel, 74x114. Signed: *Petri Pavli Rvbens...Figr;IBrveghel fec.*
■ coll. P. de la Court van der Voort, Leiden, 1766; Cabinet Prince Willem v.
● OLDENBOURG 1921 p. 219; M.L. Hairs, REVUE BELGE 63 (1957), p. 149; L. van Puyvelde, GAZ. B.A. 63 (1964), p. 94; F.W.S. van Thienen, O.K. 11 (1967), no.21, ill.; ERTZ 1979, pp. 236, 245-246, fig. 317, pp. 391, 608, no 308.
► The two figures are by Rubens, the landscape and the animals by Jan Brueghel the Elder; ca 1615. There is a drawing for Adam and Eve in Museum Boymans-van Beuningen, Rotterdam.

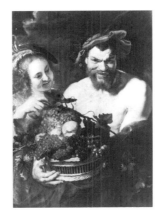

246

■ Copy after | *Faun and nymph*

Panel, 108x78.
■ donated by jhr J.L. Cremer van den Bergh, Heemstede, 1844.
● compare OLDENBOURGH 1921, p. 442.
► Later, free copy after Rubens; many other examples exist. The version in the Dresden museum may well be the original.

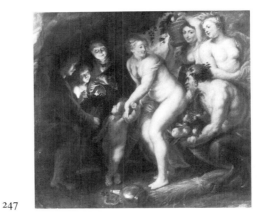

247

■ Copy after | *Sine Cerere et Baccho friget Venus* (Without Ceres and Bacchus Venus grows cold)

Canvas, 183x205.
■ Het Loo 1757 (?); Nationale Konst-Gallery, The Hague.
● MOES & BIEMA 1909, p. 215; compare OLDENBOURGH 1921, p. 137; D.P. Snoep, O.H. 84 (1969), p. 288, fig. 7; DROSSAERS & LUNSINGH SCHEURLEER 1974-76, II, p. 641, no 42.
► The original is in the Brussels museum; in Brussels the left section was replaced at a later date by Vulcan at his forge. The original left section (old woman and two children with hot coals) is in the Dresden museum. Several other copies of the original composition exist.

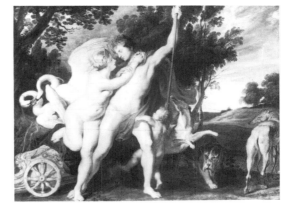

254

■ Copy after | *Venus attempting to hold back Adonis from the hunt*

Panel, 59x81.
■ coll. G. van Slingelandt, The Hague, 1768; Cabinet Prince Willem v.

• compare OLDENBOURG 1921, p. 29; DROSSAERS & LUNSINGH SCHEURLEER 1974-75, III, p. 227, no 124.
▸ Weak, free copy after Rubens; Rubens derived this subject from Titian (Prado, Madrid) and treated it in several compositions. There are three versions with a claim to be by his hand: Berlin (Kaiser-Friedrich-Museum; burnt in 1945), Düsseldorf museum, the Hermitage, Leningrad. The replica in the Mauritshuis resembles the Leningrad version; there is an almost similar replica in the Dresden museum.

155

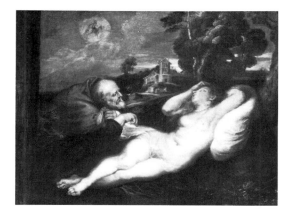

255

■ Copy after | *Angelica spied upon by the hermit*

Panel, 42*x*56.
■ purchased with the De Rainer collection, 1821.
• compare OLDENBOURG 1921, p. 220.
▸ Scene from *Orlando furioso* by Ariosto. Next to the hermit is a devil; in the sky Ruggero rides a winged horse. Weak, free copy after Rubens; many others exist. The original is in Vienna, Kunsthistorisches Museum.

■ | *View of Haarlem with bleaching grounds* (formerly: *View of Haarlem from the dunes at Overveen*)

Canvas, 55.5*x*62. Signed: *JvRuisdael*
■ purchased in 1827.
• HOFSTEDE DE GROOT 1907-28, IV, p. 25, no 65; ROSENBERG 1928, p. 75, no 48; MARTIN 1935-36, II, p. 297, fig. 159; MARTIN 1950, p. 66, no 86, ill.; STECHOW 1966, p. 47; CAT. THYSSEN-BORNEMISZA 1969, p. 341; S. Slive, ALB. AMIC. VAN GELDER 1973, pp. 274-276; R.H. Fuchs, *Tijdschrift voor geschiedenis 86* (1973), pp. 281-292, fig. 3, 4; J.D. Burke, QUART. MONTREAL 6 (1974), pp. 3-11; CAT. MAURITSHUIS 1980, pp. 90-92, 215, ill.; THE HAGUE 1981-82, pp. 127-129, no 44, ill.
▸ Other 'Haarlempjes' in Ruzicka-Stiftung, Zürich; Rijksmuseum, Amsterdam; Staatliche Museen, Berlin.

153

Jacob Isaackz. van Ruisdael | *Waterfall*

Born ca 1628/29 in Haarlem, died 1682 in Amsterdam. He was probably the pupil of his uncle S. van Ruysdael; also influenced by C. Vroom. Ca 1650 he visited Bentheim (Germany), possibly in company with C.P. Berchem. Worked in Haarlem, and from ca 1656 in Amsterdam.

Canvas, 69*x*53.3. Signed: *JvRuisdael*.
■ purchased for the Nationale Konst-Gallery, 1802; acquired through exchange with the Rijksmuseum, Amsterdam, 1825.
• HOFSTEDE DE GROOT 1907-28, IV, p. 72, no 225; ROSENBERG 1928, p. 82, no 164; CAT. MAURITSHUIS 1980, pp. 88-89, 213, ill.

534

■ | *View of the Vijverberg, The Hague*

Canvas, 62.5*x*80.5. Signed: *vR*.
■ purchased in 1886.
• HOFSTEDE DE GROOT 1907-28, IV, p. 22, no 54; ROSENBERG 1928, p. 74, no 36.
▸ A late, weak work.

728

■ | *Twilight*

Panel, 29.7x37.3. Signed and dated: *vRuisdael/164.* (the last numeral is read as 5, 6 or 8).
■ donated by C. Hofstede de Groot, 1909.
● HOFSTEDE DE GROOT 1907-28, IV, pp. 181-182, no 614; ROSENBERG 1928, p. 90, no 296, fig. 25; BCL 1969, p. 201; KEYES 1975, I, pp. 99, 140, note 70; CAT. MAURITSHUIS 1930, pp. 87-88, 212, ill.
► The foliage and cloudy sky show the influence of C. Vroom.

802

■ | *Winter landscape*

Canvas, 37.3x32.5. Signed: *JvRuisdael.*
■ donated by Princess J. de Croy, born De Lespinay, Paris, 1931.
● CAT. MAURITSHUIS 1980, pp. 89, 214, ill.

803

■ | *View of the Damrak, Amsterdam*

Canvas, 46.8x43. Signed: *v Ruisdael.*
■ donated by Princess J. de Croy, born De Lespinay, Paris, 1931.
● HOFSTEDE DE GROOT 1907-28, IV, p. 13, no 18; MARTIN 1950, p. 106, no 275, ill.; STECHOW 1966, p. 128; THE HAGUE 1981-82, p. 153.

154

■ Copy after | *Beach view*

Canvas, 53x64.5.

■ acquired through exchange with the Rijksmuseum, Amsterdam, 1825.
● HOFSTEDE DE GROOT 1907-28, IV, p. 275, no 924; ROSENBERG 1928, p. 65, fig. 143, p. 107 (under no 566); CAT. MAURITSHUIS 1980, pp. 92-93, 216, ill.
► Comparison with authentic beach views by Ruisdael clearly shows this to be a copy. A related painting in the Hermitage, Leningrad, should probably be regarded as the model for our picture. Has been attributed to J. van Kessel by J. Rosenberg.

151

Rachel Ruysch | *Flowers*

Born 1664 in Amsterdam, died there in 1750. Pupil of W. van Aelst. She married the portrait painter J. Pool. Worked in Amsterdam. temporarily in The Hague (1701) and in Düsseldorf (1708-1716) where she was court painter to the Elector Palatine.

Canvas, 79.5x60.2. Signed and dated: *Rachel Ruysch F:1700.*
■ purchased in 1826.
● HOFSTEDE DE GROOT 1907-28, X, p. 328, no 22A; M.H. Grant, *Rachel Ruysch*, Leigh-on-Sea 1956, p. 30, no 57, pl. 22.

699

Salomon van Ruysdael | *River view*

Born ca 1600/02 in Naarden, died 1670 in Haarlem. Influenced by E. van de Velde, Haarlem. There are many parallels between his early style and that of J. van Goyen, Leiden. Worked in Haarlem. Uncle of J. van Ruisdael, who was probably his pupil.

Panel, 47.3x69. Signed and dated: *SVR 16..*
■ purchased in 1905.
● STECHOW 1975, p. 131, no 398; CAT. MAURITSHUIS 1980, pp. 97-98, 219, ill.
► The date most probably is: 1648.

738

■ | *River view with church*

Panel, 75x106.5. Signed and dated: *SVRuysdael 164..*
■ given on loan in 1912; bequest of A. Bredius, 1946.
● PRESTON 1937, fig. 30; KEYES 1975, I, pp. 86, 138; STECHOW 1975, p. 124,
no 361, fig. 32; CAT. MAURITSHUIS 1980, pp. 96-97, 218, ill.

941

■ | *River-bank with old trees* (formerly: *Waterside with old trees*)

Panel, 32.8x51.3. Signed and dated: *S VR 1633.*
■ coll. Earl of Mar and Kellie, Alloa House, Schotland, 1960; kunsth. P. de
Boer, Amsterdam; purchased by the Johan Maurits van Nassau Foundation
and given on loan, 1960.
● CAT. MAURITSHUIS 1970, no 18, fig.; STECHOW 1975, p. 146, no 498-A, fig.
16; CAT. MAURITSHUIS 1980, pp. 95-96, 217, ill.

1044

■ | *View of a river with ships*

Panel, 36.4x31.7.
■ coll. C.T.F. Thurkow, The Hague; on permanent loan since 1972; bequest in
1987.
● BOL 1973, p. 152; STECHOW 1975, p. 76, no 46; CAT. MAURITSHUIS 1980, pp. 98,
220, ill.

566

■ Circle of | *The bridge*

Panel, 36x40.5. Formerly signed: *S. Ruysdael.*
■ purchased in 1892.
● STECHOW 1975, p. 143, no 481; CAT. MAURITSHUIS 1980, pp. 98-99, 221, ill.

929

François Ryckhals | *Sleeping boy in a shed*

Born 1600/05 in Middelburg, died there in 1647. Joined the Dordrecht guild
in 1633/34. Worked in Middelburg.

Panel, 36.3x32.2. Signed and dated: *FSRHALS 1640.*
■ coll. V. Bloch, The Hague; purchased in 1957.
● CAT. MAURITSHUIS 1970, no 37, ill.; BOL 1982, p. 23, fig. 6.

888

Pieter Jansz. Saenredam | *The interior of the Church of St Cunera, Rhenen*

Born 1597 in Assendelft, died 1665 in Haarlem. Son of the engraver Jan
Pietersz. Saenredam. Pupil of F.P. de Grebber, Haarlem. He was in contact
with the architect J. van Campen. Was one of the first architectural painters
to reproduce buildings with fidelity.

Panel, 50x68.8. Signed and dated: *reensche kerck / Pieter Saenredam dit met
schilderen volleijnt den / 30 april 1655* (Pieter Saenredam completed this
painting of Rhenen Church on 30 April 1655).

■ coll. C. von Aretin Haidenburg Castle, Munich, 1887; Museum Ferdinandeum, Innsbruck, 1928; kunsth. W. Feilchenfeldt, Zürich; purchased with the aid of the Rembrandt Society, 1951.
● E. Jacobsen, O.H. 15 (1897), pp. 217-218, ill.; SWILLENS 1935, pp. 17, 32, 124, no 200, fig. 125; PLIETZSCH 1960, pp. 120-121, fig. 205; UTRECHT 1961, pp. 160-161, no 107; CAT. MAURITSHUIS 1970, no 20, ill.; JANTZEN 1979, p. 233, no 415; E. Jane Connell, *Rutgers Art Review* I (1980), pp. 33-34.
► Several figures added later were removed during restoration in 1938. A preliminary drawing dated 1644 used to be in coll. jhr Six van Wimmenun, Laren.

974

■ | *The exterior of the Church of Our Lady on the Mariaplaats in Utrecht*

Panel, 44x63. Signed and dated: *Pr Saenredam fecit Ao 1659* $\frac{11}{20}$ Inscribed: *De St. Maria kerck to' Utrecht.*
■ coll. J.W. Nienhuys, Aerdenhout; purchased with the aid of the Rembrandt Society, the Prins Bernhard Fund, the Stichting Openbaar Kunstbezit and the Johan Maurits van Nassau Foundation, 1966.
● SWILLENS 1935, pp. 35, 126-127, no 207 fig. 130; PLIETZSCH 1960, p. 123; UTRECHT 1961, pp. 210-211, no 147, fig. 128; G. Schwartz, SIMIOLUS I (1966-67), pp. 69-93, note 25; CAT. MAURITSHUIS 1970, no 21, ill.
► A preliminary drawing dated 1636 is in the municipal archives in Utrecht.

538

Cornelis Saftleven | *Landscape with shepherds and cattle*

Born 1607 in Gorkum, died 1681 in Rotterdam. Influenced by the work of A. Brouwer, D. Teniers and probably E. van der Poel. His brothers Herman and Abraham were also painters.

Panel, 36.3x49.5. Signed and dated: *1660. C. Saftleven.*
■ purchased in 1887.
● BERNT 1969-70, III, no 1021, ill.; W. Schulz, *Cornelis Saftleven*, Berlin/New York 1978, p. 212, no 583; CAT. MAURITSHUIS 1980, pp. 99-100, 222, ill.

Giovanni Battista Salvi, see *Sassoferrato.*

Raphaello Santi, see *Raphael.*

336

Sassoferrato (Giovanni Battista Salvi) | *The Madonna praying*

Born 1605 in Sassoferrato, died 1685 in Rome. Pupil of his father Tarquinio.

Canvas, 48x36.5.
■ purchased by King Willem I for the Mauritshuis with the De Rainer collection, 1821; on loan to the Rijksmuseum, Amsterdam (inv.no C1370), since 1948.
► There is a replica in the Galleria Colonna, Rome (canvas. 67x47).

156

Jacob Savery the Elder | *The St Sebastian Day fair*

Born ca 1545 in Courtrai, died 1602 in Amsterdam. Probably pupil of H. Bol. Brother of the painter Roelandt. Worked mostly in Amsterdam.

Panel, 41.5x62. Signed: *Jaqs Savery.*
■ donated by A.A. des Tombe, The Hague, 1874.
● CAT. MAURITSHUIS 1968, p. 48, ill.; FRANZ 1969, p. 296, fig. 471.

157

Roelandt Savery *Orpheus enchanting the animals with his music*

Born 1576 in Courtrai, died 1639 in Utrecht. Pupil of his brother Jacob, probably in Amsterdam. Worked for Emperor Rudolf II.

Panel, 62x131.5. Signed: *Roelandt S.* Inscribed on the verso: *Ein stick von Serwie.N.18.*
■ Stadholder's Quarter, The Hague, 1632; Oranienstein Castle, 1726; Cabinet Prince Willem V.
● K. Erasmus, *Roelant Savery.* Halle a.S. 1908, p. 89, no 64: DROSSAERS & LUNSINGH SCHEURLEER 1974-76, I, p. 192, no 237, II, p. 372. no 348, III, p. 240, no 189.
► According to Erasmus the painting dates from about 1626

133

800

Cornelis Symonsz. van der Schalcke | *Slaughtered pig in a moon lit landscape*

Born 1611 in Haarlem, died there in 1671. At first influenced by A. and I. van Ostade. His later work is in the manner of J. van Goyen and P. Molijn.

Panel, 34x33. Signed and dated: *CS VD Schalck 1644.*
■ donated by C.W. Matthes, Breukelen, 1929.
● I.Q. van Regteren Altena, o.h. 43 (1926), p. 52; cat. mauritshuis 1980, pp. 100-101, 223, ill.

158

Godfried Schalcken | *Portrait of Stadholder-King Willem III (1650-1702)*

Born 1643 in Made near Dordrecht, died 1706 in The Hague. According to Houbraken he was a pupil of S. van Hoogstraten, Dordrecht, and of G. Dou, Leiden. Worked in Dordrecht. Travelled to London in 1692-1697; during this stay he painted several portraits of William III. Lived in The Hague from 1691 onwards. Spent a short time in Düsseldorf in 1703 at the court of the Elector Palatine.

Canvas, 163.7x149.7. Signed and dated: *G. Schalcken.1699.*
■ Nationale Konst-Gallery, The Hague; on loan to the Gemeentemuseum, The Hague, since 1952.
● hofstede de groot 1907-28, v, pp. 415-416, no 333; A. Staring, n.k.j. 3 (1950-51), p. 187; thiel 1981, p. 189, no 38, ill.

159

■ | *Lady in front of the mirror by candlelight*

Canvas, 76x64. Signed: *G.S.h.ecken.*
■ Cabinet Prince Willem v.
● hofstede de groot 1907-28, v, p. 393, no 235; E. de Jongh, simiolus 8 (1975-76), p. 83, fig. 13.

160

■ | *The wasted lesson in morals*

Panel, 35x28.5. Signed: *G. Schalcken.*
■ Het Loo, 1757; Cabinet Prince Willem v.
● hofstede de groot 1907-28, v, p. 349, no 92; jongh 1967, p. 42, fig. 23; drossaers & lunsingh scheurleer 1974-76, ii, p. 644, no 104, iii, p. 230, no 145; J. Becker, o.h. 90 (1976), p. 84, fig. 7; amsterdam 1976, pp. 226-227, no 58, ill.; P. Hecht, simiolus 11 (1980), p. 36, fig. 14; durantini 1983, p. 262.
► Companion piece to no 161.

161

■ | *The medical examination*

Panel, 35x28.5. Signed: *G. Schalcken.*
■ Het Loo, 1757; Cabinet Prince Willem v.
● hofstede de groot 1907-28, v, p. 364, no 144; drossaers & lunsingh scheurleer 1974-76, ii, p. 644, no 105, iii, p. 230, no 146; amsterdam 1976, pp. 226-227, no 59.
► Companion piece to no 160.

162

■ | *Young woman and pigeons*

Panel, 21.5x17.
■ coll. G. van Slingelandt, The Hague, 1768; Cabinet Prince Willem V.
● HOFSTEDE DE GROOT 1907-28, V, p. 346, no 80; DROSSAERS & LUNSINGH SCHEURLEER 1974-76, III, p. 230, no 147.

708

■ | *Portrait of Mr Diederick Hoeufft (1648-1719)*

Copper, 43x34. Signed: *G. Schalcken.*
■ bequest of Miss M.J. Singendonck, The Hague, 1907.
● HOFSTEDE DE GROOT 1907-28, V, p. 411, no 308.
▸ Son of Diederick Hoeufft (1610-1688); see ANONYMOUS, Dutch School, inv.no 710.
▸ Companion piece to no 709.

709

■ | *Portrait of Isabella Agneta Deutz (1658-1696), wife of Diederick Hoeufft*

Copper, 43x34. Signed: *G. Schalcken.*
■ bequest of Miss M.J. Singendonck, The Hague, 1907.
● HOFSTEDE DE GROOT 1907-28, V, p. 411, no 309.
▸ Companion piece to no 708.

669

Hendrik Willem Schweickhardt | *Vegetable seller*

Born 1746 in Hamm (mark Brandenburg), died 1797 in London. Probably pupil of G. Lapis, The Hague. Worked in The Hague and London.

Panel, 32x42.5. Signed: *W. Schweickhardt.*
■ bequest of A.A. des Tombe, The Hague, 1903.
● E.J. Sluijter, O.H. 89 (1975), p. 172, fig. 45.

1033

Hercules Pietersz. Segers | *River valley*

Born 1589/90 in Haarlem, died in or after 1633. Probably pupil of G. van Coninxloo, Amsterdam. Joined the Haarlem guild in 1612. Lived in Amsterdam from 1614 till 1631, thereafter in Utrecht and probably in The Hague around 1632/33.

Panel, 22.5x53. Signed: *hercules segers.*
■ coll. E.M.L. Kessler-Stoop, IJmuiden, 1926; purchased with the aid of the Rembrandt Society, the Prins Bernard Fund, the Royal Dutch Foundries and Steel Mills Ltd, IJmuiden and the Johan Maurits van Nassau Foundation, 1969.
● J. van Gelder, O.H. 68 (1953), pp. 149-151, fig. 1, 2; L.C. Collins, *Hercules Seghers*, Chicago 1953, pp. 84, 133, fig. 106; *Hercules Seghers*, Museum Boymans- van Beuningen, Rotterdam 1954, no 2, ill.; E. Haverkamp-Begemann, *Hercules Seghers*, Amsterdam 1968, pp. 11, 13; CAT. MAURITSHUIS 1970, no 28, ill.; CAT. MAURITSHUIS 1980, pp. 101-103, 224, ill.; J.P. Filedt Kok, BULL. R.M. 30 (1982), pp. 173, 176, fig 4, note 15.
▸ It is related in style and partly in composition to the landscape in the Rijksmuseum, Amsterdam, inv.no A3120. The same scene appears in mirror image in an etching.

256

Daniel Seghers | *Garland of flowers around an image of the Madonna*

Born 1590 in Antwerp, died there in 1661. Pupil of J. Brueghel the Elder. Entered the Jesuit order in 1614 as a lay brother and later visited Rome. His paintings were much sought after. Many artists, including Rubens and A. van Dyck collaborated with him.

Canvas, 151x122.7. Signed and dated: *D. Seghers.Soctis Jesu 1645*.
■ probably from Huis ten Bosch, 1654 and 1707; added to the Mauritshuis collection after 1817.
● HAIRS 1955, pp. 56, 65, 236, fig. 23; W. Couvreur, *Gentse Bijdragen* 20 (1967), p. 104 (as no 92 of the inv.); Th.H. Lunsingh Scheurleer, O.H. 84 (1969), pp. 41, 51-52, fig. 14, 15; DROSSAERS & LUNSINGH SCHEURLEER 1974-76, I, p. 281, no 1179, no 19.
► The Madonna was painted by Thomas Willeboirts Bosschaert.

257

■ | *Garland of flowers around the portrait of Stadholder-King William III (1650-1702)*

Canvas, 122.5x107. Signed: *D. Seghers. Soctis Jesv*.
■ transferred from the house of Constantijn Huygens to the Mauritshuis in 1842.
● HAIRS 1955, p. 66; BRENNINKMEYER-DE ROOIJ 1983, fig. 7.

269

Jacob Seisenegger | *Portrait of Elisabeth of Austria (1526-1545) at the age of four*

Born 1505 in Austria, died 1567 in Linz. Court painter to Ferdinand I from 1531. He painted the portrait of Charles V in Bologna in 1532, at the same time as Titian, whose style he later followed. He was in Belgium and Spain between 1535 and 1545. He settled in Linz about 1558.

Panel, 43.4x34.4. Signed: *IS*. Inscribed: *Elisabet. Ferdinandi. Hvngarie. Et. Bohemie. Regis. Filia. Anno. 1.5.30. Etatis. sve. 4*.
■ purchased with the De Rainer collection, 1821.
● G. Glück, J. KUNSTH. SAMML. WIEN 8 (1934), p. 179; K. Löcher, *Jacob Seisenegger*, München/Berlin 1962, pp. 18-20, no 20, fig. 6; CAT. MAURITSHUIS 1968, pp. 48-50, ill.; OSTEN & VEY 1969, p. 214.
► Seisenegger painted the portraits of Ferdinand's four children during the Diet of Augsburg, 1530. From 1521 Ferdinand had governed the Austrian possessions on behalf of his brother Charles V. From 1526 on he was King of Bohemia and Hungary and from 1531 on King of Germany. He was also Holy Roman Emperor from 1558 on. The portrait of the youngest son Ferdinand is lost.

270

■ | *Portrait of Anna of Austria (1528-1590) at the age of two*

Panel, 43.5x34.5. Signed: *IS*. Inscribed: *Anna. Ferdinandi. Hvngarie. Et. Bohemie. Regis. Filia. Anno. 1.5.30. Etatis. Sve. 2*.
■ See no 269.
● See no 269.
► See note to no 269.

271

■ | *Portrait of Maximilian of Austria (1527-1576) at the age of three*

Panel, 42.8x34. Signed: *IS*. Insribed: *Maximilianvs. Ferdinandi. Hvngarie. Et. Bohemie. Regis. Filivs. Primo. Genitvs. Anno 1.5.30 Etatis. Sve. 3*.
■ See no 269.
● See no 269.
► See note to no 269.

832

Michiel Sittow | *Portrait of a man*

Born probably 1469 in Revel (Tallinn in Estonia), died there in 1525. Also known as Master Michiel or Miguel Sithium. Probably a pupil of H. Memling, Bruges. Worked at various European courts, including that of Margaret of Austria in Malines. Worked in Revel from 1506 to 1514 and after 1518.

Panel, 34x24.

■ coll. Von Liphart, Ratshof Castle, Tartou (Estonia), 1918; coll. Von Liphart, Leningrad, 1921; coll. A.W. Volz, The Hague; purchase in 1946 made possible by the testamentary disposition of Mr Volz and the aid of the Rembrandt Society.

● S.J. Gudlaugsson, O.K. 4 (1960), no 33, ill.; ROTTERDAM 1965, pp. 68-70, no 5, ill.; CAT. MAURITSHUIS 1968, p. 50, ill.; CAT. MAURITSHUIS 1970, no 1, ill.; FRIEDLÄNDER 1967-76, VIII, pp. 25, 99, no 64, pl. 49; J. Trizna, *Michel Sittow, peintre Revalais de l'école brugeoise*, Brussels 1976, p. 58, notes 2, 3, p. 100, no 25, notes 1, 2, pl. XVIII; E. Köks, *Journal of Baltic Studies* 9 (1978), pp. 37, 41, fig. 3.

► Formerly attributed to Jan Gossaert.

410

Karel Slabbaert | *Soldiers in the ruins of a castle*

Born ca 1619 in Zierikzee, died 1654 in Middelburg. Probably studied in Leiden; influenced by Rembrandt. Worked in Amsterdam in 1645.

Panel, 50.5x39. Signed: *K.slabbaert*.

■ purchased in 1876.

● BERNT 1969-70, III, no 1072, ill.; L.J. Bol, *Tableau* 4 (1982), p. 587, fig. 13.

751

■ | *Portrait of a man*

Panel, 68.5x57.5. Signed and dated: *K. Slabbaert f. Aetis 50. An.o 1653. N.L.S.* (?)

■ from the Council of Indonesia, Batavia, 1916.

● G.P. Rouffaer, O.H. 12 (1894), pp. 196-197; L.J. Bol, *Tableau* 3 (1982), p. 585.

258

Frans Snijders | *Still life with huntsman*

Born 1579 in Antwerp, died there in 1657. Pupil of P. Brueghel the Younger and H. van Balen. After visiting Italy he worked in Antwerp for the rest of his life, collaborating with Rubens, A. van Dyck and J. Wildens.

Canvas, 113.7x205.5.

■ coll. G. van Slingelandt, The Hague, 1768; Cabinet Prince Willem v.

● DROSSAERS & LUNSINGH SCHEURLEER 1974-76, III, p. 231, no 149; GREINDL 1983, p. 92.

► Attributed to Adriaen van Utrecht by Greindl. The huntsman was probably painted by a pupil of A. van Dyck.

794

■ | *Still life with a dead stag*

Canvas, 121x180.

■ purchased in 1926 from funds collected on the occasion of W. Martin's 25th anniversary as director.

● GREINDL 1956, p.184.

► A free replica in the Hamburger Kunsthalle.

340

Francesco Solimena | *The annunciation*

Born 1657 in Canale di Serino near Naples, died 1747 in Barra, near Naples. Studied and worked in Naples. Influenced by G. Lanfranco, M. Preti and L. Giordano.

Canvas, 62x75.

■ purchased by King Willem I for the Mauritshuis with the De Rainer collection, 1821.

● F. Bologna, *Francesco Solimena*, Naples 1958, p. 79, fig. 92.

164

Jan Franciscus Soolmaker | *Italian landscape with sheperds*

Born ca 1635, probably in Antwerp, died after 1665, possibly in Italy. Joined the guild of St Luke, Antwerp, in 1654. In 1665 he left Amsterdam for Italy. Follower of C.P. Berchem.

Canvas, 115x133. Signed: *J. v.Soolmaker ff.*
■ purchased in 1821.
● THIERY 1953, p. 195; BERNT 1969-70, III, no 1095, ill.; CAT. MAURITSHUIS 1980, pp. 104, 225, ill.

755

Pieter Claesz. Soutman, Attributed to | *Portrait of a lady*

Born ca 1580 in Haarlem, died there in 1657. Pupil of Rubens. Active mainly as an engraver. Visited Poland about 1624 and then worked in Haarlem.

Panel, 129.3x100.
■ given on loan in 1918; bequest of A. Bredius, 1946.
▶ Formerly attributed to H.G. Pot.

165

Jan Steen | *A toothpuller*

Born 1625/26 in Leiden, died there in 1679. Presumably trained under J. van Goyen, The Hague, A. van Ostade, Haarlem, and N. Knüpfer, Utrecht. Lived successively in Leiden, The Hague, Warmond (1656-1660) and Haarlem. In 1670 he returned to Leiden.

Canvas, 32.5x26.7. Dated: *1651*.
■ coll. W. Lormier, The Hague, 1763; Cabinet Prince Willem v.
● HOFSTEDE DE GROOT 1907-28, I, p. 51, no 180; GUDLAUGSSON 1945, p. 34, fig. 27; DROSSAERS & LUNSINGH SCHEURLEER 1974-76, III, p. 229, no 141; VRIES 1977, pp. 33-34, 155, no 23; BRAUN 1980, p. 90, no 32, ill.; DURANTINI 1983, p. 299, fig. 116.

166

■ | *The poultry yard*

Canvas, 107.4x81.4. Signed and dated: *JSteen. 1660.*
■ Cabinet Prince Willem v.
● HOFSTEDE DE GROOT 1907-28, I, pp. 79-80, no 330; MARTIN 1935-36, II, pp. 251, 264, fig. 249; MARTIN 1954, p. 15, ill.; THE HAGUE 1958-59, no 13, ill.; A.B. de Vries, O.K. 11 (1967), no 61, ill.; DROSSAERS & LUNSINGH SCHEURLEER 1974-76, III, p. 230, no 134; LONDON 1976, p. 84, no 105, ill.; ROSENBERG, SLIVE & KUILE 1977, pp. 231-232, fig. 184; KIRSCHENBAUM 1977, p. 39, fig. 32; VRIES 1977, pp. 39, 47, 160, no 79; BRAUN 1980, p. 100, no 113, ill.
▶ Portrait of Bernardina Margriet van Raesfelt (born ca 1650), the adopted daughter of Anna van den Bongaerd and Johan van Raesfelt. Anna and Bernardina lived from 1657 to 1663 in Lockhorst, the house shown in this painting. The portrait was originally thought to be of Jacoba Maria van Wassenaer (1654-1683).

167

■ | *The sick girl*

Panel, 58x46.5. Signed: *JSteen.*
■ coll. G. van Slingelandt, The Hague, 1768; Cabinet Prince Willem v.
● HOFSTEDE DE GROOT 1907-28, I, p. 39, no 131; E. de Jongh, *Simiolus* 3 (1968-69), p. 37; DROSSAERS & LUNSINGH SCHEURLEER 1974-76, III, p. 229, no 142; VRIES 1977, pp. 42-43, 159, no 61; BRAUN 1980, p. 114, no 203, ill.

168

■ | *The doctor's visit*

Panel, 60.5x48.5. Signed: *JSteen*.
■ coll. W. Lormier, The Hague, 1763; Cabinet Prince Willem v.
● HOFSTEDE DE GROOT 1907-28, I, p. 39, no 130; MARTIN 1954, p. 64, fig. 69; BERNT 1969-70, III, no 1111, ill.; DROSSAERS & LUNSINGH SCHEURLEER 1974-76, III, p. 229, no 140; AMSTERDAM 1976, pp. 240-243, no 63, ill.; VRIES 1977, pp. 59, 64, 164, no 124; KIRSCHENBAUM 1977, p. 68, fig. 121; BRAUN 1980, p. 132, no 318, ill.

169

■ | *As the old sing, so twitter the young*

Canvas, 84x92.6. Signed: *J. Steen*. Inscribed: *Soo De Oude songe, Soo Pypen De Jonge*.
■ Cabinet Prince Willem v.
● HOFSTEDE DE GROOT 1907-28, I, p. 25, no 90; MARTIN 1954, p. 17, fig. 4; DROSSAERS & LUNSINGH SCHEURLEER 1974-76, p. 229, no 138; BRAUN 1980, p. 114, no 200, ill.
► Two heads were damaged during a restoration in Antwerp (before 1889) and then repainted by D.J. Bles (1821-1899).

170

■ | *The life of man*

Canvas, 68.2x82. Signed: *JSteen*.
■ Cabinet Prince Willem v.

● HOFSTEDE DE GROOT 1907-28, I, p. 143, no 595; W. Martin, *Oude Kunst 2* (1917), pp. 34-35, fig. 4, 5; MARTIN 1954, p. 49, fig. 44; THE HAGUE 1958-59, no 53, fig. 52; JONGH 1967, p. 82, fig. 70; W. Stechow, N.K.J. 23 (1972), p. 82, note 14; DROSSAERS & LUNSINGH SCHEURLEER 1974-76, III, p. 229, no 139; AMSTERDAM 1976, pp. 236-239, no 62, ill.; VRIES 1977, pp. 60, 165, no 129; BRAUN 1980, p. 122, no 261, ill.; DURANTINI 1983, pp. 198, 287.
► Formerly called *The brewery of Jan Steen*. A little boy, blowing bubbles, with a skull beside him makes clear that this is an allegory on the vanity of life.

553

■ | *Dancing peasants*

Panel, 40x58. Signed: *JSteen*.
■ given on loan in 1890; bequest of A. Bredius, 1946.
● HOFSTEDE DE GROOT 1907-28, I, p. 151; no 624; BERNT 1969-70, III, no 1115, ill.; VRIES pp. 30, 33, 154, no 1; BRAUN 1980, p. 86, no 5, ill.

664

■ | *Village fair*

Panel, 47.2x66. Signed: *JSteen*.
● given on loan in 1901; bequest of A. Bredius, 1946.
● HOFSTEDE DE GROOT 1907-28, I, pp. 151-152, no 625; GUDLAUGSSON 1945, p. 7, fig. 3; A. von Criegern, O.H. 86 (1971), p. 29, fig. 22; VRIES 1977, pp. 30, 32, 33, 154, no 3; KIRSCHENBAUM 1977, p. 83; BRAUN 1980, p. 81, no 81, ill.

736

■ | *A pig belongs in the sty*

Canvas, 86x72. Signed: *JSteen*.
■ given on loan in 1911; bequest of A. Bredius, 1946.
● HOFSTEDE DE GROOT 1907, I, p. 189, no 753; MARTIN 1954, p. 54, fig. 56;
A. von Criegern, O.H. 86 (1971), p. 23, fig. 10; VRIES 1977, p. 69, 168, no
167; BRAUN 1980, p. 140, no 362, ill.
▶ The drunken woman (also former title) is being put in the sty because of
her dissolute ways; illustration of a well-known proverb.

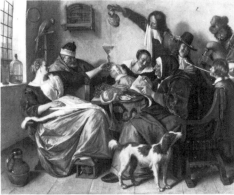

742

■ | *The way you hear it is the way you sing it*

Canvas, 134x163, Inscribed: *Soo voer gesongen, soo na gepepen, dat is al
lang g(e)bleken, ick sing u vo(or, ghy) volcht ons na(er), va(n) een tot
hon(dert) jaar.* (The way you hear it is the way you sing it, that's been
known for long, I'll sing and you follow, be ye babe or a hundred-and-one).
■ coll. Steengracht, Paris, 1913; purchased with the aid of the Rembrandt
Society, 1913.
● HOFSTEDE DE GROOT 1907-28, I, pp. 129-130, no 529; MARTIN 1935-36, I, p.
80, fig. 45; MARTIN 1954, p. 37, fig. 23; THE HAGUE 1958-59, no 29, fig. 28; J.
Engelman, O.K. 5 (1961), no 1, ill.; VRIES 1977, pp. 57-58, 61, 164, no 118;
ROSENBERG, SLIVE & KUILE 1977, p. 235, fig. 187; BRAUN 1980, p. 114, no
201, ill.; DURANTINI 1983, p. 59; PHILADELPHIA 1984, p. 311, fig. 1.
▶ According to traditon the sitters belong to Jan Steen's family. The
laughing man with hat and pipe is certainly a self-portrait.

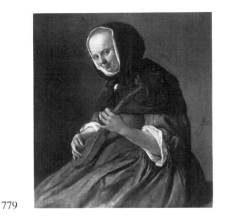

779

■ | *Woman playing the sistrum*

Panel, 31x27.5. Signed: *JSteen*.
■ purchased with the aid of private individuals, 1928.
● HOFSTEDE DE GROOT 1907-28, I, pp. 103-104, no 441a; MARTIN 1954, pp.
16-17, fig. 3; THE HAGUE 1958-59, no 19, fig. 19; VRIES 1977, pp. 57, 163, no
111; BRAUN 1980, p. 104, no 132, ill.
▶ According to tradition the sitter is the wife of the painter, Grietje van
Goyen.

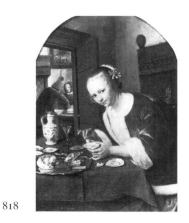

818

■ | *Girl eating oysters*

Panel, 20.5x14.5 (ends in a round arch). Signed: *IS*.
■ coll. Six, Amsterdam 1928; donated by H.W.A. Deterding, 1936.
● HOFSTEDE DE GROOT 1907-28, I, p. 218, no 853; MARTIN 1935-36, II, p. 266,
fig. 143a; MARTIN 1954, pp. 25, 33, 53, ill.; J.N. van Wessem, O.K. 1 (1957),
no 7, ill.; THE HAGUE 1958-59, no 16, fig. 17; ROSENBERG, SLIVE & KUILE
1977, p. 231; VRIES 1977, pp. 48, 161, no 84; BRAUN 1980, p. 98, no 92, ill.

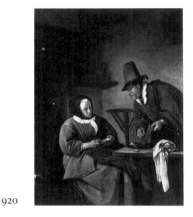

920

■ | *An old couple preparing a beverage*

Panel, 41x31.5. Signed: *JSteen*.
■ coll. J.J. Brants, Amsterdam, 1813; coll. Baron Van Verschuer, The
Hague, 1901; given on loan in 1954; donated by Miss M.C. van den Honert,
Hilversum, 1957.

• HOFSTEDE DE GROOT 1907-28, I, p. 84, no 351; THE HAGUE 1958-59, no 45, fig. 45; CAT. MAURITSHUIS 1970, no 36, ill.; VRIES 1977, pp. 41, 43, 159, no 59; BRAUN 1980 p. 98, no 95, ill.

171

Hendrick van Steenwijck the Younger | *An imaginary city square*

Born ca 1580 possibly in Antwerp, died before 1649 in London. Pupil of his father H. van Steenwijck the Elder. Lived in Antwerp for some time and perhaps in Amsterdam as well. Already in London before 1617, where he worked for the English court.

Copper, 47x70. Signed and dated: *H.V S 1614*.
■ Het Loo, 1757; Cabinet Prince Willem V.
● UTRECHT 1961, pp. 299-300, fig. 228; DROSSAERS & LUNSINGH SCHEURLEER 1974-76, II, p. 640, no 29, III, p. 232, no 155; JANTZEN 1979, pp. 36-37, 235, no 457, fig. 11.

172

Dirck Stoop | *View of Belem monastery near Lisbon*

Born ca 1610 probably in Utrecht, died there (?) possibly in 1686. It is likely that he was the pupil of his father, the glass painter W.J. Stoop. He may have visited Italy (1635-1645). Worked in Spain around 1661/62 and afterwards in England. In 1678 he probably returned to Utrecht.

Canvas, 111.5x179.
■ purchased with the Reghellini collection, 1831.

173

Abraham Storck | *Moorage*

Born 1644 in Amsterdam, died probably after 1705. Influenced by L. Bakhuizen, W. van de Velde the Younger and J. Beerstraten. Worked in Amsterdam.

Panel, 22x31. Signed and dated: *A:Storck/F.Ao 1683*.
■ Leeuwarden Palace, 1731; Cabinet Prince Willem I.
● BOL 1973, p. 339, note 586; DROSSAERS & LUNSINGH SCHEURLEER 1974-76, II, p. 405, no 507, III, p. 231, no 153; CAT. MAURITSHUIS 1980, pp. 105, 226, ill.
► Companion piece to no 174.

174

■ | *Beach view*

Panel, 22.5x31. Signed and dated: *A:Storck.F./Ao1683*.
■ Leeuwarden Palace, 1731; Cabinet Prince Willem V.
● BOL 1973, p. 339, note 586; DROSSAERS & LUNSINGH SCHEURLEER 1974-76, II, p. 405, no 507, III, p. 231, no 153; CAT. MAURITSHUIS 1980, pp. 105, 227, ill.
► Companion piece to no 173.

291

Herman van Swanevelt, Attributed to | *Wooded landscape with shepherds*

Born ca 1600 most probably in Woerden, died 1655 in Paris. Spent a long time in Rome, 1629-1641. After 1641 he worked alternately in Paris and Woerden. His work is important for the Italianate masters who worked after 1640.

Canvas, 52.5x75.5.
■ Het Loo, 1712; Cabinet Prince Willem V.
● DROSSAERS & LUNSINGH SCHEURLEER 1974-76, I, p. 698, no 77, III, p. 220, no 87; ROME 1983, pp. 11, 31, no 15, ill.

657

Michael Sweerts | *Italian shepherds with man defleaing himself*

Born 1618 in Brussels, died 1664 in Goa, India. Worked in Rome from 1646; studied the work of Caravaggio and his Roman followers as well that of P. van Laer. In 1661 he left for India with a group of French missionaries.

Canvas, 78.5x71.
■ purchased in 1901.
● W. Martin, O.H. 25 (1907), pp. 134, 151-152, no 17; KULTZEN 1954, pp. 268-269, no 36; ROTTERDAM 1958, p. 46, no 29, fig. 28; R. Kultzen, *Pantheon* 38 (1980), p. 67, fig. 6.

886

■ | *Peasant family with man defleaing himself*

Canvas, 66.5x50.
■ coll. V. Bloch, The Hague; purchased in 1951.
● R. Longhi, *Paragone* 1 (1950), p. 57, no 3; V. Bloch, MAANDBL. B.K. 26 (1950), pp. 215, 218-219, fig. 4; KULTZEN 1954, pp. 98, 277, no 47; ROTTERDAM 1958, pp. 49-50, no 36, fig. 36; BLOCH 1968, pp. 12, 20 fig. 8; CAT. MAURITSHUIS 1970, no 13, ill.; V. Bloch, ALB. AMIC. VAN GELDER 1973, p. 40; R. Kultzen in: *Essays on northern European art presented to E. Haverkamp-Begemann*, Doornspijk 1983, p. 132, fig. 6.

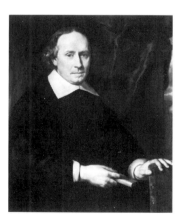

396

Abraham van den Tempel | *Portrait of Jan Antonides van der Linden (1609-1664)*

Born 1622/23 in Leeuwarden, died 1672 in Amsterdam, Pupil of his father L. Jacobsz. He possibly studied with J. Backer, Amsterdam. Worked in Leiden from 1648 to 1660, then in Amsterdam. Influenced by B. van der Helst.

Canvas, 88.5x71. Signed and dated: *AB v. Tempel ft.1660.*
■ purchased in 1876; on loan to the Stedelijk Museum De Lakenhal, Leiden, since 1922.
● WIJNMAN 1959, p. 67, ill.; B. Haak, *Rembrandt*, Amsterdam 1969, p. 315, ill.; CAT. LAKENHAL 1983, p. 333, no 428, ill.
► J.A. van der Linden was professor of medicine at Franeker, later in Leiden. In 1634 he married Helena Grondt; companion piece to no 397.

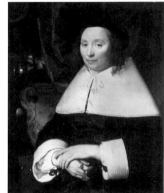

397

■ | *Portrait of Helena Grondt (1613/14- after 1665)*

Canvas, 88.5x71. Signed and dated: *AB v. Tempel f 166.*
■ purchased in 1876; on loan to the Stedelijk Museum De Lakenhal, Leiden, since 1922.
WIJNMAN 1959, p. 67, ill.; CAT. LAKENHAL 1983, p. 334, no 429, ill.
► In 1634 Helena Grondt married J.A. van der Linden; companion piece to no 396.

260

David Teniers the Younger | *Kitchen interior*

Born 1610 in Antwerp, died 1690 in Brussels. Pupil of his father, D. Teniers the Elder. Strongly influenced by A. Brouwer. Worked in Antwerp until 1651, then court painter in Brussels and keeper of the art collection of Archduke Leopold Willem. One of the founders of the Antwerp Academy.

Copper, 57x77.8. Dated and signed: *Ao 1644. David Teniers.*
■ coll. G. van Slingelandt, The Hague, 1768; Cabinet Prince Willem V.
● P.J.J. van Thiel, O.K. 14 (1970), no 40, ill.; DROSSAERS & LUNSINGH SCHEURLEER 1974-74, III, p. 232, no 156; DAVIDSON 1980, pp. 14-15, fig. 7.
► On the basis of the Habsburg coat of arms (on the pastry-crust) wrongly called *The kitchen of Archduke Leopold Willem.* Teniers was not yet in the archduke's service.

261

■ | *The alchemist*

Panel, 26.6x37.5. Signed: *D. Teniers:Fec.*
■ Het Loo (?); Binnenhof, The Hague, 1754; Cabinet Prince Willem v.
● DROSSAERS & LUNSINGH SCHEURLEER 1974-76, II, p. 480, no 33, III, p. 232, no 157; DAVIDSON 1980, pp. 14, 32-34, fig. 26.

848

■ | *Country inn*

Panel, 35x32.5. Signed: *DT*.
■ Nationale Konst-Gallery, The Hague; Rijksmuseum, Amsterdam, inv.no A400; on loan since 1948.
● MOES & BIEMA 1909, pp. 129(?), 165, 221; CAT. RIJKSMUSEUM 1979, p. 536.

Gerard Ter Borch, see Gerard ter *Borch*.

Hendrick Ter Brugghen, see Hendrick ter *Brugghen*.

262

Gillis van Tilborgh | *Family portrait*

Born ca 1625 in Brussels, died there 1678. Probably the pupil of D. Teniers the Younger, whom he sometimes followed. Influenced by J. van Craesbeeck and G. Coques.

Canvas, 80.3x104. Signed: *Tilborgh*.
■ purchased by King Willem I, ca 1826.
● BERNT 1969-70, III, no 1181, ill.

327

Jacopo Tintoretto (Jacopo Robusti), In the style of or after | *Portrait of a man*

Born 1518 in Venice, died there in 1594. Always worked in Venice. Pupil of Titian.

Canvas, 110x91.
■ purchased by King Willem I for the Mauritshuis with the De Rainer collection, 1821; on loan to the Rijksdienst Beeldende Kunst, The Hague.

811

■ | In the style of or after | *Portrait of a man*

Canvas, 58x45.
■ purchased from kunsth. J. Goudstikker, Amsterdam, 1933; on loan to the Rijksmuseum, Amsterdam (inv.no C1373), since 1984.
● CAT. MAURITSHUIS 1935, p. 341.

143

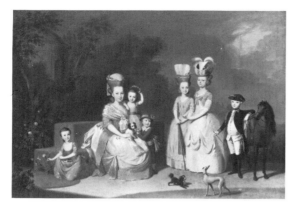

232

Anton Wilhelm Tischbein | *Portrait of Carolina Wilhelmina, Princess of Orange (1743-1787), and her children*

Born 1730 in Haina, died 1804 in Hanau. Pupil and brother of J.V. Tischbein. He attended the academy in The Hague in 1753, then worked in various places in Germany.

Canvas, 104.5x149.
■ unknown.
● LEEUWARDEN 1979-80, pp. 118-119, no 269, ill.
► Attributed to A.W. Tischbein by A. Staring; formerly considered a copy after him by G. de Spinny. Carolina Wilhelmina was the wife of Karel Christiaan van Nassau Weilburg, and a sister of Stadholder Willem V. The children depicted are, from left to right: Carolina Louise Frederika (born 1770); Amalia Charlotte Wilhelmina Louise (born 1776); Karel Frederik Willem (born 1775); Wilhelmina Louise (born 1765); Augusta Maria Carolina (born 1764); Frederik Willem (born 1768). Other versions in the private collection of the Dutch royal house and in the collection of the Grand Duke of Luxembourg.

286

Johann Friedrich August Tischbein | *Portrait of Frederika Louise Wilhelmina, Princess of Prussia (1774-1837), wife of King Willem I of The Netherlands*

Born 1750 in Maastricht, died 1812 in Heidelberg. Pupil of his father J.V. and his uncle J.H. Tischbein, Kassel. He travelled much and worked in The Hague and Amsterdam at various times.

Pastel on paper, 63x53 (oval).
■ National Konst-Gallery, The Hague.
● MOES & BIEMA 1909, p. 121, no 28, p. 127, no 375(?); STOLL 1923, p. 193.

464

■ | *Portrait of Frederika Sophia Wilhelmina, Princess of Prussia (1751-1820),wife of Stadholder Willem V*

Canvas, 172x135. Signed and dated: *Tischbein. p:1789.*
■ Nationale Konst-Gallery, The Hague.
● MOES & BIEMA 1909, p. 102, no 228, p. 127, no 372(?); STOLL 1923, p. 192.

343

Titian (Tiziano di Gregorio Vecellio), Copy after | *Venus and dog with an organist*

Born ca 1480 in Pieve di Cadore, died 1576 in Venice. Pupil of Giovanni Bellini, influenced by Giorgione. Worked in Venice.

Canvas, 157x213.
■ kunsth. Nieuwenhuys, Brussels; coll. King Willem I; coll. M. Brondgeest, 1850; coll. Prince Hendrik of The Netherlands; donated by Grand Duchess Sophie of Saxe-Weimar, Princess of The Netherlands, 1883; on loan to Kasteel Hoensbroek.
● WETHEY 1975, III, p. 200.
► Old copy after a painting by Titian and workshop, Prado Museum, Madrid (canvas, 136x220, inv.no 420).

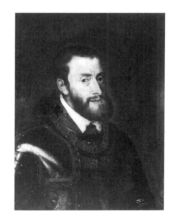

358

■ Copy after | *Portrait of Emperor Charles V*

Canvas, 67,5x54.

- purchased by King Willem I for the Mauritshuis with the De Rainer collection, 1821.
▸ Copy after a lost original by Titian (WETHEY 1975, II, pp. 193-194, no L-5).

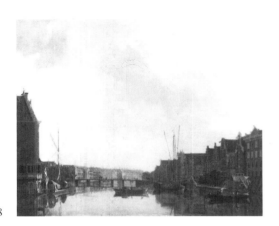

178

Gerrit Toorenburch | *View of the Amstel, Amsterdam*

Born ca 1737 in Amsterdam, died 1785 in Nijkerk. Pupil of J. ten Compe and C. Pronk. Follower of J. van der Heyden.

Canvas, 39x47. Signed: *Toorenburg Pinxit.*
- purchased between 1827 and 1830.

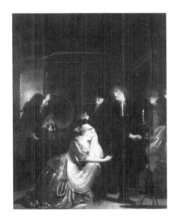

179

Cornelis Troost | *Pretended virtue exposed*

Born 1697 in Amsterdam, died there in 1750. Pupil of A. Boonen. Worked in Amsterdam. Painted genre pieces and theatre scenes.

Pastel, 60.5x49. Signed and dated: *C. Troost 1739.*
- coll. J. van der Marck, Amsterdam, 1773; coll. J.S. de Neufville Brants, Amsterdam; purchased in 1829.
● KNOEF 1947, p. 21, ill.; NIEMEIJER 1973, p. 273, no 400 T.
▸ Scene from D. Lingelbach's comedy *De Ontdekte Schijndeugd* (Pretended virtue exposed), 1690.

180

■ | *The marriage proposal on behalf of Reinier*

Pastel, 61x48.5. Signed and dated: *C. Troost 1738.*
- coll. J. Tonneman, Amsterdam, 1754; coll. J.J. de Bruyn, Amsterdam, 1798; coll. J.S. de Neufville Brants, Amsterdam; purchased in 1829.
● KNOEF 1947, p. 17, ill.; NIEMEIJER 1973, pp. 255-256, no 346 T, p. 257, ill.
▸ Scene from Asselijn's comedy *Jan Claesz. off de gewaande Dienstmaaght* (Jan Claesz. or the supposed servant girl), 1680.

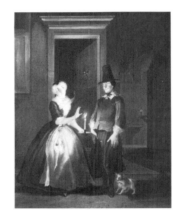

181

■ | *Reinier's declaration of love to Saartje*

Pastel, 60.5x52. Signed and dated: *C. Troost 1737.*
- coll. J. Tonneman, Amsterdam, 1754; coll. J.J. de Bruyn, Amsterdam, 1798; coll. J.S. de Neufville Brants, Amsterdam; purchased in 1829.
● KNOEF 1947, p. 16, ill.; NIEMEIJER 1973, p. 261, no 362 T.
▸ Scene from the same comedy as no 180.

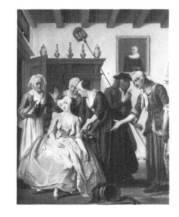

182

■ | *The discovery of Jan Claesz.*

Pastel, 60.5x49. Signed and dated: *C. Troost 1738.*
- coll. J. Tonneman, Amsterdam, 1754; coll. J.J. de Bruyn, Amsterdam, 1798; coll. J.S. de Neufville Brants, Amsterdam; purchased in 1829.
● KNOEF 1947, p. 19, ill., p. 27; NIEMEIJER 1973, p. 265, no 379 T, ill.
▸ Scene from the same comedy as nos 180 and 181.

183

━ | *The deceived rivals*

Pastel, 62x50. Signed and dated: *C. Troost 1738*.
■ coll. J.J. de Bruyn, Amsterdam, 1798; coll. J.S. de Neufville Brants, Amsterdam; purchased in 1829.
● KNOEF 1947, p. 20, ill., p. 25; NIEMEIJER 1973, p. 239, no 282 T, ill.
▶ Scene from the farce *Arlequin, toovenaar en barbier* (Arlequin, magician and barber), by W. van der Hoeven, 1730.

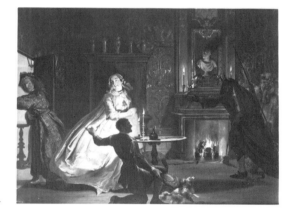

184

━ | *The aged husband put to flight*

Pastel, 55.5x72.5. Signed and dated: *C. Troost 1738*.
■ coll. J.S. de Neufville Brants, Amsterdam; purchased in 1829.
● KNOEF 1947, p. 25, ill., p. 30; NIEMEIJER 1973, pp. 251-252, no 329 T,
▶ Scene from the farce *Hopman Ulrich* by J. van Paffenrode, 1670.

185

━ | *Pefroen and the sheep's head*

Pastel, 63x50.5. Signed and dated: *C. Troost 1739*.
■ coll. J.J. de Bruyn, Amsterdam, 1798; coll. J.S. de Neufville Brants, Amsterdam, 1829; purchased in 1829.
● KNOEF 1947, p. 22, ill., p. 25; NIEMEIJER 1973, pp. 277-278, no 419 T, ill.
▶ Scene from Y. Vincent's comedy *Pefroen met het Schaapshoofd* (Pefroen with the sheep's head), 1669; this play was written after R. Poisson's *Lubin ou le sot vengé*, 1661.

186

━ | *Nemo loquebatur* (No one spoke)

Pastel on paper, 56.5x72.5. Signed and dated: *C. Troost 1740*.
■ coll. T. van Snakenburg, Leiden; coll. J. Tak, Zoeterwoude, 1781; coll. J.A. Bennet, Leiden; purchased in 1829.
● KNOEF 1947, pp. 29-30, ills.; MINNEAPOLIS 1971, p. 104; NIEMEIJER 1973, pp. 336-339, no 653-A T to 653-E T, ills.
▶ One of a series of five pastels, *A company of friends in the house of Biberius*, known as the NELRI series after the first letters of the inscriptions on the frames.

187

━ | *Erat sermo inter fratres* (The brothers were having a conversation)

Pastel on paper, 56.5x72.5. Signed and dated: *C. Troost 1740*.
■ See no 186.
● See no 186.
▶ See no 186.

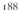

188

━ | *Loquebantur omnes* (Everyone was speaking)

Pastel on paper, 56.5x72.5. Signed and dated: *C. Troost 1740*.
■ See no 186.
● See no 186.
▶ See no 186.

189

■ | *Rumor erat in casa* (There was a commotion in the house)

Pastel on paper, 57x73. Signed: *C. Troost* .
● See no 186.
● See no 186.
► See no 186.

190

■ | *Ibant qui poterent, qui non potuere cadebant* (Those who could walk did, the others fell)

Pastel on paper, 56.5x72.5. Signed and dated: *C. Troost 1739*.Inscription beside the door: *Leveraard Biberius*.
■ See no 186.
● See no 186.
► See no 186.

191

■ | *The astronomer's dispute*

Pastel, 64x83.5. Signed and dated: *C. Troost 1741*.
■ coll. J.J. de Bruyn, Amsterdam; coll. J.S. de Neufville Brants, Amsterdam; purchased in 1829.
● KNOEF 1947, p. 45, ill.; NIEMEIJER 1973, pp. 289-290, no 450 T, ill.
► Scene from the comecdy *De Wiskunstenaars of 't gevluchte juffertje* (The mathematicians or the young lady who ran away) by P. Langendijk, 1715.

192

■ | *Twelfth night*

Pastel, 56x74. Signed: *C. Troost*. Inscribed: *O starre je moet er soo stilie niet staan (je) moet met (ons) naar Beth(lehem) gaan* (Oh star do not stand still, to Bethlehem with us if you will).
■ coll. J.S. de Neufville Brants, Amsterdam; purchased in 1829.
● KNOEF 1947, p. 55, ill.; NIEMEIJER 1973, pp. 344-345, no 668 T, ill.

193

■ | *The wedding of Kloris and Roosje*

Pastel, 64x83. Signed: *C. Troost*.
■ coll. J.J. de Bruyn, Amsterdam; coll. J.S. de Neufville Brants, Amsterdam; purchased in 1829.
● KNOEF 1947, pp. 40, 45, ill.; NIEMEYER 1973, pp. 246-247, no 314 T, ill.
► Scene from the 17th-century comedy of the same name (*De Bruiloft van Kloris en Roosje*), which is attributed to Dirk Buysero and Jacques van Rijndorp, 1688.

194

■ | *Selfportrait* (formerly: *Portrait of the painter*)

Pastel, 65x52. Signed and dated: *C. Troost. 1745*.
■ coll. Van Oosthuyse van Rijsenburg- de Jongh, The Hague, 1847; coll. C.C.J. de Ridder, Rotterdam, 1874; purchased in 1874.
● KNOEF 1947, p. 10, ill., p. 20; NIEMEYER 1973, p. 155, no 2 T, ill.

411

■ | *Lady with cupid and a songbook*

Pastel, 47.5x61.5. Signed and dated: *C. Troost. 1745.*
■ coll. J. Snellen, The Hague, 1876; purchased in 1876.
● KNOEF 1947, p. 11, ill., p. 21; NIEMEYER 1973, pp. 302-303, no 514 T, ill.
► The music sheet has the refrain of a song from the book *Vermakelijk boerenleven* (Peasants' diversions): 'Maar wagt u zoet meisje voor 't eerste snoepreisje' (But beware, sweet, of the first sweet).

609

■ | *The organ grinder*

Pastel, 51.7x68.7.
■ donated by Miss G.J.L. van Dijk, The Hague, 1897.
● KNOEF 1947, p. 53, ill.; NIEMEYER 1973, pp. 350-351, no 684 T, ill.

1034

■ | *Guardroom*

Canvas, 82x102. Signed and dated: *Cornelis Troost fecit 1747.*
■ coll. D. Ietswaart, Amsterdam, 1749; coll. J. van der Marck, Leiden, 1773; coll. H. Twent, Leiden, 1791; coll. jhr L.J. Quarles van Ufford, Haarlem, 1874; coll. jhr mr M.W.F. Boreel, Laren; purchased by the Johan van Nassau Foundation and given on loan to the Mauritshuis, 1980.
● NIEMEYER 1973, pp. 354-356, no 694 S, ill.
► On the mantelpiece there is a portrait medallion of Willem IV, who became Stadholder in 1747. His coat of arms and that of his wife Ann of Hanover are on the left and right.

342

Alessandro Turchi, called **Alessandro Veronese** or **l'Orbetto** | *Allegorical representation* (probably *The power of Venus*)

Born 1578/80 in Verona, died 1649 in Rome. Pupil of F. Brusacorsi. Influenced by Caravaggio, then by G. Reni and Annibale Carracci.

Canvas, 100x123.
■ coll. De Flines, Het Loo; Cabinet Prince Willem V; Louvre, Paris, 1795-1815; on loan to Rijksmuseum Paleis Het Loo, Apeldoorn, since 1984.
● CAT. MAURITSHUIS 1935, p. 360-361; J.G. van Gelder, O.H. 86 (1971), p. 214, note 54.
► A pen and ink drawing after this painting by J. de Bisschop was donated to the museum in 1875 by mr jhr H.A. Steengracht van Duivenvoorde and transferred to the Rijksprentenkabinet, Amsterdam, in 1951.

196

Jacob van der Ulft | *Army advancing among Roman ruins*

Born 1621 in Gorkum, died 1689 in Noordwijk. Influenced by J. de Bisschop. Probably worked his whole life in Gorkum, where he became burgomaster.

Canvas, 81.8x133.3. Signed and dated: *Jacob van der Ulft F/1671.*
■ purchased in 1825.
● CAT. MAURITSHUIS 1980, pp. 105-106, 228, ill.

1059

Moses van Uyttenbroeck | *Landscape with shepherds*

Born between 1595 and 1600, probably in The Hague, died there ca 1647. May have travelled to Italy. Worked for Stadholder Frederik Hendrik.

Panel, 42.5x67.5. Signed and dated: *MVWB FE 1626.*

■ coll. H. Girardet, Kettwich; purchased in 1979.
● U. Weisner, O.H. 79 (1964), p. 223, no 41.

197

Adriaen van de Velde | *Wooded landscape with cattle*

Born 1636 in Amsterdam, died there in 1672. Pupil of his father, W. van de Velde the Elder, later of J. Wijnants, Haarlem. Worked in Amsterdam.

Panel, 29x35.5. Signed and dated: *A v Velde/1663*.
■ coll. P.L. de Neufville, Amsterdam, 1763; Cabinet Prince Willem V.
● HOFSTEDE DE GROOT 1907-28, IV, p. 521, no 140; MARTIN 1935-36, II, p. 334, fig. 183; MARTIN 1950, p. 74, no 128, ill.; DROSSAERS & LUNSINGH SCHEURLEER 1974-76, III, p. 234, no 164; CAT. MAURITSHUIS 1980, pp. 106-108, 229, ill.; ROME 1983, p. 32, no 16, p. 97, ill.

198

 | *Beach scene*

Panel, 42x54. Signed and dated: *A. v velde f/166(5?)*.
■ coll. G. van Slingelandt, The Hague, 1768; Cabinet Prince Willem V.
● HOFSTEDE DE GROOT 1907-28, IV, pp. 586-587, no 356; PRESTON 1937, p. 51, fig. 73; MARTIN 1950, pp. 74-75, no 129, ill.; STECHOW 1966. pp. 107-108 fig. 214; L. Frerichs, O.K. 10 (1966), no 16, ill.; BOL 1973, p. 246, fig. 252; DROSSAERS & LUNSINGH SCHEURLEER 1974-76, III, p. 234, no 165; CAT. MAURITSHUIS 1980, pp. 108-109, 230, ill.

199

Esaias van de Velde | *Repast in the park*

Born 1587 in Amsterdam, died 1630 in The Hague. Was already working in Haarlem in 1609 (inscribed in the guild, 1612) and from 1618 on in The Hague. J. van Goyen and possibly P. de Neyn were his pupils.

Panel, 28.5x40. Signed and dated: *E. vanden. Velde. 1614*.
■ puchased in 1873.
● PLIETZSCH 1960, p. 94; ROSENBERG, SLIVE & KUILE 1977. p. 171; KEYES 1984, p. 136, no 63, fig. 132.

673

■ | *Winter landscape*

Panel, 26x32. Signed and dated: *E.v.Velde. 1624*.
■ bequest of A.A. des Tombe, The Hague, 1903.
● STECHOW 1966, p. 87, 90, fig. 172; BOL 1969, pp. 137-139, fig. 123; BERNT 1969-70, III, no 1240, ill.; PLIETZSCH 1960, p. 95; STECHOW 1975, p. 16, fig. 77; CAT. MAURITSHUIS 1980, pp. 109-110, 231, ill.; KEYES 1984, p. 140, no 77, fig. 206.

533

Jan van de Velde III | *Still life with levelling glass*

Born 1620 in Haarlem, died 1662 in Enkhuizen. Was in Amsterdam in 1642. Son and pupil of engraver and draughtsman J. van de Velde II.

Canvas, 54x47.5. Signed and dated: *Ian van de Velde: Ano.1660.Fecit.*
■ purchased in 1885.

200

Willem van de Velde the Younger | *Ships in the roads*

Born 1633 in Leiden, died 1707 in Greenwich. pupil of his father W. van de Velde the Elder; according to Houbraken he also was a pupil of S. de Vlieger. Initially worked in Amsterdam. Court painter to King Charles II and James II from 1674 onwards; lived in Greenwich. He made several brief visits to Holland.

Canvas, 66.5x77.2. Signed: *W. van de Velde f.*
■ coll. G. Van Slingelandt, The Hague, 1768; Cabinet Prince Willem v.
● HOFSTEDE DE GROOT 1907-28, VII, p. 36, no 109; BERNT 1969-70, III, no 1248, ill.; DROSSAERS & LUNSINGH SCHEURLEER 1974-76, III, p. 135, no 168; CAT. MAURITSHUIS 1980, pp. 110-112, 232, ill.
► The States yacht in the right foreground bears the coat of arms of Amsterdam and Holland and the flag of the Admiralty.

201

■ | *Ships in the roads* (formerly: *Charles II of England in the roads of Dordrecht, on his journey from the Moerdijk to Delft (1660)*)

Canvas, 66.5x77.2. Signed: *W/V.V.*
■ coll. P.L. de Neufville, Amsterdam, 1765; Cabinet Prince Willem v.
● HOFSTEDE DE GROOT 1907-28, VII, pp. 10-11, no 19; PRESTON 1937, p. 42, fig. 54; BAARD 1942, p. 53, ill.; MARTIN 1950, p. 80, no 158, ill.; BOL 1973, pp. 235-236, fig. 240; DROSSAERS & LUNSINGH SCHEURLEER 1974-76, III, p. 235, no 167; CAT. MAURITSHUIS 1980, pp. 112-114, 233, ill.
► Left of centre a States yacht with the arms of Willem II.
In the Cabinet Prince Willem v it was considered a companion piece to no 200.

471

■ Attributed to | *Conquest of the 'Royal Prince'*

Canvas, 42x52.
■ purchased in 1882.
● HOFSTEDE DE GROOT 1907-28, VII, p. 13, no 26; CAT. MAURITSHUIS 1980, pp. 115, 234, ill.
► Incident from the Four-Day Battle at sea, June 13, 1666.

563

■ Milieu of | *Sunset at sea*

Canvas, 36x61.5. Signed: *W.vvelde j..*
■ coll. A. Bredius; given on loan, 1892; bequest of A. Bredius, 1946.
● HOFSTEDE DE GROOT 1907-28, VII, p. 57, no 193; MARTIN 1950, p. 81, no 161, ill.; BERNT 1969-70, III, no 1249, ill.; CAT. MAURITSHUIS 1980, pp. 116, 235, ill.

202

Adriaen Pietersz. van de Venne | *Dancing beggars*

Born 1589 in Delft, died 1662 in The Hague, where he settled in 1625. Illustrated many workes by Jacob Cats.

Panel, 12x28 (grisaille). Dated and signed: *1635. A P:v:Venne.* Inscribed: *All-om-Arm* (All-round-Poor).
■ purchased in 1874.
● D. Franken Dz., *A. van de Venne*, Amsterdam 1878, p. 53, no 24; L.J. Bol, O.H. 73 (1985), p. 130, fig. 19; L.J. Bol, *Tableau* 6 (1983), p. 60, fig. 78.

611

Pieter Cornelisz. Verbeecq | *Two horsemen by a stream*

Born ca 1610/15 in Haarlem, died there ca 1652/54. Son of the marine painter C. Verbeeck. Influenced by P. van Laer. Worked in Alkmaar, Utrecht and Haarlem.

Panel, 27.5x35.2. Signed: *P.V.B.*
■ purchased in 1897.
● H. Gerson in: E.A. van Beresteyn, *De genealogie van het geslacht Van Beresteyn*, The Hague 1940, pp. 183, 189, no 6, fig. 204; BOL 1969, p. 251; BERNT 1969-70, III, no 1258, ill.

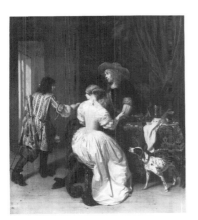

865

Jan Verkolje | *The messenger* (formerly: *Unpleasant tidings*)

Born 1650 in Amsterdam, died 1693 in Delft. According to Houbraken he was influenced by G P. van Zijl. He may have visited London between 1680 and 1684.

Canvas, 59x53.5. Signed and dated: *I. Verkolje 1674*.
■ coll. V. de Rothschild, London, 1937; coll. F. Mannheimer, Amsterdam; transferred to the Mauritshuis by the Rijksdienst Beeldende Kunst, 1960.
● PLIETZSCH 1960, p. 188, fig. 345; AMSTERDAM 1979, pp. 266-267, no 70, ill.; PHILADELPHIA 1984, pp. 335-336, fig 1.
► In the background a painting with the Death of Adonis.

724

Jan Vermeer van Haarlem | *Landscape on the edge of the dunes*

Born 1628 in Haarlem, died there in 1691. Was probably pupil of J.W. de Wet. Influenced by J. van Ruisdael.

Panel, 52x68. Signed and dated: *Jvmeer/1648.*
■ purchased in 1907.
● ROSENBERG 1928, p. 18, fig. 20, pl. XII; STECHOW 1966, pp. 48-49, 196, note 54; BOL 1969, pp. 217-218; CAT. THYSSEN-BORNEMISZA 1969, p. 397; CAT. MAURITSHUIS 1980, pp. 117, 237, ill.
► Companion piece to no 809.

809

■ | *A farm near the dunes*

Panel, 52x68. Signed: *JVMeer*.
■ purchased by the Rijksmuseum, Amsterdam, in 1906, with the aid of the Rembrandt Society (inv.no A2351); on loan since 1933.
● STECHOW 1966, pp. 48-49, BOL 1969, pp. 217-218; CAT. RIJKSMUSEUM 1976, p. 375; CAT. MAURITSHUIS 1980, pp. 117-118, 238, ill.
► Companion piece to no 724.

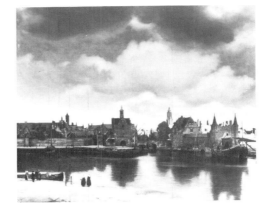

92

Johannes Vermeer van Delft | *View of Delft*

151

Born 1632 in Delft, died there in 1675. L. Bramer and C. Fabritius have been suggested as possible teachers. Vermeer was a practising art dealer. His expertise as a connoisseur was acknowledged.

Canvas, 98.5x117.5. Signed: *IVM*.
■ coll. J.A. Dissius, Delft, 1682; coll. S.J. Stinstra, Harlingen, 1822; kunsth. De Vries, Amsterdam; purchased by King Willem I in 1822.
● HOFSTEDE DE GROOT 1907-28, I, p. 607, no 48; MARTIN 1935-36, II, p. 186, fig. 93; PLIETSCH 1939, pp. 20, 24, 43, 50, 56, no 42; VRIES 1948, pp. 39, 80, 81, no 9, fig. 35; SWILLENS 1950, pp. 90-93, no 27, figs. 69 A, B; GOWING 1952, pp. 128-130, no 13, pl. 30-32; KÜHN 1968, pp. 184-185; WALSH 1973, no+fig. 30; ROSENBERG, SLIVE & KUILE 1977, pp. 198-199, 248, 327, ill.; WHEELOCK 1977, pp. 291-301; BLANKERT 1978 (2), p. 40, fig. 10; SNOW 1979, pp. 10, 12, 88, 90, 97, 138, 165, 169, fig. 11; WHEELOCK 1981, pp. 94-96, pls. 16-17; A.K. Wheelock & C.J. Kaldenback, *Artibus et Historiae, Rivista internazionale di arti visive e cinema*, 1982, no 6, pp. 9-35, fig. 1.

406

■ | *Diana and her companions*

Canvas, 98.5x105. Indistinctly signed.
■ Dirksen, The Hague; coll. N.D. Goldsmid, The Hague, 1876; purchased in 1876.
● HOFSTEDE DE GROOT 1907-28, I, pp. 588-589, no 3; MARTIN 1935-36, II, pp. 185-186; PLIETSCH 1939, pp. 14, 18, 58, no 5, fig. 2; VRIES 1948, p. 77, no 1; SWILLENS 1950, pp. 63, 64, no A, pl. 33; GOWING 1952, pp. 93-97, no IV, figs. 8, 9; A.B. de Vries, BULL. R.M. 2 (1954), pp. 40-42, ill.; J.Q. van Regteren Altena, O.H. 75 (1960), pp. 182-184, ill.; KÜHN 1968, pp. 155-202; WALSH 1973, no+fig. 18; ROSENBERG, SLIVE & KUILE 1977, p. 195; BLANKERT 1978 (2), pp. 13-17, 155, no 2, ill.; SNOW 1979, p. 36, ill.; W.J. Hofman in: *Fs. Albert Knoepfli, Von Farbe und Farben*, Zürich 1980, pp. 323-328, ill.; WASHINGTON 1980-81, pp. 210-212, no 54, ill.; WHEELOCK 1981, pp. 15, 68, 72, pl. 3.
■ Purchased as Nicolaes Maes

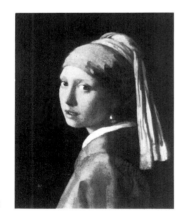

670

■ | *Head of a girl*

Canvas, 46.5x40. Signed: *JVMeer*.
■ bequest of A.A. des Tombe, The Hague, 1903.

● HOFSTEDE DE GROOT 1907-28, I, p. 606, no 44; MARTIN 1935-36, II, p. 186, fig. 94; PLIETZSCH 1939, pp. 28-29, 62, no 37, fig. 25; VRIES 1948, p. 48, no 17, fig. 43; SWILLENS 1950, p. 62, no 28, ill.; GOWING 1952, pp. 137-139, no XXII, figs. 31, 49; KÜHN 1968, pp. 155-202; WALSH 1973, p. 103, fig. 41; ROSENBERG, SLIVE & KUILE 1977, p. 205, fig. 152; BLANKERT 1987 (2), pp. 46, 59, 163, no 18, ill.; SNOW 1979, pp. 1-24, fig. 1; WHEELOCK 1981, pp. 118, 132, pl.28.
► Also known as *The girl with the pearl*.

402

Johannes Vermeulen | *Still life with books and musical instruments*

Documented in Haarlem from 1634 to 1674.

Panel, 81.5x63.5. Signed: *JVM*.
■ coll. N.D. Goldsmid; purchased in 1876.
● LEIDEN 1970, p. 29, no 34, ill.

662

■ | *Still life with books and musical instruments*

Panel, 30x38.5. Signed: *J.V.Meulen*.
■ given on loan in 1901; bequest of A. Bredius, 1946.
● MARTIN 1935-36, I, pp. 418-419, fig. 252; BERGSTRÖM 1956, p. 178; BERGAMO 1981, p. 15, fig. 8.

292

Claude-Joseph Vernet | *An Italian harbour in stormy weather* (formerly: *The harbour of Livorno in stormy weather*)

Born 1714 in Avignon, died 1789 in Paris. Pupil of his father, Antoine. Stayed in Italy between 1734 and 1753. Influenced by Claude, S. Rosa and F. Pannini.

Canvas, 101x138.
■ coll. V. Gonzaga, 1763; Cabinet Prince Willem v.
● INGERSOLL-SMOUSE 1926, no 200; DROSSAERS & LUNSINGH SCHEURLEER 1974-76, III, p. 235, no 169; 's-HERTOGENBOSCH 1984, p. 96, fig. 24, p. 220, no 170.
► Companion piece to no 293.

293

■ | *The waterfalls near Tivoli with the villa of Maecenas*

Canvas, 101x138.
■ coll. V. Conzaga, 1763; Cabinet Prince Willem v.
● INGERSOLL-SMOUSE 1926, no 199; DROSSAERS & LUNSINGH SCHEURLEER 1974-76, III, pp. 235-236, no 170; C.W. Fock, ANTIEK 1976, pp. 177, 135, note 26; *Claude-Joseph Vernet*, Musée de la Marine, Paris 1976-77, ad no 12; 's-HERTOGENBOSCH 1984, p. 201, no 147, ill.
► Companion piece to no 292.

344

Bonifazio Veronese (Bonifazio de' Pitati), Milieu of | *Study of the head of a young woman*

Born 1487 in Verona, died 1553 in Venice, where he worked all his life. Most important pupil of Palma il Vecchio.

Canvas, 53.1x41.3 (oval).
■ British Royal Collection; coll. King-Stadholder Willem III; Nationale Konst-Gallery, 1801-1809; on loan to the Rijksmuseum, Amsterdam (inv.no C1374), since 1948.
● CAT. MAURITSHUIS 1935, p. 29; D. Westphal, *Bonifazio Veronese*, München 1931, pp. 66-67, fig. 2; THIEL 1981, p. 198, no 120, ill.
► The head resembles a figure in *The finding of Moses* by Bonifazio Veronese, Galleria Brera, Milan (inv.no 144).

312

Paolo Veronese (Paolo Caliari), Copy after | *Sts Primus and Felicianus*

Born 1582 in Verona, died 1588 in Venice where he worked from 1553.

Paper on canvas, 94x49 (ends in a round arch).
■ purchased by King Willem I for the Mauritshuis with the Reghellini collection, 1831; on loan to the Ministry of Foreign Affairs, The Hague, since 1912.
► Copy after a painting by Veronese, Museo Civico, Padua (canvas, 350x192, inv.no 172).
Formerly thought to show Sts Cosmas and Damian.

606

Hendrik Verschuring | *Hunters and dogs in an Italian landscape*

Born 1627 in Gorkum, died 1690 in Dordrecht. Pupil of D. Govaertsz., Gorkum, and J. Both, Utrecht. According tot Houbraken he visited Italy, ca 1650. Worked in Gorkum.

Panel, 41.3x31.5. Signed: *H. verschuring f.*
■ donated by A. Stengeling, 1897.
● BOL 1969, p. 266; CAT. MAURITSHUIS 1980, pp. 118-119, 239, ill.

948

Johannes Cornelisz. Verspronck | *Portrait of André de Villepontoux (1616-1663)*

Possibly born between 1606 and 1609 in Haarlem, died there in 1662. Probably pupil of his father Cornelis Engelsz., influenced by F. Hals. Worked in Haarlem.

Panel, 55.6x45. Signed and dated: *Joh.vSpronck an° 1651.*
■ coll. A.M. du Peyrou-de Villepontoux; coll. J. van Breugel-du Peyrou; coll. C. baron van Breugel Douglas; on loan since 1961.
● BERNT 1969-70, III, no 1291, ill.; EKKART 1979, pp. 52, 57, 112, no 80, p. 186, ill.; AMSTERDAM 1984, pp. 143-144, fig. a.
▶ Companion piece to no 949; André de Villepontoux and Maria Hammius married in 1650.

949

■ | *Portrait of Maria Hammius, wife of André de Villepontoux*

Panel, 55.6x45. Signed and dated: *Joh. vSpronck a° 1651.*
■ coll. A.M. du Peyrou-de Villepontoux; coll. J. van Breugel-du Peyrou; coll. C. baron van Breugel Douglas; on loan since 1961.
● EKKART 1979, pp. 52, 57, 112, no 81, p. 187, ill.; AMSTERDAM 1984, pp. 143-144, fig. a.
▶ Companion piece to no 948.

659

Anthonie Verstralen | *Winter scene*

Born ca 1594, probably in Gorkum; died 1641 in Amsterdam. Influenced by H. Avercamp.

Panel, 26.2x43. Signed and dated: *AVS 1603 (1623?).*
■ Donated by Dr. C. Hofstede de Groot, The Hague, 1901.
● BOL 1969, p. 157; BERNT 1969-70, III, no 1294, ill.; CAT. MAURITSHUIS 1980, pp. 119, 240, ill.

542

David Vinckboons | *Country fair*

Born 1576 in Mechelen, died ca 1632 possibly outside Amsterdam. Probably a pupil of his father Philip; contacts with G. van Coninxloo. Worked in Amsterdam from 1591 onwards.

Panel, 40.5x67.5. Signed and dated: *Dvinck-Boors Ano 1629.* Inscribed: *Sotcap.*
■ purchased in 1888.
● K. Goossens, *David Vinckboons*, Antwerp/The Hague 1954, pp. 126-133, fig. 69; BERNT 1969-70, III, no 1310, ill.; SCHNACKENBURG 1981, I, p. 26; PHILADELPHIA 1984, pp. 351-352, no 122, pl. 2.

558

Simon Jacobsz. de Vlieger | *Beach view*

Born ca 1601, probably in Rotterdam, died 1653 in Weesp. Worked in Rotterdam until 1633, in Delft until 1638, then in Amsterdam until 1649 and afterwards in Weesp. Influenced by J. Porcellis.

Panel, 60.6x83.5. Signed and dated: *S. De Vlieger A 1643*.
- coll. A. Bredius; purchased in 1892.
- MARTIN 1935-36, I, pp. 263-264, fig. 150; PRESTON 1937, p. 26, fig. 22; STECHOW 1966, p. 104; BERNT 1969-70, III, no 1316, ill.; BOL 1973, p. 182-183, fig. 184; PRESTON 1974, p. 62; CAT. MAURITSHUIS 1980, pp. 119-121, 241, ill.

203

Hendrick Cornelisz. van Vliet | *View of the Oude Kerk in Delft*

Born 1611/12 in Delft, died there in 1675. According to Houbraken he was a pupil of his father Willem, and of M.J. van Mierevelt. Influenced by Gerard Houckgeest.

Canvas, 77.5x68.2 Indistinctly signed.
- purchased in 1820.
- BERNT 1969-70, III, no 1321, ill.; JANTZEN 1979, pp. 102, 238, no 550, fig. 49; LIEDTKE 1982, pp. 65, 106, no 50, fig. 48.

677

Karel van Vogelaer, Attributed to | *Portrait of a man*

Born 1653 in Maastricht, died 1695 in Rome. Worked in France and especially in Rome, where he was known as Carlo dei Fiori. Collaborated with C. Maratta.

Canvas, 90x72.
- bequest of A.A. des Tombe, 1903.

204

Arie de Vois | *Self-portrait as a hunter*

Born ca 1632 in Utrecht, died 1680 in Leiden. Possibly pupil of N. Knupfer in Utrecht and A. van den Tempel in Leiden; influenced by G. Dou and F. van Mieris. Worked in Leiden, ca 1673 in Warmond.

Panel, 29x22. Signed: *ADVois f.*
- coll. W. Lormier, The Hague, 1763; coll. B. da Costa, The Hague; coll. G. Braamcamp, Amsterdam, 1771; Cabinet Prince Willem V.
- B.J.A. Renckens, O.H. 65 (1950), pp. 160-162; BILLE 1961, I, pp. 39, 112, II, p. 127, no 252; BERNT 1969-70, III, no 1324, ill.; DROSSAERS & LUNSINGH SCHEURLEER 1974-76, III, p. 236, no 171.

404

Elias Vonck | *Dead birds*

Born 1605 in Amsterdam, died there in 1652. Painter of dead game.

Panel, 35.5x54. Formerly signed.
- purchased in 1876.

249

Marten de Vos | *Moses showing the tables of the law to the Israelites*

Born 1532 in Antwerp, died there in 1603. Probably pupil of his father Pieter, influenced by F. Floris, Antwerp. Visited Italy, possibly with P. Brueghel the Elder, ca 1552/58. Worked in Antwerp, where he had many pupils.

Panel, 153x237.5. Dated: *1574/5*. Inscribed on the original frame: *Als Moysi den tweedemaal die tafelen des weets van den Heere op den berch Synai ontfangen/hadde is nederghecomen en heeft gheheel Israel vergaedert/ende heeft haer die gheboden des Heeren voer ghehouden opdat sy maken souden allen sieraten/des tabernakels die de Heere bevolen hadde Moysi te doene. Exodus 34.35.* (When Moses came down from Mount Sinai the second time with the tables of the law the Lord had given him, gathered all the children of Israel and held up the Lord's commandments. For them to make all the adornments for the tabernacle as the Lord had commanded Moses).
▪ coll. Panhuys since the 16th century; bequest of jhr P. van Panhuys, Leiden, 1836.
● CAT. MAURITSHUIS 1968, pp. 51-53, ill.; A. Zweite, *Marten de Vos als Maler*, Berlin 1980, pp. 288-289, no 59, fig. 73; J.W. Zondervan, *Jaarboek van het Centraal Bureau voor Genealogie en het Iconografisch Bureau* 36 (1982), pp. 74-116.
▶ This painting contains many portraits of the Panhuys family: Peeter (1529-1585) and Margarita Panhuys, their children and relatives.

259

Pauwel de Vos | *Deer hunt*

Born ca 1596, died 1678 in Antwerp. Pupil of D. van Hove and D. Remeeus; influenced by F. Snijders. Worked in Antwerp.

Canvas, 212x349.
▪ Coll. P. de la Court van der Vaart, Leiden, 1766; coll. G. Braamcamp, Amsterdam, 1771;
● BILLE 1961, I, p. 105, II, p. 118, no 207; DROSSAERS & LUNSINGH SCHEURLEER 1974-76, III, p. 231, no 148.
▶ The landscape is by J. Wildens. A study of the dog in the Koninklijk Museum van Schone Kunsten, Antwerp.

740

▪ | *Hunting dogs chasing up partridges*

Canvas, 112.5x251.3.
▪ bequest of R.T. baron van Pallandt van Eerde, 1913.

955

Huygh Pietersz. Voskuyl | *Self-portrait*

Born ca 1592/93 in Amsterdam, died there in 1665. Pupil of P. Isaaksz. in Amsterdam.

Panel, 42.4x31.9. Signed and dated: *HP voskuijl fe Ao. 1638 AETATIS SUAE 46*.
▪ kunsth. S. Nystad, The Hague; purchased in 1963.
● I.H. van Eeghen, *Amstelodamum 50* (1963), pp. 123-129; DELFT 1964, p. 96, no 116; CAT. MAURITSHUIS 1970, no 22, ill.
▶ On the man's stock the house-mark of his family.

205

Roelof Jansz. van Vries | *Herdsmen with cattle*

Born ca 1630/31, probably in Haarlem, died after 1681, probably in Amsterdam. Influenced by J. van Ruisdael. Worked in Leiden and Amsterdam.

Canvas, 66x80.5. Signed: *R. Vries.*
▪ purchased in 1873.
● CAT. MAURITSHUIS 1980, pp. 121, 242, ill.

206

Jan Weenix | *Dead swan*

Born 1642 in Amsterdam, died there in 1719. Pupil of his father Jan Baptist, and possibly of his uncle Gijsbert d'Hondecoeter. Worked in Utrecht (1664-1668), Amsterdam and Düsseldorf (1702-1712).

Canvas, 245.5x294. Signed: *J.Weenix fc.*
■ St. Sebastiaansdoelen, Amsterdam; purchased in 1821.
● MARTIN 1935-36, III, p. 441, fig. 233; PLIETZSCH 1960, p. 163, fig. 289; SCHLOSS 1982, p. 52, note 34.

207

■ | *Hunting still life*

Canvas, 79.2x69.5.
■ coll. P. de la Court van der Voort, Leiden, 1766; Cabinet Prince Willem V.
● DROSSAERS & LUNSINGH SCHEURLEER 1974-76, III, p. 238, no 176.

642

■ | *Dead hare*

Canvas, 115.3x92.3. Signed and dated: *J. Weenix. f 1689.*
■ gift of Dowager C.J. van Lynden van Pallandt, 1900.

788

■ | *Still life with game and fruit*

Canvas, 121x98. Signed and dated: *J. Weenix f 1704.*
■ coll. Van Heteren Gevers. The Hague, 1809; Rijksmuseum, Amsterdam, inv.no A463; on loan since 1925.
● MOES & BIEMA 1909, pp. 155, 166; CAT. RIJKSMUSEUM 1976, p. 596.

901

Jan Baptist Weenix | *Italian landscape with inn and ruins*

Born 1621 in Amsterdam, died ca 1660 in Huis ter Mey, near Utrecht. According to Houbraken pupil of J. Micker, A. Bloemaert and N. Moeyaert. He was probably in Italy from 1643 to 1647. His work is related to J. Asselijn and C.P. Berchem.

Panel, 68.2x87.2. Signed and dated: *Gio Batta Weenix f. A° 1658 10m/20d in het huys ter Mey.*
■ coll. Randon de Boisset, Paris, 1777; coll. Van Pallandt, 1900; coll. Van Regteren Limpurg-van Lynden; kunsth. S. Nystad, The Hague, 1946; purchased in 1952.
● W. Stechow, *Art Quarterly* 11 (1948), p. 188, figs. 7, 8; CAT. MAURITSHUIS 1970, no 44, ill.; PARIS 1970-71, p. 240; BLANKERT 1978 (1), pp. 183-184, no 105, ill.; C. Schloss, O.H. 97 (1983), pp. 70, 78, fig. 28.

940

■ | *Dead partridge*

Canvas, 50.6x43.5. Signed: *Gio.Batta:Weenix f.*
■ coll. Wttewael van Stoetwegen, Laren; kunsth. S. Nystad, The Hague; purchased by the Johan Maurits van Nassau Foundation and given on permanent loan, 1960.
● BOL 1969, p. 282; CAT. MAURITSHUIS 1970, no 45, ill.; ROSENBERG, SLIVE & KUILE 1977, pp. 342-343.

1058

■ + Claes Pietersz. Berchem | *The calling of St Matthew*

See C.P. Berchem

208

Adriaen van der Werff | *Portrait of a man*

Born 1659 in Kralingen, died 1722 in Rotterdam. Pupil of C. Picolet and E. van der Neer. Worked in Rotterdam. From 1697 onwards court painter to Johann Wilhelm, Elector Palatine, who knighted him. Was architect as well. Visited Düsseldorf several times.

Canvas, 48.5x39.5. Signed and dated: *Adrn.vand.Werff fec ano. 1689.*
■ purchased in 1822.
● HOFSTEDE DE GROOT 1907-28, X, p. 289, no 201; ROTTERDAM 1973, p. 23, no 27, fig. 7.

209

■ | *The flight to Egypt*

Panel, 47x36.5. Signed and dated: *Chevr.vr.werff.fe.ano 1710.*
■ Cabinet Prince Willem V.
● N. de Roever, O.H. 5 (1887), pp. 67-71; HOFSTEDE DE GROOT 1907-28, X, pp. 247-248, no 41; E. Plietzsch, *Art Quarterly* 14 (1951), p. 146; ROTTERDAM 1973, p. 21, no 18, fig. 14.
▶ A preliminary drawing in Paleis voor Schone Kunsten, Brussels.

210

Jan Jansz. Westerbaen the Elder | *Portrait of Arnoldus Geesteranus (1593-1658)*

Born ca 1600 in The Hague, died there in 1686. Pupil of E.C. van der Maes in 1619.

Panel, 67.5x57.5. Signed and dated: *Ao 1647 W.*
■ gift of H.P. van Ede van de Pals to King Willem III, 1863, who transferred the work to the Mauritshuis.
▶ Geesteranus was a Remonstrant minister who was imprisoned at Loevestein from 1624 to 1631. Companion piece to no 211.

211

■ | *Portrait of Susanna Pietersdr. Oostdijk (b.1597), wife of Arnoldus Geesteranus*

Panel, 67.5x57.5. Signed and dated: *I.W.B. 1647.*
■ gift of H.P. van Ede van de Pals to King Willem III, 1863, who transferred the work to the Mauritshuis.
▶ Arnoldus Geesteranus and Susanna Oostdijk married in 1627. Companion piece to no 210.

264

Rogier van der Weyden | *Lamentation of Christ with the donor Pierre de Ranchicourt and saints*

Born ca 1400 in Tournai, died 1464 in Brussels. Pupil of R. Campin, Tournai. Worked in Brussels. He travelled to Italy in 1450.

Panel, 80.7x130.3.

■ Arras college, Louvain; purchased in 1827.

● E. Panofsky, ART BULL. 33 (1951), p. 33, fig. 6; FRIEDLÄNDER 1967-76, II,
p. 69, no 46, p. 93, p. 100, note 44, pl. 68; CAT. MAURITSHUIS 1968, pp. 54-
56, ill.; M. Davies, *Rogier van der Weyden*, London 1972, p. 216, pl. 119; O.
Kerber, *Giessener Beiträge zur Kunstgeschichte* 3 (1975), pp. 18-20, fig. 8;
SILVER 1984, p. 205 pl. 22.

▶ De Ranchicourt was appointed Bishop of Arras in 1463. The painting was
probably completed by the pupils of Van der Weyden after his death.

469

Thomas Wijck | *The alchemist*

Born ca 1616 in Beverwijk, died 1677 in Haarlem. It is uncertain whether
Wijck visited Italy. Worked in Haarlem from 1642 onwards. Ca 1660 he
spent some years in England.

Panel, 48.5x41.

■ purchased in 1882.

● J. van Lennep, REVUE BELGE 35 (1966), p. 161, note 4, ill. of a print after
this painting on p. 158.

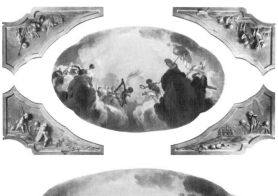

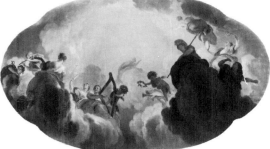

731-735

Jacob de Wit | *Ceiling painting. Apollo surrounded by the nine muses* (centre
piece); *the pastoral song; the epos; the comedy; the elegy* (corner pieces)

Born 1695 in Amsterdam, died there in 1754. Pupil of A. van Spiers,
Amsterdam, and J. van Hal, Antwerp; influenced by the art of Rubens and
A. van Dyck. Returned to Amsterdam 1717.

Canvas, 395x636 (oval). Signed and dated: *I D Wit F. 1743* (center piece).
Canvas, 270x398 (triangle; grisaille; corner pieces).

■ made for Diederik van Leyden van Vlaardingen, Rapenburg 48, Leiden;
purchased in 1910.

● STARING 1958, pp. 79, 86, 112, 152, fig.

▶ The muses (centre piece), from left to right: Calliope, Euterpe,
Terpsichore, Polyhymnia, Erato, Clio, Melpomene, Thalia and Urania.

159

473

Emanuel de Witte | *Interior of an imaginary Catholic church*

Born ca 1616 in Alkmaar, died 1691/92 in Amsterdam. Worked in Alkmaar, Rotterdam, Delft, and from 1652 onwards in Amsterdam. Influenced by G. Houckgeest.

Canvas, 110x85. Signed and dated: *E.De Witte fecit Ao 1668.*
■ purchased in 1883.
● MARTIN 1935-36, II, p. 410, fig. 215; MARTIN 1950, p. 110, no 293; MANKE 1963, pp. 46, 115, no 156, fig. 68; JANTZEN*1979, pp. 123, 241, no 630, fig. 61; LIEDTKE 1982, pp. 89, 95, 96, fig. 90.

824

■ | *The Oude Kerk in Amsterdam during a service*

Canvas, 50x41.5.
■ purchased with the aid of the Rembrandt Society, 1936.
● MANKE 1963, p. 41, no 59, fig. 19; JANTZEN 1979, pp. 118-119, 241, no 616; LIEDTKE 1982, pp. 87-88.

267

Victor Wolfvoet | *Abraham and Melchizedek*

Born 1612 in Antwerp, died there in 1652. Influenced by Rubens.

Copper, 37.5x27.5. Signed: *V.W.*
■ Nationale Konst-Gallery, The Hague.

● HELD 1980, I, pp. 143-144; THIEL 1981, p. 199, no 122, ill.
► Companion to no 268.
Copy after a sketch by Rubens in the Fitzwilliam Museum, Cambridge.

268

■ | *The rain of manna*

Copper, 37.5x27.5.
■ Nationale Konst-Gallery, The Hague.
● HELD 1980, I, p. 148; THIEL 1981, p. 198, no 118, ill.
► Companion piece to no 267.
Copy after a sketch by Rubens in the Musée Bonnat, Bayonne.

214

Philips Wouwermans | *The arrival in the stable*

Born 1619 in Haarlem, died there in 1668. According to Cornelis de Bie he was a pupil of F.Hals, Haarlem and E. Decker, Hamburg. Influenced by P. van Laer.

Panel, 43x58.8. Signed twice: *PHILS. W.*
■ coll. G. van Slingelandt, The Hague, 1768; Cabinet Prince Willem v.
● HOFSTEDE DE GROOT 1907-28, II, p. 394, no 487; MARTIN 1935-36, II, p. 364; MARTIN 1950, p. 78, nos 144, 145, ills.; DROSSAERS & LUNSINGH SCHEURLEER 1974-76, III, p. 239, no 184 (or 185); CAT. MAURITSHUIS 1980, pp. 129, 253, ill.
► Companion piece to no 215.

215

■ | *The departure from the stable*

Panel, 43x59. Signed: *PHILS. W.*

■ coll. G. van Slingelandt, The Hague, 1768; Cabinet Prince Willem v.

● HOFSTEDE DE GROOT 1907-28, II, pp. 394-395, no 488; MARTIN 1935-36, II, p. 364; MARTIN 1950, p. 77, no 143, ill.; DROSSAERS & LUNSINGH SCHEURLEER 1974-76, III, p. 239, no 185 (184); CAT. MAURITSHUIS 1980, pp. 129-130, 253, ill.

▸ Companion piece to no 214.

216

■ | *Falconry*

Panel, 39.5x50.5. Signed: *PHILS.W.*

■ coll. Prince De Carignan, Amsterdam, 1749; Het Loo, 1757; Stadholder's Quarter, The Hague, 1763; Cabinet Prince Willem v; on loan to the Gemeentemuseum, Arnhem, since 1952.

● HOFSTEDE DE GROOT 1907-28, II, p. 453, no 652, p. 461, no 676; DROSSAERS & LUNSINGH SCHEURLEER 1974-76, II, p. 644, no 96, III, p. 18, no 4, p. 239, nr. 182; CAT. MAURITSHUIS 1980, pp. 127-128, 250, ill.

217

■ | *The riding school*

Canvas, 66x76.2. Signed: *PHILS.W.*

■ coll. G. van Slingelandt, The Hague, 1768; Cabinet Prince Willem v.

● HOFSTEDE DE GROOT 1907-28, II, p. 265, no 51; DROSSAERS & LUNSINGH SCHEURLEER 1974-76, III, p. 239, no 183; CAT. MAURITSHUIS 1980, pp. 217, 251, ill.

218

■ | *The hay wagon*

Panel, 40x48. Signed: *PHILS.W.*

■ coll. W. Lormier, The Hague, 1763; coll. G. van Slingelandt, The Hague, 1768; Cabinet Prince Willem v.

● HOFSTEDE DE GROOT 1907-28, II, p. 558, no 937; BERNT 1969-70, III, no 1429, ill.; DROSSAERS & LUNSINGH SCHEURLEER 1974-76, II, p. 239, no 186; CAT. MAURITSHUIS 1980, pp. 126-127, 248, ill.

219

■ | *Cavalry battle*

Canvas, 127x245. Signed: *PHILS.W.*

■ Cabinet Prince Willem v.

● HOFSTEDE DE GROOT 1907-28, II, pp. 484-485, no 746; MARTIN 1935-36, II, pp. 362-363, fig. 196; BERNT 1969-70, III, no 1428; DROSSAERS & LUNSINGH SCHEURLEER 1974-76, III, p. 28, no 192, p. 238, nr. 177; CAT. MAURITSHUIS 1980, pp. 126, 247, ill.

220

■ | *Army camp*

Canvas, 70x100. Signed: *PHILS.W.*

■ Het Loo, 1757; Cabinet Prince Willem v.

● HOFSTEDE DE GROOT 1907-28, II, p. 526-527, no 853; DROSSAERS & LUNSINGH SCHEURLEER 1974-76, II, p. 644, no 95, p. 652, no D, III, p. 18, no 3, p. 238, no 180; CAT. MAURITSHUIS 1980, pp. 128-129, 252, ill.

221

■ | *Hunting party at rest*

Panel, 35x40.5. Signed: *PHILS* (partly cut off).
■ Cabinet Prince Willem V.
● HOFSTEDE DE GROOT 1907-28, II, pp. 453-454, no 653; DROSSAERS & LUNSINGH SCHEURLEER 1974-76, III, p. 238, 179; CAT. MAURITSHUIS 1980, pp. 127, 249, ill.

222

■ | *Hunters at rest*

Panel, 35x44. Signed: *PHW*.
■ Het Loo 1657; Cabinet Prince Willem V.
● HOFSTEDE DE GROOT 1907-28, II, p. 454, no 654; MARTIN 1950, no 141, ill.; DROSSAERS & LUNSINGH SCHEURLEER 1974-76, II, p. 640, no 34, p. 652, no C, III, p. 18, no 6, p. 238, no 181; CAT. MAURITSHUIS 1980, pp. 125-126, 246, ill.

223

Joachim Antonisz. Wtewael | *Mars and Venus surprised by Vulcan*

Born 1566 in Utrecht, died there in 1638. Pupil of his father and of J. de Beer. Influenced by A. Bloemaert. Was in Italy and France between 1586 and 1590.

Copper, 21x15.5. Signed and dated: *IOACHIM WTE/WAEL ECIT 1601*.
■ Het Loo, 1763.

● C.M.A.A. Lindeman, *J.A. Wtewael*, Utrecht 1929, pp. 70-72, 251, no XXI; A. Lowenthal, *The paintings of Joachim Anthonisz. Wtewael (1566-1638)*, New York 1975 (diss.), pp. 86, 195-197, no A-17; DROSSAERS & LUNSINGH SCHEURLEER 1974-76, II, p. 646, note 146; J. Foucart, *Revue du Louvre* 31 (1981), p. 119.

212

Jan Wijnants | *Forest edge*

Possibly born ca 1625 in Haarlem, died 1684 in Amsterdam. Initially influenced by the early work of J. van Ruisdael. Worked in Haarlem until 1659, then in Amsterdam. According to Houbraken, A. van de Velde, Wijnant's pupil, painted staffage figures in his works.

Canvas, 67x87. Signed and dated: *J. Wijnants/1659*.
■ purchased in 1829.
● HOFSTEDE DE GROOT 1907-28, VIII, p. 582, no 481; CAT. MAURITSHUIS 1980, pp. 123-124, 244, ill.

213

■ | *Road in the dunes*

Canvas, 77.2x101.5. Signed and dated: *J. Wijnants.f.Ao 1675*.
■ purchased in 1830.
● HOFSTEDE DE GROOT 1907-28, VIII, p. 595, no 536; CAT. MAURITSHUIS 1980, pp. 124, 245, ill.

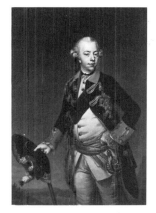

462

Johann Georg Ziesenis | *Portrait of Willem V (1748-1806), Prince of Orange-Nassau*

Born 1716 in Copenhagen, died 1776 in Hanover. Pupil of his father. Worked in The Hague from 1765, then in Hanover, Braunschweig and Berlin.

Canvas, 141x101.
■ unknown.
► A replica is in the Dutch royal collection.
Companion piece to no 463.

463

■ | *Portrait of Frederika Sophia Wilhelmina (1751-1820), Princess of Prussia, wife of Prince Willem V*

Canvas, 141x101.
■ unknown.
► A replica is in the Dutch royal collection. A miniature after this painting is in the Rijksmuseum, Amsterdam (Holland school ca 1770; inv.nr. A4453). Companion piece to no 462.

350

Francesco Zuccarelli | *A ford in the forest*

Born 1702 in Pittigliano, Tuscany, died 1788 in Florence. Trained in Florence and Rome. Worked several times in England, and from 1730 mostly in Venice.

Canvas, 111x131.
■ purchased by King Willem I for the Mauritshuis with the Reghellini collection, 1831; on loan to the Ministry of Economic Affairs, The Hague, since 1938.
● THIEME-BECKER 1907-1947. XXXVI, p. 570; DONZELLI 1957, p. 266.

675

Bernard Zwaerdecroon | *Portrait of two children as shepherds*

Born 1617 in Utrecht, died there in 1654. Worked in Utrecht. Painted mainly portraits.

Canvas, 145x159.5. Signed: *BZ*.
■ bequest of A.A. des Tombe, The Hague, 1903; on loan to the Centraal Museum, Utrecht, since 1931.
● C. Hofstede de Groot, O.H. 13 (1895), p. 47; KETTERING 1983, pp. 66, 79, fig. 74.

790

Master of Alkmaar | *Triptych with the Adoration of the kings, departure of the kings at left, group of horsemen at right.* Verso wings: *St Anthony Abbot and St Adrian*

Documented from 1502, died 1540 in Haarlem. May be identical to C. Buys, brother of J. Cornelisz. van Oostsanen, or to P. Gerritz. Worked in Haarlem; executed commissions in Alkmaar and for the Abbey of Egmond.

Panel, centre 48x36.8, wings 45.5x14. Signed with the painter's mark.
■ donated by J.H. van Heek, Lonneker, 1926; on loan to the Rijksmuseum, Amsterdam, since 1948, inv.no C1364.
● CAT. MAURITSHUIS 1935, p. 193; N.F. van Gelder-Schrijver, O.H. (1930), p. 115; HOOGEWERFF 1936-47, II, p. 369; FRIEDLÄNDER 1967-76, X, pp. 25, 73-74, no 49, pl. 28-29; CAT. RIJKSMUSEUM 1976, p. 629, ill.; COLOGNE 1982, pp. 202-203, cat. no 82, ill.
► Although the wings also bear the painter's mark, they were in fact painted by another artist, from Bruges; they were formerly attributed to A. Isenbrandt.

844

Master of the legend of St Barbara | *Sacrifice to a heathen god*

Active ca 1445-1470 in the territory of the Duke of Burgundy. Influenced by R. van der Weyden.

Panel, 97x69.

● Rijksmuseum, Amsterdam, inv.no A2057; on loan since 1948.
● FRIEDLÄNDER 1967-76, IV, p. 79, no 66, pl. 62; CAT. MAURITSHUIS 1968, p. 31, ill.
► Formerly thought to represent the idolatry of Solomon. Possibly an episode from the life of St Géry, Bishop of Courtrai. The identification of the subject and dating of ca 1448 are based on the painting's similarity to a miniature in the manuscript of Jean Wauquelin's translation of the *Chroniques de Hainaut* by Jacques de Guise, ca 1446/48. The subject of the miniature is De opperpriester der Belgen raadpleegt de godin Diana (The high priest of the Belgians consulting the goddess Diana).

752

Master of the Brandon portrait | *Man with a Samson medal*

Flemish master, influenced by G. David. Probably worked at the English court about 1510-1530.

Panel, 34x24.7.
■ coll. A. Pallavicini-Grimaldi, Genoa, 1899; coll. L. Nardus, Paris; purchased with the aid of the Rembrandt Society and friends of the museum, 1916.
● W. Martin, BULL. N.O.B. 10 (1917), pp. 214-219, ill.; W. Martin, JAARVERSL. VER. REMBRANDT 1917, p. 6, ill.; M.J. Friedländer, GENTSE BIJDRAGEN 4 (1937), p. 12; CAT. MAURITSHUIS 1968, pp. 32-33, ill.
► Formerly attributed to A. Cornelis, has also been attributed to the Master of Bruges; attributed to the Master of the Brandon portrait by Friedländer.

845

Master of the female half-lengths | *Madonna and child*

Active in Flanders ca 1520-1540.

Panel, 24x19.
■ Rijksmuseum Amsterdam, inv.no A3130; on loan since 1948.
● FRIEDLÄNDER 1967-76, XII, p. 96, no 61, p. 144, note 61; CAT. MAURITSHUIS 1968, pp. 36-37, ill.; CAT. RIJKSMUSEUM 1976, p. 633, ill.

536

■ | *Landscape with soldiers at rest*

Canvas, 93x86.
■ From the Cabinet of Her Majesty at the Korte Vijverberg, The Hague, 1886; on loan to the Kantongerecht, The Hague.
► Formerly attributed to J.P. Schoeff (1608?-after 1666).

694

■ | *Vanitas*

Panel, 34.2x26 (ends in a round arch.). Inscribed: *Momento Mori*.
■ bequest of T.H. Blom Coster, The Hague, 1904.
● E. Weiss, *Jan Gossaert, sein Leben und seine Werke*, Parchim i.M. 1913, p. 77; WETSHOF-KRUMMACHER 1965, pp. 88-89, note 121, no 5; CAT. MAURITSHUIS 1968, pp. 50-51, ill.

695

■ | *Portrait of a lady*

Canvas, 112.3x94. Inscription on the skull: *Sum quod eris* (I am what you shall be).
■ bequest of T.H. Blom Coster, The Hague, 1904.
● E. Greindl, *Corneille de Vos*, Strassburg 1944, p. 107; J. Held, O.H. 80 (1965), p. 113.
► Formerly attributed to Cornelis de Vos.

702

■ | *Portrait of a lady encircled by a wreath of flowers*

Panel, 36.7x27.5.
■ bequest of Miss J.C.H. Roels, The Hague, 1906.
► Companion piece to no 703.

703

■ | *Portrait of a man encircled by a wreath of flowers*

Panel, 37.2x27.8.
■ bequest of Miss J.C.H. Roels, The Hague, 1906.
► Companion piece to no 702.

725

■ | *The lamentation*

Panel, 19.2x15.5 (ends in a round arch).
■ bought by A. Bredius in Ronda, Spain; given on loan, 1907; bequest A. Bredius, 1946.
● MARLIER 1957, pp. 92-93, no 46, fig. VI; V. Loewinson-Lessing, N. Nicouline, *Les primitifs flamands: Le musée de l'Ermitage, Leningrad*, Brussels 1965, p. 23; CAT. MAURITSHUIS 1968, p. 12, ill.
► School of Bruges. Formerly attributed to A. Isenbrandt and to A. Benson. This composition, of which there are many other versions, is based on paintings with the same subject by G. David.

741

Monogrammist AVE | *Italian landscape with hunting party*

Possibly identical with Adriaen van Emont (Dordrecht ca 1626-1662 Dordrecht).

Canvas, 67.3x97. Formerly falsely signed: *JBoth*.
■ bequest of Baron R.T. van Pallandt van Eerde, 1913.
● B.J.A. Renckens, o.h. 69 (1954), p. 123; CAT. MAURITSHUIS 1980, pp. 130-131, ill. p. 255.
► Formerly attributed to Ludolf de Jongh.

692

Monogrammist B.E. | *The rumble-pot player* (formerly: *The noisemaker*)

Follower of F. Hals

Canvas, 97x81. Signed: *B.E.*
■ bequest of T.H. Blom-Coster, The Hague, 1904; on loan to the Rijksdienst Beeldende Kunst, The Hague.
► The only known work of this artist.

960

Braunschweig monogrammist | *Ecce homo*

Active in the second quarter of the 16th century, probably in Antwerp. Can possibly be identified with Jan van Amstel.

Panel, 55x89.5.
■ Rijksmuseum, Amsterdam, inv.no A1603; on loan since 1963.
● CAT. MAURITSHUIS, 1968, pp. 13-14, ill.; P. Wechser, J. BERLINER MUSEEN 12 (1970), pp. 50-53; J.A. Emmens, ALB. AMIC. VAN GELDER 1973, pp. 98-99, fig. 16; K.P.F. Moxey, JAARBOEK ANTWERPEN 1976, pp. 109-112, fig. 2; R. Genaille, BULL. MUS. ROY. BELG. 23-29 (1974-80), pp. 66-67, 82, 85, 92, no 4, fig. 3; CAT. RIJKSMUSEUM 1976, p. 626, ill.; CAT. MAURITSHUIS 1977, p. 56, ill.; R. Genaille, JAARBOEK ANTWERPEN 1979, p. 159; R. Genaille, JAARBOEK ANTWERPEN 1981, p. 81.
► There are several versions of this work.

105

Dutch school | *Portrait of James I, King of England (1566-1625)*

Canvas, 62x51.5. Inscribed: *1614. Jacqves.Roy.de.la.Grande Bretaigne.*
▪ traditionally said to be from Honselaarsdijk Castle; no evidence to be found. Since 1875 in the Mauritshuis; on loan to the Stedelijk Museum het Prinsenhof, Delft, since 1957.
▸ James I is wearing the Order of the Garter.

229

■ | *Simeon and the Christ child*

Copper, 17x13.
▪ unknown.

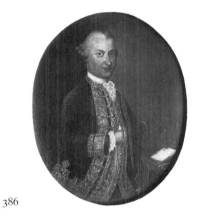

386

■ | *Portrait of a man*

Panel, 25.5x21 (oval).
▪ unknown.

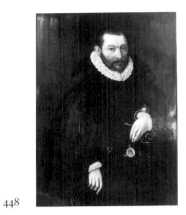

448

■ | *Portrait of François de Virieu (died 1596), majordomo of Prince Willem I*

Panel, 95.5x71.5.
▪ donated by the heirs of F.W. de Virieu, 1879; on loan to the Maarten van Rossum Museum, Zaltbommel.
▸ Companion piece to no 449. François de Virieu and Françoise de Witte married in 1572.

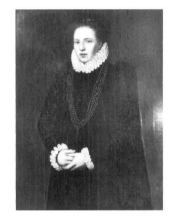

449

■ | *Portrait of Françoise de Witte (died 1605/06), wife of François de Virieu*

Panel, 95.5x71.5.
▪ donated by the heirs of F.W. de Virieu, 1879; on loan to the Maarten van Rossum Museum, Zaltbommel.
▸ Companion piece to no 448.

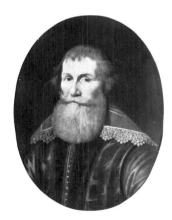

496

■ | *Portrait of Cornelis Haga (1578-1654), Dutch legate in Stockholm and Constantinople*

Panel, 62x46.5 (oval).
▪ donated by Mrs A.J.S. Dibbets-Kaas, in memory of her son J.E. Dibbets, 1873; on loan to the Rijksmuseum, Amsterdam, since 1933 (inv.no C1225).
● CAT. RIJKSMUSEUM 1976, p 661, ill.

504

■ | *Portrait of Princess Anne of England (1709-1759), wife of Stadholder Willem IV*

Canvas, 82x70.
■ unknown; on loan to the Rijksdienst Beeldende Kunst.
► Copy after J.F.A. Tischbein.

540

■ | *Portrait of Adriana Johanna van Heusden (1741-1800), wife of Johan Arnold Zoutman*

Pastel, 35.5x28.5. Inscription illegible.
■ donated by jhr V. de Stuers, 1887, together with a portrait of her husband, Vice-Admiral Johan Arnold Zoutman, by P.F. de la Croix (no 539); on loan to the Nederlands Scheepvaartmuseum, Amsterdam, since 1931 (inv.no B 179 (2)).

547

■ | *Merry company*

Panel, 38.5x54. Formerly falsely signed: *G. Metsu.*
■ coll. F. Kayser; purchased in 1889; on loan to the Amsterdams Historisch Museum.
► Later attributed to M. Naiveu.

561

■ | *Portrait of Stadholder Willem V (1748-1806)*

Pastel, 52.5x54 (oval).
■ unknown; on loan to the Raad van State, The Hague, since 1922.

603

■ | *A child of the Honigh family on its deathbed*

Panel, 45.5x57.6.
■ donated by C.L.M. Lambrechtsen van Ritthem, Amsterdam, 1895.
● H.P. Bremmer, *Beeldende Kunst* 4 (1917), vol. 7, pp. 80-81, no 54.

610

■ | *Study of an old woman*

Panel, 19.7x15.8.
■ coll. Sideroff, St Petersburg; coll. A. Bredius; given on loan in 1897; bequest of A. Bredius, 1946.
● BROWN 1981, p. 133, no R8, fig. 66.
Formerly attributed to Rembrandt and to C. Fabritius. Neither attribution is tenable.

626

■ | *Minerva*

Panel, 61.7x53.5.
■ coll. A. Bredius; given on loan in 1899; bequest of A. Bredius, 1946.
● HOFSTEDE DE GROOT 1907-28, VI, p. 467; VRIES 1978, pp. 194-199, no 2, ill.; SUMOWSKI 1983, p. 525, no 242, ill.; J. Bruyn, O.H. 98 (1984), p. 161.
► Circle of Rembrandt; the attribution to Rembrandt by A. Bredius was disputed by Hofstede de Groot and is presently not accepted. May have been painted by H. Pot. Sumowski attributed the painting to G. Dou, which is not accepted by J. Bruyn.

654

■ | *Vanitas*

Canvas, 45x56.
■ coll. A. Bredius; given on loan, 1901; bequest of A. Bredius, 1946.

674

■ | *Town on a river*

Panel, 35x54. Signature illegible and dated: *1637* (?).
■ bequest of A.A. des Tombe, The Hague, 1903; on loan to the Ministry of General Affairs, The Hague.
► Formerly attributed to J. van Goyen.

680

■ | *Donkey and children at play*

Canvas, 113x122.5 (grisaille).
■ bequest of A.A. des Tombe, The Hague, 1903; on loan to the Dutch embassy in Athens.

701

■ | *Old man with a tankard and pipe*

Panel, 31x24.5.
■ donated by L. Nardus, Arnouville, 1906; on loan to the Ministry of Economic Affairs, The Hague.

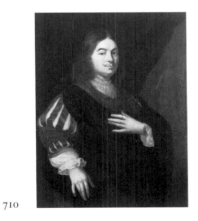

710

■ | *Portrait of Diederick Hoeufft (1610-1688)*

Panel, 43.5x32.5.
■ bequest of Miss M.J. Singendonck, 1907; on loan to the Museum Mr Simon van Gijn, Dordrecht.
► Companion piece to no 711. Probably painted ca 1680 after an original of ca 1650. The sitter is the father of the man in no 780, a portrait by Schalcken.

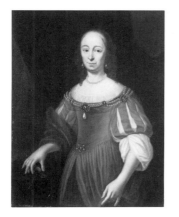

711

■ | *Portrait of Marie de Witt (1620-1681), wife of Diederick Hoeufft*

Panel, 43.5x32.5.
■ bequest of Miss M.J. Singendonck, 1907; on loan to the Museum Mr Simon van Gijn, Dordrecht.
▶ Companion piece to no 710.

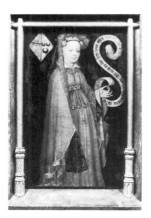

831

■ | *Portrait of Lysbeth van Duvenvoorde (died 1472)*

Parchment, 32.5x20.5; inscribed: *Mi verdriet lange te hopen-Wie is hi die sijn hert hout open* (To hope for long grieves me- who is keeping his heart free).
■ purchased in 1944; on loan to the Rijksmuseum, Amsterdam, since 1959 (inv.no C454).
● HOOGEWERFF 1936-47, p. 50, fig. 23; M.M. Tóth-Ubbens, O.K. 12 (1968), pp. 2-2a; CAT. RIJKSMUSEUM 1976, p. 651, ill.
▶ Coat of arms showing alliance Van Adrichem-Van Duvenvoorde. Left wing of a diptych; right wing (location unknown) portraying Symon van Adrichem, whom the sitter married in 1430, according to the inscription on the back of the painting.

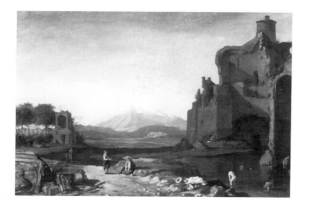

932

■ | *Italian landscape* (formerly: *Landscape with the Aurelian wall*)

Canvas, 52x79.
■ coll. P. de la Court van der Voort, Leiden; coll. Wyndham, Somerset until 1953; kunsth. A. Brod, London; purchased in 1958.

● M. Kitson, *Connoisseur* 1955, pp. 30-35, ill.; (A. Blankert), *Nederlandse 17e eeuwse italianiserende landschapsschilders*, Centraal Museum, Utrecht 1965, pp. 83-86, no 30, fig. 31; E. Brochhagen, *Kunstchronik* 18 (1965), p. 179; J. Nieuwstraten, BURL. MAG. 107 (1965), pp. 272-273; CAT. MAURITSHUIS 1980, pp. 131-132, ill.; M. Roethlisberger, *Bartholomeus Breenbergh: The paintings*, Berlin/New York 1981, p. 101, no 306.
▶ Attributed to B. Breenbergh until 1965, when Blankert ascribed it to an unknown Dutch master of the 1630s. Since then many tentative attributions have been made, none of them convincing.

967

■ | *Country house and park*

Panel, 50.5x69.2.
■ donated by kunsth. E. Speelman, London, 1963.
● MAURITSHUIS 1970, no 49.
▶ Has been attributed to Johan Post (1639 - ca 1690). Possibly not Dutch and not 17th-century.

1042

■ | *Allegory of peace*

Canvas, 118x79.
■ unknown.

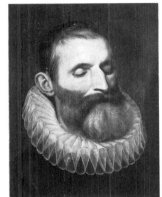

227

Flemish school | *Portrait of a deceased man*

Panel, 39.5x32. Dated: *1617*.
- donated by Van Eersel, Antwerp, to King Willem I, 1817, who added it to the Mauritshuis collection.

230

■ | *Portrait of an officer*

Canvas, 89x69.
- unknown; on loan to the Raad van State, The Hague, since 1922.

235

■ | *Banquet of the gods* (possibly *The banquet of Achelous*)

Panel, 53x77.5.
- purchased by King Willem I for the Mauritshuis with the Reghellini collection, 1831.
- ERTZ 1979, pp. 415, 536, note 670; HÄRTING 1983, no B 222.
▸ Formerly attributed to H. van Balen, the landscape to J. de Momper. Härting suggests Jan van Balen with the landscape by Lucas van Uden.

319

■ | *The penitent St Magdalene*

Panel, 67x52.
- uncertain.
- THIEL 1981, p. 196, no 106, ill.

353

■ | *Cupid asleep*

Canvas, 62x65
- Nationale Konst-Gallery, The Hague.
- THIEL 1981, p. 210, no 185, ill.
▸ Formerly thought to be an Italian work of the 16th century.

431

■ | *The penitent St Magdalene*

Canvas, 137x121.
- Gift from Dowager L.V.S. Barones van Rijckevorsel van Rijsenburg-Dommer van Poldersveld, 1887; on loan to the Rijksdienst Beeldende Kunst, The Hague.

846

■ Circle of the | *The judgment of Paris*

Panel, 10x15.5.
■ Rijksmusem, Amsterdam, inv.no A3255; on loan since 1948.
● FRIEDLÄNDER 1967-76, XII, p. 100, no 109, pl. 47; CAT. MAURITSHUIS 1968, p. 37; KOCH 1968, p. 56, note 3, p. 61; CAT. RIJKSMUSEUM 1976, p. 633, ill.

854-855

Master of Frankfurt | *St Catharine of Alexandria and St Barbara*

Born ca 1460. Worked in Antwerp.

Two panels, 158x71 (each).
■ coll. G. Donaldson, London, before 1917; coll. C. van Pannwitz, Heemstede; transferred to the Mauritshuis by the Rijksdienst Beeldende Kunst, 1960.
● FRIEDLÄNDER 1967-76, p. 77, no 137, pl. 107; CAT. MAURITSHUIS 1968, pp. 34-35, ill.; S. GODDARD, JAARBOEK ANTWERPEN 1983, pp. 65-66, fig. 11.
► Wings of a triptych; probably belonged to an altarpiece, the Holy Family and music-making angels, in the Walker Art Gallery, Liverpool. Probably based on an altarpiece by J. Gossaert in the National Museum in Lisbon.

872

■ | *St Christopher*

Panel, 46x31.
■ coll. O. Mayer, Berlin; kunsthandel P. Cassirer, Amsterdam; transferred to the Mauritshuis by the Rijksdienst Beeldende Kunst, 1960.

● WINKLER 1924, p. 209, fig. 125; FRIEDLÄNDER 1967-76, p. 79, no 155, pl. 114; CAT. MAURITSHUIS 1968, p. 34, ill.

433

Master of the Solomon triptych | *Triptych with the life of Solomon*; verso left: *coat of arms of Willem Simonsz. (1498-1577), lord of the manors of Stavenisse and Cromstrijen*; verso right: *coat of arms of his wife, Adriana van Duyveland (1506-1545)*

Active ca 1525, probably in Antwerp. Named by Friedländer after the Mauritshuis triptych.

Panel, centre 107.5x77, wings 107.5x32.5.
■ bequest of jhr J. de Witte van Citters, The Hague, 1876.
● C. van Balen, *De blijde inkomst der renaissance in de Nederlanden*, Leiden 1930, p. 25; R.H. Wilenski, *Flemish painters*, London 1960, I, pp. 118, 126, 137, 254, II, pl. 286-288; FRIEDLÄNDER 1967-76, p. 55, p. 73, no 64, pl. 65; CAT. MAURITSHUIS 1968, pp. 35-36, ill.; OSTEN & VEY 1969, p. 194.
► Made in Antwerp under strong influence of prints by L. van Leyden.

784

■ | *The building of the tower of Babel*

Panel, 20x18.
■ purchased by the Rijksmuseum, Amsterdam, from N. Beets, 1921, (inv.no A2851); on loan since 1924.
● P. Wescher, *Art Quarterly* 9 (1946), p. 197, fig. 1; F. Winkler, *Festschrift Edwin Redslob*, Berlin 1955, p. 91, p. 95, note 2; H. Minkowski, *Der Turm zu Babel*, Berlin 1960, p. 49, fig. 138; CAT. RIJKSMUSEUM 1976, p. 696, ill.
► School of Bruges. Has formerly been attributed to S. Bening.

944

■ | *The meeting of Abraham and Melchizedek* (recto) *The synagogue* (verso)

Panel, 101x71.
■ former convent of St Agnes, Goes; purchased by the Rijksmuseum, Amsterdam, inv.no A866, 1976; on loan since 1960.
● WINKLER 1924, p. 221; HOOGEWERFF 1937-47, III, pp. 43-44; CAT. MAURITSHUIS 1968, pp. 42-43, ill.; CAT. RIJKSMUSEUM 1976, p. 647, ill.
► Left wing of a triptych (right wing no 945); the location of the middle panel is unknown. Painted ca 1515 in Zeeland, under strong Antwerp influence, or possibly in Antwerp.

945

■ | *The rain of manna* (recto) *Ecclesia* (verso)

Panel, 101x71.

■ former convent of St Agnes, Goes; purchased by the Rijksmuseum, Amsterdam, inv.no A867, 1867; on loan since 1960.
● See no 944.
► Right wing of a triptych (left wing no 944).

1031

■ | *The sudarium of St Veronica*

Panel, 53.5x48.
■ unknown, since 1908 in the Mauritshuis.
► Probably from the circle of M. de Vos.

432

French school | *Portrait of the three Châtillon-Coligny brothers*

Canvas, 191x163.
■ from Noordeinde Palace; on loan to the Stedelijk Museum het Prinsenhof, Delft, since 1931.
● S.W.A. Drossaers, O.H. 47 (1932), p. 224, fig. 8; *Coligny, protestants et catholiques en France au XVIe siècle*, Hotel de Rohan, Paris 1972-73, p. 119, no 401, ill.
▶ The sitters are Gaspard de Coligny, Count of Châtillon (1519-1572), leader of the Huguenots; Odet de Coligny, Cardinal of Châtillon, Bishop and Count of Beauvais (1517-1571); François de Coligny, lord of Andelot (1521-1569).

897

German school | *The birth of Mary*

Panel, 110x97 (ends in a round arch).
■ coll. F. Lippmann, Berlin, until 1912; coll. C. von Pannwitz, Heemstede; coll. H. Göring 1940-1945; transferred to the Mauritshuis by the Rijksdienst Beeldende Kunst, 1960.
● BASLE 1960, p. 348, no 445; CAT. MAURITSHUIS 1968, p. 6, ill.; OSTEN & VEY 1969, p. 101.
▶ Formerly attributed to H. von Kulmbach and to S. Holbein. Painted in the milieu of H. Holbein the Elder in Augsburg.

896

■ | *St Dionysius the Aeropagite in prayer*

Panel, 49x35. Inscribed: *Magnum mysterium et mirabile sacramentum* and *Divus dionysius parisior. episcopus theologus ariopagita.*
■ Rijksmuseum, Amsterdam, inv.no A3116; on loan since 1951.
● G. Ring, *A century of French painting 1400-1500*, London 1949, no 275, fig. 174; CAT. MAURITSHUIS 1968, pp. 22-23, ill.; CAT. RIJKSMUSEUM 1976, p. 640, ill.
▶ School of Avignon.
No distinction was made between the three saints named Dionysius (Aeropagite, the early Christian theologian and the first bishop of Paris); St Dionysius was worshipped as though he were a single saint.

305

Italian school | *St Sebastian*

Canvas, 76x62.
■ purchased by King Willem I for the Mauritshuis with the Reghellini collection, 1831.
► Probably 17th-century, north Italian. Formerly attributed to Annibale Carracci.

317

■ | *Christ*

Panel, 51x41.5.
■ purchased by King Willem I for the Mauritshuis with the Reghellini collection, 1831; on loan to the Raadhuis, Wychen, since 1936.
► Was considered a copy after Bonifazio Veronese. Formerly believed to be a copy after C. Dolci.

330

■ | *Landscape with Mary Magdalene*

Canvas, 39.5x56.
■ purchased by King Willem I for the Mauritshuis with the De Rainer collection, 1821; on loan to the Raad van State, The Hague, since 1922.
► Companion piece to no 331.
Formerly attributed to S. Rosa.

331

■ | *St Paul of Thebes as a hermit in the countryside*

Canvas, 39.5x56.
■ purchased by King Willem I for the Mauritshuis with the De Rainer collection, 1821; on loan to the Raad van State, The Hague, since 1922.
► Companion piece to no 330.
Formerly attributed to S. Rosa.

334

■ | *Prometheus*

Canvas, 110x120.
■ purchased by King Willem I for the Mauritshuis with the Reghellini collection, 1831.
► Companion piece to no 335.
Formerly attributed to S. Rosa and L. Giordano. May possibly be attributed to G.B. Langetti.

335

■ | *Sisyphus*

Canvas, 110x120.
■ purchased by King Willem I for the Mauritshuis with the Reghellini collection, 1831.
► Companion piece to no 334.
Formerly attributed to Salvator Rosa and Luca Giordano. May possibly be attributed to G. B. Langetti.

349

■ | *A goddess*

Panel, 67.5x51.3.
■ purchased by King Willem I for the Mauritshuis with the De Rainer collection, 1821; on loan to the Rijksmuseum, Amsterdam (inv.no C1354), since 1948.
● CAT. RIJKSMUSEUM 1976, p. 646, ill.
▶ Possibly 16th-century; possibly depicting Venus.

351

■ | *The adoration of the shepherds*

Panel, 40x50.5.
■ purchased by King Willem I for the Mauritshuis at the auction of Comtesse De Bourke, Paris, 1823; on loan to the Rijksdienst Beeldende Kunst, The Hague.
▶ Probably 16th-century, possibly Ferrarese.

352

■ | *Madonna and child with St Dominic and St Anthony of Padua*

Canvas, 34x30 (oval).
■ coll. Rottiers; purchased by King Willem I for the Mauritshuis, 1823; on loan to the Rijksdienst Beeldende Kunst, The Hague.

355

■ | *John the Baptist*

Canvas, 64x52.
■ purchased by King Willem I for the Mauritshuis with the Reghellini collection, 1831.
▶ Possibly Florentine, 17th-century.
Formerly attributed to C. Dolci.

356

■ | *Samson and Delilah*

Canvas, 96x125.
■ purchased by King Willem I for the Mauritshuis with the Reghellini collection, 1831; on loan to the Raad van State, The Hague, since 1922.
▶ Probably 17th-century.
Formerly attributed to L. Giordano.

359

■ | *God the Father and the Holy Ghost*

Canvas, 64x42.
■ Nationale Konst-Gallery, The Hague; on loan to the Raadhuis, Wychen, since 1936.

All the miniatures are in watercolour, unless otherwise stated.

387

Johannes Anspach, Attributed to | *Portrait of a lady*

Born 1752 in Niederingelheim, Palatinate, died 1823 in Rotterdam, where he lived from 1792.

Pastel on paper, 13.5x11.5 (oval).
■ unknown.

997

Benjamin Arlaud, Attributed to | *Portrait of Stadholder-King Willem III (1650-1702) in royal robes*

Born in Geneva ca 1670, died before 1721. Brother of the miniaturist J.A. Arlaud. Is thought to have been in England ca 1701-1714.

Vellum stuck to table-book leaf, 9.4x7.1 (oval).
■ Rijksmuseum, Amsterdam, inv.no A4296; on loan since 1951.
● DELFT 1966, p. 15, no 19; CAT. RIJKSMUSEUM 1976, pp. 750-751, ill.; CAT. MAURITSHUIS 1977, p. 277, ill.
► Formerly attributed to L. Crosse; probably after Sir G. Kneller, Windsor Castle, inv.no 217.

982

John Bettes, Attributed to | *Portrait of Edward VI, King of England (1537-1553), at the age of two or three*

Born ca 1530 in London (?), died after 1580.

Vellum without a card support, 4.8x3.5 (oval). Partially legible inscription on the back: *.../peint par/...*
■ Rijksmuseum, Amsterdam, inv.no A4297; on loan since 1951.
● CAT. MAURITSHUIS 1977, p. 277, ill.
► There is no evidence to support an attribution to Bettes. According to J. Murrell it is plausible that nos 982, 983, 984, 986 and 987 are by the same hand – possibly that of a French 18th-century copyist (written communication, Mauritshuis 1984).

983

Arnold van Brounckhurst, Attributed to | *Portrait of James I, King of England (1566-1625), as a child*

Flemish artist who is known to have lived in Britain from ca 1565 onwards. Worked for the Scottish court in 1580. Only one signed and dated (1578) portrait by him has been found.

Oil on a playing card with one heart verso, 5x3.7 (oval).
■ Rijksmuseum, Amsterdam, inv.no A4302; on loan since 1951.
● AUERBACH 1961, p. 269, fig. 239, p. 332, note 274; CAT. RIJKSMUSEUM 1976, p. 752, ill.
► Formerly attributed to Stretes; attributed to Brounckhurst by E. Auerbach. According to J. Murrell this attribution is questionable as it is not even certain that Van Brounckhurst painted miniatures. It is plausible that the nos 982, 983, 984, 986 and 987 are by the same hand – possibly that of a French copyist (written communication, Mauritshuis 1984).

1008

Alexander Cooper, Attributed to | *Portrait of James, Duke of Cambridge (1661-1667), son of James II, or Stadholder Willem II (1626-1650)*

Born ca 1605 in England, died in Stockholm in 1660 (?). Was pupil of his uncle J. Hoskins, together with his younger brother Samuel. Went to Holland in 1631, lived 1644-1646 in The Hague. He was court painter in Sweden (1647-57), and also worked for the King of Denmark.

Vellum stuck to table-book leaf, 4.4x3.4 (oval).
■ Rijksmuseum, Amsterdam, inv.no A4303; on loan since 1951.
● A. Staring, OUDH. JAARBOEK 12 (1943), pp. 93-94; CAT. RIJKSMUSEUM 1976, p. 752, ill.
▶ Staring presumes this to be a portrait of Willem II.

991

Samuel Cooper | *Portrait of a lady*

Born 1609 in London, died there in 1672. He and his elder brother Alexander were pupils of their uncle J. Hoskins. Sometimes worked after A. van Dyck. Was patronised by Charles II and his court. Possibly travelled on the continent between 1635 and 1642.

Vellum stuck to table-book leaf, 6.8x5.5 (oval). Signed and dated: *SC:fe: 1643*.
■ Rijksmuseum, Amsterdam, inv.no A4306; on loan since 1951.
● FOSKETT 1974, p. 108; CAT. RIJKSMUSEUM 1976, p. 753, ill.

992

■ | *Portrait of George Gordon (died 1649), second Marquess of Huntley*

Vellum stuck to table-book leaf, 5.5x4.5 (oval). Signed: *SC* and dated indistinctly: *16...*
■ Rijksmuseum, Amsterdam, inv.no A4305; on loan since 1951.
● DELFT 1966, p. 12, nr. 16; FOSKETT 1974, p. 111; LONDON 1974, p. 8, no 10; CAT. RIJKSMUSEUM 1976, pp. 752-753, ill.
▶ Based on a portrait by A. van Dyck (see: GLÜCK 1931, p. 446).

993

■ | *Portrait of Charles II, King of England (1630-1685), in royal robes*

Vellum stuck to table-book leaf, 17x13.2 (oval). Signed and dated: *1665 SC*.
■ Rijksmuseum, Amsterdam, inv.no A4307; on loan since 1951.
● LONDON 1974, p. 51, no 112, ill.; CAT. RIJKSMUSEUM 1976, p. 753, ill.; MURDOCH 1981, p. 113, fig. 128.
▶ A larger, rectangular version, also signed and dated: *SC 1665*, is in the collection of the Earl of March and Kinrara, Goodwood (LONDON 1974, p. 50, no 111).

995

■ | *Portrait of a lady, probably Henrietta, Duchess of Orléans (1644-1670)*

Vellum stuck to table-book leaf, 6.8x5.7 (oval). Signed and dated: *SC: 1670*.
■ Rijksmuseum, Amsterdam, inv.no A4309; on loan since 1951.
● FOSKETT 1974, pp. 25-26, p. 118, fig. 70; LONDON 1974, p. 63, no 130, ill.; CAT. RIJKSMUSEUM 1976, p. 753, ill.; CAT. MAURITSHUIS 1977, p. 279, ill.

996

■ | *Portrait of Frances Teresa, Duchess of Richmond and Lennox (1648-1702), called 'La belle Stuart', in male costume*

Vellum stuck to table-book leaf, 8.5x6.9 (oval). Signed and dated: *SC: 1666.*
■ Rijksmuseum, Amsterdam, inv.no A4308; on loan since 1951.
● VRIES 1969, p. 13, no 17, ill.; RANITZ 1971, p. 8, fig. 12; LONDON 1974, p. 55, no 19, ill.; CAT. RIJKSMUSEUM 1976, p. 753, ill.

994

Richard Gibson, Attributed to | *Portrait of Mary Stuart (1662-1695), wife of Stadholder-King Willem III, as a child*

Born 1615 in Cumberland (?), died in London 1690. Called 'The dwarf'. Influenced by Sir P. Lely. Appointed page to Charles I. Went to Holland 1667, was in The Hague from 1681 till 1688(?).

Vellum stuck to plain card, 5.7x4.9 (oval).
■ Rijksmuseum, Amsterdam, inv.no A4312; on loan since 1951.
● DELFT 1966, p. 10, no 12, ill.; CAT. RIJKSMUSEUM 1976, p. 754, ill.; CAT. MAURITSHUIS 1977, p. 279, ill.
▸ Formerly attributed to J. Hoskins, S. Cooper and N. Dixon. Attributed to Gibson by J. Murrell; Gibson was Mary's drawing master and travelled with her to Holland (written communication, Mauritshuis 1984).

998

David des Granges, Attributed to | *Portrait of Henrietta Maria Stuart (1631-1660), wife of Stadholder Willem II*

Born 1611 or 1613 in London, died ca 1675. Worked for Charles I and Charles II. Accompanied the latter to Scotland in 1651.

Vellum stuck to table-book leaf, 4.5x3.8 (oval).
■ Rijksmuseum, Amsterdam, inv.no A4314; on loan since 1951.
● LONG 1929, p. 123; CAT. RIJKSMUSEUM 1976, p. 754, ill.; NEW YORK 1979, p. 80, no 36, ill.
▸ Traditionally attributed to D. des Granges. Long was doubtful about this attribution. J. Murrell assumes this miniature and no 999 to be by the same hand, not by D. des Granges but probably by A. Cooper (written communication, Mauritshuis 1984).

999

■ Attributed to | *Portrait of Albertina Agnes (1634-1687), daughter of Frederik Hendrik and wife of Willem Frederik, Stadholder of Friesland*

Vellum stuck to plain card, 4.5x3.9 (oval).
■ Rijksmuseum, Amsterdam, inv.no A4315; on loan since 1951.
● LONG 1929, p. 123; CAT. RIJKSMUSEUM 1976, p. 755, ill; NEW YORK 1979, p. 72, no 28, ill
▸ Traditionally attributed to D. des Granges. J. Murell assumes this miniature and no 998 to be by the same hand, not by D. des Granges but probably by A. Cooper (written communication, Mauritshuis 1984).

1000

Nicolas Hilliard | *Portrait of Elizabeth I, Queen of England (1533-1603)*

Born 1547 in Exeter, died 1619 in London. Also active as a jeweller and goldsmith. Was first influenced by H. Holbein the Younger and later by E. Clouet. Visited France 1576-1578/79. Worked for Queen Elizabeth I and James I. Had many pupils and followers.

Vellum stuck to plain card, 4x3.2 (oval).
■ Rijksmuseum, Amsterdam, inv.no A4321; on loan since 1951.
● AUERBACH 1961, p. 92, fig. 59, p. 296, note 54; VRIES 1969, p. 166, fig. 3; CAT. RIJKSMUSEUM 1976, p. 756, ill.

1023

■ | *Lady Margaret Douglas, Countess of Lennox (1515-1578)*

Vellum stuck to plain card, 4.5 diameter (round). Dated: *Año.Dni. 1575. AEtatis.Suae...*
■ Rijksmuseum, Amsterdam, inv.no A4323; on loan since 1951.
● AUERBACH 1961, pp. 68-69, fig. 28, p. 291, note 25; CAT. RIJKSMUSEUM 1976, p. 757, ill.; LONDON 1983, pp. 65-66, no 64.
▶ Formerly attributed to Levina Teerlinc. The Fitzwilliam Museum, Cambridge, has a severly damaged replica (inv.no 3851).

1015

■ Studio of | *Portrait of James I, King of England (1566-1625)*

Vellum stuck to plain card, 5.4x4.6 (heart-shaped).
■ Rijksmuseum, Amsterdam, inv.no A4322; on loan since 1951.
● LONG 1929, p. 318; AUERBACH 1961, p. 164, fig. 163, p. 317, note 173; CAT. RIJKSMUSEUM 1976, p. 756, ill.; LONDON 1983, p. 147, no 241, ill.
▶ Wearing the Order of the Garter. Formerly attributed to I. Oliver; in LONDON 1983 R. Strong attributed this portrait to Laurence Hilliard, Nicolas's son (1582-1647/48).

1004

John Hoskins | *Portrait of Queen Henrietta Maria (1609-1669), wife of Charles I of England*

Worked from ca 1620, died in London 1664/65. Uncle and tutor of the Cooper brothers. Was appointed limner to Charles I in 1640. Influenced by A. van Dyck, P. Oliver and N. Hilliard.

Vellum stuck to plain card, glued to panel, 17.6 in diameter (round). Signed and dated: *1632 iH*, marked with crowned monogram *HMR*.
■ Rijksmuseum, Amsterdam, inv.no A4326; on loan since 1951.
● LONDON 1974, p. 78, no 145, ill.; CAT. RIJKSMUSEUM 1976, p. 757, ill.; CAT. MAURITSHUIS 1977, pp. 283-284, ill.; MURDOCH 1981, p. 101, fig. 110.
▶ After A. van Dyck (see GLÜCK 1931, pp. 374, 376). Influenced by P. Oliver.

1005

■ | *Portrait of Queen Henrietta Maria (1609-1669), wife of Charles I of England*

Vellum stuck to a playing card with diamonds verso, which have been covered by black paint, 6.1x5 (oval). Signed: *iH.f* (iH in monogram, with the crowned monogram *HMR* above; also monogrammed on the back).
■ Rijksmuseum, Amsterdam, inv.no A4327; on loan since 1951.
● F. Lugt, *Oude Kunst* I, (1915), p. 158, fig. 19; CAT. RIJKSMUSEUM 1976, pp. 757-758, ill.
▶ After a portrait by A. van Dyck (see: GLÜCK 1931, p. 383).

1006

■ | *Portrait of Charles I, King of England (1600-1649)*

Vellum stuck to table-book leaf, 7.9x6.4 (oval). Signed: *iH fe*.
■ Rijksmuseum, Amsterdam, inv.no A4325; on loan since 1951.
● F. Lugt, *Oude Kunst* I (1915), p. 152; DELFT 1966, p. 8, no 8, ill.; CAT. RIJKSMUSEUM 1976, p. 757, ill.
▶ Wearing the Order of the Garter. Replica of the smaller version in the Koninklijk Huis Archief, The Hague; there is another signed copy in Windsor Castle.

1007

■ | *Portrait of Queen Henrietta Maria (1609-1669), wife of Charles I of England*

Vellum stuck to plain card, 6.2x3.3 (oval). Signed *IH*.
■ Rijksmuseum, Amsterdam, inv.no A4328; on loan since 1951.
● CAT. RIJKSMUSEUM 1976, p. 758, ill.; MURDOCH 1981, p. 101, fig. 112.
► Formerly identified as Elizabeth Stuart (1596-1662), sister of Charles I and wife of Frederick V of the Palatinate. Identified as Queen Henrietta Maria by R. Strong (written communication, Mauritshuis 1961).

1027

Johann Friedrich Hurter, Attributed to | *Portrait of Cornelis Ploos van Amstel (1726-1798)*

Born 1734 in Schaffhausen, died 1799 in Düsseldorf. Worked in Bern (1768-1779), Paris and The Hague (1772), settled in London 1777, where he became court painter. Worked for Lord Dartrey.

Enamel on copper, 4x3.5 (oval).
■ Koninklijk Oudheidkundig Genootschap, Amsterdam; on loan since 1951.
● STARING 1948, p. 86; CAT. MAURITSHUIS 1977, p. 280, ill.; NIEMEYER 1980, p. 78, fig. 35.
► After the portrait by J. Buys (1724-1801), dated 1766 in the Rijksmuseum, Amsterdam (inv.no C515). Formerly thought to be Dutch school. Attributed to Hurter by Staring, which is plausible according to Niemeyer and to J. Murrell (written communication, Mauritshuis 1984).

1010

Robert Mussard | *Portrait of Stadholder Willem V (1748-1806) at the age of three*

Born 1713 in Geneva, died 1777 in Paris. Worked in the Netherlands and in Paris.

Vellum stuck to a playing card with clubs verso, 5.7x7.5. Inscribed on the verso: *R. Mussard pinxit agé de 3 ans e-demi dans l'année 1751.*
■ Rijksmuseum, Amsterdam, inv.no A4340; on loan since 1951.
● CAT. RIJKSMUSEUM 1976, p. 761, ill.; NEW YORK 1979, p. 117, no 89, ill.

1011

■ | *Portrait of Stadholder Willem V (1748-1806) as a child*

Vellum stuck to a playing card with queen verso, 5.4x7.2
■ Rijksmuseum, Amsterdam, inv.no A4343; on loan since 1951.
● CAT. RIJKSMUSEUM 1976, p. 761, ill.; NEW YORK 1979, p. 117, no 89, ill.

1012

■ *Portrait of princess Wilhelmina Carolina (1743-1787), sister of Willem V*

Vellum stuck to a playing card with clubs verso, 5.5x7.3.
■ Rijksmuseum, Amsterdam, inv.no A4342; on loan since 1951.
● CAT. RIJKSMUSEUM 1976, p. 761, ill.; NEW YORK 1979, p. 117, no 89.

1001

Isaac Oliver | *Portrait of a young woman as Flora*

Born in Rouen. Was in England in 1568, active from ca 1587. Died 1617 in London. Pupil of N. Hilliard. Worked for the royal family. Visited Venice in 1596.

Vellum stuck to a playing card with hearts verso, 5.2x4.1 (oval).
■ Rijksmuseum, Amsterdam, inv.no A4347; on loan since 1951.
● LONDON 1947, p. 44, no 181; C. Winter, BURL. MAG. 1947, p. 176; CAT. RIJKSMUSEUM 1976, p. 762, ill.; LONDON 1983, pp. 138-139, no 223, ill.; STRONG 1983, p. 178, fig. 233.
▸ Formerly attributed to Hilliard and wrongly considered to be a portrait of Elizabeth I. Attributed to Oliver by C. Winter and G. Reynolds (LONDON 1947).

1002

■ | *Portrait of a lady*

Vellum stuck to a playing card with diamonds verso, 5.2x4.3 (oval).
■ Rijksmuseum, Amsterdam, inv.no A4346; on loan since 1951.
● LONDON 1947, p. 41, no 148; AUERBACH 1961, p. 243, fig. 205; CAT. RIJKSMUSEUM 1976, p. 762, ill.
▸ Formerly attributed to Hilliard; attribution to Oliver by G. Reynolds (LONDON 1947).

1013

■ | *Portrait of Ludovic Stuart (1574-1623/24), first Duke of Richmond and second Duke of Lennox, or Thomas Howard (1561-1628), Earl of Suffolk*

Vellum stuck to plain card, 5x3.9 (oval).
■ Rijksmuseum, Amsterdam, inv.no A4345; on loan since 1951.
● AUERBACH 1961, pp. 245-246, fig. 213, no 248; CAT. RIJKSMUSEUM 1976, pp. 761-762, ill.
▸ Wearing the Order of the Garter. Formerly identified as Robert Devereux, Earl of Essex (1567-1601). R. Strong identified the sitter as Ludovic Stuart or Thomas Howard (written communication, Mauritshuis 1961).

1014

■ | *Portrait of a lady, thought to be Arabella Stuart (1575-1615), daughter of Charles Lennox*

Vellum stuck to a playing card with hearts verso, 6.9x5.6 (oval). Signed: *IO* (in monogram).
■ Rijksmuseum, Amsterdam, inv.no A4344; on loan since 1951.
● CAT. RIJKSMUSEUM 1976, p. 761, ill.

1016

Peter Oliver | *Portrait of Charles I, King of England (1600-1649), as Prince of Wales*

Born ca 1594, died 1647 in London. Was a pupil of his father Isaac. Also completed and copied his father's work.

Vellum stuck to a playing card with hearts verso, 5.7x4.5 (oval). Signed and dated: *PO 1621*.
■ Rijksmuseum, Amsterdam, inv.no A4348; on loan since 1951.
● LONG 1929, p. 322; CAT. RIJKSMUSEUM 1976, p. 762, ill.
▶ Wearing the Order of the Garter. Another version in the British Royal Collection, also signed and dated 1621.

1019

■ | *Portrait of Frederick v, Elector Palatine and King of Bohemia (1596-1632), called the 'Winter King'*

Vellum stuck to table-book leaf, 5.1x4.05 (oval). Signed: *PO*.
■ Rijksmuseum, Amsterdam, inv.no A4349; on loan since 1951.
● CAT. RIJKSMUSEUM 1976, p. 762, ill.
▶ Wearing the Order of the Garter.

1017

■ Attributed to | *Portrait of George Villiers, Duke of Buckingham (1592-1628), in Roman dress*

Vellum stuck to table-book leaf, 5.05x4 (oval).
■ Rijksmuseum, Amsterdam, inv.no A4352; on loan since 1951.
● LONG 1929, p. 322; CAT. RIJKSMUSEUM 1976, p. 763, ill.
▶ Possibly companion piece to no 1018. Another version in the Koninklijk Huis Archief, signed by P. Oliver, and one in the British Royal Collection, signed by I. Oliver.

1018

■ Attributed to | *Portrait of Henry Frederick, Prince of Wales (1594-1612), eldest son of James I, in Roman dress*

Vellum stuck to a playing card with spades verso, 5.1x4 (oval).
■ Rijksmuseum, Amsterdam, inv.no A4351; on loan since 1951.
● LONG 1929, p. 322; CAT. RIJKSMUSEUM 1976, p. 762, ill.; LONDON 1983, p. 142, no 230; STRONG 1983, p. 171, fig. 224.
▶ Possibly companion piece to no 1017. There are other versions in the National Portrait Gallery, London (inv.no 1572), the Fitzwilliam Museum, Cambridge (inv.no 3903, signed: *IO*), and in the British Royal Collection.

1020

■ Attributed to | *Portrait of Charles I, King of England (1600-1649), as a young man*

Vellum stuck to a playing card with a club verso, 5.4x4.1 (oval).
■ Rijksmuseum, Amsterdam, inv.no A4350; on loan since 1951.
● CAT. RIJKSMUSEUM 1976, p. 782, ill.
▶ Wearing the Order of the Garter. Another version in the British Royal Collection (attributed to I. Oliver).

1021

■ Attributed to | *Portrait of François Duquesnoy (1594-1643/6), sculptor, called Il Fiammingo*

Vellum stuck to table-book leaf, 7.6x5.9 (oval).
■ Rijksmuseum, Amsterdam, inv.no A4353; on loan since 1951.

• LONG 1929, p. 322; RANITZ 1971, pp. 8-10, fig. 5; CAT. RIJKSMUSEUM 1976, p. 763, ill.
▶ After the portrait of Duquesnoy by Van Dyck, Palais des Beaux-Arts, Brussels (inv.no 3928). Has also been attributed to S. Cooper. Attributed to Hans van der Brughen by J. Murrell (written communication, Mauritshuis 1984).

1022

Loch Phaff | *Portrait of Frederika Sophia Wilhelmina of Prussia (1751-1820), wife of Stadholder Willem V*

There are no available data of this artist.

Ivory backed with paper, 10.05x7.7 (oval). Signed: *Loch.Phaff*.
■ Rijksmuseum, Amsterdam, inv.no A4360; on loan since 1951.

1009

Nathaniel Tach | *Portrait of Charles II, King of England (1630-1685), as a young man*

Born 1617 in Barrow, Suffolk. Worked ca 1650 in London. Possibly worked for a time on the continent.

Vellum stuck to plain card, 4.5x3.7 (oval). Signed and indistinctly dated: *NTach F 165..*
■ Rijksmuseum, Amsterdam, inv.no A4369; on loan since 1951.
• RANITZ 1971, pp. 7-8; KUILE 1976, pp. 68-69, no 14; CAT. RIJKSMUSEUM 1976, p. 763, ill.; CAT. MAURITSHUIS 1977, p. 289, ill.
▶ Wearing the Order of the Garter. After a lost original by A. Hanneman.

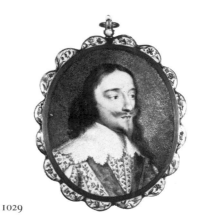

1029

Henry Toutin | *Portrait of Charles I, King of England (1600-1649)*

Born 1614 in Châtaudun, died after 1683 in Paris. Son and pupil of J. Toutin the Elder.

Enamel on gold, 6.5x5.5 (oval with scalloped edge). Inscribed verso: *henry Toutin Orphevre a paris afait ce cy lan. 1636.*
■ Rijksmuseum, Amsterdam, inv.no A4370; on loan since 1951.
• CAT. RIJKSMUSEUM 1976, p. 766, ill.
▶ Wearing the Order of the Garter.

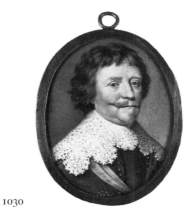

1030

■ Attributed to | *Portrait of Stadholder Frederik Hendrik (1584-1647)*

Enamel on gold, 4.3x3.4.
■ Rijksmuseum, Amsterdam, inv.no A4371; on loan since 1951.
• CAT. RIJKSMUSEUM 1976, p. 766, ill.
▶ Wearing the Order of the Garter. After G. van Honthorst. cf. inv.no A 4432, Rijksmuseum, Amsterdam, also after Honthorst (CAT. RIJKSMUSEUM 1976, p. 782, ill.).
Has formerly been attributed to P. Prieur.

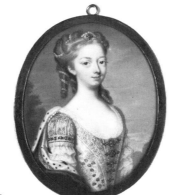

1025

Christian Friedrich Zincke, Attributed to | *Portrait of an English princess*

Born in Dresden ca 1683, died in London 1767. Went to England 1706. Pupil of C. Boit.

Enamel on gold. 7.6x6 (oval).
■ Rijksmuseum, Amsterdam, inv.no A4375; on loan since 1951.
• CAT. MAURITSHUIS 1977, p. 290, ill.

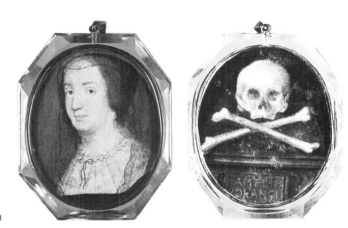

981

Dutch school | *Portrait of Amalia van Solms (1602-1675), wife of Frederik Hendrik, as a widow*

Vellum stuck to table-book leaf, 4.7x3.8 (oval). Verso: a memento mori, on thick parchment, with the inscription: *AMELIE ORANGE*.
■ Rijksmuseum, Amsterdam, inv.no A4437; on loan since 1951.
● CAT. RIJKSMUSEUM 1976, pp. 782-783, ill.
▶ After a portrait of Amalia by G. van Honthorst, Oranjezaal (koepel), Huis ten Bosch, The Hague.

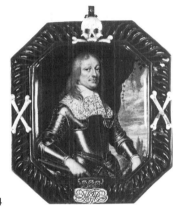

1024

 | *Portrait of Willem Frederik, Count of Nassau (1613-1664), Stadholder of Friesland*

Enamel on gold, 7x6.1 (octagonal). Frame bearing the monogram *FWF* with two hearts and a royal crown.
■ Rijksmuseum, Amsterdam, inv.no A4436; on loan since 1951.
● KUILE 1976, pp. 106-107, no 66, fig. 74; CAT. RIJKSMUSEUM 1976, p. 782, ill.; NEW YORK 1979 p. 73, no 29, ill.
▶ After a portrait by A. Hanneman of 1661 (Staatliche Kunstsammlungen, Schlossmuseum, Weimar). Our painting of P. Nason (inv.no 124) is also after this portrait by Hanneman.

1026

■ | *Portrait of a lady, thought to be Frederika Sophia Wilhelmina of Prussia (1751-1820), wife of Stadholder Willem v*

Enamel on copper, 3.9x3.2 (oval).
■ Rijksmuseum, Amsterdam, inv.no A4458; on loan since 1951.
● CAT. RIJKSMUSEUM 1976, p. 784, ill.; CAT. MAURITSHUIS 1977, p. 280, ill.

989

English school | *Portrait of a man*

Oil on copper, 6x4.8 (oval).
■ Rijksmuseum, Amsterdam, inv.no A4395; on loan since 1951.
● CAT. MAURITSHUIS 1977, p. 282, ill.

984

French school | *Portrait of James 1, King of England (1566-1625), at about the age of ten*

Vellum without card backing, 4.5x3.6 (oval)
■ Rijksmuseum, Amsterdam, inv.no A4390; on loan since 1951.
● CAT. MAURITSHUIS 1977, p. 281, ill.
▶ Formerly thought to be English school. According to J. Murrell it is plausible that the inv.nos 982, 983, 984, 986 and 987 are by the same hand; probably 18th-century (written communication, Mauritshuis 1984).

985

■ | *Portrait of a lady, thought to be Mary Stuart, Queen of Scotland (1542-1587)*

Oil on copper, 4.9x4 (oval).
■ Rijksmuseum, Amsterdam, inv.no A4392; on loan since 1951.
● CUST & MARTIN 1906, p. 44, ill.; CAT. MAURITSHUIS 1977, p. 281, ill.
► Formerly thought to be English school. Probably 18th- or 19th-century.

986

■ | *Portrait of a lady, perhaps Mary Stuart, Queen of Scotland (1542-1587)*

Vellum without card backing, 3.6 in diameter (round).
■ Rijksmuseum, Amsterdam, inv.no A4391; on loan since 1951.
● CAT. MAURITSHUIS 1977, p. 281, ill.
► Formerly thought to be English school, has also been attributred to N. Hilliard. According to J. Murrell it is plausible that the inv.nos 982, 983, 984, 986 and 987 are by the same hand; probably 18th-century (written communication, Mauritshuis 1984).

987

■ | *Portrait of Henry Stuart, Lord Darnley (1547-1567), husband of Queen Mary Stuart*

Vellum without card backing, 5.1x4 (oval).
■ Rijksmuseum, Amsterdam, inv.no A4393; on loan since 1951.
● CUST & MARTIN, p. 47, ill.; CAT. MAURITSHUIS 1977, p. 281, ill.
► Formerly thought to be English school. According to J. Murrell it is plausible that the inv.nos 982, 983, 984, 986 and 987 are by the same hand; probably 18th-century (written communication, Mauritshuis 1984).

360

Jan Blommendael | *Full-length portrait of Stadholder-King Willem III (1650-1702)*

Born ca 1645 in The Hague or Breda, died probably 1703 in The Hague. Pupil of R. Verhulst.

White marble, height 79. Signed and dated: *J. Blommendael. F:An:1676.*
■ Nationale Konst-Gallery, The Hague.
● NEURDENBURG 1948, p. 229, fig. 185; A. Staring, N.K.J. 3 (1950-51), p. 178, fig. 20; G. v. Osten, *Niederdeutsche Beiträge zur Kunstgeschichte* I (1961), p. 249, fig. 188.

361

■ | *Bust of Stadholder-King Willem III (1650-1702)*

White marble, height 80. Signed and dated: *J. Blommendael.F. 1699. HAGAE COMITIS.*
■ Probably collection Willem V, The Hague; tranferred to the Mauritshuis by King Willem I, 1816.
● NEURDENBURG 1948, p. 230; A. Staring, N.K.J. 3 (1950-51), pp. 190-191, fig. 32; G. v. Osten, *Niederdeutsche Beiträge zur Kunstgeschichte* I (1961), p. 249, fig. 190; *Euopäische Barockplastik am Niederrhein*, Kunstmuseum, Düsseldorf 1971, pp. 265-266, no 199, fig. 119; NEW YORK 1979, p. 104, no 71, ill.

906

Etienne Maurice Falconet | *Amor ('l'amour menaçant')*

Born 1716 in Paris, died there in 1791. Pupil of J.B. Le Moyne. Worked in Paris, St Petersburg and The Netherlands.

White marble, height 87. Signed and dated: *E. Falconet. 1757.* Inscribed: *Qui que tu sois, voicy ton maître / il l'est, le fut, ou le doit être* (adapted from Voltaire).
■ coll. F. Mannheimer, Amsterdam; transferred to the Mauritshuis by the Rijksdienst Beeldende Kunst, 1960; on loan to the Rijksmuseum, Amsterdam, since 1963 (inv.no R.B.K. 1963-101).
● CAT. RIJKSMUSEUM 1973, pp. 429-431, no 752, ill.
► There is a replica in the Louvre, Paris, and a bronze version in the coll. W.A. Clark, Corcoran Gallery of Art, Washington, D.C.

379

Marie Anne Falconet, born **Collot** | *Bust of Stadholder Willem v (1748-1806)*

Born 1748 in Paris, died 1821 in Morimont, near Nancy. Pupil of E.M. Falconet and married to his son, the portrait painter Pierre Etienne. Worked in Russia, but mostly in Paris and 1779-1780 in The Hague.

White marble, height 79. Signed and dated: *par M.A. falconet née Collot 1782.*
■ coll. Prince Willem v; Koninklijk Museum, The Hague, 1808; transferred to the Mauritshuis by King Willem I, 1816.
● J.A.G. Verspyck Mynssen, *Oude Kunst* 1918, no 3, pp. 78-79, ill.;
STARING 1947, p. 87, fig. 32; ROSENBERG, SLIVE & KUILE 1977, p. 427.
► Companion piece to no 380.

380

 | *Bust of Frederika Sophia Wilhelmina, Princess of Prussia (1751-1820), wife of Stadholder Willem v*

White marble, height 84. Signed and dated: *par M.A. falconet née Collot 1782.*
■ coll. Prince Willem v; Koninklijk Museum, The Hague, 1808; transferred to the Mauritshuis by King Willem I, 1816.
● J.A.G. Verspyck Mynssen, *Oude Kunst* 1918, no 3, pp. 78-79, ill.;
STARING 1947, p. 87, fig. 33; ROSENBERG, SLIVE & KUILE 1977, p. 427.
► Companion piece to no 379.

373

Jean Antoine Houdon | *Bust of the French vice-admiral, Pierre André de Suffren de Saint-Tropez (1725-1788)*

Born 1741 in Versailles, died 1828 in Paris. Pupil of R.M. Slodtz, J.B. Le Moyne and J.B. Pigalle. Influenced by A. Canova during his stay in Rome. Worked mostly in Paris from 1771. Made a bust of George Washington in Philadelphia.

White marble, height 90.5. Inscription on the pedestal: *Petrus Andreas de SUFFREN, Groot-Kruis van St. Jan, Generaal van Malta, Ridder van de Hn. Geest, Vice-Admiraal van Frankrijk, Verdediger van de Nederlandsche Coloniën, in Oost-Indiën. 1781* (Petrus Andreas de Suffren, Grand Cross of St John, General of Malta, Knight of the Holy Spirit, Vice-Admiral of France, Defender of the Dutch possessions in the East Indies).
■ Oostindische Compagnie, Middelburg, until 1798.
● A. Staring, O H. 57 (1940), p. 212; L. Réau, *Houdon*, Paris 1964, no 195; A.B. de Vries, O.K. 13 (1969), pp. 3A-3B.
► Commissioned by the Dutch East India Company. De Suffren aided the Dutch in defending the Cape Colony against the English and recaptured the colonies of Cuddalore in India and Trincomale in Ceylon (1781-1782).

362

Hendrick de Keyser | *Bust of Willem 1, Prince of Orange (1533-1584)*

Born 1565 in Utrecht, died 1621 in Amsterdam. Pupil of C. Bloemaert and probably of W. Tetterode. Worked in Amsterdam from 1591, where he became municipal sculptor. Was an architect as well. Father of the portrait painter T. de Keyser.

Terracotta, later gilded, height 80.
■ Nationale Konst-Gallery, The Hague; on loan to the Oranje Nassau Museum, Delft, since 1926.
● NEURDENBURG 1948, p. 44; CAT. RIJKSMUSEUM 1974, p. 185, no 231, ill.
► There is another example in the Rijksmuseum, Amsterdam, inv.no N.M. 5757.

378

Martin Claude Monnot | *Bust of Friedrich Wilhelm 11, King of Prussia (1744-1797)*

Born 1738 in Paris, died there in 1803. Pupil of L.C. Vassé. Stayed in Rome 1763-1768.

White marble, height 85.
■ The Stadholder's Quarter, the Binnenhof, The Hague, 1796; Nationale Konst-Gallery, Cabinet at the Buitenhof, The Hague, 1808.
► Two similar plaster busts were formerly in the Schloss Monbijou, Berlin, both signed and one dated 1782.

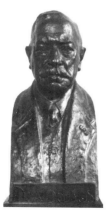

812

Theo van Reijn | *Bust of Abraham Bredius (1855-1946), art connoisseur and collector*

Born 1884 in Breda, died in Haarlem. Pupil of Bart van Hove. Winner of the Prix de Rome 1911.

Bronze, height 68. Signed and dated: *Theo van Reijn 1933.*
■ commissioned and donated by the Government Advisory Commission for Creative Arts, 1933.
► A. Bredius was director of the Mauritshuis from 1889 to 1909. His bequest is the most valuable the museum ever received.

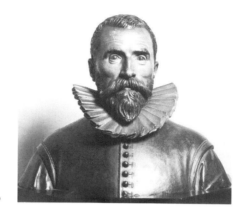

550

Jan Jorisz. van der Schardt, Attributed to | *Bust of a man*

Born ca 1530 in Nijmegen, died after 1581, probably in Nuremberg where he worked mostly from 1570. Visited Italy and Vienna.

Earthenware and polychromy, height 40.5.
■ donated by H. Willet, Brighton, 1889.
● CAT. MAURITSHUIS 1968, p. 58, ill.

369

Rombout Verhulst | *Portrait of Michiel Adriaensz. de Ruyter (1607-1676)*

Born 1625 in Mechelen, died 1698 in The Hague. Trained in Mechelen. Worked in Amsterdam and from 1664 in The Hague. A. Quellinus and Verhulst were the most important sculptors at work in the new Town Hall of Amsterdam.

Terracotta, height 37.
■ Nationale Konst-Gallery, The Hague, 1804-1808; Koninklijk Kabinet van Zeldzaamheden, The Hague, 1825; on loan to the Rijksmuseum, Amsterdam, since 1923 (inv.no N.M. 1351).
● NOTTEN 1907, p. 65, ill.; NEURDENBURG 1948, p. 219, fig. 178; R. van Luttervelt, BULL. R.M. 5 (1957), pp. 64-66, ill.; CAT. RIJKSMUSEUM 1973, p. 239, no 316, ill.
► Probably a study for the portrait on the mausoleum in the Nieuwe Kerk, Amsterdam.

370

■ *Portrait of Willem Joseph, Baron van Gendt (died 1672)*

Terracotta, height 41.
■ Nationale Konst-Gallery, The Hague, 1804-1808; Koninklijk Kabinet van Zeldzaamheden, The Hague, 1825; on loan to the Rijksmuseum, Amsterdam, since 1923 (inv.no N.M. 1350).
● NOTTEN 1907, p. 59-60, ill.; NEURDENBURG 1948, p. 219, fig. 177; CAT. RIJKSMUSEUM 1973, p. 239, no 315, ill.
► Probably a study for the portrait on the mausoleum in the Domkerk, Utrecht.

364

■ Studio of | *Bust of Stadholder Frederik Hendrik (1584-1647)*

White marble, height 77. Signed and dated: *R.V.H. 1683 fe.*
■ Soestdijk Palace, 1799; Nationale Konst-Gallery, The Hague, 1801-1808.
● NOTTEN 1907, p. 85, ill.; NEURDENBURG 1948, p. 221.
► Companion piece to nos 365, 366 and 367.

365

■ Studio of | *Bust of Stadholder Willem II (1626-1650)*

White marble, height 78. Signed and dated: *R.V.H. 1683 fe.*
■ Soestdijk Palace, 1799; Nationale Konst-Gallery, The Hague, 1801-1808.
● NOTTEN 1907, p. 85, ill.; NEURDENBURG 1948, p. 221.
Companion piece to nos 364, 366 and 367.

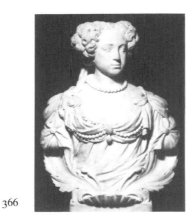

366

■ Studio of | *Bust of Mary Stuart (1662-1695), wife of Stadholder Willem III*

White marble, heigth 79. Signed and dated: *R.V.H. 1683 fe.*
■ Soestdijk Palace, 1799; Nationale Konst-Gallery, The Hague, 1801-1808.
● NOTTEN 1907, p. 85, ill.; NEURDENBURG 1948, p. 221.
► Companion piece to nos 364, 365 and 367.

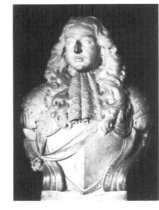

367

■ Studio of | *Bust of Stadholder-King Willem III (1650-1702)*

White marble, height 77. Signed and dated: *R.V.H. 1683 fe.*
■ Soestdijk Palace, 1799; Nationale Konst-Gallery, The Hague, 1801-1808.
● NOTTEN 1907, p. 85, ill.; NEURDENBURG 1948, p. 221; A. Staring, N.K.J. 3 (1950-51), p. 182, fig. 24; A. Staring, O.H. 80 (1965), p. 221.
► Companion piece to nos 364, 365 and 366. Based on the portrait type of Willem III by Sir P. Lely (1677).

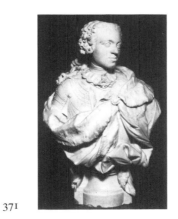

371

Jean Baptiste Xavery | *Bust of Stadholder Willem IV (1711-1751)*

Born 1697 in Antwerp, died in 1742. Probably pupil of his father Albert. Visited Italy. Worked from 1720 mostly in The Netherlands, especially The Hague.

White marble, height 82. Signed and dated: *J:B:Xavery. f:1733.*
■ Probably the Oranjezaal, Huis ten Bosch, The Hague; transferred to the Mauritshuis in 1816 by King Willem I.

• H.R. Hoetink, o.k.6 (1962), pp. 22a-22b, ill.; M.D. Ozinga in: *Miscellanea I.Q. van Regteren Altena*, Amsterdam 1969, p. 170; L.J. van der Klooster, N.K.J. 21 (1970), pp. 108-109.

▸ Companion piece to no 372. Design in terracotta in the Rijksmuseum, Amsterdam, inv.no R.B.K. 1959-78.

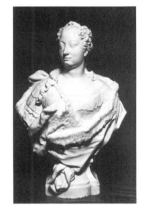

372

■ | *Bust of Anne, Princess of England (1709-1759), wife of Stadholder Willem IV*

White marble, height 85. Signed and dated: *J:B:Xavery. f:1733.*
■ Probably the Oranjezaal, Huis ten Bosch, The Hague; transferred to the Mauritshuis in 1816 by King Willem I.
• M.D. Ozinga in: *Miscellanea I.Q. van Regteren Altena*, Amsterdam 1969, p. 170; L.J. van der Klooster, N.K.J. 21 (1970), pp. 108-109.
▸ Companion piece to no 371.

ANONYMOUS SCULPTURES

922

Flemish school | *Mourning woman from a passion scene*

Oak with polychromy, height 57.2. Inscribed: *BENEDICTU(S) ES DNS (IN FIR)MA(M)EN(TO) CE(LI) LAUDABILIS (GLORIOS)US ET SU(PER) EXALT(A)TUS IN SECULA GLORIA* (Glory to God in eternal heaven, forever praise).
■ kunsth. J. Böhler, Munich; kunsth. Rosenberg and Stiebel, New York; purchased in 1955 by the Johan Maurits van Nassau Foundation; given on permanent loan.
• D.P.R.A. Bouvy, o.k. 12 (1968), pp. 19a-b, ill.; CAT. MAURITSHUIS 1968, p. 57, ill.
▸ Strong Antwerp influence.

973

■ | *St Mary Magdalene*

Oak with polychromy, height 49.
■ coll. Wertheimer, Paris; purchased from an art dealer in Switzerland in 1966.
• CAT. MAURITSHUIS 1968, pp. 57-58, ill.; CAT. MAURITSHUIS 1970, no 3, ill.
▸ School of Brabant. From a retable of a crucifixion. Influence of altarpieces with crucifixions by R. van der Weyden.

374

French school | *Bust of Mr. Pierre Lyonet (1706-1789), jurist in The Hague, Secretary to the States-General, entomologist and engraver*

Terracotta, height 77.
■ Gift from G.T.B. Croiset to King Willem I; Koninklijk Kabinet van Zeldzaamheden, The Hague, 1825; transferred to the Mauritshuis before 1881.
• STARING 1947, p. 128; W.H. Seters, o.h. 62 (1947), pp. 156-164, fig. 1; ROSENBERG, SLIVE & KUILE 1977, p. 427.
▸ Has been attributed to J.B. Le Moyne, J. Caffieri and M.A. Falconet-Collot.

Appendix. Acquisitions 1985-1993

Appendix. Acquisitions 1985-1993

1073

Balthasar van der Ast | *Wan-Li vase with flowers*

Born 1593 or 1594 in Middelburg, died 1657 in Delft. Influenced by his brother-in-law and master Ambrosius Bosschaert. Worked in Utrecht from 1619, and in Delft from 1632.

Panel, 41x32. Signed: *B. van der ast fe.*
■ bequest of Mrs L. Thurkow-Van Huffel, The Hague, 1987.
● BROOS/VAN LEEUWEN ET AL. 1991, pp. 100-101, no. XXVII, ill.

1091

Claes Pietersz Berchem | *Allegory of summer*

Born 1620 in Haarlem, died 1683 in Amsterdam. Pupil of his father, the still-life painter Pieter Claesz and of Claes Moeyaert, Pieter de Grebber, Jan Wils and Jan van Goyen. Influenced by Jan Baptist Weenix. He probably stayed in Italy from 1653 to 1655. Upon his return he worked in Haarlem and in Amsterdam.

Canvas, 93x88. Signed: *Berchem f.*
■ sale Herman van Swoll, Amsterdam 1699; sale C.J. Nieuwenhuys, London 1886; Rijksdienst Beeldende Kunst, The Hague; on loan to the Mauritshuis since 1992.
● HOSTEDE DE GROOT 1907-28, IX, p. 69, no. 68; SCHAAR 1958, p. 109; F.J. Duparc & L.L. Graif, *Italian Recollections. Dutch Painters of the Golden Age*, Montreal 1990, p. 73, no. 13b.
► From a series of the four seasons.

1098

Bartholomeus Breenbergh | *Diana (?) and her nymphs*

Born 1598 in Deventer, died 1657 in Amsterdam. Travelled to Rome in 1619. Influenced by Paul Bril, Cornelis van Poelenburch and Pieter Lastman.

Panel, 37.5x50. Signed and dated: *B. Breenbergh.f/1647* (BB in ligature).
■ purchased with the aid of the Rembrandt Society, 1993.
● M. Roethlisberger, *Bartholomeus Breenbergh*, n.pl. (New York) 1991.

1072

Jan Brueghel the Elder | *Vase with flowers*

Born 1568 in Brussels, died 1625 in Antwerp. Son of Pieter Brueghel the Elder. Travelled to Italy (1590-1596) and Prague (1604). Worked in Brussels and especially in Antwerp.

Panel, 42x34.5.
■ bequest of Mrs L. Thurkow-Van Huffel, The Hague, 1987.
● ERTZ 1979, pp. 276, 283, 286, fig. 356 and p. 592, no. 208; BRENNINKMEIJER-DE ROOIJ/BROOS ET AL. 1992, p. 72, ill.
► Autograph variations in Madrid, Museo del Prado and Campione, Silvano Lodi.

1089

Jacob van Campen | *Portrait of Constantijn Huygens and Suzanne van Baerle*

Born 1595 in Haarlem, died 1657 in Amersfoort. Pupil of the painter Frans de Grebber in Haarlem. In 1617 he travelled to Italy. He was an architect and

painter of historical subjects. Together with Pieter Post he built the Mauritshuis.

Canvas, 95x78.5.
■ purchased in 1992 by the Friends of the Mauritshuis Foundation with the aid of private individuals.
● J.S. Held, ART BULL. 73 (1991), pp. 653-668; B. Broos, *Een portret van Huygens en zijn 'Sterre' voor het Mauritshuis*.

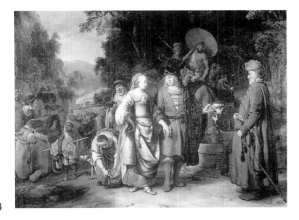
1084

Gerbrandt van den Eeckhout | *Isaac and Rebecca*

Born 1621 in Amsterdam, died there in 1674. Pupil of Rembrandt. Very productive both as a painter and as a draughtsman. Painted biblical paintings in the style of Rembrandt, for his portraits he adapted a Flemish style and his genre pieces are reminiscent of Pieter de Hooch.

Canvas, 129x171. Signed and dated: *G. v. Eeckhout. fe A° 1665.*
■ coll. J.E. Fizeaux, Amsterdam 1797; art dealer Hoogsteder, The Hague 1986-1989; purchased in 1989 by the Friends of the Mauritshuis Foundation with support from the 'Fondation Mauritshuis' in Geneva; on permanent loan to the Mauritshuis.
● B. Broos, *Mauritshuis Cahier* (1989), no. 1; BROOS/VAN LEEUWEN ET AL. 1991, pp. 110-111, no. XXXII, ill.

1088

Caesar Boetius van Everdingen | *Trompe-l'oeil with a bust of Venus*

Born 1617 in Alkmaar, died there in 1678. Brother of the landscape painter, Allert van Everdingen. Caesar, a history and portrait painter, worked together with the architect and painter Jacob van Campen on the decoration of the Oranjezaal in Huis ten Bosch Palace in The Hague.

Canvas, 74x60.8. Signed and dated: *CVE AN°.16.65.* (CVE in ligature).
■ art dealer Vitale Bloch, The Hague; coll. Mr A. Staring, Vorden 1939-1980; donated by a private collector in 1992.
● R. van Leeuwen, *Tableau* 15 (1992-1993), nr. 2, pp. 94-100.

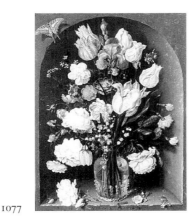
1077

Jacob de Gheyn II | *Glass with flowers*

Born 1565 in Antwerp, died 1629 in The Hague. Pupil of his father, the stained-glass artist Jacob de Gheyn I. Studied ca 1585 with Hendrick Goltzius, who strongly influenced his engravings. From 1594 active in The Hague as a draughtsman, engraver and painter. Few flower still-lifes by him are known.

Copper, 58x44. Signed and dated: *1612* (or *JG 12*)/ *JACOBUS DE GHEYN FE:.*
■ on loan from the Gemeentemuseum, The Hague, since 1987.
● BRENNINKMEIJER-DE ROOIJ/BROOS ET AL. 1992, pp. 15, 76-77, no. 13, ill.

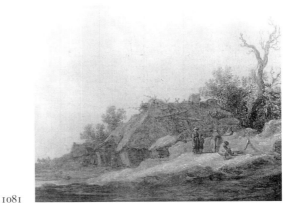
1081

Jan van Goyen | *Dilapidated farmhouse with peasants*

Born 1596 in Leiden, died 1656 in The Hague. According to Houbraken he was a pupil of Esaias van de Velde in Haarlem. Made several journeys, one of them probably to France in 1615. Worked in The Hague from 1632.

Panel, 40x54. Signed and dated: *VG 1631.*
■ art dealer Goudstikker, Amsterdam, 1928; donated by Mrs S.F. Duin-Priester, Apeldoorn, 1987.
● BECK 1973, II, p. 485, no. 1100, ill.; BROOS/VAN LEEUWEN ET AL. 1991, pp. 102-103, no. XXVIII, ill.

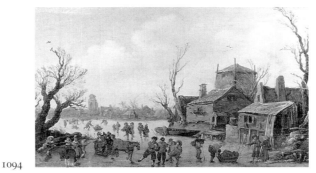
1094

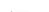 | *Winter landscape*

Panel, 32.5x50. Signed and dated: *I.V.GOYEN 1626.*
■ coll. J.T. Irving, Glasgow, 1934; art dealer D. Katz, Dieren 1934-1935; coll. H.L. Larsen, Wassenaar, 1943; Rijksdienst Beeldende Kunst, The Hague; on

loan to the Mauritshuis since 1993.

• BECK 1973, II, p. 21, no. 39, ill.; E. van Straaten, *Koud tot op het bot*, The Hague 1977, pp. 108-109, ill.

1095

Karel du Jardin | *Landscape with cattle*

Born 1626 in Amsterdam; died 1678 in Venice. Probably a pupil of Claes Pietersz Berchem. Travelled to France and Italy. On his return in 1652 he worked in Amsterdam, The Hague and then again in Amsterdam. Visited Italy a second time in 1675 via North Africa and Tangier.

Panel, 41x37. Signed: *K. DU. JARDIN fec.*
■ coll. A. Schouman, Rotterdam, 1753; coll. J. & P. Bisschop, Rotterdam, 1753-1771; coll. Hope, Amsterdam, 1771-1798, London, 1798-1898; art dealer Wertheimer, London; coll. Widener, Philadelphia, 1898?-1923; art dealer Knoedler, New York, 1923; coll. G.L.M. van Es, Dordrecht; art dealer Vitale Bloch, The Hague, 1942; Rijksdienst Beeldende Kunst, The Hague; on loan to the Mauritshuis since 1993.
• HOFSTEDE DE GROOT 1907-28, IX, p. 318, no. 88; BROCHHAGEN 1958, p. 96; C. Boschma, J.M. de Groot et al., *Meesterlijk vee. Nederlandse veeschilders 1600-1900*, Dordrecht/Leeuwarden 1988-89, pp. 170-171, no. 29, ill.; F.J. Duparc & L.L. Graif, *Italian Recollections. Dutch Painters of the Golden Age*, Montreal 1990, pp. 130-131, no. 37, ill.; J.M. Kilian, *The Paintings of Karel du Jardin (1626-1675)* (diss.), New York 1993, pp. 369-371, no. 76, ill.

1085

Willem Bartel van der Kooi | *Portrait of King Willem I*

Born 1768 in Augustinusga, died 1837 in Leeuwarden. Pupil of Johannes Verrier. Taught at the Academy in Franeker and was a successful portrait painter.

Canvas, 237x157. Signed and dated: *W.B. van der Kooi/ pinx. 1818.*
■ on loan from the Hannema-de Stuers Foundation in Heino since 1989.
• C. Boschma, *Willem Bartel van der Kooi (1768-1836) en het tekenonderwijs in Friesland*, Leeuwarden 1978, pp. 164-165, no. B15, ill.

1074

Pieter Lastman | *David and Uriah*

Born ca 1583 in Amsterdam, died there in 1633. Pupil of Gerrit Pietersz Sweelinck ca 1602 in Amsterdam. Developed in Rome and Venice (1603-1607?) under the influence of Adam Elsheimer and Caravaggio. Later worked in Amsterdam, where Jan Lievens (ca 1618-1620) and Rembrandt (1623) were his pupils.

Panel, 50x62. Signed and dated: *P Lastman fecit 1619.*
■ Rijksdienst Beeldende Kunst, The Hague; on loan to the Mauritshuis since 1987.
• WASHINGTON 1980-81, pp. 130-131, no. 22, ill.; A. Tümpel, P. Schatborn et al., *Pieter Lastman. the man who taught Rembrandt*, Amsterdam 1991, pp. 108-109, no. 12, ill.

1078-1079

Ger Lataster | *Designs for 'Icarus Atlanticus'*

Born 1920 in Schaesberg. Painter, draughtsman and graphic artist. Belongs to the generation of artists who renewed Dutch landscape painting after 1945, developing an increasingly free and abstract style. His larger canvases come close to action painting.

Canvas, each 100x100.5.
■ on loan from the artist in 1987; donated by the artist to Hans R. Hoetink, director of the Mauritshuis, in 1988; donated by Hans R. Hoetink to the Mauritshuis in 1988.
• BROOS/VAN LEEUWEN ET AL. 1991, pp. 108-109, no. XXI, ill.

1082-1083

■ | *Icarus Atlanticus. Allegory of human vanity and allegory of the working man*

Cotton, each ca 500x500. Signed and dated: *G. Lataster 87*
■ commissioned for a ceiling on the first floor of the Mauritshuis, 1987.
• J. Rempt, *Dutch art and Architecture Today* (1988), no. 23, pp. 20-21; J.A. Berkhof, *Beelding* (1988), April, pp. 12-14; J. Wolf, *Holland Herald* 24 (1989), no. 6, pp. 34-37.

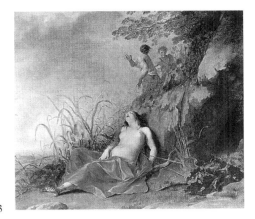

1093

Dirck van der Lisse | *Sleeping nymph*

Born 1607 in The Hague, died there in 1657. Moved to Utrecht in 1640, and to Amsterdam in 1642. Married in The Hague in 1644, where he was several times burgomaster. Follower of Cornelis Poelenburch.

Panel, 44x51.8. Signed: *DVL* (in ligature).
■ coll. Q. van Biesum, Rotterdam, 1719; coll. F.C. Butôt, St. Gilgen; donated by Mrs Stubbé-Bûtot, Wassenaar, 1993.
● SALERNO 1977-80. I, p. 268, no. 46; F.C. Butôt, L.J. Bol & G.S. Keyes, *Netherlandish Paintings and Drawings from the Collection of F.C. Butôt by little-known and rare Masters of the Seventeenth Century*, London 1981, pp. 196-197, no. 81, ill.

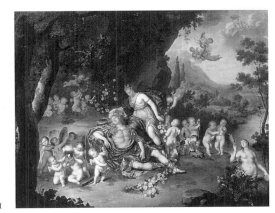

1071

Willem van Mieris | *Rinaldo and Armida*

Born 1662 in Leiden, died there in 1747. Pupil of his father, Frans van Mieris. Follower of his father and of Gerard Dou.

Panel, 67x85. Signed and dated: *W. van Mieris Fe. Anno 1709.*
■ coll. Pieter de la Court van der Voort, Leiden 1709-1739; coll. H. van Kretschmar, The Hague, 1747-1757; Brod Gallery, London 1982-1987; purchased in 1987.
● E.J. Sluijter, M. Erklaar & P. Nieuwenhuizen, *Leidse fijnschilders. Van Gerrit Dou tot Frans van Mieris de Jonge. 1630-1760*, Leiden 1988, p. 43, ill. and p. 166; BROOS/VAN LEEUWEN ET AL. 1991, pp. 92-93, no. XXIII, ill.
► Several paintings and drawings by Van Mieris of the same subject are known.

1075

Hendrick Gerritsz Pot | *Portrait of Jean Fontaine*

Born ca 1585 in Haarlem, died 1657 in Amsterdam. Possibly a pupil of Carel van Mander together with Frans Hals. Dean of the painter's guild in Haarlem, where he painted portraits and genre scenes. Moved to Amsterdam in 1648.

Panel, 18.5x15.5.
■ bequest of Abraham baron Calkoen, The Hague; Rijksdienst Beeldende Kunst, The Hague; on loan to the Mauritshuis since 1987.
● B. Broos, *Acquisitions of the Mauritshuis 1981-1987*, The Hague 1987.
► Original frame. Companion piece to no. 1076.

1076

■ | *Portrait of Anna Hooftman, wife of Jean Fontaine*

Panel, 18.5x15.5.
■ bequest of Abraham baron Calkoen, The Hague; Rijksdienst Beeldende Kunst, The Hague; on loan to the Mauritshuis since 1987.
● B. Broos, *Acquisitions of the Mauritshuis 1981-1987*, The Hague 1987.
► Original frame. Companion piece to no. 1075.

1096

Pieter Dircksz van Santvoort | *Dune landscape*

Born in Amsterdam after 1603, died there 1635. His family came from Flanders. Few paintings by Santvoort are known.

Panel, 31.5x46. Signed: *[D] Sant.*
■ art dealer J. Goudstikker, Amsterdam; art dealer D. Katz, Dieren, 1940; Rijksdienst Beeldende Kunst, The Hague; on loan to the Mauritshuis since 1993.

• C. Brown, *Dutch Landscape. The Early Years*, London 1986, p. 231, no. 117, ill.; E. Buijsen et al., *Between Fantasy and Reality. 17th Century Dutch Landscape Painting*, Leiden 1993, pp. 88, 165-166, no. 29, ill.
▸ Previously attributed to Pieter Molijn.

1092

David Teniers the Younger | *Guardroom of monkeys*

Born 1610 in Antwerp, died 1690 in Brussels. Pupil of his father, David Teniers the Elder. Strongly influenced by Adriaen Brouwer. Worked in Antwerp until 1651, then court painter in Brussels and keeper of the art collection of the Archduke Leopold Willem. One of the founders of the Antwerp Academy.

Panel 41.5x58.
■ coll. Reinhardt, New York, 1927; art dealer J. Goudstikker, Amsterdam; coll. Göring; Rijksdienst Beeldende Kunst, The Hague; on loan to the Mauritshuis since 1992.
• M. Klinge, *David Teniers de Jonge. Schilderijen. Tekeningen*, Antwerpen 1991, pp. 38-39, no. 6, ill.

1068

Cornelis Troost | *Portrait of an unknown man*

Born 1697 in Amsterdam, died there in 1750. Pupil of Arnold Boonen. Painted portraits, genre pieces and theatre scenes.

Canvas, 90x72. Signed and dated: *C. Troost, 1730*.
■ art dealer Hoogsteder, The Hague; purchased in 1986.
• BROOS/VAN LEEUWEN ET AL. 1991, pp. 84-85, no. XIX, ill.; E. Buijsen, J.W. Niemeyer & M. de Boer, *Cornelis Troost and the Theatre of his Time. Plays of the 18th Century*, The Hague 1993, pp. 34-35, no. 2.
▸ Companion piece probably in Düsseldorf, Kunstmuseum, inv.no. 266.

1097

Moses van Uyttenbroeck | *Landscape with Hermaphroditus and Salmacis*

Born ca 1590 in The Hague, died there ca 1646. Worked at Honselaarsdijk. Probably did not travel to Italy, but borrowed motifs for his southern landscapes from Adam Elsheimer and Jacob Pynas.

Panel, 43x66. Signed and dated: *Mo v WB 162[7?]* (WB in ligature).
■ art dealer Vitale Bloch, The Hague; coll. J.H. Gosschalk, The Hague, 1931; Rijksdienst Beeldende Kunst, The Hague; on loan to the Mauritshuis since 1993.
• P. Sutton, *Masters of 17th-Century Dutch Landscape Painting*, Amsterdam/Boston/Philadelphia 1987-88, pp. 535-537, ill.; E. Buijsen et al., *Between Fantasy and Reality. 17th Century Dutch Landscape Painting*, Leiden 1993, pp. 118, 208-209, no. 66, ill.

1070

Augustus Wijnantz | *View of the Mauritshuis*

He was a trumpeteer in the cavalry and a painter of interiors and townscapes. He died in The Hague in 1848.

Panel, 22.5x27.5. Signed and dated: *A. Wynantz* [18]3[0?].
■ donated by H.H. baron Thyssen Bornemisza, Lugano, 1986.
• BROOS/VAN LEEUWEN ET AL. 1991, pp. 88-89, no. XXI, ill.

1090

1069

Dutch school | *Portrait of a man*

Copper, 8.2x6.6. Signed and dated: *A° 1606/ R.F.*
■ private collection, Düsseldorf; art dealer Douwes, Amsterdam; donated by Mr C.W. van Blijenburgh, Hilversum, 1992.
● *Een verzameling schilderijen uit de 17de, 18de en 19de eeuw*, Leiden 1980, pp. 22, 39, no. 39, ill.

Johann Heinrich Schepp | *Relief with a portrait of Arnout Vosmaer (1726-1798)*

Born 1736 in Diez, Germany. Specialized in medals and cameos. From 1772 until 1787 he worked as a medallist in The Hague, where Prince Willem V was one of his patrons.

Terracotta, 31.5x26.5.
■ donated by Mrs M.D. Vosmaer-Hudig, Leiden, 1986.
● A. Staring, O.H. 64 (1949), p. 99; F.L. Bastet, J.F. Heijbroek, N. Maas et al. *De verzameling van mr. Carel Vosmaer (1826-1888)*, Amsterdam 1989, p. 160, fol. 1; BROOS/VAN LEEUWEN ET AL. 1991, pp. 86-87, no. XX, ill.
► Vosmaer was curator of the collections of Prince Willem V.

Changed attributions

Collaborators

Works reattributed since the publication of the *Mauritshuis Illustrated General Catalogue,* The Hague 1977.

387	J. Anspach	→ MINIATURES, J. Anspach
826	F. Bol	→ J. Backer
932	B. Breenbergh	→ ANONYMOUS, Dutch School
881	Bruges school	→ P. Pourbus
994	N. Dixon (miniatures)	→ MINIATURES, R. Gibson
719	Dutch school	→ N. van Ravesteyn
723	Dutch school	→ G. Alberts
1024	Dutch school (miniatures)	→ MINIATURES, J.H. Hurter
984	English school (miniatures)	→ MINIATURES, ANONYMOUS, French school
985	English school (miniatures)	→ MINIATURES, ANONYMOUS, French school
986	English school (miniatures)	→ MINIATURES, ANONYMOUS, French school
987	English school (miniatures)	→ MINIATURES, ANONYMOUS, French school
235	F. Francken II	→ ANONYMOUS, Flemish school
304	Italian school	→ N. Regnier
354	Italian school	→ Parmigianino (copy)
357	Italian school	→ Raphael (copy)
741	L. de Jongh	→ MONOGRAMMISTS, Monogrammist AVE
776	C.A. van Loo	→ L.J.F. Lagrenée
856	A. de Lorme	→ C. de Man
297	J. van Oost	→ P. van Mol
967	J. Post	→ ANONYMOUS, Dutch school
626	Rembrandt	→ ANONYMOUS, Dutch school
536	J.P. Schoeff	→ ANONYMOUS, Flemish school
317	B. Veronese	→ ANONYMOUS, Italian school

Reattributed since the publication of *The Royal Picture Gallery Mauritshuis,* The Hague 1985.

1042	ANONYMOUS, Dutch school	→ M. Terwesten

Artists who contributed to a painting by another master.

H. van Balen	→ 233	J. Brueghel the Elder
H. van Balen	→ 281	H. Rottenhammer
H. van Balen	→ 282	H. Rottenhammer
H. van Balen	→ 283	J. Brueghel the Elder
T.W. Bosschaert	→ 256	D. Seghers
J. Brueghel the Elder	→ 234	H. van Balen
J. Brueghel the Elder	→ 281	H. Rottenhammer
J. Brueghel the Elder	→ 282	H. Rottenhammer
D. van Delen	→ 238	G. Coques
F. Francken II	→ 248	P. Neeffs
J. van Hughtenburgh	→ 690	G. Berckheyde
J. Lingelbach	→ 121	F. de Moucheron
J. de Momper	→ 235	ANONYMOUS, Flemish school
A. van Ostade	→ 440	C. Dusart
School of C. van Poelenburch	→ 79	A. Keirincx
E. van de Velde	→ 9	B. van Bassen
W. van de Velde the Younger	→ 19	F. Bol
W. van de Velde the Younger	→ 585	F. Bol
P. Vredeman de Vries	→ 244	F. Francken II
J. Wildens	→ 259	P. de Vos

Subject index

Inventory numbers

393 P.P. Lastman
394 C.C. Moeyaert
395 C.C. Moeyaert
396 A. van den Tempel
397 A. van den Tempel
398 D. Feti
399 B. van der Ast
400 C.P. Bega
401 A.H. van Beyeren
402 J. Vermeulen
404 E. Vonck
405 G. d'Hondecoeter
406 J. Vermeer
407 J.M. Molenaer
408 W.C. Duyster
409 P.S. Potter
410 K. Slabbaert
411 C. Troost
414 J.A. van Ravesteyn
415 J.A. van Ravesteyn
416 J.A. van Ravesteyn
417 J.A. van Ravesteyn
418 J.A. van Ravesteyn
419 J.A. van Ravesteyn
420 J.A. van Ravesteyn
421 J.A. van Ravesteyn
422 J.A. van Ravesteyn
423 J.A. van Ravesteyn
424 J.A. van Ravesteyn
425 J.A. van Ravesteyn
426 J.A. van Ravesteyn
427 J.A. van Ravesteyn
428 G. van Honthorst
429 A. Hanneman
430 G. van Honthorst
431 ANONYMOUS, Flemish school
432 ANONYMOUS, French school
433 MASTERS WITH ACQUIRED NAMES, Master of the Solomon Triptych
437 S. de Bray
438 J.A. van Ravesteyn
439 J.A. van Ravesteyn
440 C. Dusart
445 P. Codde
446 G. Lairesse
447 P.J. Quast
448 ANONYMOUS, Dutch school
449 ANONYMOUS, Dutch school
454 J. de Baen
455 J.A. van Ravesteyn
456 J.A. van Ravesteyn
457 J.A. van Ravesteyn
459 F. Hals
460 F. Hals
461 J.A.J. Aved
462 J.G. Ziesenis
463 J.G. Ziesenis
464 J.F.A. Tischbein
468 Maria van Oosterwijck
469 T. Wijck

470 J. Hackaert
471 W. van de Velde the Younger
472 A. van Dyck
473 E. de Witte
474 C. Pierson
475 H.G. Pot
476 A. van Nieulandt
496 ANONYMOUS, Dutch school
498 A. Raguineau
504 ANONYMOUS, Dutch school
507 M.J. van Mierevelt
530 F. Bol
531 J. van der Heyden
532 O. Marseus van Schrieck
533 J. van de Velde III
534 J.I. van Ruisdael
535 J.A. Bellevois
536 ANONYMOUS, Flemish school
537 J. Olis
538 C. Saftleven
539 P.F. de la Croix
540 ANONYMOUS, Dutch school
541 S. van Beest
542 D. Vinckboons
543 J.A. Backer
544 R. Brakenburgh
545 B. van der Helst
546 H.A. Pacx
547 ANONYMOUS, Dutch school
548 A.H. van Beyeren
549 P. Mulier the Elder
550 SCULPTURES, J.J. van der Schardt
551 J.J. van Goyen
553 J. Steen
554 G. du Bois
556 Rembrandt
558 S.J. de Vlieger
559 A. Mor van Dashorst
560 Rembrandt
561 ANONYMOUS, Dutch school
562 Q.G. Brekelenkam
563 W. van de Velde the Younger
564 Judith Leyster
565 Rembrandt
566 S. van Ruysdael
567 J. van de Cappelle
568 B. van der Helst
569 B. van der Helst
572 J.M. Molenaer
573 J.M. Molenaer
574 J.M. Molenaer
575 J.M. Molenaer
576 J.M. Molenaer
579 Rembrandt
580 A. van Ostade
584 Rembrandt
585 F. Bol
595 H. Memling

596 W.C. Heda
598 Rembrandt
599 J. van Loo
601 J. van Haensbergen
602 P. van Noordt
603 ANONYMOUS, Dutch school
605 C. Fabritius
606 H. Verschuring
607 A. Brouwer
608 J. de Reyger
609 C. Troost
610 ANONYMOUS, Dutch school
611 P.C. Verbeeck
613 J.D. de Heem
615 A. Palamedesz
618 F. Hals
621 Rembrandt
623 C. Hals
624 J.J. van Goyen
626 ANONYMOUS, Dutch school
627 A. Cuyp
642 J. Weenix
654 ANONYMOUS, Dutch school
655 P. Moreelse
656 J.B.S. Chardin
657 M. Sweerts
658 P.J. Quast
659 A. Verstralen
662 J. Vermeulen
664 J. Steen
665 A.H. van Beyeren
669 H.W. Schweickhardt
670 J. Vermeer
671 C. van de Berghe
672 C. van de Berghe
673 E. van de Velde
674 ANONYMOUS, Dutch school
675 B. Zwaerdecroon
676 G. Flinck
677 K. van Vogelaer
678 A.H. van Beyeren
679 A. Bosschaert
680 ANONYMOUS, Dutch school
681 H. ten Oever
682 A. van der Neer
685 Rembrandt
686 Constantijn Netscher
687 J. Fijt
688 C. Jonson van Ceulen I
689 T. de Keyser
690 G.A. Berckheyde
681 J.M. Molenaer
692 MONOGRAMMISTS, Monogrammist B.E.
693 A. Hanneman
694 ANONYMOUS, Flemish school
695 ANONYMOUS, Flemish school
696 G. Flinck
697 A.H. van Beyeren
698 E.L. van der Poel
699 S. van Ruysdael

701 ANONYMOUS, Dutch school
702 ANONYMOUS, Felmish school
703 ANONYMOUS, Flemish school
705 J. Moreelse
706 F. Post
707 Rembrandt
708 G. Schalcken
709 G. Schalcken
710 ANONYMOUS, Dutch school
711 ANONYMOUS, Dutch school
712 P. van Dijk
713 P. van Dijk
714 Caspar Netscher
715 Caspar Netscher
716 Caspar Netscher
717 N. Maes
718 N. Maes
719 N. van Ravesteyn
720 J. van Haensbergen
721 Constantijn Netscher
722 I. Luttichuys
723 G. Alberts
724 J. Vermeer van Haarlem
725 ANONYMOUS, Flemish school
728 J.I. van Ruisdael
729 G. van der Mijn
730 G. van der Mijn
731 J. de Wit
732 J. de Wit
731 J. de Wit
734 J. de Wit
735 J. de Wit
736 J. Steen
737 A. de Gelder
738 S. van Ruysdael
739 B. Bruyn the Elder
740 P. de Vos
741 MONOGRAMMISTS, Monogrammist A.V.E.
742 J. Steen
744 G. ter Borch
745 I. van Ostade
746 J.A. Berckheyde
747 J.A. Backer
748 M. van Musscher
749 M.J. van Mierevelt
750 M.J. van Mierevelt
751 K. Slabbaert
752 MASTERS WITH ACQUIRED NAMES, Master of the Brandon Portrait
754 A. van Calraet
755 P.C. Soutman
756 H. Hals
757 A. de Gelder
759 J.J. van Goyen
760 K. du Jardin
762 D. Bouts
764 H. Pothoven
765 P.J. Post
766 P.J. Post

Key to abbreviated literature

1055 A.F. Heijligers
1056 A.H. van Beyeren
1057 J.A. Backer
1058 C.P. Berchem & J.B. Weenix
1059 M. van Uyttenbroeck
1060 D. Hals
1061 M. Hobbema
1062 J. van Campen
1063 F. Post
1065 C. van Poelenburch
1066 B. van der Ast
1067 J.S. van Hemessen

APPENDIX

1068 C. Troost
1069 J.H. Schepp
1070 A. Wijnantz
1071 W. van Mieris
1072 J. Brueghel the Elder
1073 B. van der Ast
1074 P. Lastman
1075 H.G. Pot
1076 H.G. Pot
1077 J. de Gheyn II
1078 G. Lataster
1079 G. Lataster
1081 J. van Goyen
1082 G. Lataster
1083 G. Lataster
1084 G. van den Eeckhout
1085 W.B. van der Kooi
1088 C.B. van Everdingen
1089 J. van Campen
1090 Flemish school
1091 C.P. Berchem
1092 D. Teniers the Younger
1093 D. van der Lisse
1094 J. van Goyen
1095 K. du Jardin
1096 P.D. van Santvoort
1097 M. van Uyttenbroeck
1098 B. Breenbergh

ALB. AMIC. VAN GELDER 1973
Album amicorum J.G. van Gelder, The Hague 1973.
ALPERS 1983
S. Alpers, *The art of describing: Dutch art in the seventeenth century*, Chicago 1983.
AMSTERDAM 1976
E. de Jongh et al., *Tot lering en vermaak*, Rijksmuseum, Amsterdam 1976. AMSTERDAM 1977
Opkomst en bloei van het Noordnederlandse stadsgezicht in de 17de eeuw, Amsterdams Historisch Museum/Art Gallery of Ontario, Toronto, Amsterdam 1977.
AMSTERDAM 1982
S. Segal, *Een bloemrijk verleden: overzicht van de Noord- en Zuidnederlandse bloemschilderkunst, 1600 – heden*, Kunsth. P. de Boer, Amsterdam/ Noordbrabants Museum, 's-Hertogenbosch, Amsterdam 1982.
AMSTERDAM 1982-83
J.F. Heijbroek, et al., *Met Huygens op reis*, Rijksprentenkabinet, Amsterdam/Museum voor Schone Kunsten, Ghent, Amsterdam 1982-83.
AMSTERDAM 1983 (1)
A. Blankert et al., *The impact of a genius: Rembrandt, his pupils and his followers in the seventeenth century*, Kunsth. K. & V. Waterman, Amsterdam 1983.
AMSTERDAM 1983 (2)
S. Segal, *A fruitful past*, Kunsth. P. de Boer, Amsterdam/Herzog Anton Ulrich-Museum, Brunswick, Amsterdam 1983.
AMSTERDAM 1984
P.J.J. van Thiel, C.J. de Bruyn Kops, *Prijs de lijst: de Hollandse schilderijlijst in de zeventiende eeuw*, Rijksmuseum, Amsterdam 1984.
ANTIEK
Antiek: Tijdschrift voor Liefhebbers en Kenners van Oude Kunst en Kunstnijverheid, Lochem.
ARPS-AUBERT 1932
R. von Arps-Aubert, *Die Entwicklung des reinen Tierbildes in der Kunst des Paulus Potter*, Halle 1932.
ART BULL.
The Art Bulletin: A Quarterly Published by the College Art

Association of America, New York.
AUCKLAND 1982
E. de Jongh et al., *Still-life in the age of Rembrandt*, Art Galleries of Auckland, Wellington and Christchurch, Auckland 1982.
AUERBACH 1961
E. Auerbach, *Nicholas Hilliard*, London 1961.
BAARD 1942
H.P. Baard, *Willem van de Velde de Oude en Willem van de Velde de Jonge*, Amsterdam 1942.
BACCI 1976
M. Bacci, *L'opera completa di Piero di Cosimo*, Milan 1976.
BACHMANN 1982
F. Bachmann, *Aert van der Neer*, Bremen 1982.
BARDON 1960
H. Bardon, *Le festin des dieux: essai sur l'humanisme dans les arts plastiques*, Paris 1960.
BASEL 1960
Die Malerfamilie Holbein in Basel, Kunstmuseum, Basel 1960.
BASEL 1974
D. Koepplin, T. Falk, *Lukas Cranach; Gemälde, Zeichnungen, Druckgrafik*, Kunstmuseum, Basle 1974, 2 vols.
BAUCH 1926
K. Bauch, *Jacob Adriaansz. Backer*, Berlin 1926.
BAUCH 1966
K. Bauch, *Rembrandt: Gemälde*, Berlin 1966.
BECK 1973
H.-U. Beck, *Jan van Goyen 1596-1656*, Amsterdam 1973, 2 vols.
BERENSON 1907
B. Berenson, *North Italian painters of the Renaissance*, London 1907.
BERENSON 1963
B. Berenson, *Italian pictures of the Renaissance: Florentine school*, London 1963.
BERGAMO 1981
A. Veca, *Vanitas: il simbolismo del tempo*, Galleria Lorenzelli, Bergamo 1981.
BERGSTRÖM 1956
I. Bergström, *Dutch still-life painting in the seventeenth century*, London 1956.
BERGSTRÖM 1977
I. Bergström and C. Grimm, *Natura in prosa*, Milan 1977.
BERNT 1948-62
W. Bernt, *Die niederländischen*

Maler des 17. Jahrhunderts, Munich 1948-62, 4 vols.
BERNT 1969-70
W. Bernt, *Die niederländischen Maler des 17. Jahrhunderts*, Munich 1969-70, 3 vols.
BIESBOER 1983
P. Biesboer, *Schilderijen voor het stadhuis Haarlem*, Haarlem 1983.
BILLE 1961
C. Bille, *De tempel der kunst of het kabinet van den Heer Braamcamp*, Amsterdam 1961.
BLANKERT 1978 (1)
A. Blankert, *Nederlandse 17e eeuwse Italianiserende landschapschilders*, Soest 1978 (originally published in 1965 as catalogue of the exhibition of the same name in the Centraal Museum, Utrecht).
BLANKERT 1978 (2)
A. Blankert, *Vermeer of Delft*, Oxford 1978 (revised from the Dutch edition Utrecht/Antwerp 1975).
BLANKERT 1982
A. Blankert, *Ferdinand Bol, Rembrandt's pupil*, Doornspijk 1982.
BLOCH 1968
V. Bloch, *Michael Sweerts*, The Hague 1968.
BOL 1960
L.J. Bol, *The Bosschaert dynasty: painters of flowers and fruit*, Leigh-on-Sea 1960.
BOL 1969
L.J. Bol, *Holländische Maler des 17. Jahrhunderts nahe den grossen Meistern*, Brunswick 1969.
BOL 1973
L.J. Bol, *Die holländischen Marinemaler des 17. Jahrhunderts*, Brunswick 1973.
BOL 1982
L.J. Bol, *Goede onbekenden: hedendaagse herkenning en waardering van verscholen, voorbijgezien en onderschat talent*, Mijdrecht 1982.
BOSQUE 1975
A. de Bosque, *Quinten Metsys*, Brussels 1975.
BRAUN 1966
H. Braun, *Gerard und Willem van Honthorst*, Göttingen 1966 (diss.).
BRAUN 1980
K. Braun, *Alle tot nu toe bekende schilderijen van Jan Steen*, Rotterdam 1980.

BRAUNSCHWEIG 1979
Jan Lievens: ein Maler im Schatten Rembrandts, Herzog Anton Ulrich-Museum. Brunswick 1979.
BREDIUS 1935
A. Bredius, *Rembrandt: schilderijen*, Utrecht 1935.
BREDIUS & GERSON 1969
A. Bredius & H. Gerson, *Rembrandt: the complete edition of the paintings*, London 1969.
BRENNINKMEYER-DE ROOIJ 1983
B.M.J. Brenninkmeyer-de Rooij, *Jan Davidsz. de Heem (1606-1683/84): allegorisch portret van Prins Willem III*, The Hague 1983.
BRENNINKMEIJER-DE ROOIJ/BROOS ET AL. 1992
B. Brenninkmeijer-De Rooij, B. Broos, F.G. Meijer & P. van der Ploeg, *Bouquets from the Golden Age. The Mauritshuis in bloom*, The Hague 1992
BROCHHAGEN 1958
E. Brochhagen, *Karel Dujardin: ein Beitrag zum Italianismus in Holland im 17. Jahrhundert*, Cologne 1958.
BROOS/VAN LEEUWEN ET AL. 1991
B. Broos, R. van Leeuwen, E. Buijsen & P. van der Ploeg, *Twee decennia Mauritshuis. Ter herinnering aan Hans R. Hoetink. directeur 1972-1991*, The Hague 1991.
BROULHIET 1938
G. Broulhiet, *Meindert Hobbema*, Paris 1938.
BROWN 1981
C. Brown, *Carel Fabritius*, London 1981.
BRUSSELS 1971
Rembrandt en zijn tijd, Paleis voor Schone Kunsten, Brussels 1971.
BRUSSELS 1977
Albrecht Dürer in de Nederlanden: zijn reis (1520-1521) en invloed, Paleis voor Schone Kunsten, Brussels 1977.
BULL. MUS. ROY. BELG.
Bulletin des Musées Royaux de Beaux-Arts de Belgique, Brussels.
BULL. N.O.B.
Bulletin uitgegeven door de (Koninklijke) Nederlandse Oudheidkundige Bond, Amsterdam.
BULL. R.M.
Bulletin van het Rijksmuseum, The Hague.
BURKE 1976
J.D. Burke, *Jan Both: paintings,*

drawings and prints, New York 1976.
BURL. MAG.
The Burlington Magazine for Connoisseurs, London.
CAT. LAKENHAL 1983
Stedelijk Museum de Lakenhal: catalogus van schilderijen en tekeningen, Leiden 1983.
CAT. MAURITSHUIS 1935
Catalogue raisonné des tableaux et sculptures, The Hague 1935.
CAT. MAURITSHUIS 1968
Schilderijen en beeldhouwwerken 15e en 16e eeuw, Cat. I, The Hague 1968.
CAT. MAURITSHUIS 1970
Vijfentwintig jaar aanwinsten Mauritshuis, 1945-1970, The Hague 1970.
CAT. MAURITSHUIS 1977
Illustrated general catalogue, The Hague 1977.
CAT. MAURITSHUIS 1980
Hollandse schilderkunst: landschappen 17de eeuw, The Hague 1980.
CAT. RIJKSMUSEUM 1973
Beeldhouwkunst in het Rijksmuseum: catalogus, The Hague/Amsterdam 1973.
CAT. RIJKSMUSEUM 1976
All the paintings of the Rijksmuseum in Amsterdam: a completely illustrated catalogue, Maarssen 1976.
CAT. THYSSEN-BORNEMISZA 1969
The Thyssen-Bornemisza collection, Castagnola 1969.
CAT. UFFIZI 1979-80
Gli Uffizi: Catalogo generale, Florence 1979-80.
COLDING 1953
T.H. Colding, *Aspects of miniature painting: its origins and development*, Copenhagen 1953.
COLLINS BAKER 1912
C.H. Collins Baker, *Lely and the Stuart portrait painters: a study of English portraiture before and after Van Dyck*, London 1912, 2 vols.
COLOGNE 1955
Barthel Bruyn 1493-1555: Gesamtverzeichnis seiner Bildnisse und Altarwerke aus Anlass seines vierhundertsten Todesjahres, Wallraf-Richartz-Museum, Cologne 1955.
COLOGNE 1982
Die Heiligen drei Könige: Darstellung und Verehrung.

Joseph-Haubrich-Kunsthalle, Cologne 1982.
CORPUS 1982
J. Bruyn et al., *A corpus of Rembrandt paintings*, I, The Hague/Boston/London 1982.
CUST & MARTIN 1906
L. Cust & K. Martin, 'The portraits of Mary Queen of Scots', *The Burlington Magazine* 19 (1906-07), pp. 38-47.
DAVIDSON 1980
J.P. Davidson, *David Teniers the Younger*, London 1980.
DELBANCO 1928
G. Delbanco, *Der Maler Abraham Bloemaert 1564-1651*, Strasbourg 1928.
DELFT 1964
De schilder en zijn wereld: van Jan van Eyck tot Van Gogh en Ensor, Stedelijk Museum 'Het Prinsenhof'. Delft/Paleis voor Schone Kunsten, Antwerp, Delft 1964.
DELFT 1966
L. de Vries, *Twintig miniaturen uit Koninklijk- en Rijksbezit*, Stedelijk Museum 'Het Prinsenhof'. Delft 1966.
DOBRZYCKA 1966
A. Dobrzycka, *Jan van Goyen*, Poznan 1966.
DONZELLI 1957
C. Donzelli, *I pittori veneti del Settecento*, Florence 1957.
DORDRECHT 1977-78
Aelbert Cuyp en zijn familie: schilders te Dordrecht, Dordrechts Museum, Dordrecht 1977-78.
DROSSAERS & LUNSINGH SCHEURLEER 1974-76
S.W.A. Drossaers & T.H. Lunsingh Scheurleer. *Inventarissen van de inboedels in de verblijven van de Oranjes en daarmede gelijk te stellen stukken 1567-1795*, The Hague (Rijks Geschiedkundige Publicatiën) 1974-76, 3 vols.
DURANTINI 1983
M.F. Durantini, *Studies in the role and function of the child in seventeenth century Dutch painting*, Ann Arbor, Michigan 1983.
EKKART 1979
R.E.O. Ekkart, *Johannes Cornelisz. Verspronck*, Haarlem 1979.
ENSCHEDE 1980
Landschappen, stads- en dorpsgezichten 17de- en 19de

eeuw, Rijksmuseum Twente, Enschede 1980.
ERTZ 1979
K. Ertz, *Jan Brueghel der Ältere (1568-1625): die Gemälde*, Cologne 1979.
FAGGIN 1968
G. Faggin, *La pittura ad Anversa nel Cinquecenio*, Florence 1968.
FOSKETT 1974
D. Foskett, *Samuel Cooper 1609-1672*, London 1974.
FRANZ 1969
H. Franz, *Niederländische Landschaftsmalerei im Zeitalter des Manierismus*, Graz 1969, 2 vols.
FREISE 1911
K. Freise, *Pieter Lastman, sein Leben und seine Kunst*, Leipzig 1911.
FRIEDLÄNDER 1967-76
M.J. Friedländer, *Early Netherlandish painting*, Leiden/Brussels 1967-76 (English version of the German edition, Berlin 1924-37), 14 vols.
FRITZ 1932
R. Fritz, *Das Stadt- und Strassenbild des 17. Jahrhunderts in der holländischen Malerei*, Stuttgart 1932
FUCHS 1968
R.H. Fuchs, *Rembrandt en Amsterdam*, Rotterdam 1968.
GANZ 1950
P. Ganz, *Hans Holbein*, Basel 1950.
GAZ. B.A.
Gazette des Beaux Arts: Courier Européen de l'Art et de la Curiosité, Paris.
GEIGER 1949
B. Geiger, *Alessandro Magnasco*, Bergamo 1949.
GELDER 1921
J.J. de Gelder. *Bartholomeus van der Helst*, Rotterdam 1921.
GENOA 1949
Mostra del Magnasco, Palazzo Bianco, Genoa 1949.
GENTSE BIJDRAGEN
Gentse bijdragen tot kunstgeschiedenis en oudheidkunde, Ghent.
GERSON 1951
H. Gerson, *Schilderkunst van Geertgen tot Frans Hals*, Amsterdam 1951.
GERSON 1968
H. Gerson, *Rembrandt paintings*, Amsterdam 1968.

GLÜCK 1931
G. Glück, *Van Dijck: des Meisters Gemälde*, Stuttgart/Berlin (Klassiker der Kunst) 1931.

GOWING 1952
L. Gowing, *Vermeer*, London 1952.

GRANT 1954
M.H. Grant, *Jan van Huysum*, Leigh-on-Sea 1954.

GREINDL 1956
E. Greindl, *Les peintres Flamands de nature morte au XVIIe siècle*, Brussels 1956.

GREINDL 1983
E. Greindl, *Les peintres Flamands de nature morte au XVIIe siècle*, Brussels 1983.

GRIMM 1972
C. Grimm, *Frans Hals: Entwicklung, Werkanalyse, Gesamtkatalog*, Berlin 1972.

GRISEBACH 1974
L. Grisebach, *Willem Kalf*, Berlin 1974.

GUDLAUGSSON 1945
S.J. Gudlaugsson, *De komedianten bij Jan Steen en zijn tijdgenoten*, The Hague 1945.

GUDLAUGSSON 1959-60
S.J. Gudlaugsson, *Katalog der Gemälde Gerard ter Borch*, The Hague 1959-60, 2 vols.

HAAGEN 1932
J.K. Van der Haagen, *De schilders Van der Haagen en hun werk*, Voorburg 1932.

HÄRTING 1983
W.A. Härting, *Studien zur Kabinettbildmalerei des Frans Francken II 1581-1642*, Hildesheim 1983.

THE HAGUE 1958-59
Jan Steen, Mauritshuis, The Hague 1958-59.

THE HAGUE 1974
Gerard Ter Borch, Mauritshuis, The Hague/Landesmuseum für Kunst und Kulturgeschichte, Münster, The Hague 1974.

THE HAGUE 1979-80
Zo wijd de wereld strekt, Mauritshuis, The Hague 1979-80.

THE HAGUE 1981-82
Jacob van Ruisdael 1628/29-1682, Mauritshuis, The Hague 1981-82.

THE HAGUE 1982
Terugzien in bewondering, Mauritshuis, The Hague 1982.

HAIRS 1955
M.L. Hairs, *Les peintres Flamands de fleurs au XVIIe siècle*, Brussels/Paris 1955.

HELD 1980
J.S. Held, *The oil sketches of P.P. Rubens, a critical catalogue*, Princeton, N.J. 1980, 2 vols.

'S-HERTOGENBOSCH 1984
Herinneringen aan Italië: kunst en toerisme in de 18de eeuw, Noordbrabants Museum, 's-Hertogenbosch/Kasteel 'Het Nijenhuis', Heino/Frans Halsmuseum, Haarlem, Zwolle 1984.

HIRSCHMANN 1916
O. Hirschmann, *Hendrick Goltzius als Maler 1600-1617*, The Hague 1916.

HÖHNE 1959
E. Höhne, *Adriaen Brouwer*, Leipzig 1959.

HOFSTEDE DE GROOT 1907-28
C. Hofstede de Groot, *Beschreibendes und kritisches Verzeichnis der Werke der hervorragendsten holländischen Maler des XVII. Jahrhunderts*, Erlingen/Paris 1907-28, 10 vols.

HOOGEWERFF 1936-47
G.J. Hoogewerff, *De Noord-Nederlandse schilderkunst*, The Hague 1936-47, 4 vols.

HULST 1982
R.A. d'Hulst, *Jacob Jordaens*, Antwerp 1982.

HYMANS 1910
H. Hymans, *Antonio Moro: son oeuvre et son temps*, Brussels 1910.

INGERSOLL-SMOUSE 1926
F. Ingersoll-Smouse, *Joseph Vernet I*, Paris 1926.

JAARBOEK ANTWERPEN
Jaarboek van het Koninklijk Museum voor Schone Kunsten, Antwerp.

JAARVERSL. VER. REMBRANDT
Verslag. Vereniging Rembrandt tot Behoud en Vermeerdering van Kunschatten in Nederland, Amsterdam.

JANTZEN 1979
H. Jantzen, *Das Niederländische Architekturbild*, Brunswick 1979 (the Leipzig 1910 edition extended and improved).

J. BERLINER MUSEEN
Jahrbuch der Berliner Museen: Neue Folge Jahrbuch Preussischer Kunstsammlungen, Berlin.

J. HAMB. KUNSTSAMML.
Jahrbuch der Hamburger Kunstsammlungen, Hamburg.

J. KUNSTH. SAMML. A.K.
Jahrbuch der Kunsthistorischen Sammlungen des Allerhöchsten Kaiserhauses, Vienna.

J. KUNSTH. SAMML. WIEN.
Jahrbuch der Kunsthistorischen Sammlungen in Wien, Vienna.

J. KUNSTW.
Jahrbuch für Kunstwissenschaft, Leipzig/Berlin.

JONGE 1983
C.H. de Jonge, *Paulus Moreelse: portret- en genreschilder te Utrecht 1571-1638*, Assen 1938.

JONGH 1967
E. de Jongh, *Zinne- en minnebeelden in de Nederlandse schilderkunst van de zeventiende eeuw*, Amsterdam/Antwerp 1967.

J. OUD UTRECHT
Jaarboekje van Oud Utrecht: Vereniging tot beoefening en ter verspreiding van de kennis der geschiedenis van Utrecht en omstreken, Utrecht.

J. PREUSS. KUNSTSAMML.
Jahrbuch der Königlich Preussischen Kunstsammlungen, Berlin.

KETTERING 1983
A. McNeil Kettering, *The Dutch arcadia: pastoral art and its audience in the golden age*, Montclair 1983.

KEYES 1975
G. Keyes, *Cornelis Vroom: marine and landscape artist*, Alphen aan den Rijn 1975, 2 vols.

KEYES 1984
G. Keyes, *Esaias van de Velde*, Doornspijk 1984.

KIRSCHENBAUM 1977
B.D. Kirschenbaum, *The religious and historical paintings of Jan Steen*, New York 1977.

KNOEF 1947
J. Knoef, *Cornelis Troost*, Amsterdam 1947.

KNUTTEL 1962
G. Knuttel, *Adriaen Brouwer: the master and his work*, The Hague 1962.

KOCH 1968
R.A. Koch, *Joachim Patenir*, Princeton 1968.

KONSTHIST. TIDSKR.
Konsthistorisk Tidskrift: Revy för Konst och Konstforskning, Stockholm.

KRAEMER-NOBLE 1973
M. Kraemer-Noble, *Abraham Mignon*, Leigh-on-Sea 1973.

KÜHN 1968
H. Kühn, ' A study of the pigments and the grounds used by Jan Vermeer', *National Gallery of Art Report and Studies in the History of Art* 2 (1968), pp. 155-202.

KUILE 1976
O. ter Kuile, *Adriaen Hanneman, een Haags portretschilder*, Alphen aan den Rijn 1976.

KULZEN 1954
R. Kulzen, *Michael Sweerts 1624-1664*, Hamburg 1954.

KURETSKY 1979
S. Donahue Kuretsky, *The paintings of Jacob Ochtervelt (1634-1682)*, Oxford 1979.

LARSEN 1962
E. Larsen, *Frans Post*, Amsterdam/Rio de Janeiro 1962.

LEEUWARDEN 1979-80
C. Dumas, *In het zadel: het Nederlandse ruiterportret van 1550 tot 1900*, Fries Museum, Leeuwarden/Noordbrabants Museum, 's-Hertogenbosch/Provinciaal Museum van Drente, Assen, Leeuwarden 1979-80.

LEIDEN 1966
Gabriël Metsu, Stedelijk Museum 'De Lakenhal', Leiden 1966.

LEIDEN 1970
IJdelheid der ijdelheden: Hollandse vanitas-voorstellingen uit de zeventiende eeuw, Stedelijk Museum 'De Lakenhal', Leiden 1970.

LIEDTKE 1982
W. Liedtke, *Architectural painting in Delft*, Doornspijk 1982.

LILIENFELD 1914
K. Lilienfeld, *Arent de Gelder: sein Leben und seine Kunst*, The Hague 1914.

LONDON 1947
G. Reynolds, *Nicolas Hilliard and Isaac Oliver*, Victoria & Albert Museum, London 1947.

LONDON 1974
D. Foskett, *Samuel Cooper and his contemporaries*, National Portrait Gallery, London 1974.

LONDON 1976
Art in seventeenth century Holland, National Gallery, London 1976.

LONDON 1983
R. Strong, *Artists of the Tudor court: the portrait miniature rediscovered*, Victoria & Albert Museum, London 1983.

LONG 1929
B.S. Long, *British miniaturists*, London 1929.

MAASTRICHT 1982
Adriaen Brouwer, David Teniers the Younger, Kunsth. Noortman & Brod, New York/Maastricht 1982.

MACLAREN 1960
N. MacLaren, *The Dutch school* (National Gallery catalogues), London 1960.

MANKE 1963
I. Manke, *Emanuel de Witte*, Amsterdam 1963.

MARBURGER J.
Marburger Jahrbuch für Kunstwissenschaft, Marburg.

MARLIER 1934
G. Marlier, *Anthonis Mor van Dashorst (Antonio Moro)*, Brussels 1934.

MARLIER 1957
G. Marlier, *Ambrosius Benson et la peinture au temps de Charles Quint*, Damme 1957.

MARTIN 1901
W. Martin, *Het leven en de werken van Gerrit Dou beschouwd in verband met het schildersleven van zijn tijd*, Leiden 1901.

MARTIN 1935-36
W. Martin, *De Hollandsche schilderkunst in de zeventiende eeuw*, Amsterdam 1935-36, 2 vols.

MARTIN 1950
W. Martin, *De schilderkunst in de tweede helft van de 17de eeuw*, Amsterdam 1950.

MARTIN 1954
W. Martin, *Jan Steen*, Amsterdam 1954.

MINNEAPOLIS 1971
Dutch masterpieces from the eighteenth century. paintings and drawings 1700-1800, Minneapolis Institute of Arts/Toledo Museum of Art/Philadelphia Museum of Art, Minneapolis 1971.

MITCHELL 1973
P. Mitchell, *European flower painters*, London 1973.

MAANDBL. B.K.
Maandblad voor Beeldende Kunsten, Amsterdam.

MOES & BIEMA 1909
E.W. Moes & E. van Biema, *De Nationale Konst-Gallerij en het Koninklijk Museum: bijdrage tot de geschiedenis van het Rijksmuseum*, Amsterdam 1909.

MOLTKE 1965
J.W. von Moltke, *Govert Flinck*, Amsterdam 1965.

MONTREAL 1969
Rembrandt and his pupils, Montreal Museum of Fine Arts/ Art Gallery of Ontario, Toronto 1969.

MÜNSTER 1979-80
Stilleben in Europa, Westfälisches Landesmuseum für Kunst und Kulturgeschichte, Münster/ Staatliche Kunsthalle, Baden-Baden, Münster 1979-80.

MURDOCH 1981
J. Murdoch, *The English miniature*, New Haven 1981.

NAUMANN 1981
O. Naumann, *Frans van Mieris*, Doornspijk 1981, 2 vols.

NEURDENBURG 1948
E. Neurdenburg, *De zeventiende eeuwsche beeldhouwkunst in de Noordelijke Nederlanden*, Amsterdam 1948.

NEW YORK 1979
William & Mary and their house, The Pierpont Morgan Library, New York 1979.

NICOLSON 1979
B. Nicolson, *The international Caravaggesque movement*, Oxford 1979.

NIEMEIJER 1973
J.W. Niemeijer, *Cornelis Troost 1696-1750*, Assen 1973.

NIEMEIJER 1980
J.W. Niemeijer et al., *Cornelis Ploos van Amstel 1726-1798: kunstverzamelaar en prentuitgever*, Assen 1980.

N.K.J.
Nederlands Kunsthistorisch Jaarboek. The Hague.

NOTTEN 1907
H. van Notten, *Rombout Verhulst, beeldhouwer 1624-1698: een overzicht zijner werken*, The Hague 1907.

O.H.
Oud Holland: Tweemaandelijks Nederlands Kunsthistorisch Tijdschrift, Amsterdam.

O.K.
Openbaar Kunstbezit: Stichting voor esthetische vorming door middel van de radio, in woord en beeld, Amsterdam.

OLDENBOURG 1911
R. Oldenbourg, *Thomas de Keysers Tätigkeit als Maler: ein Beitrag zur Geschichte des Holländischen Porträts*, Leipzig 1911.

OLDENBOURG 1921
R. Oldenbourg, *P.P. Rubens: des Meisters Gemälde*, Stuttgart/ Berlin (Klassiker der Kunst) 1921

ONS AMSTERDAM
Ons Amsterdam: Maandblad van de Gemeentelijke Commissie Heemkennis, Amsterdam.

OS & PRAKKEN 1974
H.W. van Os & M. Prakken, *The Florentine paintings in Holland, 1300-1500*, Maarssen 1974.

OSTEN & VEY 1969
G. von der Osten & H. Vey, *Painting and sculpture in Germany and the Netherlands 1500-1600*, Harmondsworth 1969.

OUDH. JAARBOEK
Oudheidkundig Jaarboek, Utrecht.

PARIS 1970-71
Le siècle de Rembrandt: tableaux hollandais des collections publiques françaises, Musée du Petit Palais, Paris 1970-71.

PHILADELPHIA 1984
P.C. Sutton et al., *Masters of seventeenth-century Dutch genre painting*, Philadelphia Museum of Art/Gemäldegalerie, Staatliche Museen Preussischer Kulturbesitz, Berlin-Dahlem/ Royal Academy of arts, London, Philadelphia 1984.

PIGLER 1974
A. Pigler, *Barockthemen*, Budapest 1974, 3 vols.

PLIETZSCH 1939
E. Plietzsch, *Vermeer van Delft*, Munich 1939.

PLIETZSCH 1960
E. Plietzsch, *Holländische und Flämische Maler des 17. Jahrhunderts*, Leipzig 1960.

PRESTON 1937
L. Preston, *Sea and river painters of the Netherlands in the 17th century*, London 1937.

PRESTON 1974
R. Preston, *The seventeenth century marine painters of the Netherlands*, Leigh-on-Sea 1974.

PUYVELDE 1953
L. van Puyvelde, *Jordaens*, Paris/ Brussels 1953.

QUART. MONTREAL
A Quarterly Review of the Montreal Museum of Fine Arts, Montreal.

RANITZ 1971
L.C. de Ranitz, 'Portretminiaturen uit het Rijksmuseum', *Bulletin van het Rijksmuseum* 19 (1971), pp. 7-10.

REISS 1975
S. Reiss, *Aelbert Cuyp*, London 1975.

REVUE BELGE
Revue Belge d'Archéologie et d'Histoire de l'Art, Brussels/Paris.

ROBINSON 1974
F.W. Robinson, *Gabriel Metsu*, New York 1974.

ROME 1973
La pastorale Olandese nel Seicento: l'inspirazione poetica della pittura nel secolo d'oro, Istituto Olandese, Rome 1983.

ROSENBERG 1900
A. Rosenberg, *Adriaen und Isack van Ostade*, Bielefield/Leipzig 1900.

ROSENBERG 1928
J. Rosenberg, *Jacob van Ruisdael*, Berlin 1928.

ROSENBERG, SLIVE & KUILE 1977
J. Rosenberg, S. Slive & E.H. ter Kuile, *Dutch art and architecture 1600-1800*, Harmondsworth 1977.

ROTTERDAM 1953
Olieverfschetsen van Rubens, Museum Boymans-van Beuningen, Rotterdam 1953.

ROTTERDAM 1958
Michael Sweerts en zijn tijdgenoten, Museum Boymans-Van Beuningen, Rotterdam 1958.

ROTTERDAM 1965
Jan Gossaert genaamd Mabuse, Museum Boymans-van Beuningen, Rotterdam/ Groeningemuseum, Bruges, Rotterdam 1965.

ROTTERDAM 1973
Adriaen van der Werff: Kralingen 1659-1722 Rotterdam, Historisch Museum, Rotterdam 1973.

RUSSELL 1975
M. Russell, *Jan van de Cappelle*, Leigh-on-Sea 1975.

SALERNO 1977-80
L. Salerno, *Pittori di paesaggio del Seicento a Roma*, Rome 1977-80, 3 vols.

SALVINI & GROHN 1971
R. Salvini & W. Grohn, *Das gemalte Gesamtwerk von Hans Holbein der Jürgere*, Milan 1971.

SCHAAR 1958
E. Schaar, *Studien zu Nicolaes Berchem*, Cologne 1958.

SCHLOSS 1982
C. Skeeles Schloss, *Travel, trade and temptation: the Dutch Italianate harbor scene, 1640-1680*, Ann Arbor, Michigan 1982.

SCHNACKENBURG 1981
B. Schnackenburg, *Adriaen van Ostade, Isack van Ostade Zeichnungen und Aquarelle*, Hamburg 1981, 2 vols.

SCHNEIDER 1933
A. von Schneider, *Caravaggio und die Niederländer*, Marburg 1933.

SCHNEIDER & EKKART 1973
H. Schneider & R.E.O. Ekkart, *Jan Lievens: sein Leben und seine Werke*, Amsterdam 1973 (the edition of 1932 revised).

SCHUURMAN 1947
K.E. Schuurman, *Carel Fabritius*, Amsterdam (1947).

SCHWARTZ 1984
G. Schwartz, *Rembrandt: zijn leven, zijn schilderijen*, Maarssen 1984.

SILVER 1984
L. Silver, *The paintings of Quinten Massys: with catalogue raisonné*, Oxford 1984.

SIMIOLUS
Simiolus: Kunsthistorisch Tijdschrift, Utrecht; later *Simiolus: Netherlands Quarterly for the History of Art*, Bussum/Maarssen.

SLIVE 1970-74
S. Slive, *Frans Hals*, London 1970-74, 3 vols.

SLUIJTER-SEIJFFERT 1984
N.C. Sluijter-Seijffert, *Cornelis van Poelenburch (ca. 1593-1667)*, Enschede 1984.

SMITH 1982
D.R. Smith, *Masks of wedlock: seventeenth century Dutch marriage portraiture*, Ann Arbor, Michigan 1982.

SNOW 1979
E.A. Snow, *A study of Vermeer*, London 1979.

SOUSA-LEÂO 1973
J. de Sousa-Leâo, *Frans Post*, Amsterdam 1973.

SPETH-HOLTERHOFF 1957
S. Speth-Holterhoff, *Les peintres flamands de cabinets d'amateurs au xvii-ième siècle*, Brussels 1957.

STARING 1947
A. Staring, *Fransche kunstenaars en hun Hollandsche modellen in de 18de eeuw en in de aanvang der 19de eeuw*, The Hague 1947.

STARING 1948
A. Staring, *Kunsthistorische verkenningen: een bundel kunsthistorische opstellen*, The Hague 1948.

STARING 1951
A. Staring, *De portretten van den Koning-Stadhouder*, The Hague 1951.

STARING 1956
A. Staring, *De Hollanders thuis: gezelschapstukken uit drie eeuwen*, The Hague 1956.

STARING 1958
A. Staring, *Jacob de Wit 1695-1754*, Amsterdam 1958.

STECHOW 1966
W. Stechow, *Dutch landscape painting of the 17th century*, London 1966.

STECHOW 1975
W. Stechow, *Salomon van Ruysdael*, Berlin 1975 (revised and extended from edition Berlin 1938).

STELAND-STIEF 1971
A.C. Steland-Stief, *Jan Asselijn nach 1610 bis 1652*, Amsterdam 1971.

SUIDA 1958
B. Suida-Manning, W. Suida, *Luca Cambiaso*, Milan 1958.

STOLL 1923
A. Stoll, *Der Maler Johann Friedrich August Tischbein und seine Familie: ein Lebensbild nach den Aufzeichnungen seiner Tochter Caroline*, Stuttgart 1923.

STRONG 1983
R. Strong, *The English Renaissance miniature*, London 1983.

SUMOWSKI 1983
W. Sumowski, *Gemälde der Rembrandt-Schüler*, Landau 1983, dl. 1.

SUTTON 1980
P.C. Sutton, *Pieter de Hooch*, Oxford 1980.

SWILLENS 1935
P.T.A. Swillens, *Pieter Janszoon Saenredam: schilder van Haarlem 1597-1665*, Amsterdam 1935.

SWILLENS 1950
P.T.A. Swillens, *Johannes Vermeer, painter of Delft 1632-1675*, Utrecht/Brussels 1950.

THIEL 1981
P.J.J. van Thiel, 'De inrichting van de Nationale Konst-Gallerij in het openingsjaar 1800', *Oud Holland* 95 (1981), pp. 170-227.

THIEME-BECKER 1907-47
U. Thieme, F. Becker, *Allgemeines Lexikon der bildenden Künstler von der Antike bis zur Gegenwart*, Leipzig 1907-47, 36 vols.

THIERY 1953
Y. Thiéry, *Le paysage Flamand au xviie siècle*, Paris/Brussels 1953.

TRIVAS 1941
N.S. Trivas, *The paintings of Frans Hals*, London 1941.

UTRECHT 1961
Pieter Jansz. Saenredam, Centraal Museum, Utrecht 1961.

VALENTINER 1923
W.R. Valentiner, *Frans Hals: des Meisters Gemälde*, Stuttgart/Leipzig (Klassiker der Kunst) 1923.

VLIET 1966
P. van Vliet, 'Spaanse schilderijen in het Rijksmuseum, afkomstig van schenkingen van koning Willem I', *Bulletin van het Rijksmuseum* 14 (1966). pp. 131-149.

VRIES 1948
A.B. de Vries, *Jan Vermeer van Delft*, Amsterdam 1948.

VRIES 1969
L. de Vries, 'Vorstelijke beeltenissen in miniatuur', *Spiegel Historiael* 4 (1969), pp. 165-168.

VRIES 1977
L. de Vries, *Jan Steen, de kluchtschilder*, Groningen 1977.

VRIES 1978
A.B. de Vries, *Rembrandt in the Mauritshuis*, Alphen aan den Rijn 1978.

VRIES 1984
L. de Vries, *Jan van der Heyden*, Amsterdam 1984.

VROOM 1945
N.R.A. Vroom, *De schilders van het monochrome banketje*, Amsterdam 1945.

VROOM 1980
N.R.A. Vroom, *A modest message, as intimated by the painters of the 'monochrome banketje'*, Schiedam 1980.

WAGNER 1971
H. Wagner, *Jan van der Heyden*, Amsterdam/Haarlem 1971.

WALLRAF-R. J.
Wallraf-Richartz Jahrbuch herausgegeben von der Wallraf-Richartz Gesellschaft in Köln, Cologne.

WALSH 1973
J. Walsh Jr., 'Vermeer', *The Metropolitan Museum of Art Bulletin* 31 (1973), pp. 1-100.

WASHINGTON 1980-81
Gods, saints and heroes, National Gallery of Art, Washington/The Detroit Institute of Arts/Rijksmuseum, Amsterdam, Washington 1980-81.

WESTHOFF-KRUMMACHER 1965
H. Westhoff-Krummacher, *Barthel Bruyn der Ältere als Bildnismaler*, Munich/Berlin 1965.

WESTRHEENE 1867
T. van Westrheene Wz., *Paulus Potter: sa vie et ses oeuvres*, The Hague 1867.

WETHEY 1975
H.E. Wethey, *The paintings of Titian*, London 1975, 3 vols.

WHEELOCK 1977
A.K. Weelock, *Perspective, optics, and Delft artists around 1650*, New York 1977.

WHEELOCK 1981
A.K. Wheelock, *Jan Vermeer*, New York 1981.

WIJNMAN 1959
H.F. Wijnman, *Uit de kring van Rembrandt en Vondel*, Amsterdam 1959.

WILLIAMSON 1904
G.C. Williamson, *The history of portrait miniatures*, London 1904, 2 vols.

WINKLER 1924
F. Winkler, *Die Altniederländische malerei: Die Malerei in Belgien und Holland von 1400-1600*, Berlin 1924.

WINKLER 1959
F. Winkler, *Hans von Kulmbach*, Kulmbach 1959.

WRIGHT 1982
C. Wright, *Rembrandt: self-portraits*, London 1982.

ZEITSCHR. B.K.
Zeitschrift für Bildende Kunst, Leipzig.